karim rashid evolution

UNIVERSE

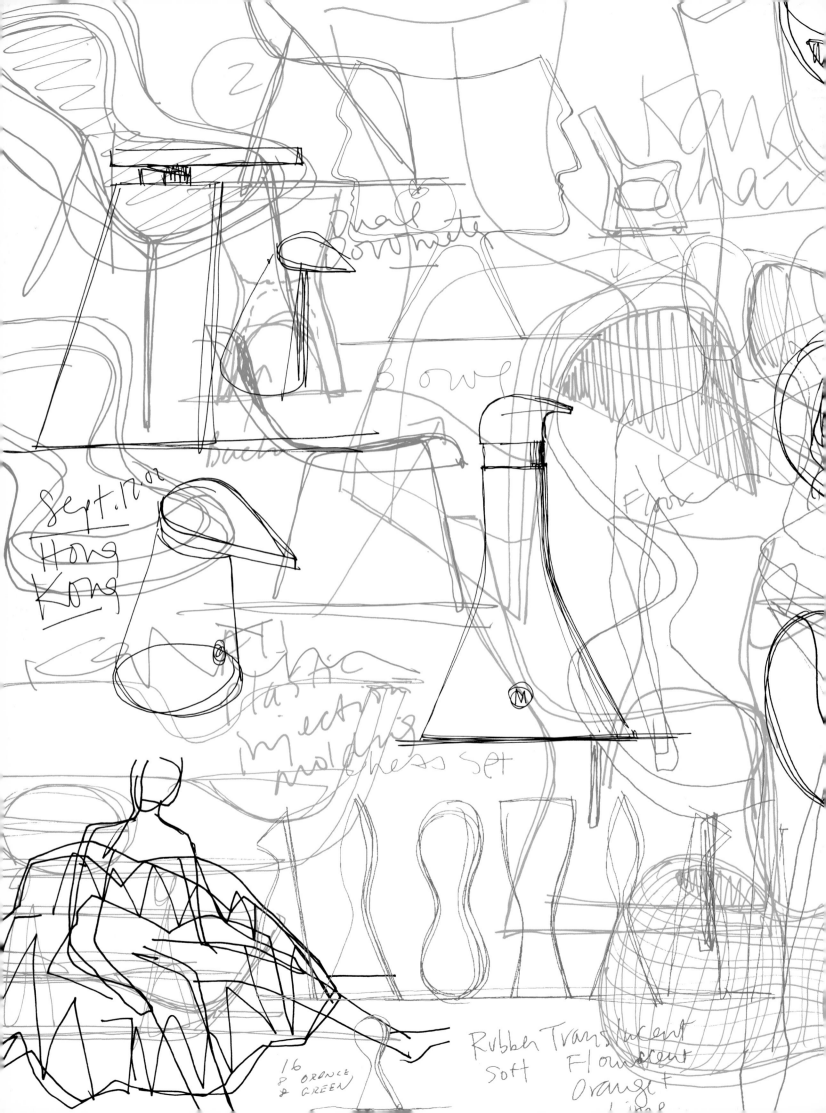

Sept. 12.02
Hong Kong

chess set

16
P ORANGE
& GREEN

Rubber Translucent
Soft Flourecent
 Orange

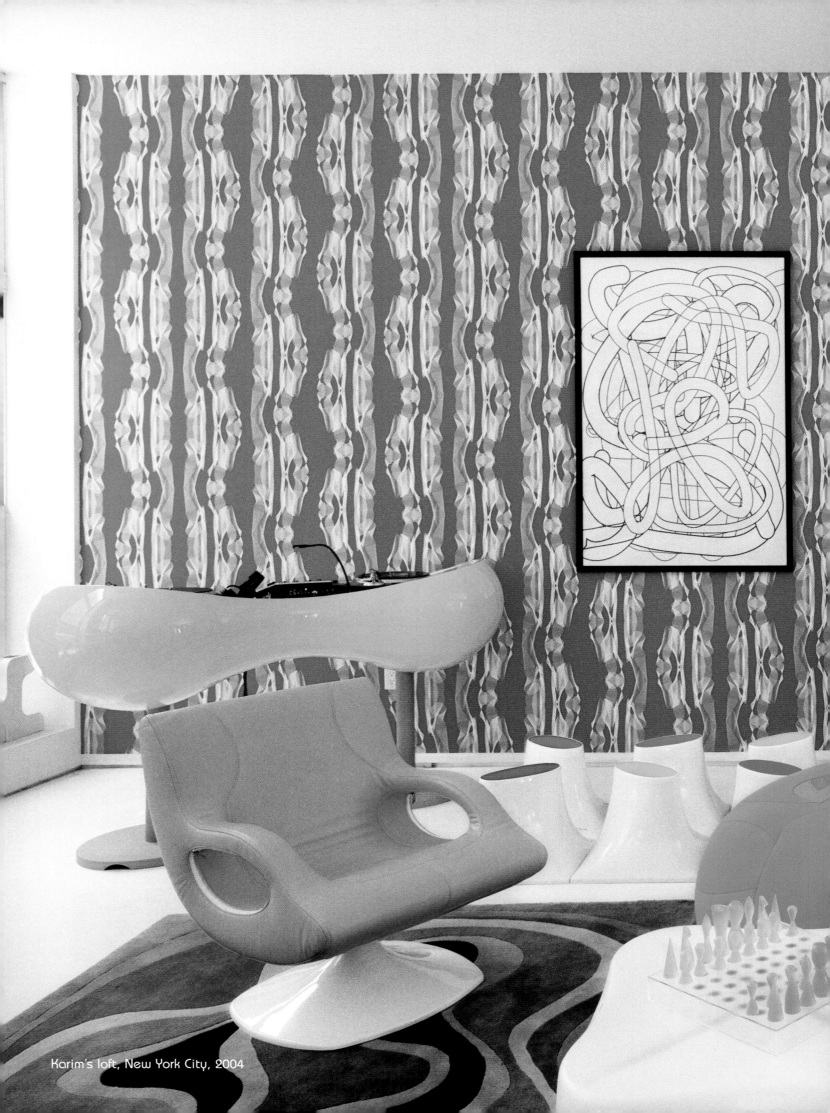

Karim's loft, New York City, 2004

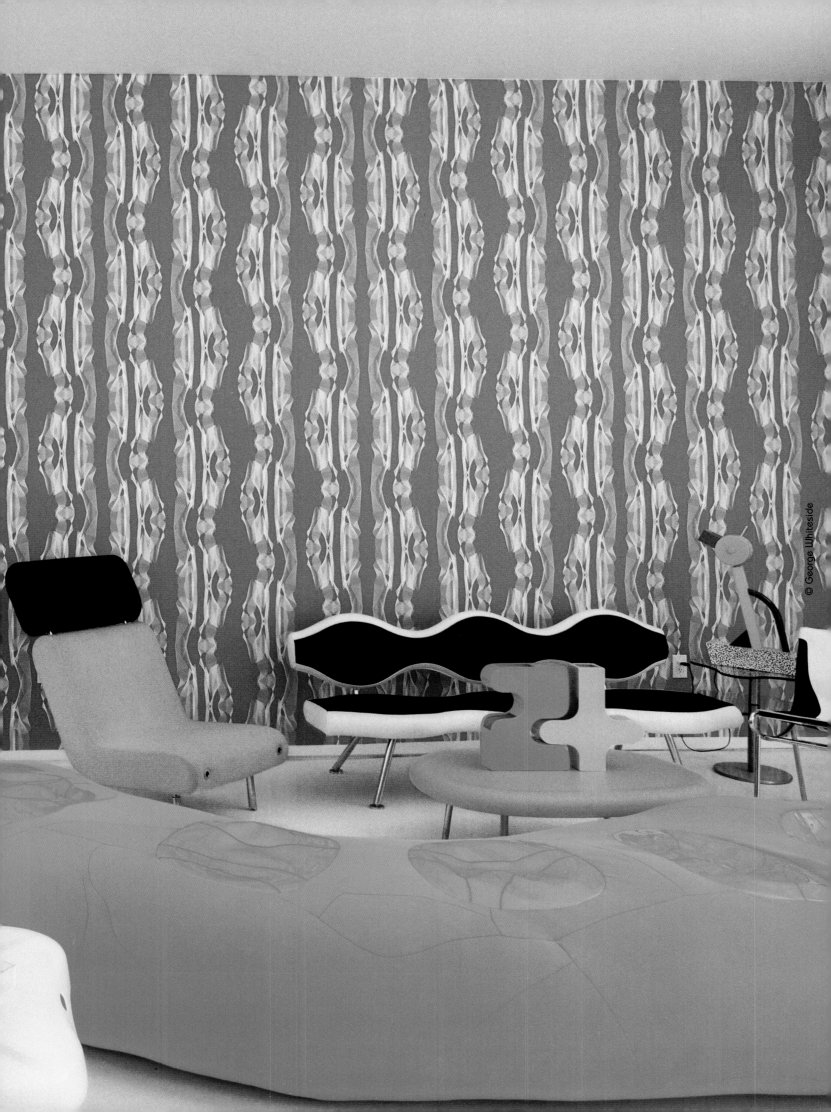

This book is dedicated to my father—an artist, a designer, and a creator 1911–2003

Contents

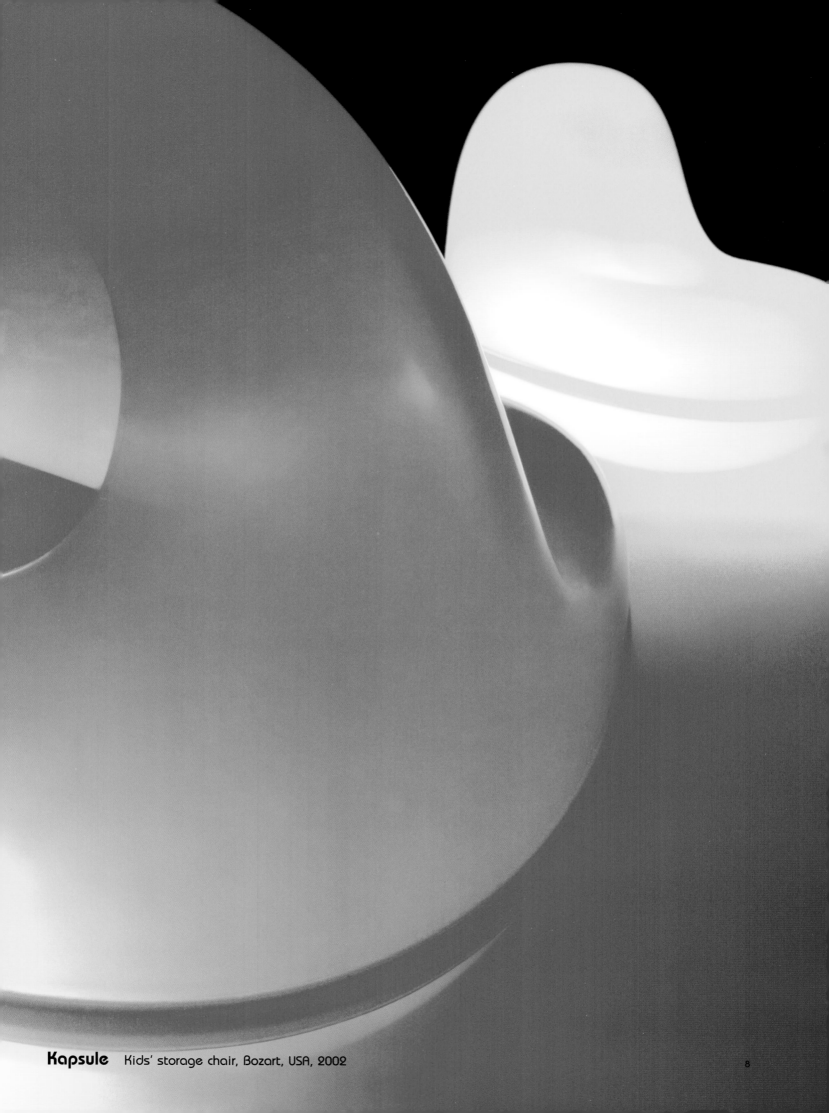

Kapsule Kids' storage chair, Bozart, USA, 2002

FAST FOREWARD Recent polls have
found that shopping has become more popular than
sex. Religion and architecture, once the hegemonic purveyors of
cultural production and codification, now find themselves dominated by
entertainment and consumer products. Karim's time has come. Aestheticization's
influence on popular culture can now be seen operating within a context that relates
phenomena as diverse as *Wallpaper** to *The Wall Street Journal*, Venturi to Versace, and
Artforum to *Penthouse Forum*. Today, contemporary design is creatively employed in the nat-
uralization of desire, and no designer seems more attuned to this than Karim. Not only a bril-
liant propagandist of design, Karim is also a true character of contemporaneity. ¶ Another man of
his time, the designer Raymond Loewy, in one of his more oft-quoted anecdotes from *Never Leave
Well Enough Alone*, wrote how late one evening a client took him on a nighttime ride through the
Ohio countryside to visit his gigantic manufacturing plant. Silently gliding along the darkened
interstate, cars formed a continuous ribbon of lights moving swiftly in opposite directions.
With powerful precision, the car crested a hill and the sprawling plant came into view
underneath the clear, star-filled winter sky. "It was ablaze with blue mercury
light. Over certain areas, the sky was shivering with the blue-white
flashes of automatic welding. White, red, green, and blue signal
lights would punctuate the night. The whole sky was
aglow." Utterly moved by the magnificent slipstream of
productivity, Loewy had the sublime sense of "see-
ing the actual flow of the rich red blood of young,
vibrant America." ¶ I'm reminded of the time when
on a trip together, now many years ago, Karim
and I were touring the injection-molding factory
of a potential client in Japan. Amid the scrappy
outlying rural countryside, housed within an
unassuming and well-worn box of a building, we
encountered a large, gleamingly bright, and
seamlessly shiny space, where buff metal cavities
mated in an intricate orgy all around us. Mechanical
arms whirred, midwifing pneumatically ejected parts of
all colors and plastics. Soft and translucent, hard and shiny,
large and small—thousands of silent and perfect souls were
being born into life amid a raw and chaotic world. We were both struck
by the aesthetic ballet, unlike any American plant we had seen, where man and
machine were true symbiotes. Not satisfied to revel in the sheer spectacle before us,
Karim began to plan a documentary, and immediately took on the imaginary role of film direc-
tor, framing shots, sequencing scenes, scoring the action. He needed to make visible all of the
optimistic wonders this commodity consummation represented. We were awestruck witnesses to
some technological sublime, and he needed to share this, as a missionary may seek to convert the
uninitiated masses to an unseen higher order. It is this zeal for transgressive progress that fuels
Karim's optimistic belief that one need only see the latent potential that the wonders of
(man)ufacturing offer, in order to initiate a true understanding and deeper appreciation of the
magic of our neo-natural existence—and the bliss of living here and now. ¶ In this sense,
Karim is today's preeminent *phactory filosopher*. Nourishment from Italo Calvino's *Six
Memos for the Next Millennium* inspired him to reinterpret six postmodern literary
characteristics as the attributes for the post-postmodern objects he is busy
creating today: ecology of artifacts embodying the *nu-essential*
traits of lightness, quickness, exactitude, visibility, mul-
tiplicity, and consistency. >

In his approach of blurring the bound-
aries between art, fashion, design, and business,
Karim is astutely aware that in the contemporary hypermarket,
a product's durability is overrated, because objects are technologically
and telegenically destined to go out of date. In that he is resolutely of his time.
While many of his designs can be formally described as futuristic, structurally they
are unabashedly contemporary, residing unapologetically in a Jamesonian perpetual-
present within the fashion system in which they operate like haute couture—evanescent
and ephemeral yet knowing of what they speak. ¶ Half a century ago, Raymond Loewy pio-
neered a methodological axiom he termed MAYA (Most Advanced Yet Acceptable). It was much
maligned by modernist purists as a cynical strategy meant to appease the public with designs
that proceeded toward the "most advanced" possible but willfully stopped at the threshold of
local market acceptability, and he was criticized for believing that in order to maximize market
potential, one must target the lowest common denominator. A quick glance at Karim's over-
whelming output, his inventive neologisms, and visible success within the marketplace
may prompt one to make such a hasty comparison. But I suggest that another more
ingenuous strategy may be in play, one in which he uses Loewy's "most
advanced" as an engine thrusting the threshold of public accept-
ability further outward, reaching for the highest common
denominator. Karim places his faith in the belief that by
expanding the range of intellectual and formal
inquiry, and with the catalyzing role of the design-
er engaged in production, manufacturers—and
subsequently the public—will be stimulated to
respond to contemporaneity in new and hopeful-
ly profound ways. ¶ Karim's designs are not only
solid objects, they also represent new systems
of communication in a seamlessly homogenous
and technologically sophisticated world. Unlike
Loewy, who was seeking to define a new American
idiom for design within an international style con-
scious of its own national manifestation, Karim moves
the design project to a glossy formal language, eliminating
any specific cultural or social inflection: a global language of poly-
sexual forms, disorienting digital hues, employing a multivalent symbolic
vocabulary widely and equally understood as much for its soft spiritualism as for
its hard mathematics. With his style, certain regional or corporate forms of expression
become conflated with Karim's specifically literate set of forms and symbols. Not accidentally,
this gives rise to a personal logo-set effectively co-branding him with (and co-opting his mass-
market clients into) the *Nu global FashiN tribe of CT sophisticates Hu Spk 2DAYz techno-Esperanto.*
Members of this *Altrntve GNR8N* easily have more attitudes and expectations in common with one
another than they do with the rural populations of their own native countries. ¶ The world con-
tinues to become technologically distilled into experiences that are more simulated and more
stimulated. In the midst of this, Karim is enthusiastically creating tomorrow's world today. In
his striving to fuse sensual experience + spiritual elevation + contemporary materials +
technological innovation, he calls into question the longstanding divide between
design's two fundamental creative camps—that of the aesthete and that of the
functionalist. In doing so he is challenging himself (and design in general)
to reconcile modernity's spiritual division between mind and
body. ¶ To Karim, design is a religion, and in his church
God owns an MP4. **Peter Stathis**

10

method

dish soap

ultra concentrated for

aroma: lavender

13 FL OZ (384mL)

Dish soaps, special one-way valve, Method, USA, 2002

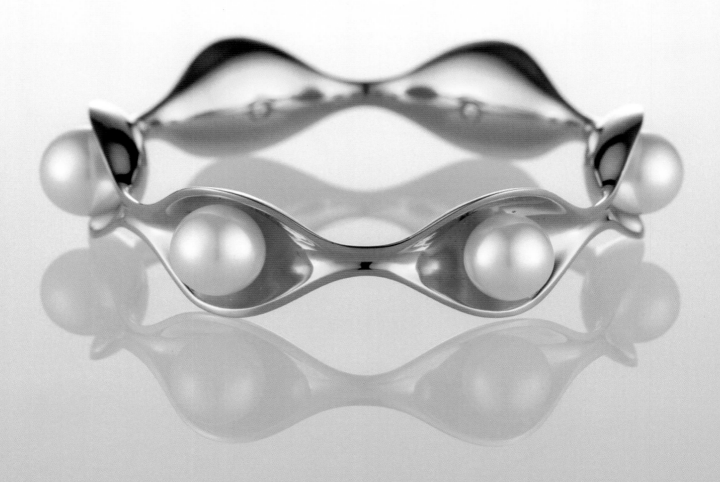

Pearl jewelry collection, Golay, Switzerland, 2004

SensualMINIMALISM Modernism eradicated the idea of the decorative or extraneous: a designed product spoke only of its necessary, inseparable constructs. Design was to be based on the ultimate and most reduced structure to achieve a "pure," minimized condition. The result was a landscape of clean, unadulterated aesthetics, where pure abstraction consisted of sacred geometry and mass production created a universal, "global" result—the perfect composition of the "essential." Due to its sacred geometric language, removed from history and nature, minimalism lacks the human aspect; this is possibly why it is seen as a divine spiritual aesthetic—non-referential, purely abstract, and artificial. I like design that traverses the boundaries of the associative and touches on the sensual, one that goes beyond the modernist doctrine of *beinahe nichts* (almost nothing). ¶ Minimalism seems to be shifting to a more sensual minimalism, or Sensualism, where objects communicate, engage, and inspire, yet remain fairly minimal *a posteriori*. They can speak simply and directly, without being superfluous. These new objects can be Smart, fuzzy, or low-tech. The marriage of new material and technology with pure geometry is significant and symbolic of a personal language. The new materials are reflective, smooth, glowing, pristine, glossy, mutable, flexible, tactile, synthetic, high-contrast, sensual, cold, hot, chrome, liquid, glass, lacquered, fluorescent, smart, interactive, and illusory. These materials formulate and inspire new languages. Is the language easy? It's undeniably beautiful, but is it human? Is it a language or philosophy that goes beyond the design community and touches people's souls? Regardless, it is here to stay and will reach a even higher form of perfection. ¶ I have described my work as Sensualism (sensual minimalism). It is a broad term I use to explain that minimalism is dead—it is too austere for the average person. It is not about real living; in fact, it is uncomfortable and challenging. Sensualism is about contraindicating minimalism; it is about having only what is essential, but with a friendlier, engaging, and organic relationship. ¶ There are several strategies to "deproductize" and develop successful products: **1** Design objects that meet all the criteria, not just one: beauty, performance, meaning, cost, seamless production, no manual labor, ease of assembly, Smart material, recyclable, spatial, human, behavioral, democratic and simple. **2** Make companies aware of the humanism of our products—the human connection and condition are key to successful objects. **3** Show companies that quality creates higher margins and greater brand loyalty. **4** Subtract SKUs (stock-keeping units) that are complex, confusing, non-communicative, labor-intensive, made from too many parts, high-maintenance and culturally irrelevant. **5** Design flexible, extensive, relaxed, modular, interchangeable, reconfigurable, multi-functional products. **6** Remove collateral, streamline distribution, manufacture on demand, drop-ship, manufacture locally, use global positioning, etc. **7** Promote, educate, and disseminate a direct, simple philosophy—design experiences versus objects, form follows subject. **8** Design creates its own market. **9** The OBJECT is the brand. **Karim Rashid**

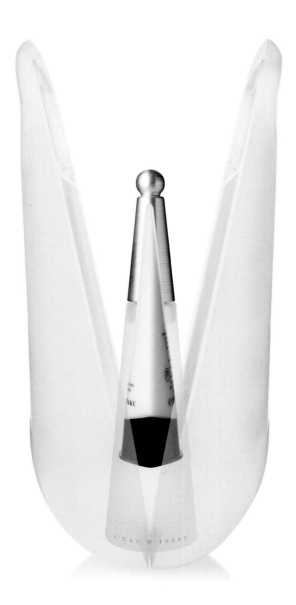

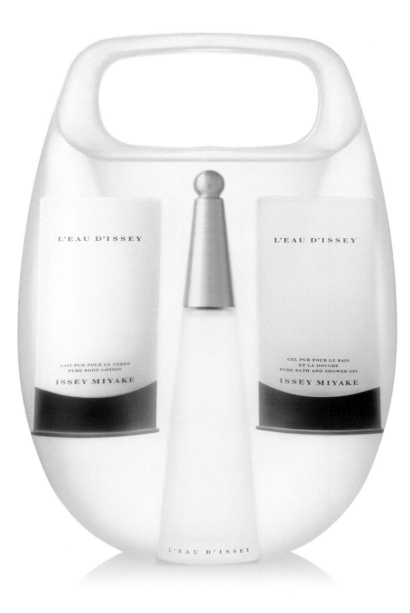

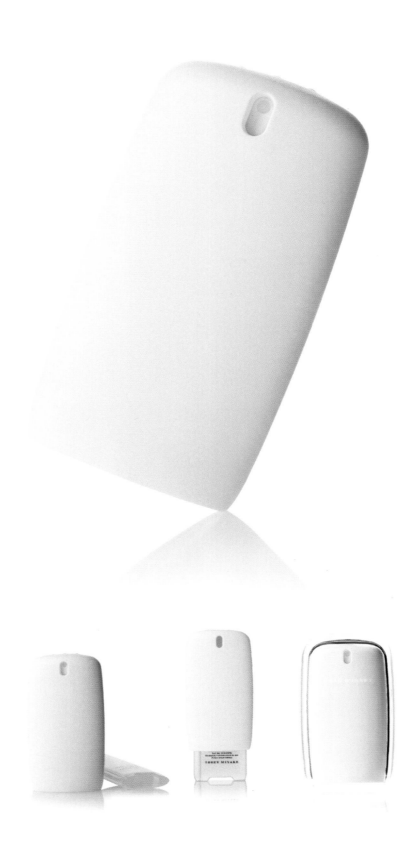

Issey In Your Pocket Refillable travel spray, BPI, France, 2003

Korus Umbra, Canada, 2002

Echo Woman's fragrance, Davidoff, France, 2004

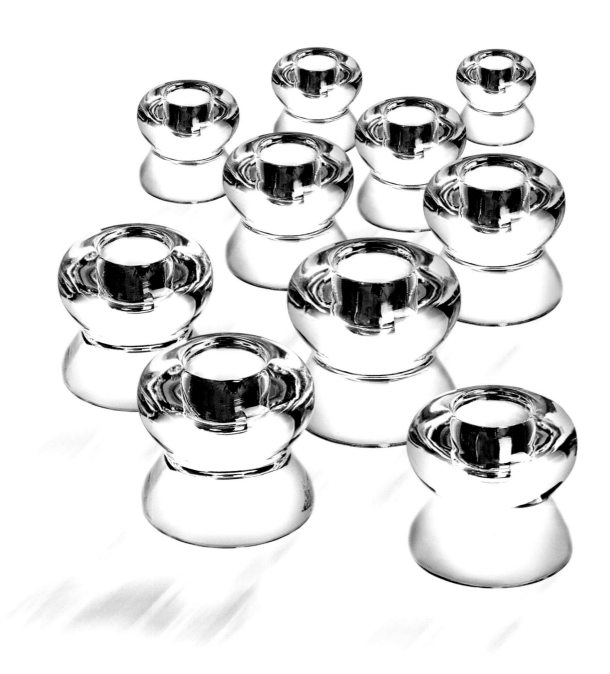

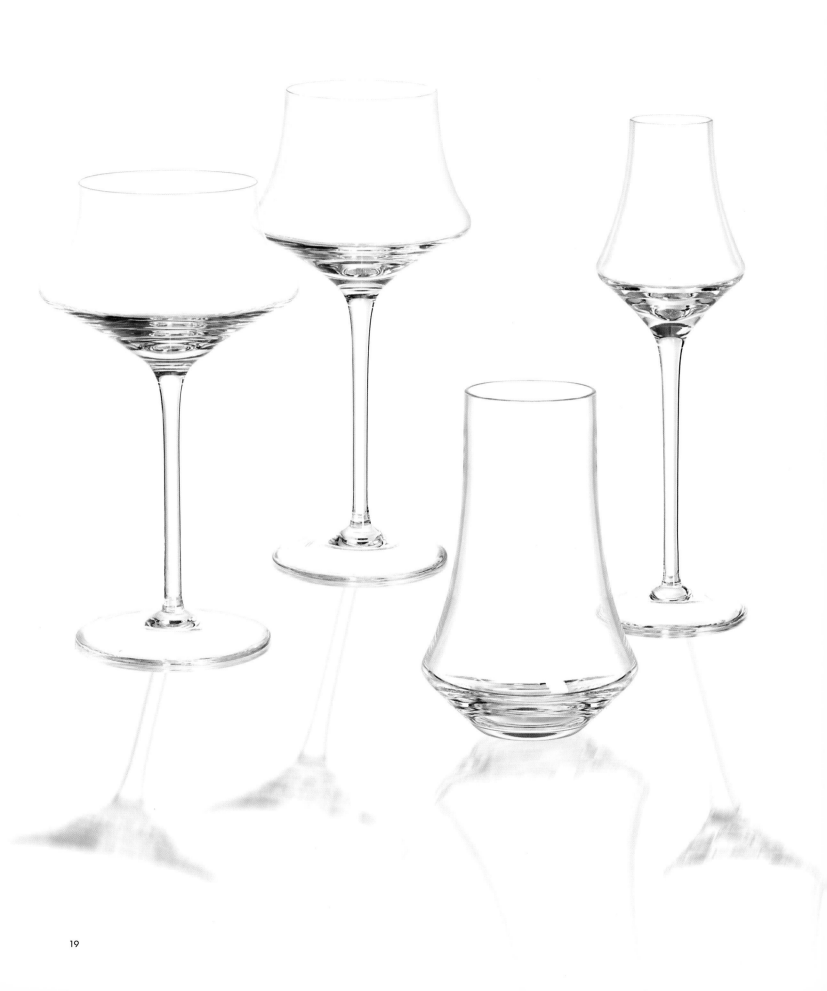

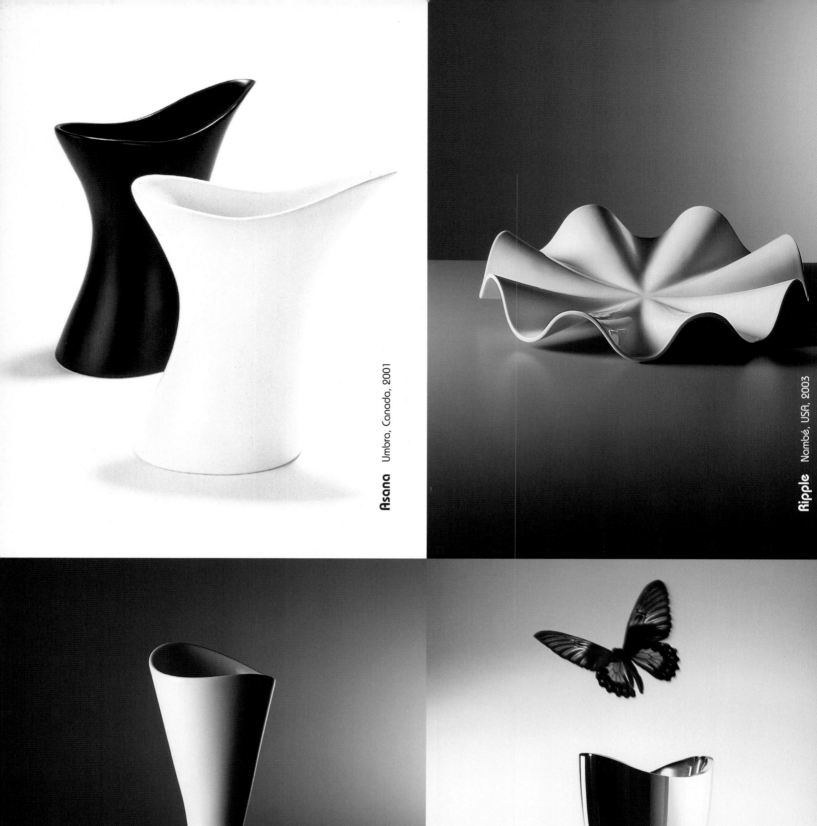

Asana Umbra, Canada, 2001

Ripple Nambé, USA, 2003

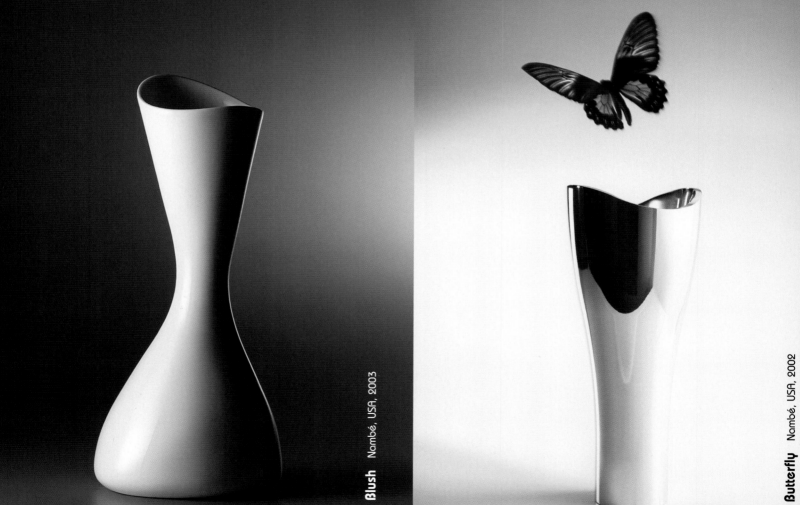

Blush Nambé, USA, 2003

Butterfly Nambé, USA, 2002

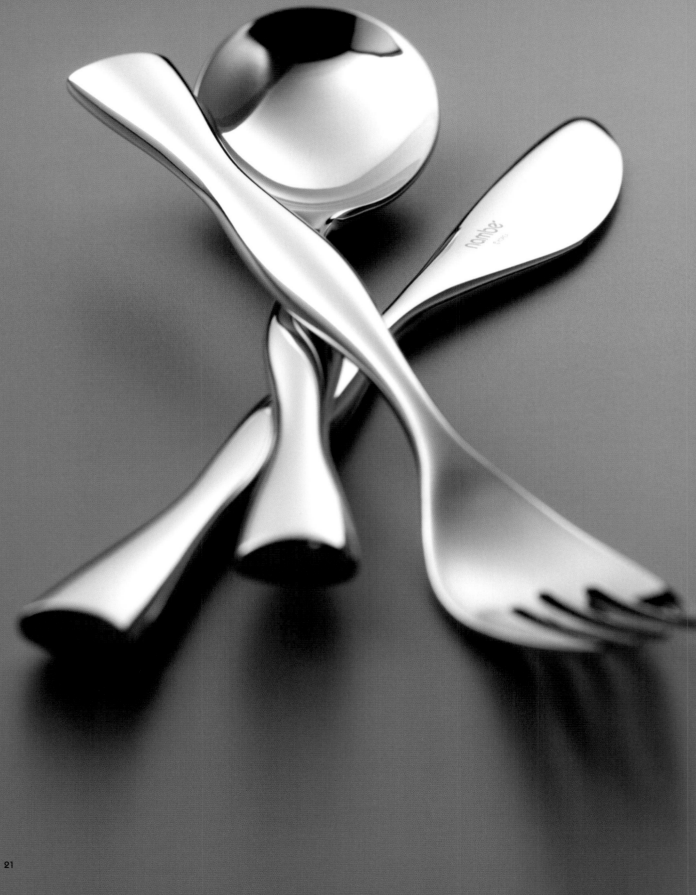

Yoono Mikasa, USA, 2003

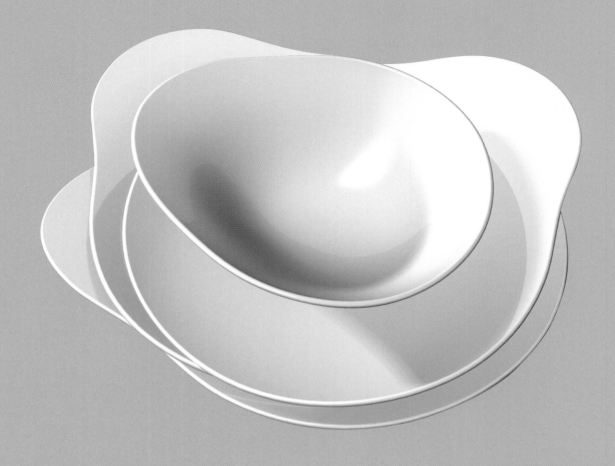

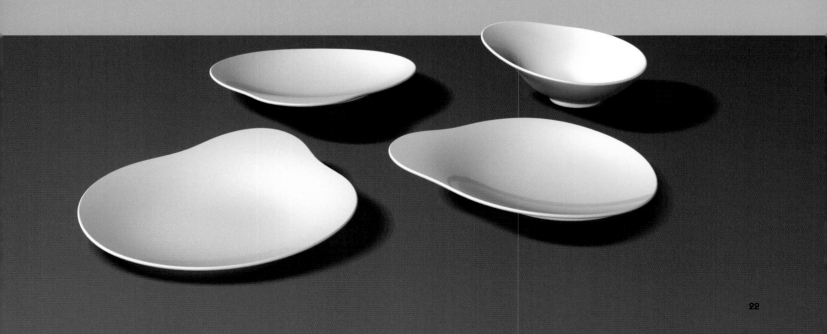

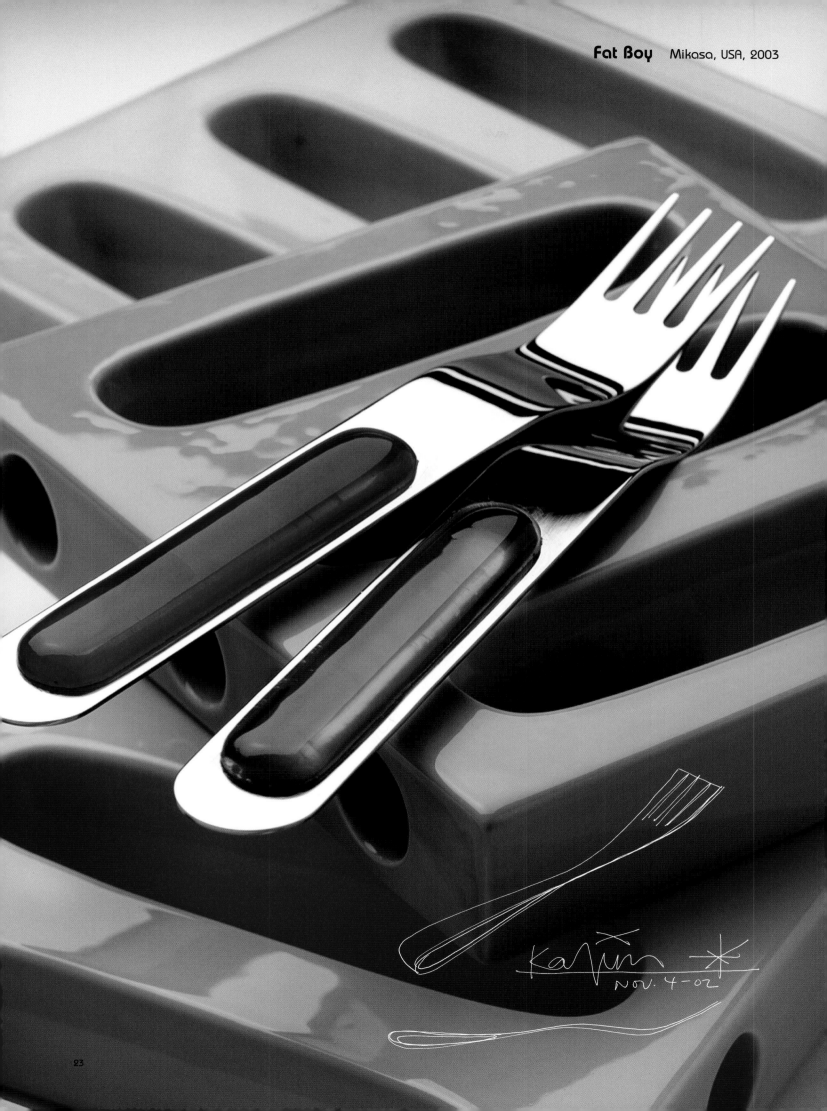

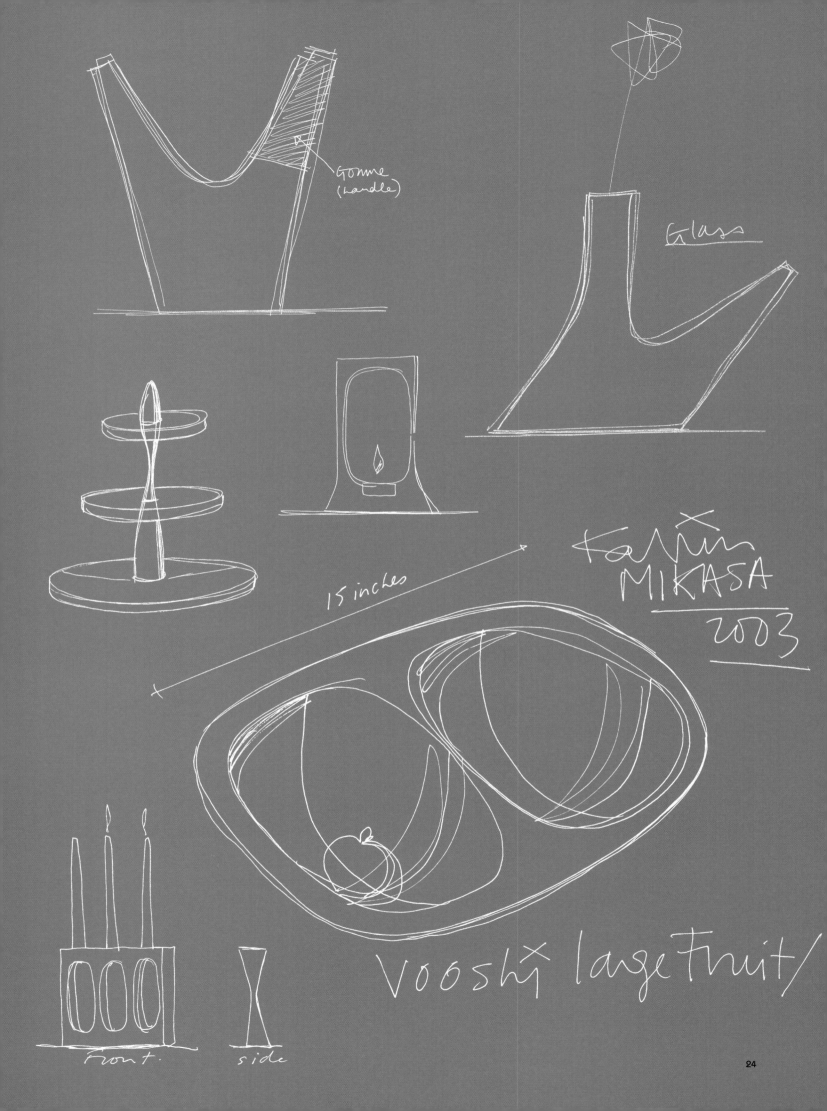

Gomme
(handle)

Glass

15 inches

Karim
MIKASA
2003

Vooshi large fruit/

front. side

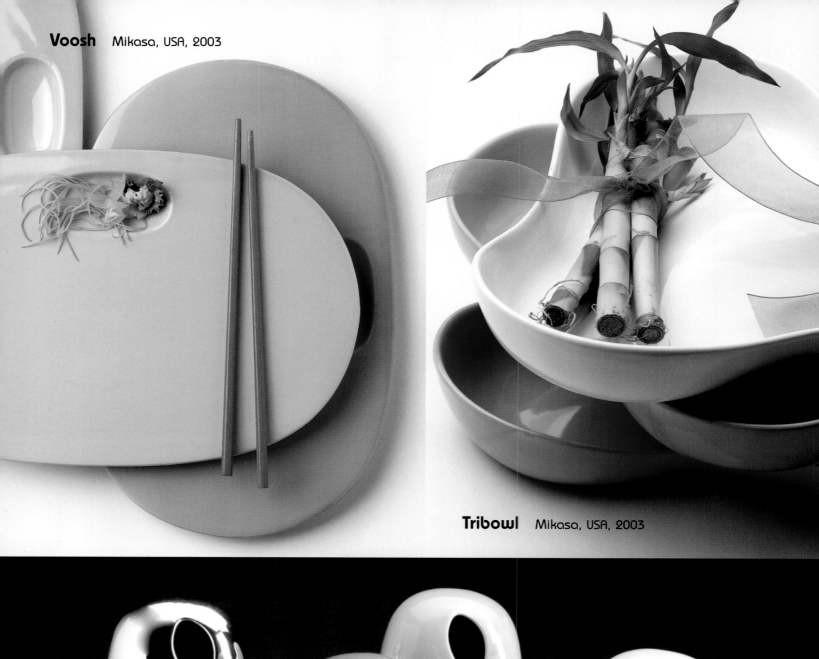

Voosh Mikasa, USA, 2003

Tribowl Mikasa, USA, 2003

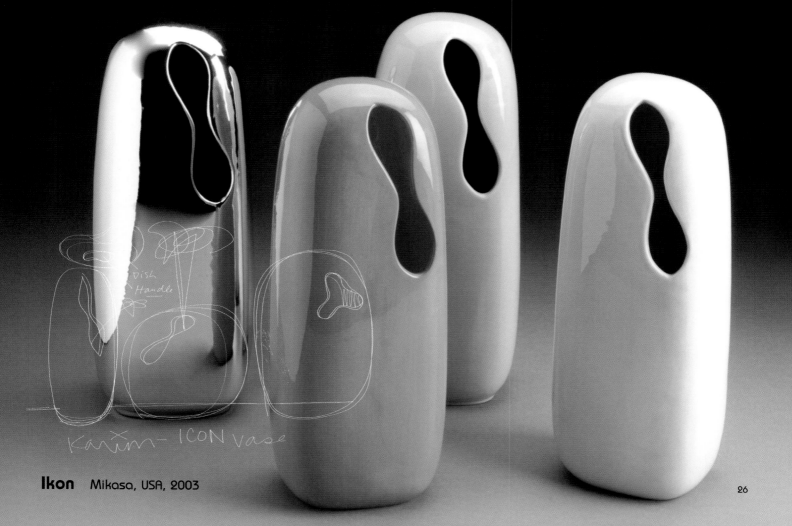

Ikon Mikasa, USA, 2003

26

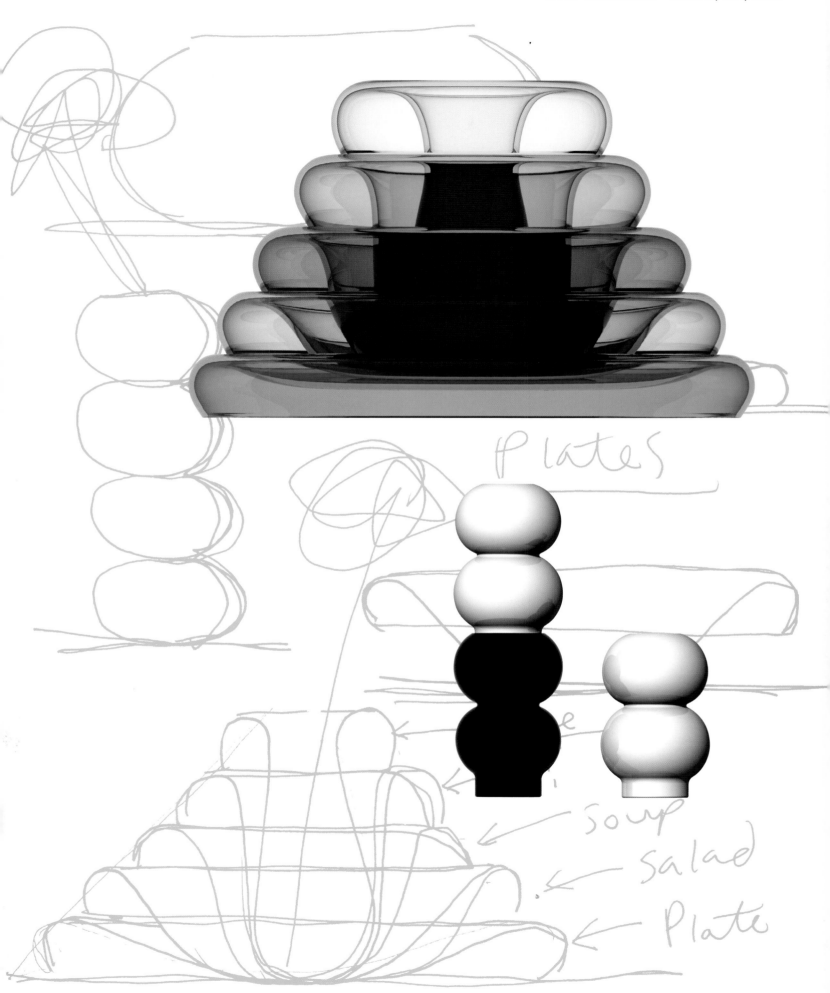

Plates

soup
salad
Plate

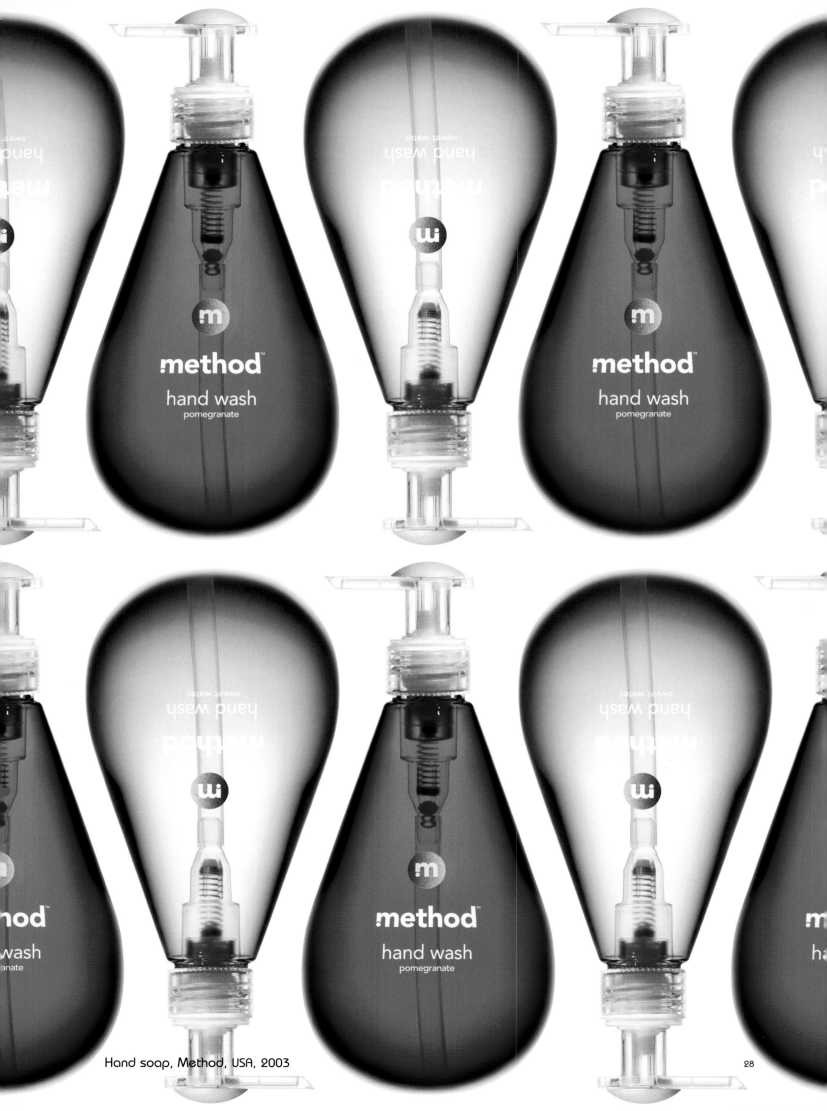

Hand soap, Method, USA, 2003

Limited edition Perrier Jouet Champagne tote for
House & Garden, produced by Leeds, USA, 2003

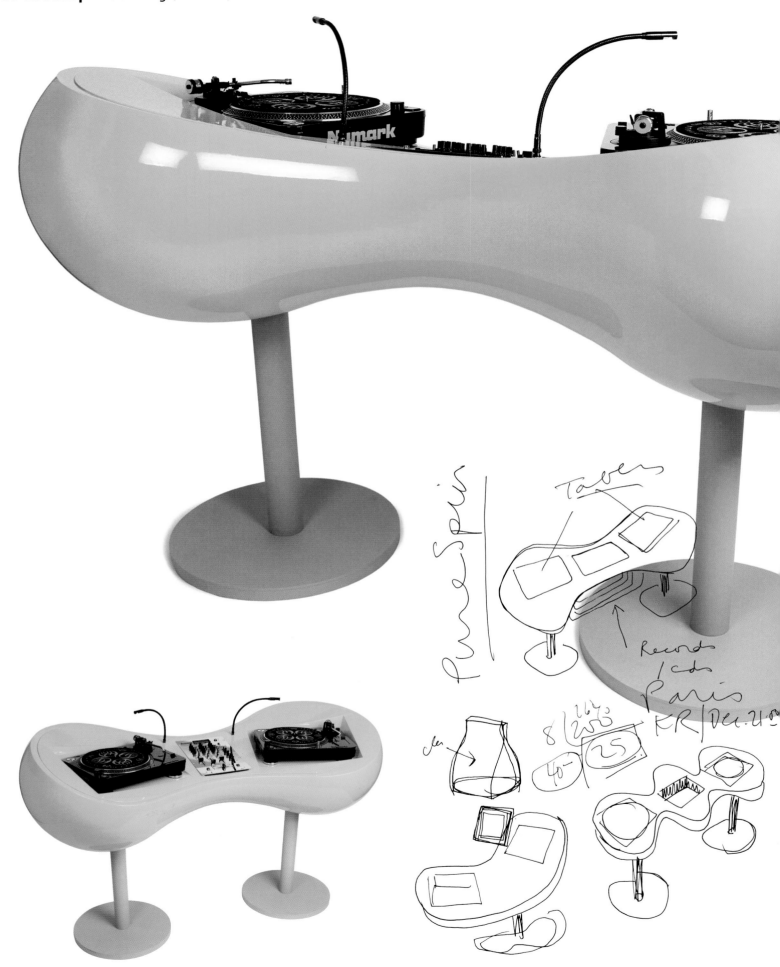

Musik

I have always been interested in music—my first job was in a record store in 1974. In addition to my love of drawing and design, I started deejaying for my high school, then university, and eventually discos through the late 70s and 80s. I became a jazz-buyer in a record store in Toronto and built a large collection of music spanning a wide range of genres. I equate designing a great democratic object with writing a hit pop song. Few people can do it and, when it happens, it's an amazing feeling to have such an impact on our collective memory. I have recently revived this hobby by deejaying at the Guggenheim and Cooper Hewitt museums, and other special events—ideally with iPods and laptops. Recently, I designed a deejay table that is photographed with my original 1978 Numark turntables on it. As much as I believe in progress and dematerialization, I designed it for turntables, because there is a strong market for them (I owned more than 20,000 records until I had to sell them in 1993 in order to survive and start my practice in New York). I have released mixed compilations globally and am now designing my own music—an immaterial exploration of my material world.

CD compilations and packaging design
by Karim Rashid, Neverstop, USA, 2003

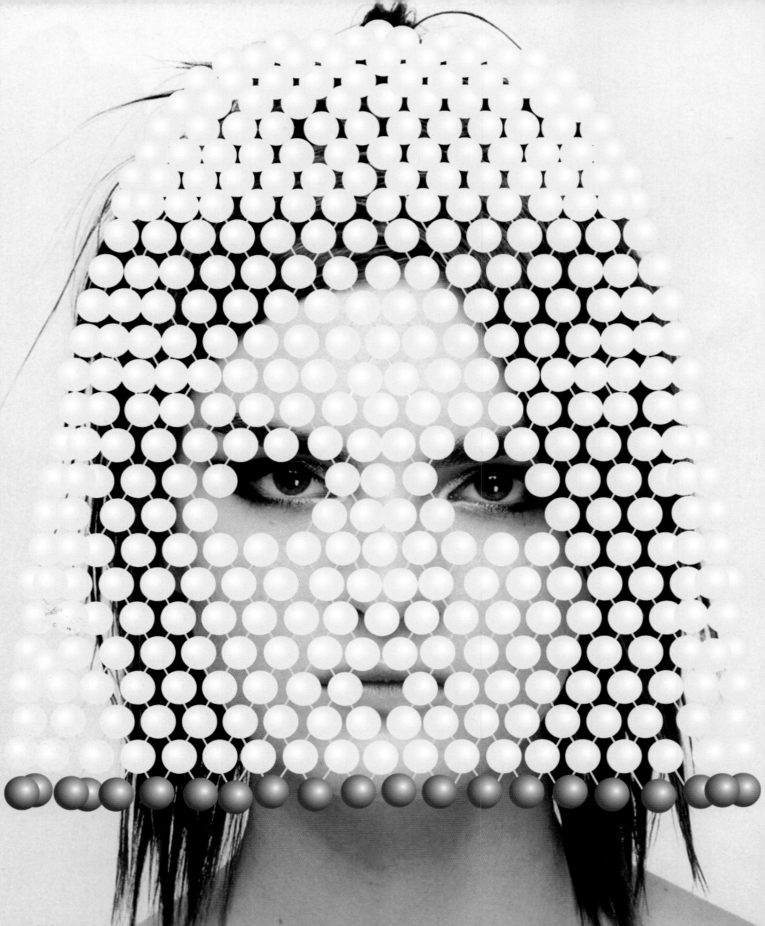

In 2001, I developed a collection of thirty pieces of jewelry for Golay in Switzerland. Pearls represent their primary business and this particular collection was to project them into the 21st century by removing their stigma for young people as being too traditional or even antiquated. The designs were developed to emphasize, compliment, and showcase pearls as the complex gems and truly beautiful, organic phenomena that they are. Having learned of the processes developed by scientists to cultivate a diverse range of pearls, I proposed to create new shapes (crosses, oblongs, and figure "8"s) by placing small CNC-machined (computer numerically controlled) stones inside the mollusks. I also explored techniques whereby pearls could be artificially induced to grow in new personalized forms—a process that would take approximately 4 years.

Pearl jewelry collection concepts, Golay, Switzerland, 2002

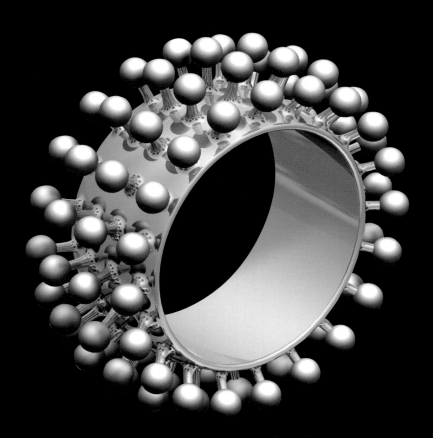

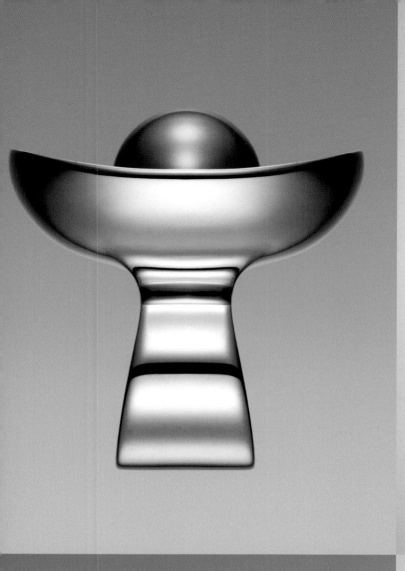
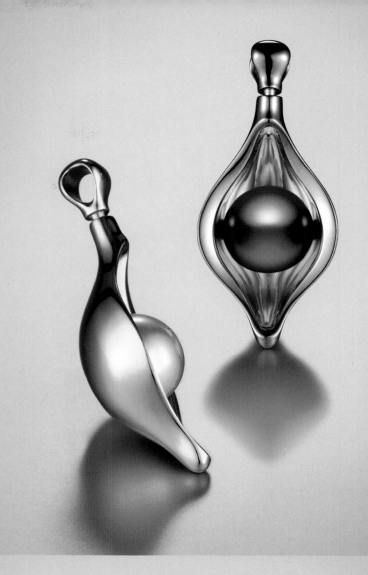
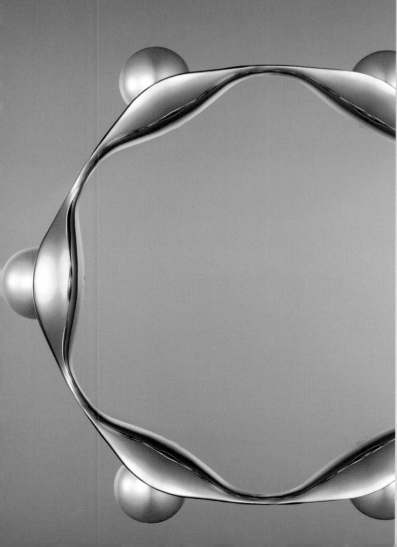
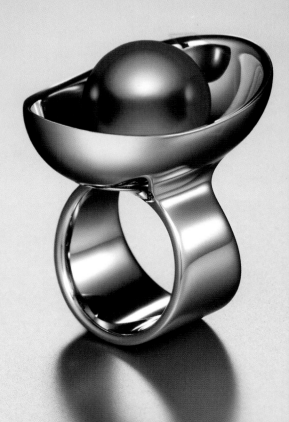

Pearl jewelry collection, Golay, Switzerland, 2004

Newspaper box and brand identity concepts, Madison Ave BID, New York City, 2003

At age five, I realized my life's mission. I used to go sketching with my father in London, drawing churches, parks, landscapes, and people. He introduced me to perspective and taught me to see. I soon learned that I could design anything I wanted and affect all aspects of our physical landscape. I remember drawing the facade of a cathedral, deciding I didn't like the shape of the windows, and redesigning them. Although we live in a world that others have shaped for us—and accept it how it is—I realized that I could also shape it myself. I could contribute to the world, and I could change the world. ¶ I am half English and half Egyptian, with cosmopolitan parents who exposed our family to multiple cultures and perspectives. Although I was born in Cairo, we traveled and lived in many countries in Europe and were brought up to be very open-minded about language, culture, and religion. Although we visited churches and mosques, more often we went to museums. ¶ My father, a painter and set designer, introduced us to a wide range of artists, from Gauguin to Warhol, ancient Rome to ancient Egypt, the Renaissance to the Romantics. He taught me about architecture, design, and fashion: he designed furniture for our home and dresses for my mother, painted graphic patterns on the walls, and continually changed the interior of our domestic environment. Everything he touched, he reinterpreted and personalized. ¶ Throughout my childhood, I was obsessed with drawing: eyeglasses, shoes, radios, luggage, buildings, cars, lamps, furniture, and games. When we immigrated to Canada, I won a drawing competition for children—I was so intrigued by the rituals of packing, moving, and storage, that I drew a luggage rack for a car. I had no idea that what I was doing thirty-seven years ago was industrial design. In 1967 we moved to Montreal and visited the Expo over and over; each time, I would take back with me the poetic, imaginative implications of these proposals for the future. I was so struck by these utopias that I immediately began drawing future worlds where everything was techno-logical, space-age, and immaterial. I read about Raymond Loewy and saw documentaries on

evolution

Buckminster Fuller, Le Corbusier, and many others. ¶ Although initially torn between architecture and fashion, I ended up studying industrial design. I went to university in Canada—a school marked by a Teutonic, Bauhausian pedagogy (the entire faculty was either Dutch or German)—and later pursued graduate studies in Italy, where the approach was somewhat antithetical. My eclectic degree—a combination of engineering, architecture, and social science—gave me a broad perspective on our built environment, and I was fortunate to have Marshall McLuhan and other important teachers as visiting faculty. It was then that I understood that design went well beyond the product itself. ¶ All this time, I never stopped sketching. Sketching and drawing allowed me to express my many ideas quickly and simply. I drew every day, filling sketchbook after sketchbook. Even as a child, when I would wake up in the middle of the night, I would sketch my dreams. Drawing is a fundamental element of communication. Even now, many of my clients the world over prefer to select concepts from my sketches or my initial mnemonic doodles, rather than from highly resolved computer renderings. I don't know whether it is nostalgic (the sketch as high-art and personal craft) or simply that a sketch is unfinished and therefore evokes a sense of potential—of how one is thinking rather than what one has designed. ¶ I now work in twenty-five countries, and I have drawn in every one of them—on tablecloths, sketchbooks, napkins, menus, walls, and bodies. I even sketch digitally on my laptop. I am what you might call a global nomad: I have the freedom and cultural autonomy to understand and work with diverse cultures. As these cultural differences disappear and we become one world, I analyze and dissect everything from a global perspective instead of a local or regional one. I have learned that the world is a vast, complex farrago of beauty, and that the idea of an "International style" is an antiquated one. The world has layers upon layers of style that are not regional but, rather, hybrids of cultures, races, creeds, and values. I was brought up globally and see the world as if I were from another planet—observing, perceiving, engaging, and contributing. ¶ I am often inspired when I am traveling—designing and coordinating projects from the road, air, or hotel—and I love being isolated when I draw: I can really focus. On planes for example, I can fill a sketchpad (about 100 pages) on a single transatlantic flight. I read, write proposals, answer press questions, strategize, develop ideas, and directions, and dream about what I really want to do (as opposed to what I think I should do). I travel about 180 days a year. I have crazy days in the office. I must sleep seven and a half hours exactly or I have trouble performing. I wake up at 8:00 AM, brew the strongest cup of espresso, answer all my e-mails (usually European or Japanese at that time), and then go to the office (I live above my office—a convenient and enjoyable condition that allows me to work very late). I review issues with my office manager, answer more e-mails, write articles, proposals, etc., then work my way though the list of projects (I probably review work on ten projects a day with my staff and I have about fifty projects going on at once). Each project inspires the next. The Blob lamps I designed for Foscarini were inspired by another twenty projects over the last three years—studies of organic landscapes, undulating surfaces, and natural terrains. I have between three and five client meetings a day, eat a nicoise salad practically every day, drink a soy shake (in a ten-minute break), four strong coffees, one late-afternoon decaf, and a cup of tea at 5:00 PM every day. >

I keep going until about 8:00 PM, then either go to the gym, out for dinner, or to an opening. I try not to work past 10:00 PM because I work seven days a week. I multitask continually. ¶ When I encounter a client or approach a potential project (I have so many ideas that I create many projects myself, thirty percent of my work is conceptual—non-client, "for-the-love-of-design"), I immediately have several ideas that I sketch directly after the meeting, whether in a hotel, cafe, or office. Then I keep sketching, over and over, between researching and learning about the relevant typology, category, or field. I then bring together my senior staff and explain the concepts so that they can start to develop them digitally, with three-dimensional modeling programs. In the meantime, I continue to research pragmatic, ergonomic/interactive issues, new materials, technologies, etc. Each project has a very different process, sometimes vertical, sometimes linear, sometimes "hypertextual." I used to do the drafting, rendering, and engineering—the entire process—but now I don't have the time. My most important contribution is that I am like a sponge, I learn everything about a project, the culture of the company, the production, materials, market, and costs, everything I can in the shortest amount of time possible. It is essential to absorb information quickly, rigorously, even deeply. I always say that as soon as you take on a new project you have to "dive in the deep end." ¶ All relationships are collaborative. If I work with a company, the expectation is a marriage of my brand, vision, and ideas with their company culture. Generally, the companies I work with have a very similar philosophy, and this is ideal. It is a myth that designers have an idea and a company produces it; the real work is in the collaborative merging of minds, vision, and ideology. It took me many years to learn the importance of the right relationship. Relationships are everything in life: love, business, friendship, support. ¶ I think the one thing we designers have to ask ourselves as professionals is whether we are simply producing more goods or really have something to contribute. Contribution does not necessarily have to be a technological or material innovation; it could be more poetic than that. By "poetic" I mean a more human, or humanized, innovation. We've seen a lot of minimalism in the last several years, but I think we've taken it about as far as we can. In a sense, I'm a believer that "more is more," and I want to continue pouring energy into various endeavors, making products that are more beautiful, decorative, and stimulating. True industrial design is of a scale that has strong market appeal; it has to create a market. It's not just design for design's sake, but design to shift and evolve humankind. ¶ I would love to design everything that we come into contact with as human beings, especially things that have an impact on our psyche. There is so much to do: I want to design cars, planes, clothes, houses, and robots. I want to shape the future. I want to host a design TV show, I want to create more music, I want to design a small museum, and I want to live in constant inspiration. ¶ I think that in the future we will have many more products and experiences but we will own nothing—we lease cars, we lease houses, and soon we will learn to lease everything, experience it for a short while, and move on to the next thing. We will create a hyper-consumptive, forever dynamic, ever more vast, and changing human condition, where everything will be cyclical, sustainable, biodegradable, and seamless. The idea of permanence will be obsolete in everything from architecture to commodities. This is Utopia, freedom, Nirvana. All the goods in the world will only exist if they give us a new or necessary experience. ¶ I believe in a NUTOPIA—a place of the future where everything is beautiful, romantic, positive, energetic, intellectual, and seamless, with no banalities or tedious human paradigms; where we live in constant inspiration—where we are smarter, faster, and stronger. I want to implant a microchip in my eye that allows me to see everything. We should have microchips planted in our minds that give us higher communication skills that enhance our potential. We will have the cure for cancer, HIV, and heart disease. Our planes will travel at Mach 6 and we will have a global paradigm (a single global culture), clothes that you can spray on your body from an aerosol can, total robotic production (no manual labor or assembly lines), no high-tech products—everything will be immaterial, communication, entertainment, and information; multilingual voice-chips, safe implants, anti-aging devices, and Smartoos (intelligent tattoos that include ID, passport, social security, and bank account numbers; e-money, credit cards, health statistics, etc.) embedded in our arms. We will have Smart houses and efficient hydrogen cars. We will have great virtual sex, create by waving our hands in the air like conductors, no paper, no pens, no chairs, just a virtual plane in space that is highly customized, completely "reconfigurable," personalized goods, desktop manufacturing, and the ability to design our own objects and spaces as well as experience those of others. Everything will be available 24 hours a day, humans will be more human than ever, and creativity will be the new religion. ¶ Essential to design is a perceptive pulse on social life, behavior, and human culture. Even though we have a vision for the future, artists do not see into the future, they see the present (everyone else sees the past). Digital technology is the instrument for the new tower of Babel. The world started as one dialect, one religion, one culture, and then the tower of Babel was built to reach Utopia-Heaven-Nirvana-God. I want to reach Utopia, one global culture, one religion—the religion of love, harmony, beauty, and high energy. I want to climb the new tower of Babel. I want to change the world. **Karim Rashid**

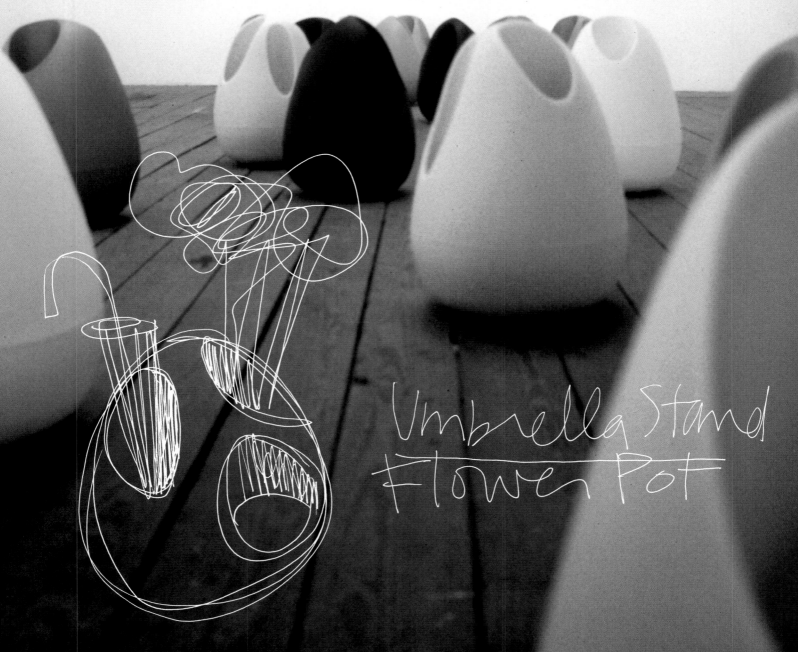

Umbrella Stand
Flower Pot

Plomb *Serralunga, Italy, installation at Deitch Projects, New York City, 2003*

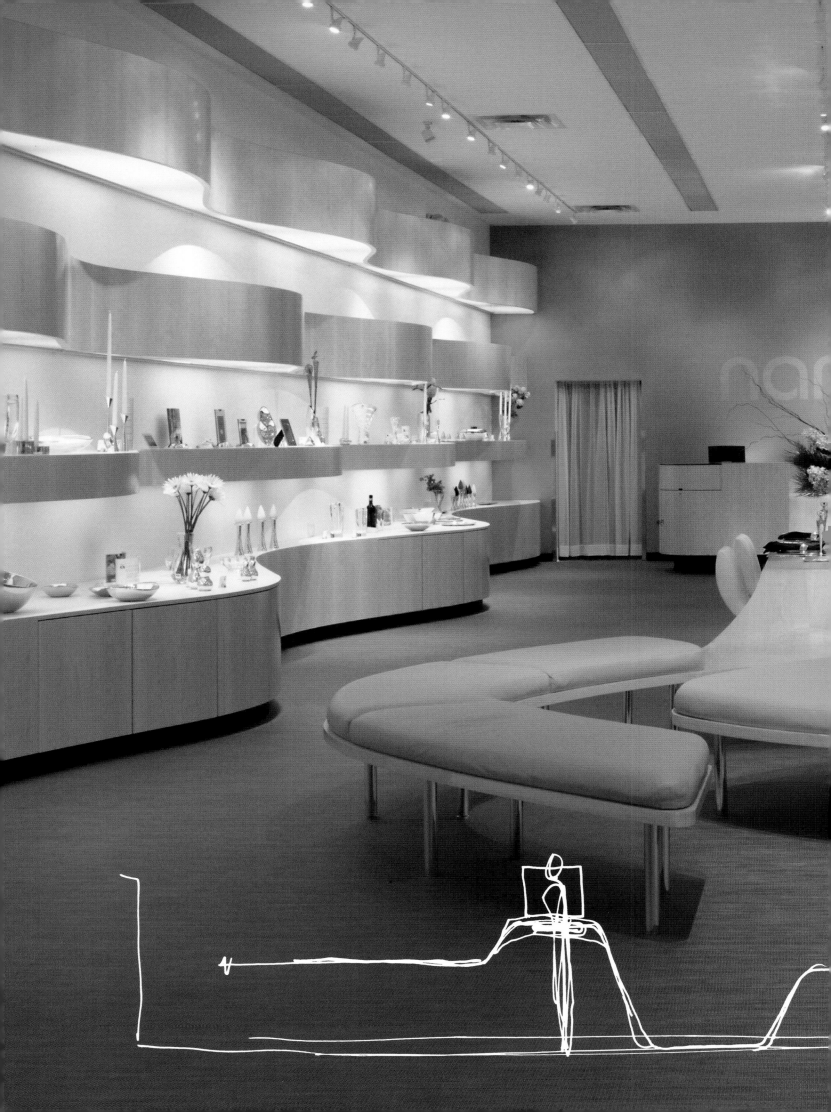

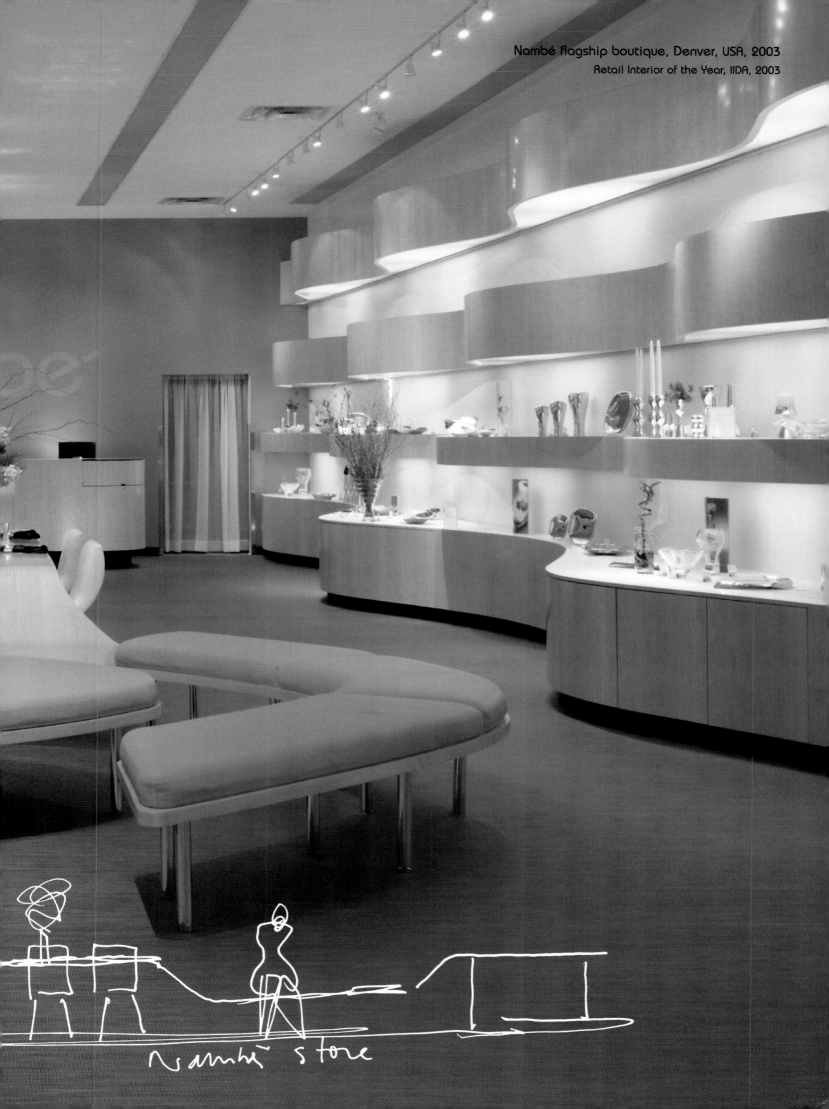

Nambé flagship boutique, Denver, USA, 2003
Retail Interior of the Year, IIDA, 2003

Nambé store

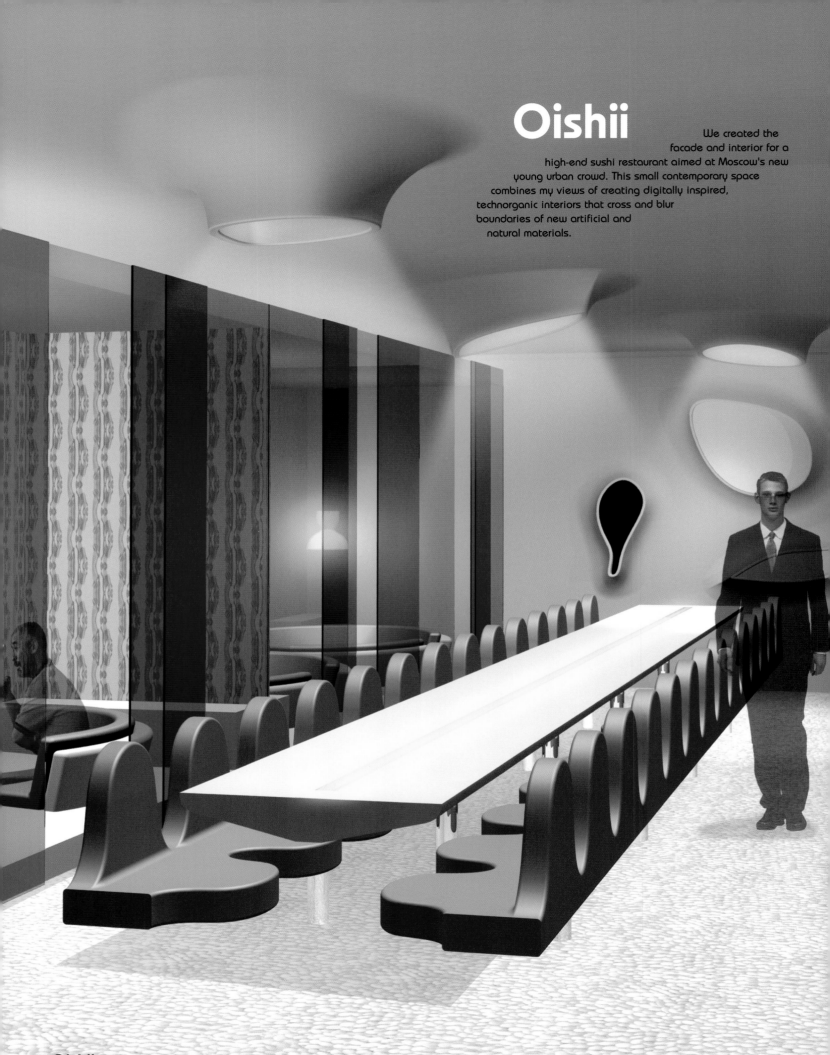

Oishii

We created the facade and interior for a high-end sushi restaurant aimed at Moscow's new young urban crowd. This small contemporary space combines my views of creating digitally inspired, technorganic interiors that cross and blur boundaries of new artificial and natural materials.

Oishii Japanese restaurant, Moscow, Russia, 2003–2004

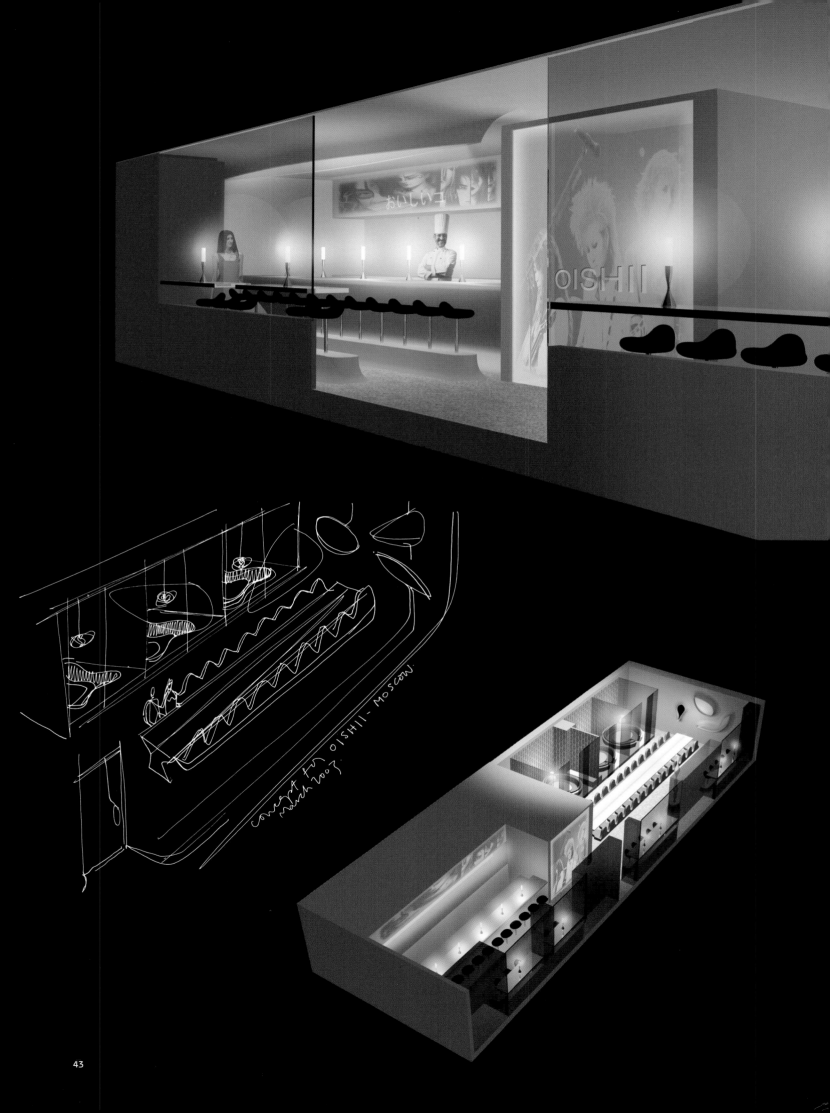

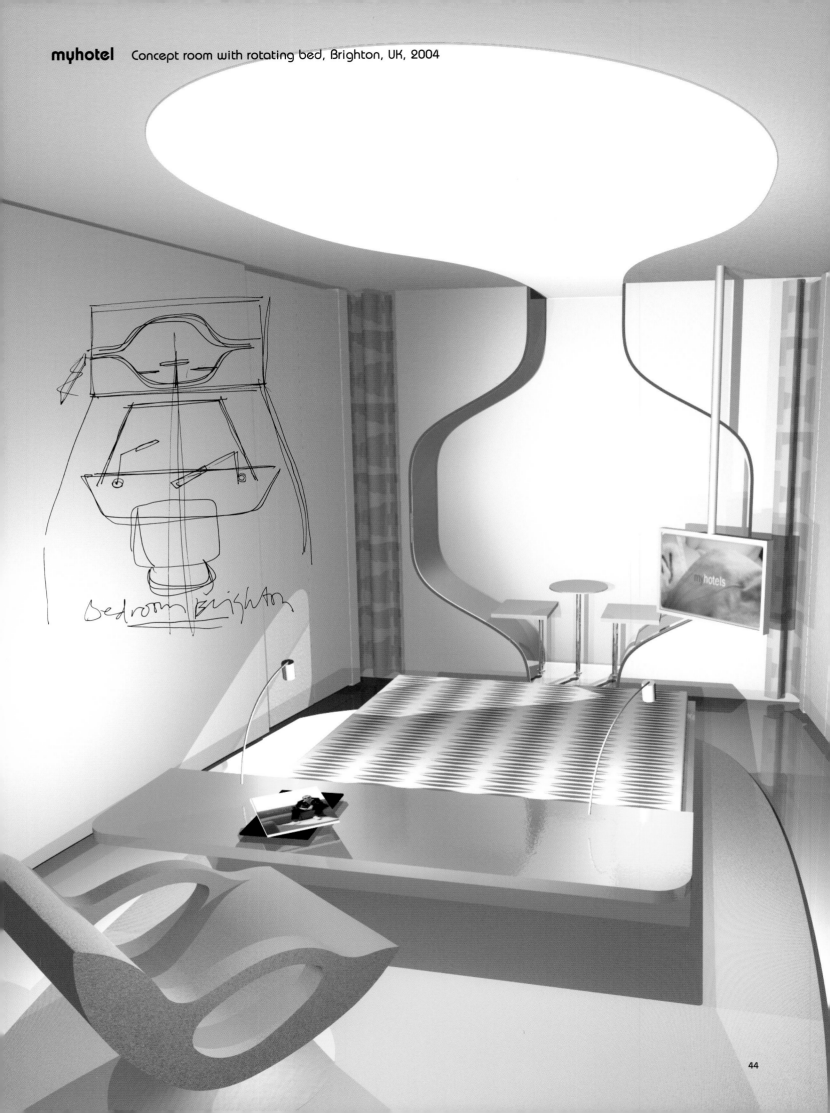

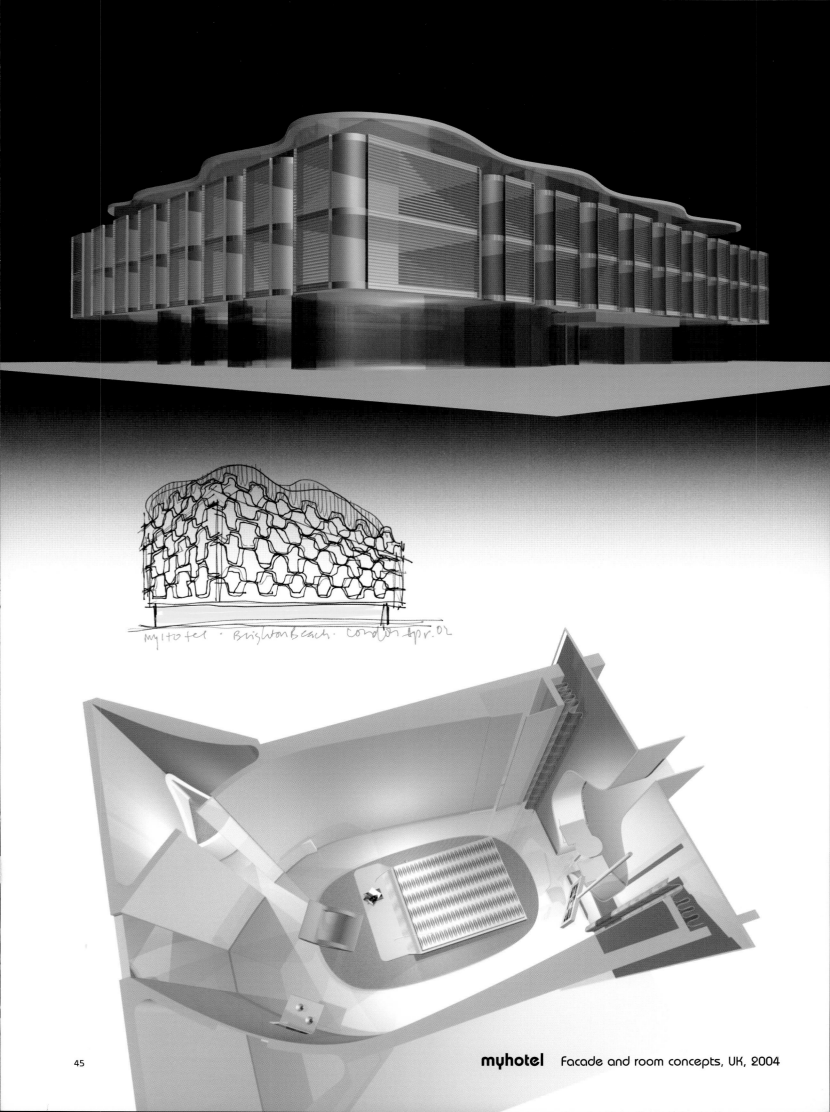

myhotel facade and room concepts, UK, 2004

Carim Capellini, Italy, 2003

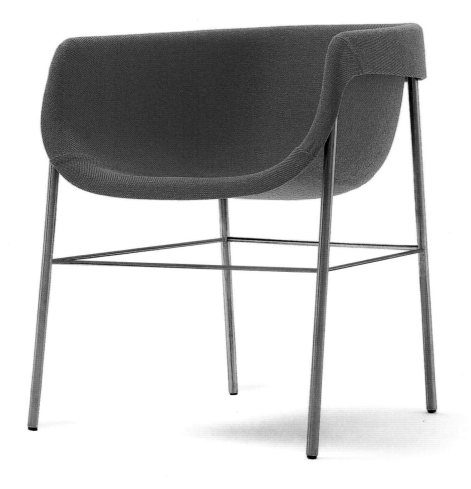

DESIGNOCRACY

It seems, at one point that postmodernism
became design for design's sake. In turn, our everyday
goods lacked meaning, poetry, aesthetics, and function. Since
childhood I wondered why there couldn't be a more democratic design that
everyone could enjoy. The essence of industrialization was to create inexpensive
goods for the masses, so small, elite companies only engaged design as a perpetual
ideological model for new ideas and new behaviors. Hence, design bifurcated itself from
everyday life. Very few companies believed that real progressive design could create a market.
But today, manufacturers realize that design can sell. We've arrived at an age where design can
participate in culture and is infiltrating every part of our lives, from the banal to the luxurious, from low-
tech to high-tech. One thing that has happened in the market is that differentiation has become vital.
Brands have taken on greater significance and everyone is aware of them. In the 80s many companies tried to
follow the leader (me tooism). They reverse engineered objects and ended up with similar if not derivative
proposals. It was less risky to come into the market with an appropriated product than with something original
or new. Marketing only critiques what exists, not what can exist. But we have arrived at an age in which
innovation is the only way to keep a brand alive and differentiation is essential to create a brand in the first
place. The origins of the industrial revolution were to create mass products using production methods for a larger
audience and greater accessibility. Innovation made it possible for high design and poetic ideas to become
available to everyone at inexpensive price-points. This is Designocracy—a democratic movement in design.
Consumer product success is determined by the market—the supreme design validating power is vested in
the consumer and exercised by them directly as they 'vote' with their purchases. Let the market edit the
world's products! We are living now in a fantastic time that accepts the blurring of boundaries and
categories in design for the first time. I was brought up in a household where my father designed
everything, from my mother's clothes to the furniture in the house. I decided that when I
ran my own practice, I would stay as pluralist as possible, like a Warhol factory or an
Eames studio, and to try to do cross-discipline kinds of things. I have already
designed a fashion line, jewelry, eyeglasses, radios, furniture, interiors,
architecture and have done painting, film, and music. The common
thread of all these disciplines is Industrial Design. They
are all part of the world of the Designocracy.
Karim Rashid

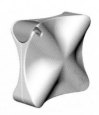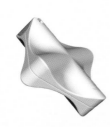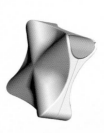

Echo Travel Nomad 2004

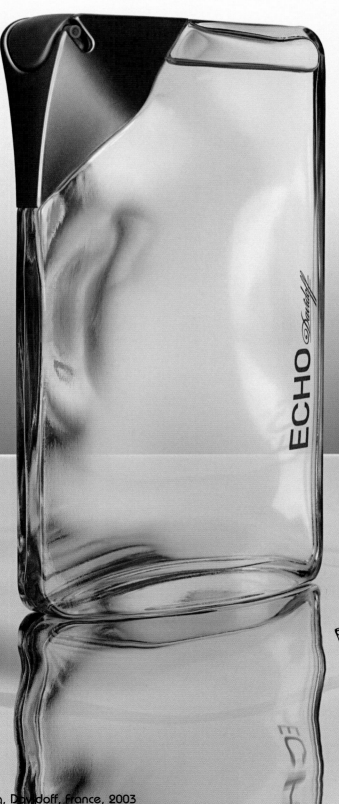

Echo Men's fragrance packaging, Davidoff, France, 2003

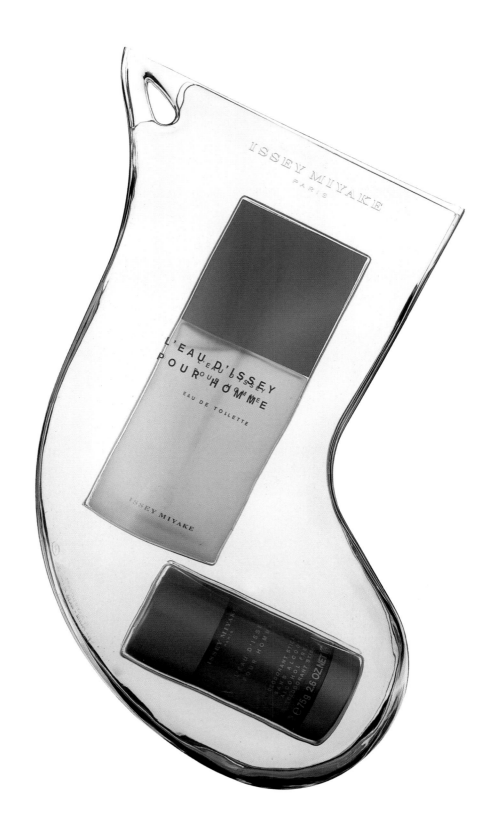

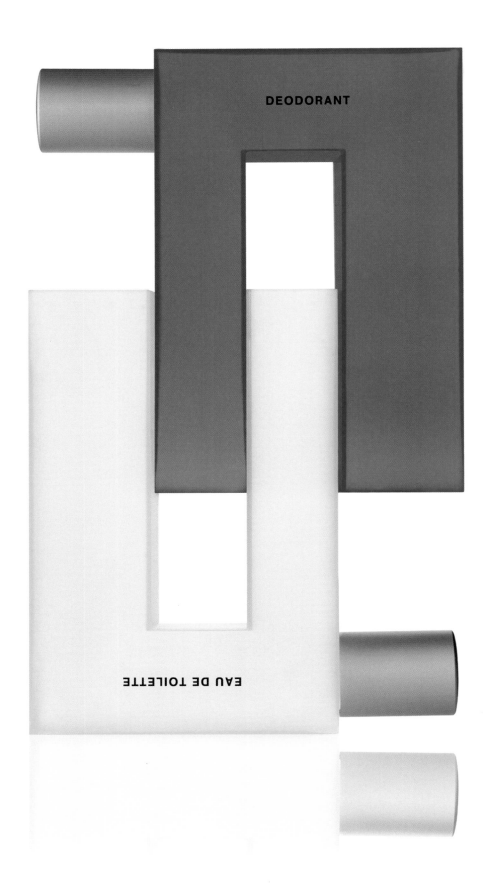

DEODORANT

EAU DE TOILETTE

2 in 1 Issey Miyake men's travel bottles, BPI, France, 2003

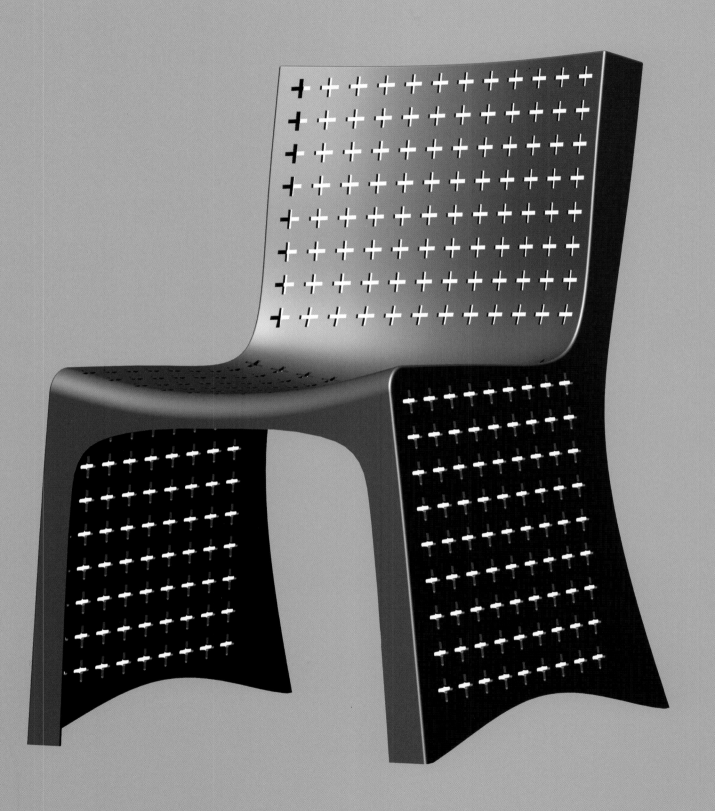

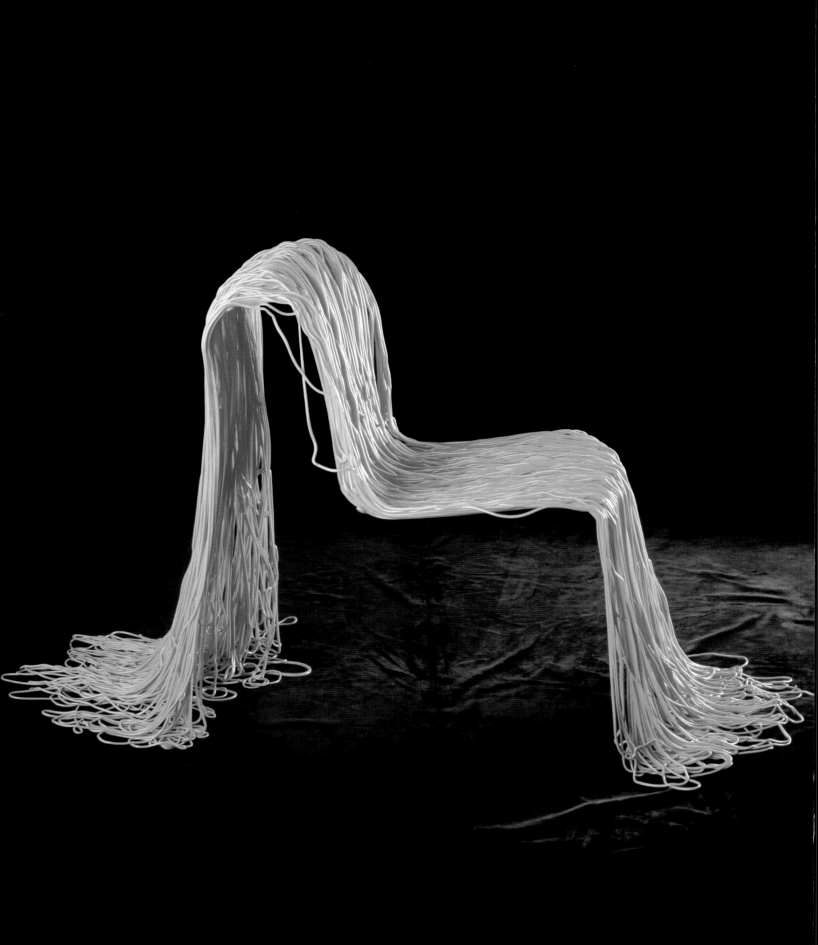

Mystik Chair prototype, 2002

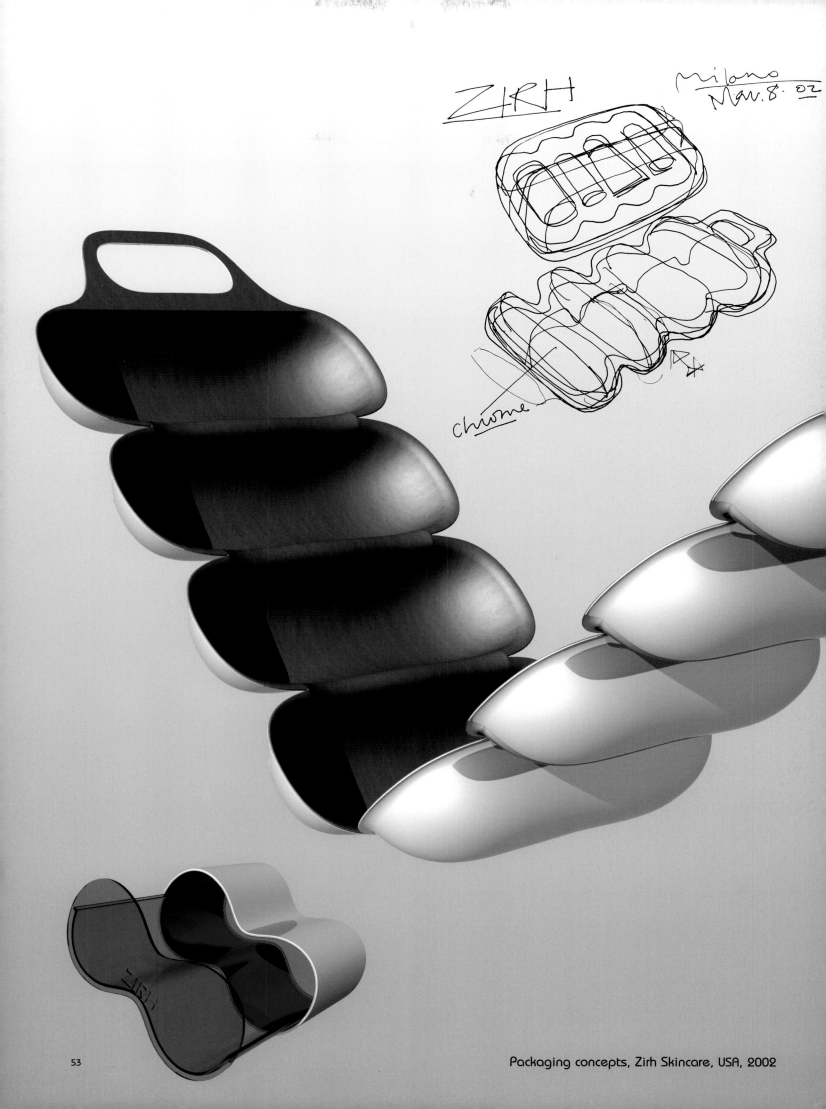

ZIRH

Milano
Mar. 8. 02

Chrome

Packaging concepts, Zirh Skincare, USA, 2002

Room Stool Umbra, Canada, 2002

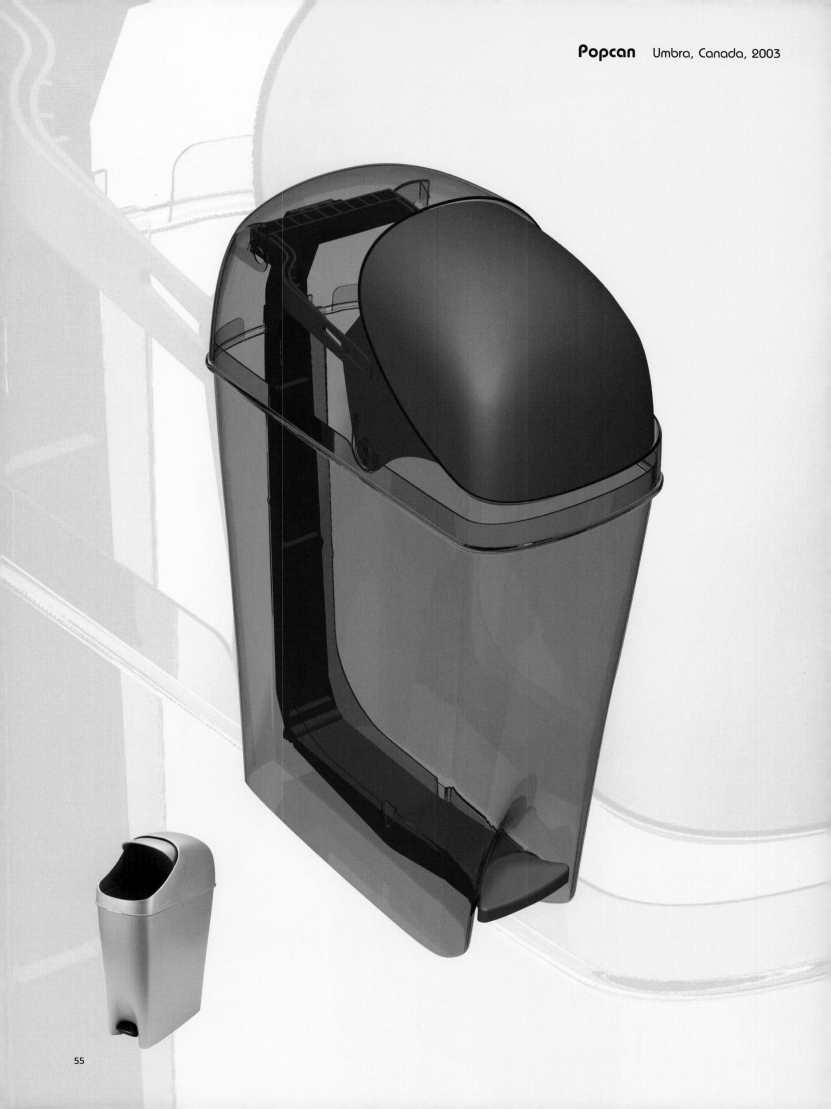

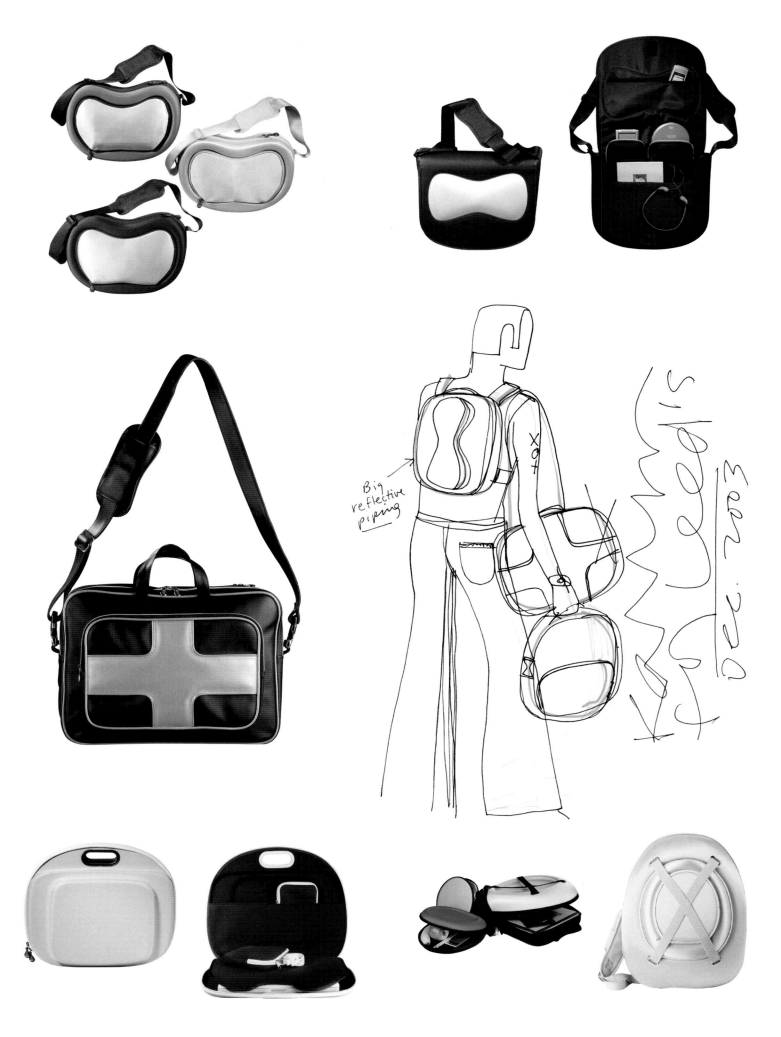

Luggage prototypes, Leeds, USA, 2004

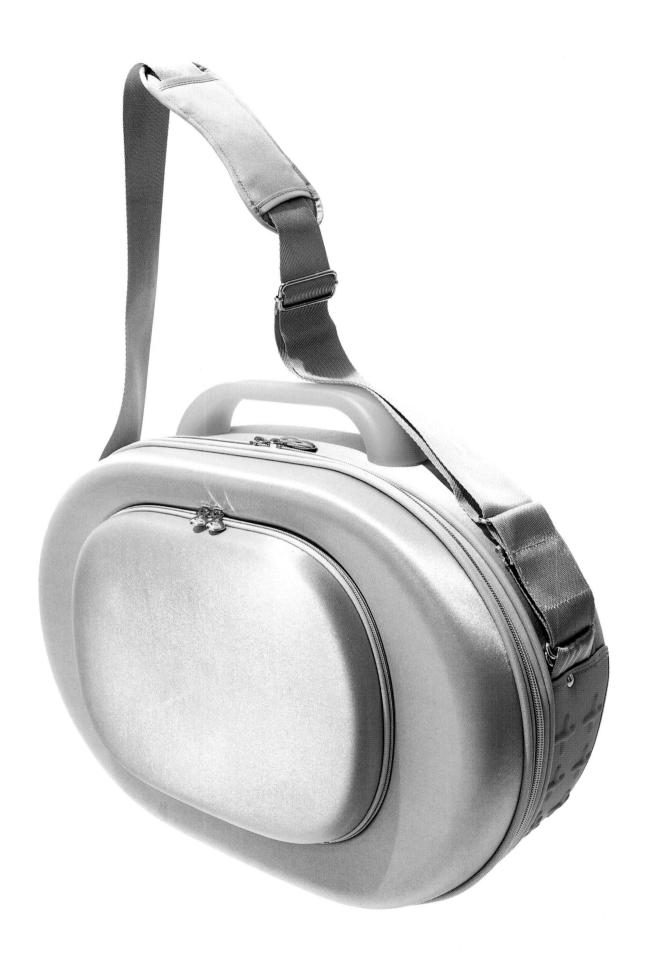

Boog Luggage prototype, Leeds, USA, 2004

Bloop ACME Studio, Maui, USA, 2003

ADDITION BY SUBTRACTION

In a material world, in a consumer society, the
notion of consumption makes us feel guilty, yet there is no
turning back. The mechanization of the industrial revolution and the 20th
century are here to stay. With free enterprise and competition, businesses are
urged to increase the volume of their output. As more goods are produced, both
quality and prices improve and, consequently, innovation is also stimulated. Brands
create new products at rapidly accelerating rates. In order to succeed companies must
continue to produce new models and variations. Global competition and free enterprise
have created some positive ramifications: the fact that companies must innovate, must
improve, and must increase quality in order to retain market share. This open-door policy
of positive competition elevates our standard of living, contributes to a better lifestyle
and to our well being. Information has also contributed to our educated consumption.
We are more aware of what we consume, can easily research it on the Internet, do
price-comparison shopping, learn more about the subject, and most important,
read other consumers' reviews and ratings. In the last several years I have
bought a car, a house, a toilet, appliances, books, music, clothes, and
other things on the Web. Going to shops is boring and time-
consuming, and most stores lack the infinite choice of the
"global mall." In the excrescence of goods and the
system of objects, the possibility of over-con-
suming, of addition, and immediate satis-
faction of consumption, is dangerous. We
surround ourselves in life with effigies,
objects, products to find meaning in our
existence, and to create a sense of memory,
of presence, and of belonging. But we also con-
sume to occupy time and to fulfill some strange
need of reward and ego. We will forever have objects in
our world, and I am not advocating to not consume or to not
have "things," but to be hyperconscious of our things and love and
enjoy them. If not, do without them. Objects denote our time, place, and
relationship with others and the outside world. Objects can have a phenom-
enal relationship with us and our daily lives; at the same time objects can be
obstacles in our lives, complicating them, and creating stress. To add more to one's
life, one can also subtract or remove, so that instead of consuming, one deconsumes,
a theory of addition by subtraction where less can be more. But not in the Miesian ideal
of more is less (Mies Van de Rohe 1939), not a minimal or reductive approach but
instead, a way of enriching one's life, of increasing experiences through beautiful things,
through things that we love: A way to edit our choices and have a richer life, creating
ultimately the most important luxury of the 21st century—"free time." If we can
remove banalities, frustrations, and time-consuming scenarios, we can spend
more time thinking, creating, loving, being; fulfilling our dreams, our desires;
and use our time in a more constructive, more contributive role. We can
also just be happier because we are no longer bombarded with
pettiness, mediocre issues, and banal experiences.
We can grow by subtracting. >

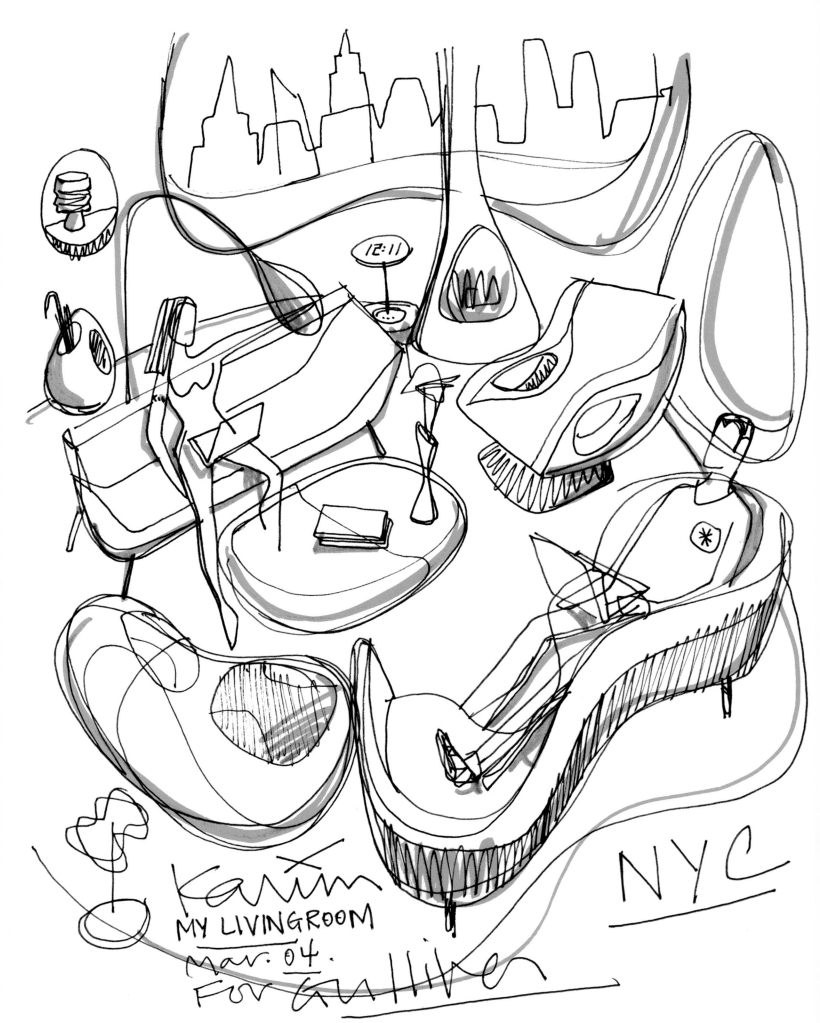

Karim
MY LIVINGROOM
Mar. 04.
For Gulliver

NYC

60

How does one add by subtracting? Here are 30 ways to have more in life with less: **1** Analyze each object in your home and ask yourself when was the last time you used it, why do you have it, and does it bring meaning, memory, love, function, experience, pleasure, or real need to your life? **2** For every new object or thing you attain, you must ideally dispose of a similar object or thing. **3** Every object, every decorative artifact, should have meaning in your life— an important memory, a religious, or iconoclastic reference. If not, discard it. **4** Everything in your life should provide a positive and uplifting human experience. **5** Have less but better furniture in your domestic environment. **6** The objects that are discarded are not thrown away but taken to a second-hand shop, or given to someone else when possible. **7** Downsize by using only one credit card (same card as a bankcard) and try not to carry cash or coins. We should have done away with arcane coins by now. **8** Read magazines and papers immediately and then recycle them. **9** Consume immateriality—like music, and other digital goods that increase experience. **10** Try not to commute—find a job close by or move. **11** Keep only two or three colors (at the most) in your wardrobe—I prefer white, silver, and pink. **12** Downsize your technology. For example you do not need a Palm Pilot, laptop, iPod, CD player, cassette player, MP3, DVD player, answering machine, cellular phone, home computer, etc. Decide on a single medium. Own only one television. **13** Have only one global e-mail address, one phone number (use a global cell for everything, forget a hard-wired phoneline). **14** Don't use business cards—just tell people your e-mail address. **15** Use your proper name for your e-mail address. **16** Wait, save, and then buy the best—the thing you love the most. **17** Have 10 pairs of the same brand and colored socks, underwear, and t-shirts—then you never have to match socks again. **18** Either read the news on the Web or watch it, but don't do both. Do this once a day only. **19** Don't watch the same film twice, read the same book twice, or go to the same location on vacation twice. Seek new experiences. **20** Don't use your middle name. **21** Don't own a car if you do not really really need it. **22** Support culture—next time you are going to the mall think about if you really need anything, and then go to the museum instead. **23** Clean your home for ten minutes a day, then it will always be clean. **24** Pay all your bills on line—don't use mail. **25** Pleasure is more psychological than physical. **26** If you do not like your job, quit! **27** Don't work on your weaknesses, work on your strengths. **28** Return every e-mail, phone call, and fax the same day it arrives, regardless of where you are in the world. **29** Keep your desk neat, clean, and empty. This means you are staying on top of everything. **30** Now that you have more time, try to have one new experience everyday. **Karim Rashid**

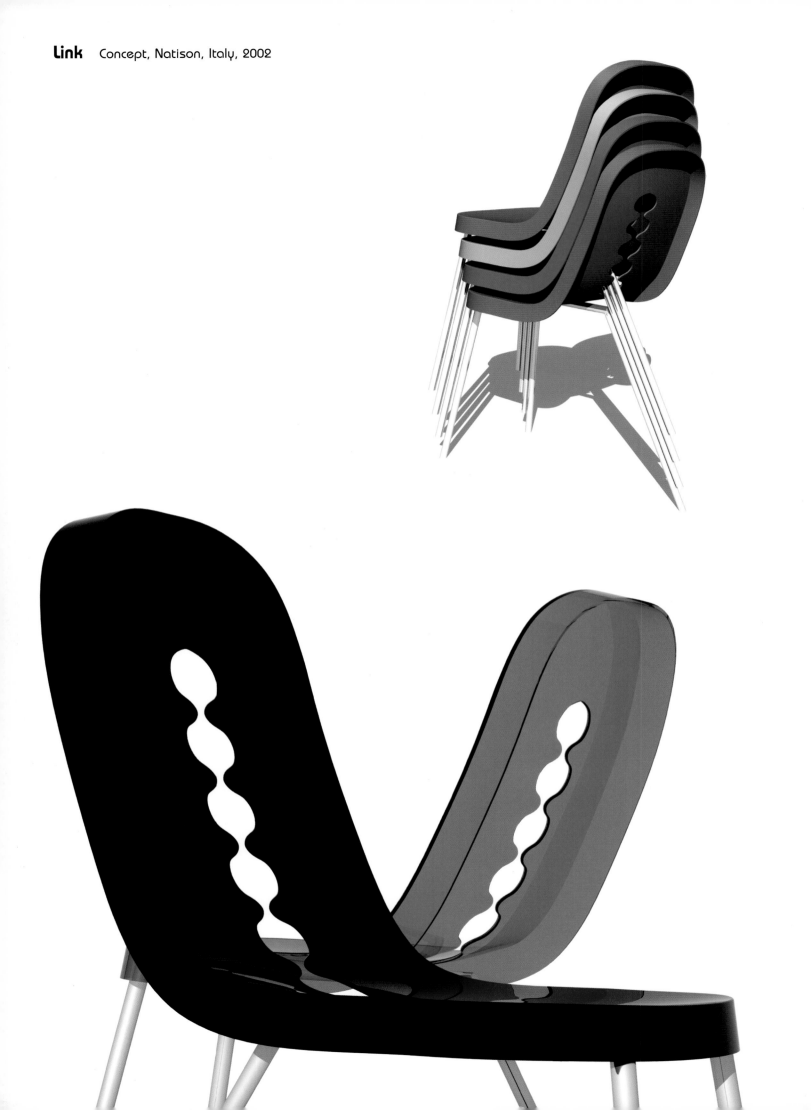

Link Concept, Natison, Italy, 2002

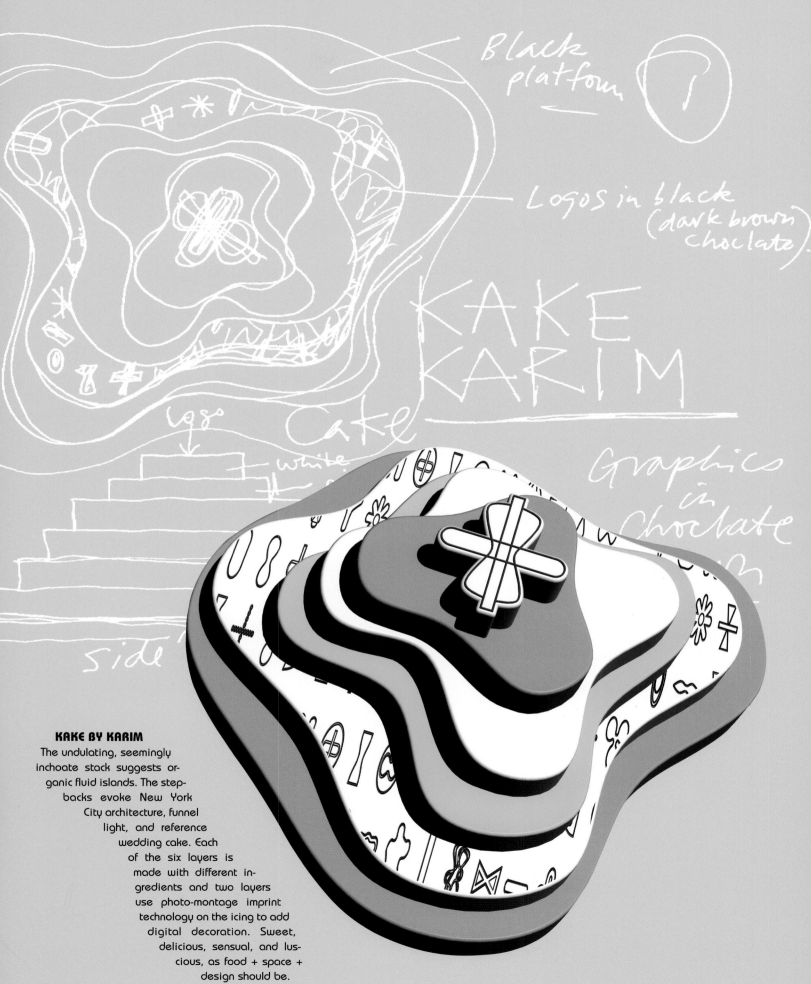

Black
platform

Logos in black
(dark brown
choclate).

KAKE
KARIM

logo

Cake

Graphics
in
Choclate

white

side

KAKE BY KARIM
The undulating, seemingly inchoate stack suggests organic fluid islands. The step-backs evoke New York City architecture, funnel light, and reference wedding cake. Each of the six layers is made with different ingredients and two layers use photo-montage imprint technology on the icing to add digital decoration. Sweet, delicious, sensual, and luscious, as food + space + design should be.

63

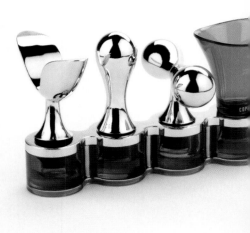

Barware Kollection Copco, USA, 2003

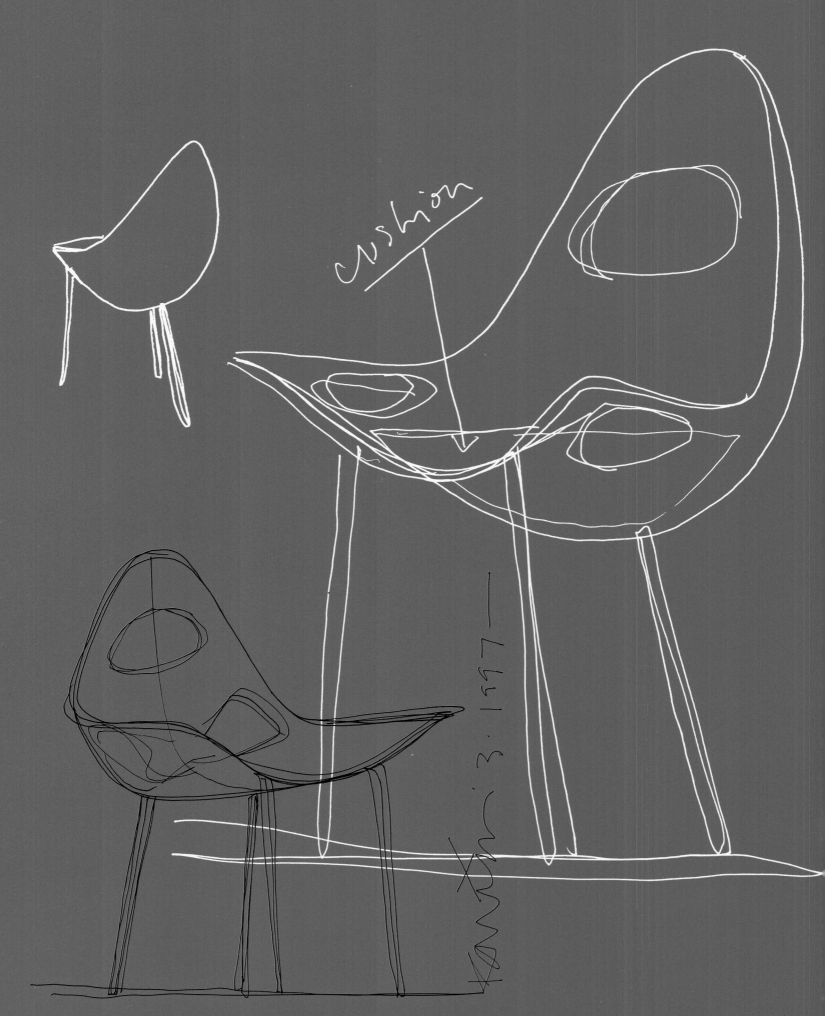

cushion

66

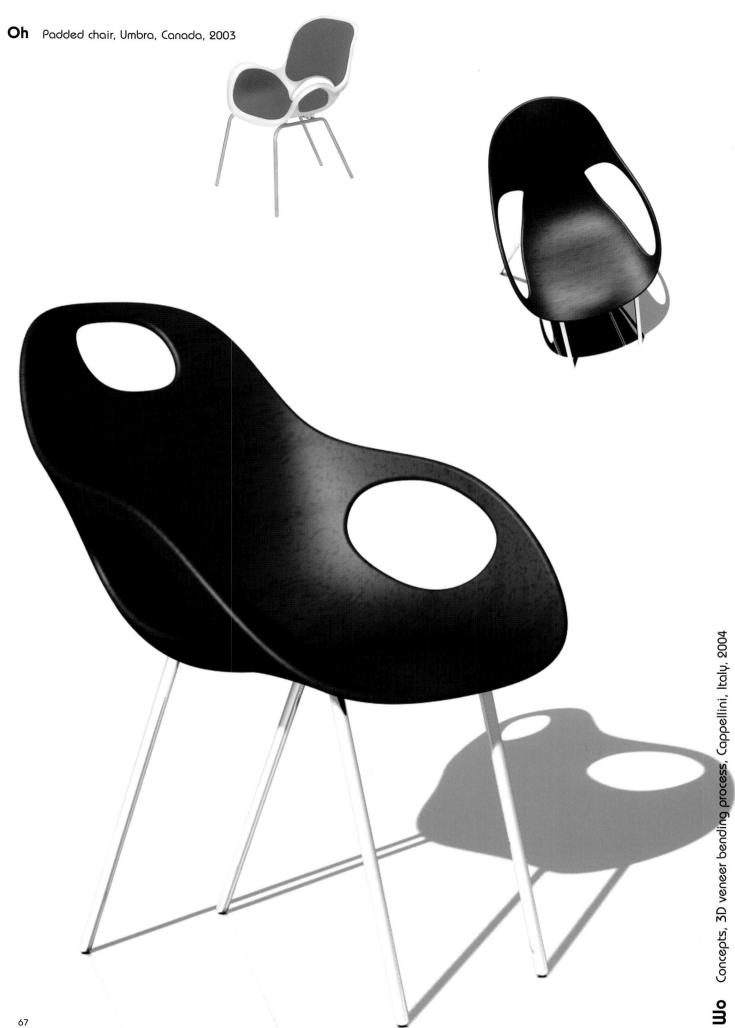

Oh *Padded chair, Umbra, Canada, 2003*

ϖ Concepts, 3D veneer bending process, Cappellini, Italy, 2004

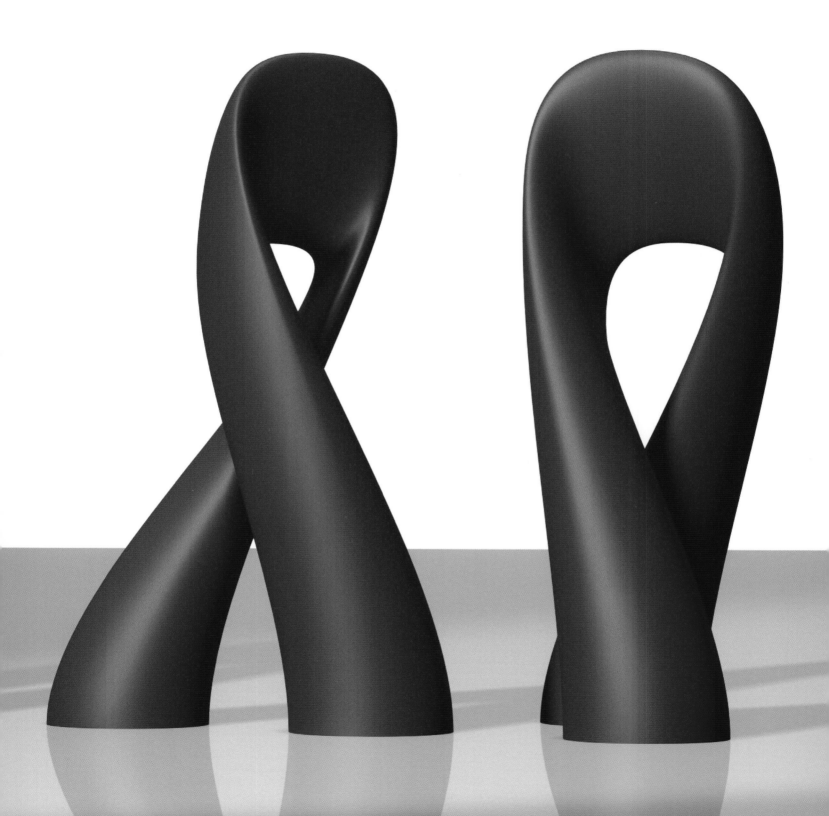

Youth AIDS Award USA, 2003

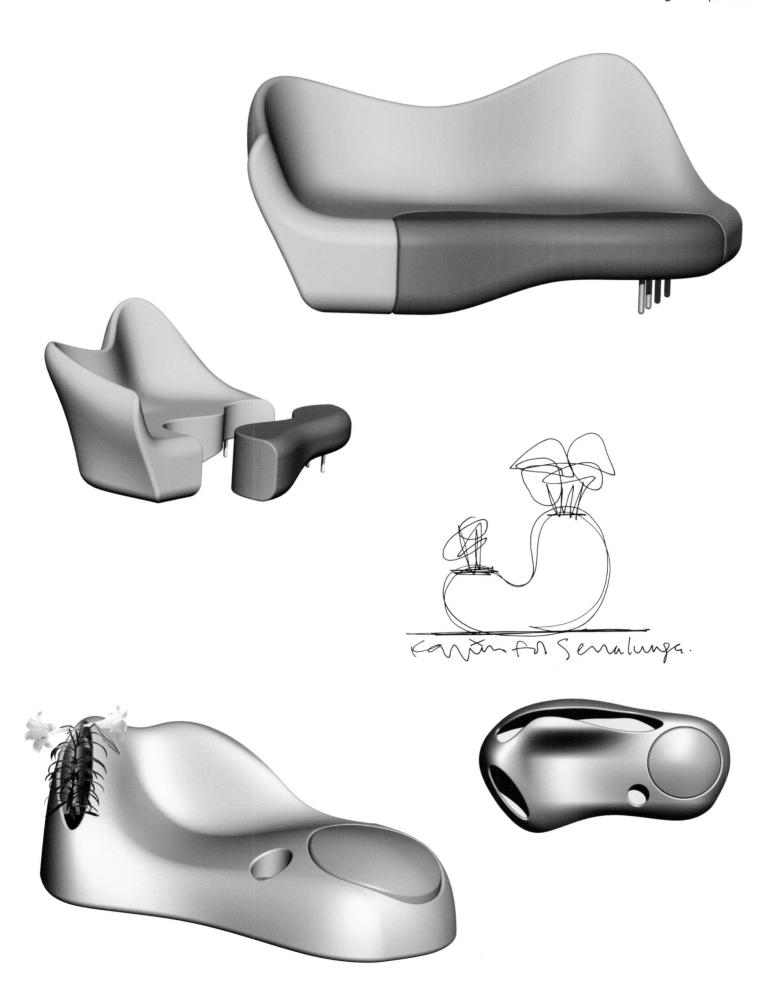

karim for Serralunga.

Plant Chair Concept, Driade, Italy, 2003

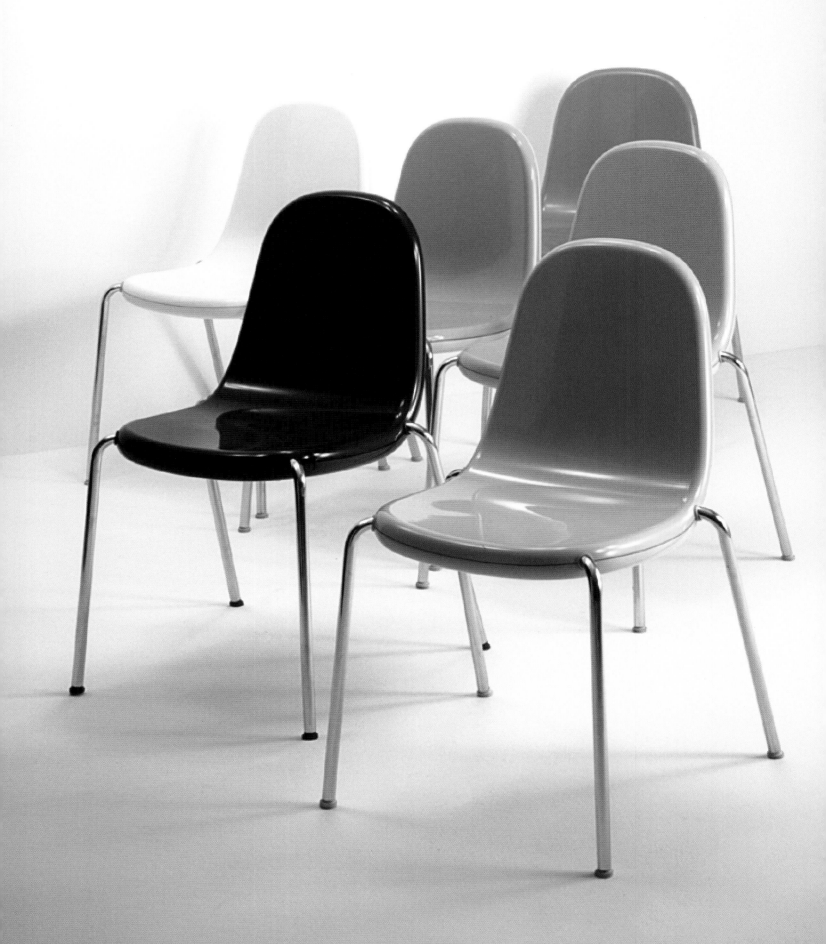

Butterfly Magis, Italy, 2002

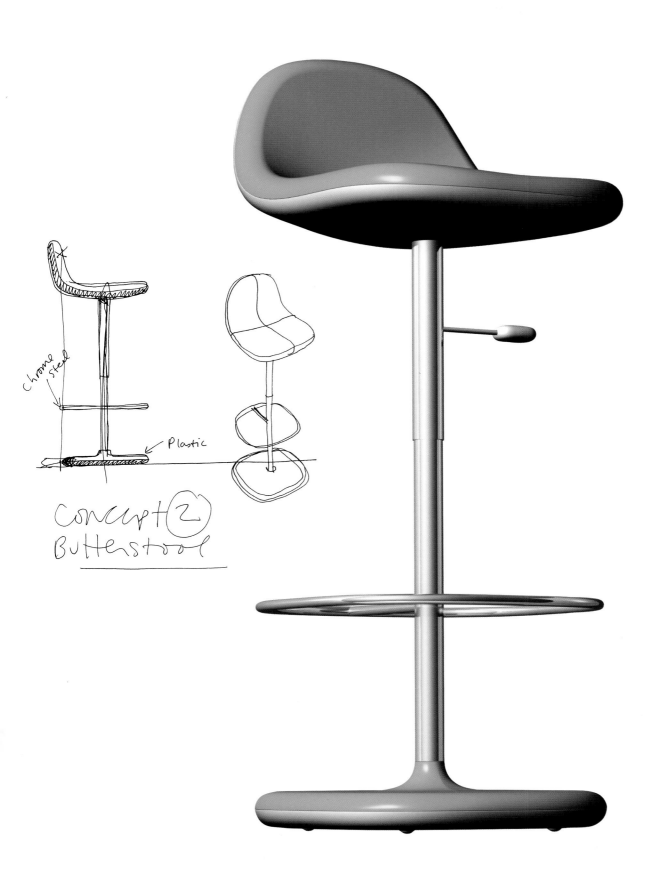

Chrome
steel

Plastic

Concept ②
Butterstool

Butterfly Stool Prototype, Magis, Italy, 2002

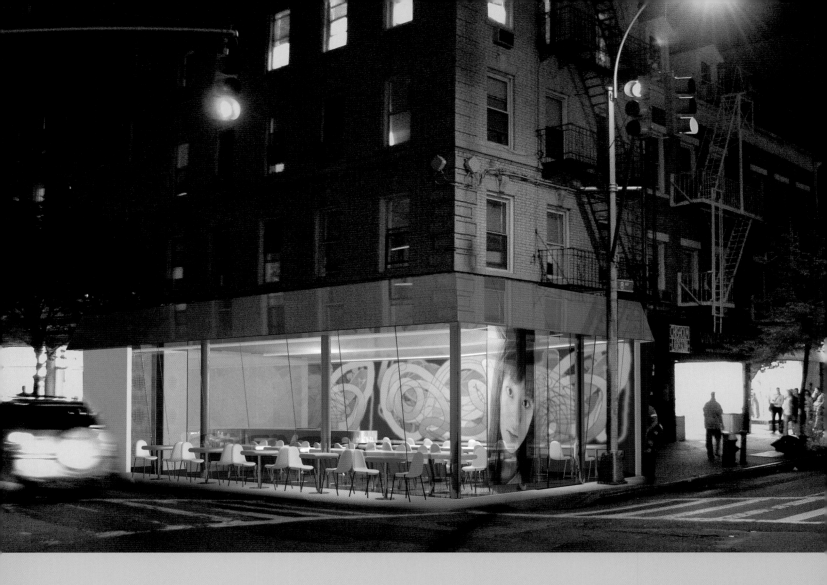

Nooch.KARIM

conseal.
Pink

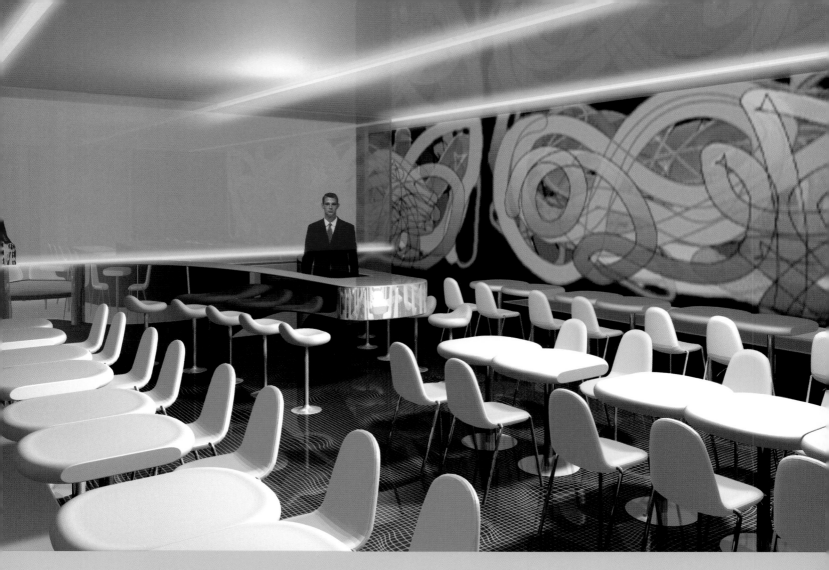

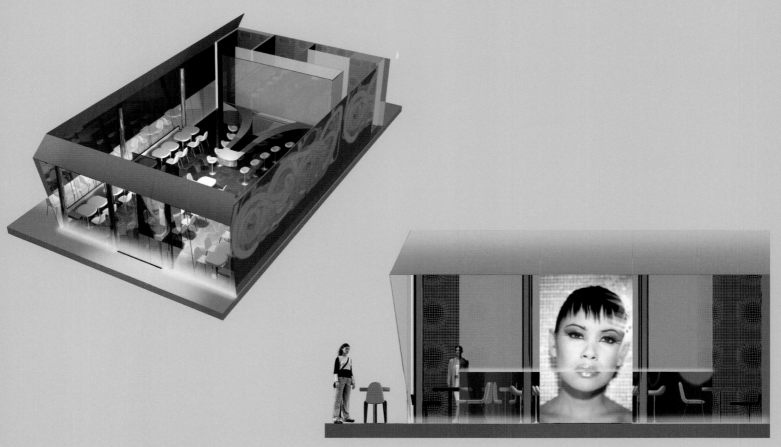

Nooch Noodle restaurant concept, New York City, 2004

KARIMAGOLOGOS

These symbols are an alpha-
bet—contemporary hieroglyphics—
a personal code that I have developed
over twenty years. Each has its own meaning,
I can write prose with them and I can dissemi-
nate messages like Morse code. Each symbol was
developed over time to express a certain emotion,
subject, idea, or philosophy. In the 80s, I signed my
work subversively with these symbols because in North
America, unlike Europe, it was very rare that a designer
would have his name on a product. I developed decorative
icons to sign my work without the client really knowing. I
would hide the symbols inside molding or enlarge and find
functions for them: I used them to shape ventilation holes on
high-tech products, for example, or the perforations in a strain-
er, or the handle of a chair or tray. Alternately, the forms
became coasters, mouse pads, mats, carpets, tables, tags,
fabric patterns, and so on. These icons can move from a dec-
orative language that implies a digital communication to a
strong, bold, strictly graphic presence. The beauty of lan-
guage is that it inspires, it is complex and broad, but
also specific and not global. The beauty of the symbol
is its power to communicate globally as one lan-
guage—to differentiate but, most important, to
be interpreted by each individual—to take on
new meaning, to be used in new ways, to
morph over time, like language, but far
more abstract and interpretive.

Karim Rashid

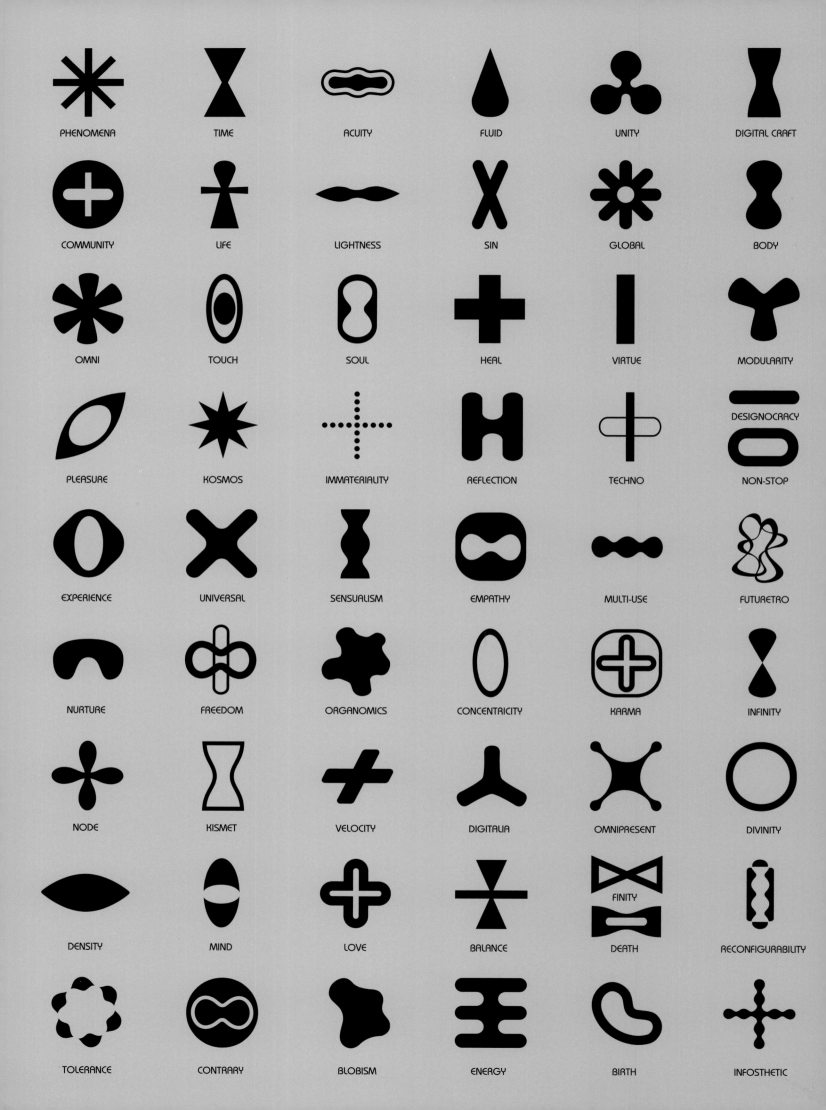

PHENOMENA TIME ACUITY FLUID UNITY DIGITAL CRAFT

COMMUNITY LIFE LIGHTNESS SIN GLOBAL BODY

OMNI TOUCH SOUL HEAL VIRTUE MODULARITY

PLEASURE KOSMOS IMMATERIALITY REFLECTION TECHNO DESIGNOCRACY / NON-STOP

EXPERIENCE UNIVERSAL SENSUALISM EMPATHY MULTI-USE FUTURETRO

NURTURE FREEDOM ORGANOMICS CONCENTRICITY KARMA INFINITY

NODE KISMET VELOCITY DIGITALIA OMNIPRESENT DIVINITY

DENSITY MIND LOVE BALANCE FINITY / DEATH RECONFIGURABILITY

TOLERANCE CONTRARY BLOBISM ENERGY BIRTH INFOSTHETIC

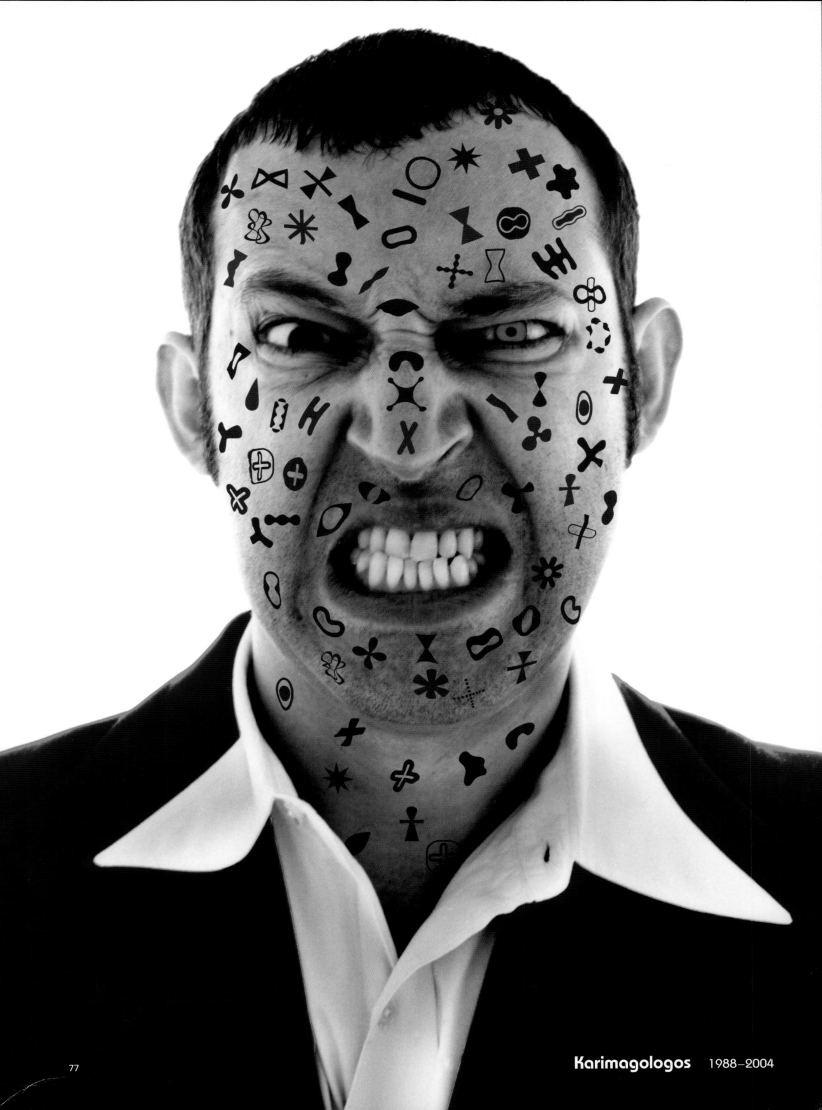

Karimagologos 1988–2004

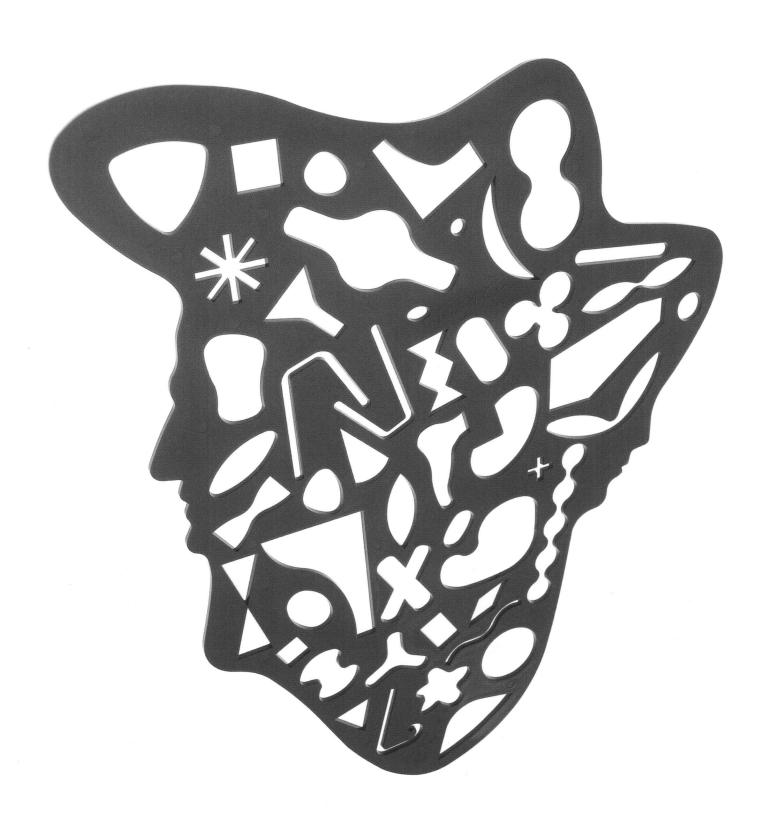

K Stencil Plastic drawing template, Bozart, USA, 2003

design? i dunno,

design? aren't we all a little bit

embarrassed to like design as much

as we do? i remember, for example, calling a

friend of mine a few years ago because i had just seen

eero saarinen's gateway arch and i was rhapsodic and beside myself and i was

describing how i had actually gotten teary eyed and choked up when standing near the

arch. or when i found an eames dcw lounge chair and i bought it because it just looks so

remarkable and it really doesn't serve much of a purpose but i really like to look at it, just

sitting there, kind of glowing with its warm maple finish. so yes, design. ¶ i mean, if we've

conquered hunger and figured out how to not freeze to death in the winter, then

shouldn't we spend our time somehow representing the human and universal

conditions through art and music and design? or does that sound nonsensical?

but doesn't everything seem kind of nonsensical when looked at in the

temporal context of us vs. the universe? here we are, puttering around

for 60 or 70 years, attaching significance to our work and our lives,

when we know full well that the universe is 15 billion years old and,

seemingly, not getting any younger and, seemingly, not all that

interested in us and our creative output. but design makes us happy. sex

makes us happy. waterparks make us happy. and that's all ok, right? we

shouldn't be embarrassed by benign things that make us happy. well, that's my

opinion anyway. and even though it's futile to spend our time making things and

having sex and playing in waterparks, it's still more fun than sitting around and

waiting for entropy to tap us on the shoulder and turn us into dust. right? ¶ so let's

celebrate design and art and music and sex and food and all of the things that make

our tiny little lives somehow more interesting. we know that in the grand scheme

of things we're little nothings. but let's be entertaining nothings, and striving

nothings, and interesting nothings. ars brevis, vita brevis.

in fact everything that we know is kind of brevis.

and if we weren't such contextually short-

lived little creatures we probably

wouldn't make such cool

stuff, right? **moby**

DIGIPOP I love meaningful decoration. Historically, decoration was used as a form of language, as well as a means to demonstrate the potential of the human hand, the richness of craft, the workmanship of a period. With mass production, decoration became expensive if not impossible so the machine age parted with the ornate. With automation and the industrial revolution decoration was developed to carry on the spirit of the past and as a way of "humanizing" industrial objects. But eventually production technology reached a point where decoration became more cost effective, a way of hiding flaws, a way of camouflaging defects, and a way of cheapening product. Today, ornamentation no longer necessitates more work or more cost as it did when things were handmade. For example, some crystal today is highly cut or decorated to hide air bubbles, fake weave holes in plastic "wicker" hampers are there to reduce the amount of plastic, or hide sink marks and bad quality moldings. Decoration became the myth of value, a mode of making objects or products appear richer or more luxurious, a bourgeois paradigm. Yet the irony is that it is now cheaper to create something decorated, than something pure and clean. Simply surfacing the product is the fastest and simplest way of giving a consumer choice and tribe-niche (i.e. fascias for cell-phones, car wraps, bus ads, 3-D labeling, tattooing, etc.), but decoration is also a great opportunity to create diversity, variation, and customization. New meanings have surfaced: signs for technology such as "fake venting" (that originally started out as real vents for airflow), perforations, or holes for speakers have all become high-tech signifiers in products. In the past few decades Op art, pop art, illusory perception, and graffiti have been among the means to communicate personalized or more rarified mass goods. Now, in our digital age, we see a new digitally inspired decorative language taking place, an extension of the rave flyer movement, a techno-rave new world. Once decoration spoke of ritual, religious iconography, or spiritual imagoes, now I am interested in it speaking to us about our new spiritualism—the spirit of the digital age. Decoration needs to be revisited in our product and architectural landscape to communicate our milieu, our time. I think the digital age has a new language, a vernacular I refer to as the Infosthetic (the aesthetics of information). I also call this period "Digipop," that is, a graphic movement that has its roots in the computer age and is driven by digital technology. The premise is using new tools to create complex 2-dimensional graphic work that is perceived as 3-dimensional. A characteristic of the movement of graphic design and application and the use of composition techniques only made possible through the use of new technologies and software. The new movement of techno graphics is creating a landscape that is hypertextual, hypergraphic, hypertrophic, and energetic. **Karim Rashid**

Digipop carpet concept, L'Art Du Temps, USA, 2003

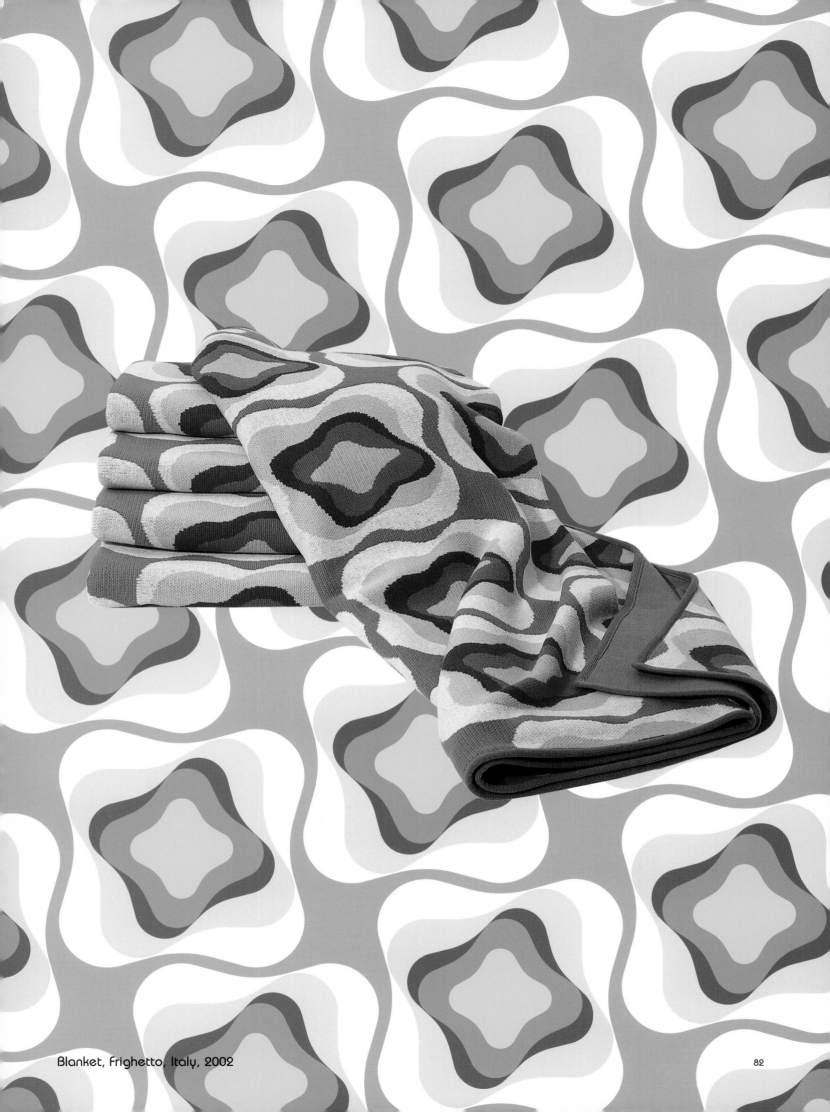

Blanket, Frighetto, Italy, 2002

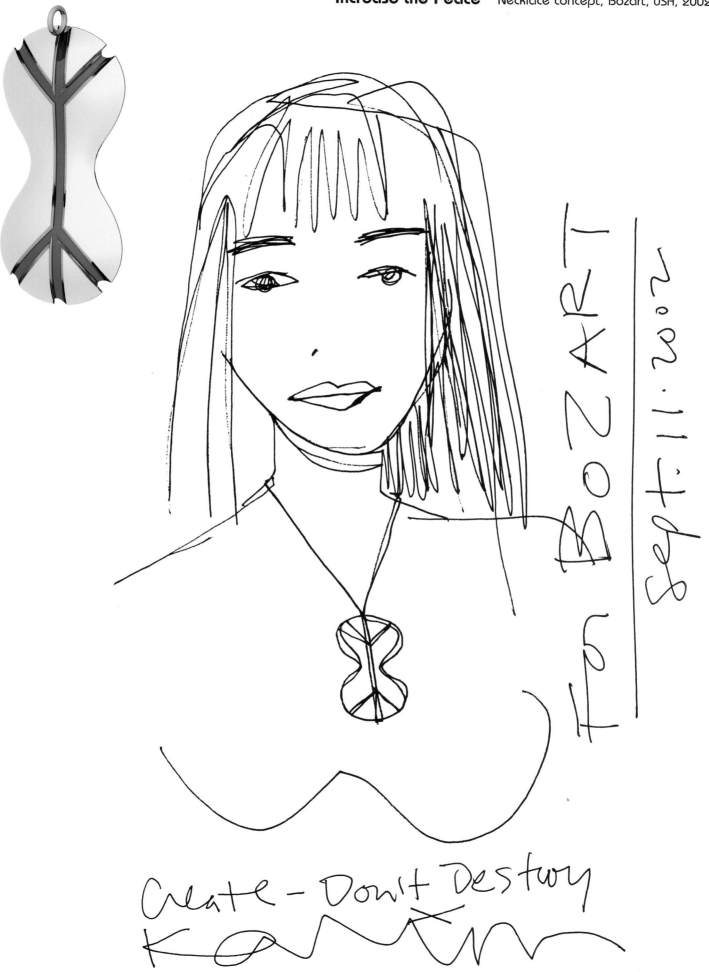

To BOZART
Sept. 11. 2002

Create - Don't Destroy
Karim

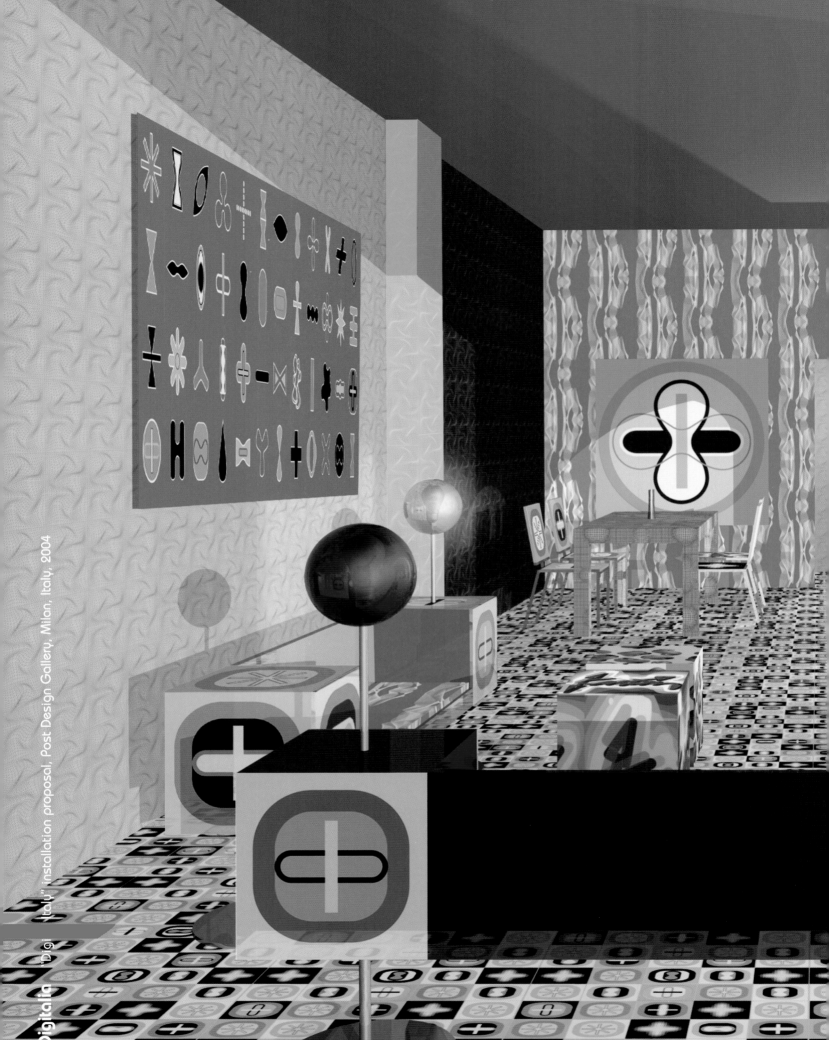

Digitalia, "Digit Italy" installation proposal, Post Design Gallery, Milan, Italy, 2004

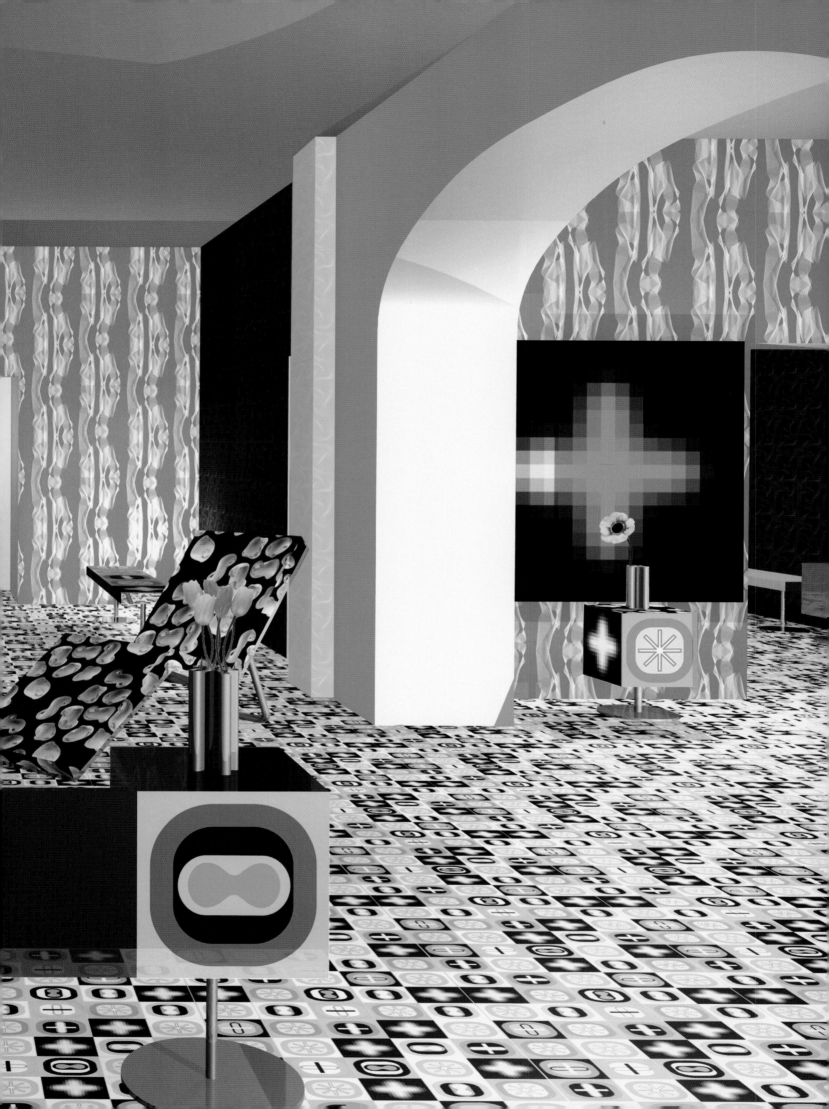

Vase collections, Egizia, Italy, 2003

Linescape

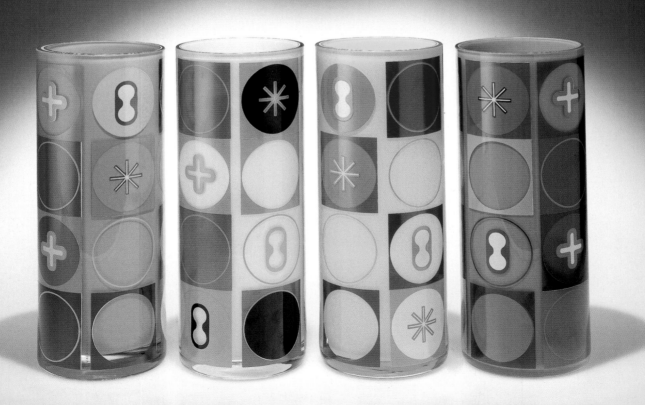

Komposition

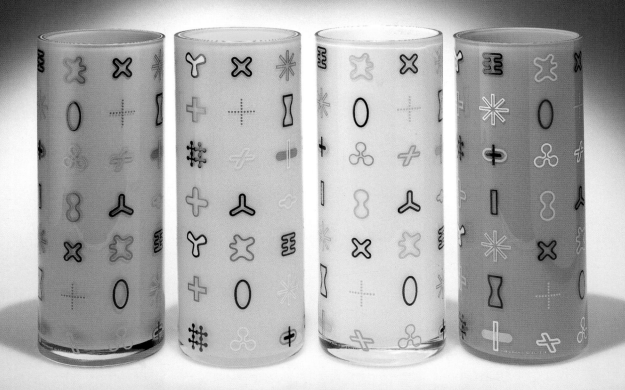

Ikon

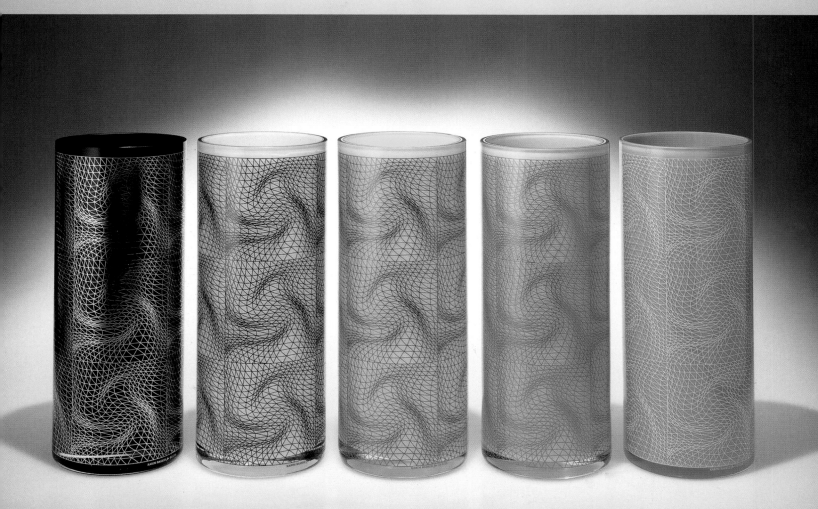

Flexous

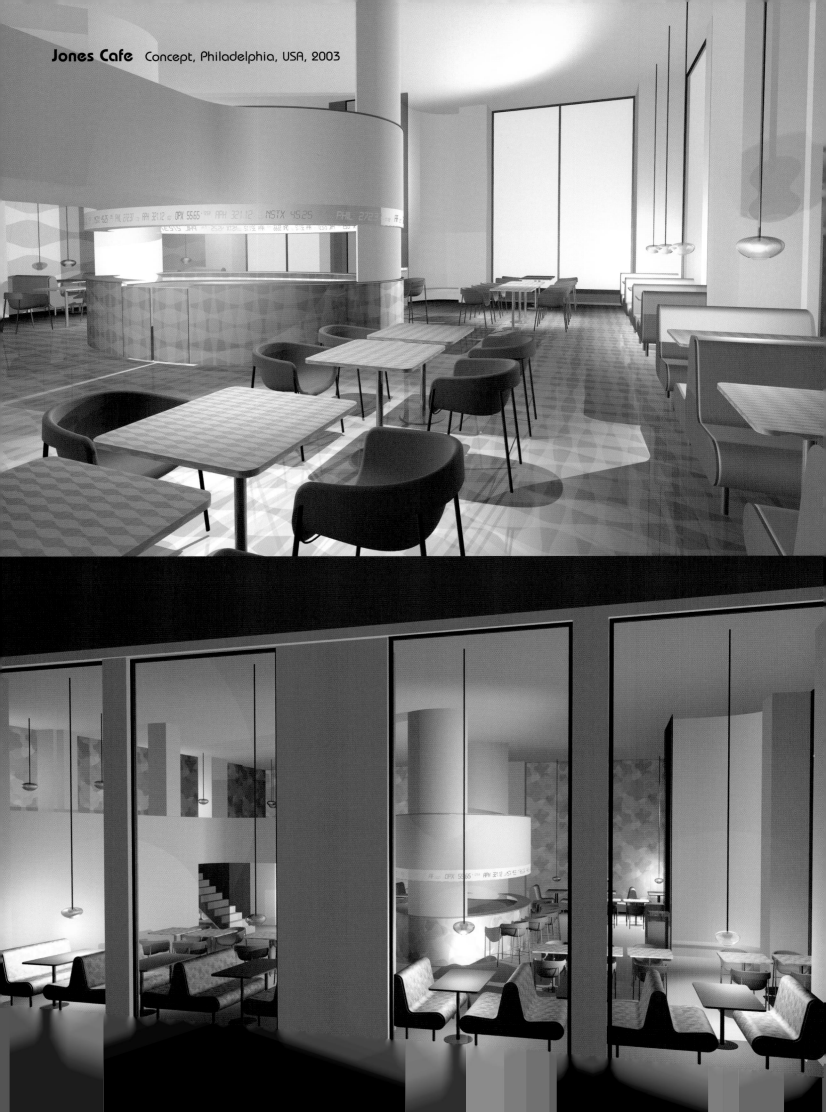

Jones Cafe Concept, Philadelphia, USA, 2003

Jones Cafe

Starr Enterprises requested a proposal
for a casual, inexpensive contemporary diner. I found the
idea of revisiting the classic American diner very inspiring and immedi-
ately considered developing a wallpaper and plastic-laminate motif (both typi-
cal diner surfaces) that would communicate a softer, more fluid space, where scale
and color would vary from one surface to
another. I also envisioned a soft can-
tilevered bar that would project out-
ward, disseminating the menu
with scrolling LEDs.

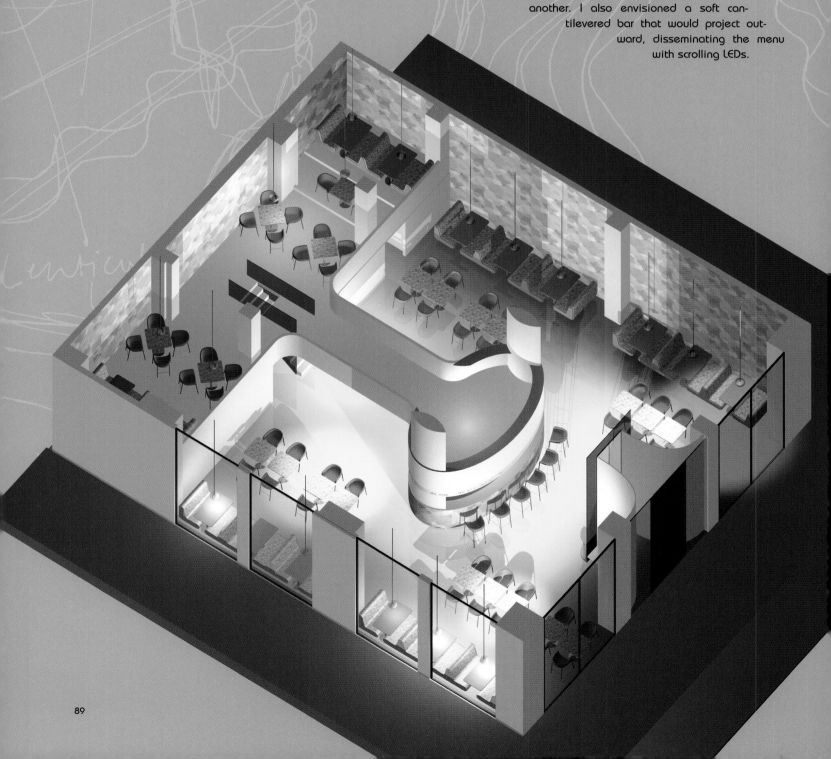

Surfacescape Edra and Surface magazine, 2002

KARIM RASHID Design has always been strict, intransigent, dogmatic, haughty. Perhaps because it was invented by an elitist German school, one that believed that democracy was a question of imposing that form follow function on those who otherwise may have sought forms that followed "fiction." Design has always had exacting masters that preached the impudence of any industry that expropriates creative work. Then Karim Rashid appeared, six-foot two, strikingly white-clad in winter and summer alike, with his dark Mikli bug-eye glasses—and things began to change. ¶ He does not oppose industry theoretically but loves it passionately—he seeks it out, surrounds it, so that it allows him to design something, anything. To him, giving shape is as vital as breathing. He cannot abstain from leaving fingerprints on paper, textiles, laminates, carpeting, etc. He designs for everyone, shamelessly, and is seemingly never satiated. Things come easily to him; for this reason they are conciliatory. They do not reveal strain or tension but enthusiasm and faith. His projects mediate because they are simple and spontaneous, because they don't require decoding. They are variants repeated ad nauseam of an uninhibited sign, nourished by popular culture, streamlining, psychedelic colors, and a good dose of kitsch. Purists may turn their noses and fear the invasion of his banal sinuous forms and the expansion of his ego, which is as great as his stature. But for the design world in general, it is a great fortune to have Karim Rashid—his impetuousness, generosity, longing for recognition, and conspicuous design. ¶ With the expansion of his organically shaped products, of his blobs and superblobs, Rashid humanizes design. Bordering on bad taste, he makes design tolerant and popular. He declares that he wants to change the world with his objects. Unfortunately, the salvation of the world seems ever more remote, but perhaps he is capable of saving design from its intransigence, disciplinary rigor, and dogmatism. Designing candy-like chess pieces, perfume bottles as malleable as rubber balls, sofas like soft islands to dive into head first, and lamps like luminous slopes, Rashid mutates the landscape of forms. His ideal house looks like a nightclub in which to be dazed by music, extravagant shapes, and brilliant colors—where, fortunately, the beautiful fits in as well as the ugly, which has its own aesthetic. As Karl Rosenkranz claims in his *Aesthetics of Ugliness*, "The ugly is part of the beautiful, its negative counterpart. It is a rebellious beauty that has to be subdued after a tough battle." ¶ Unconditioned multiplication is an intrinsic quality. Karim cannot be discrete or moderate. He counts because he is immoderate. His objects are invasive but it is a peaceful invasion, because they are conciliatory, instinctive, and beneficial. Beneficial because they help us gain confidence in a design that, at times, is still a little frightening. **Cristina Morozzi**

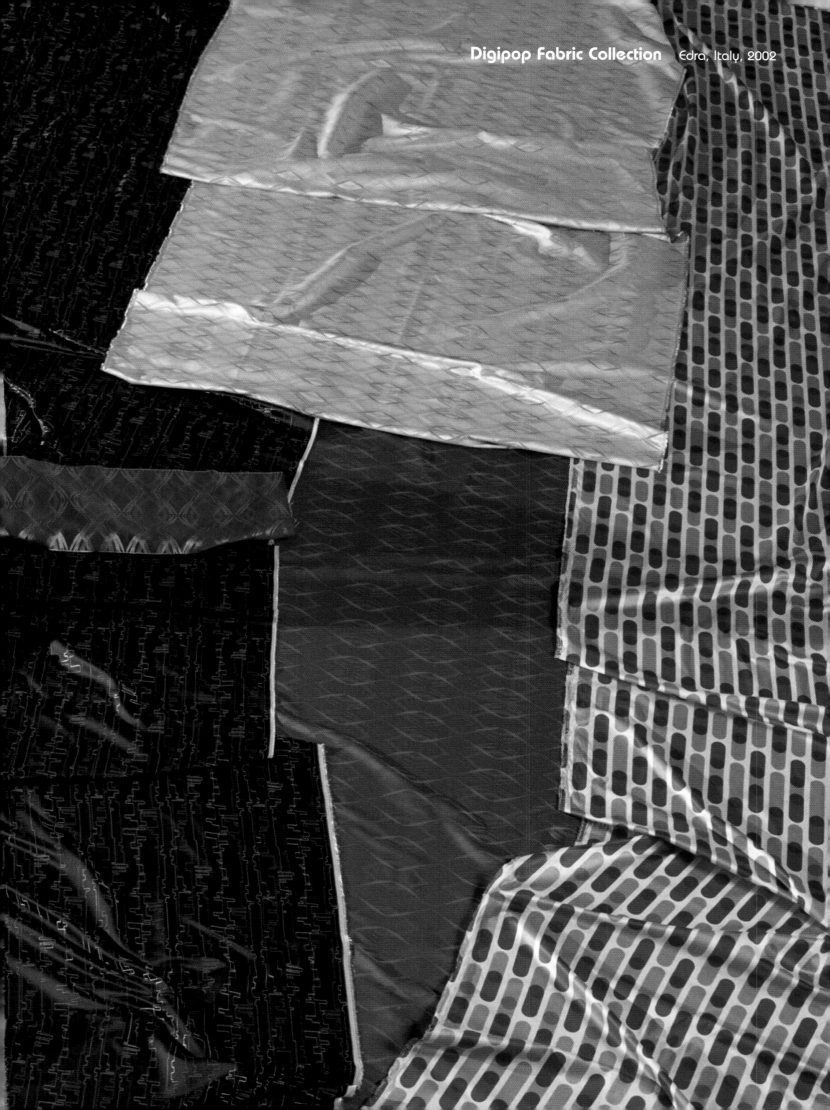

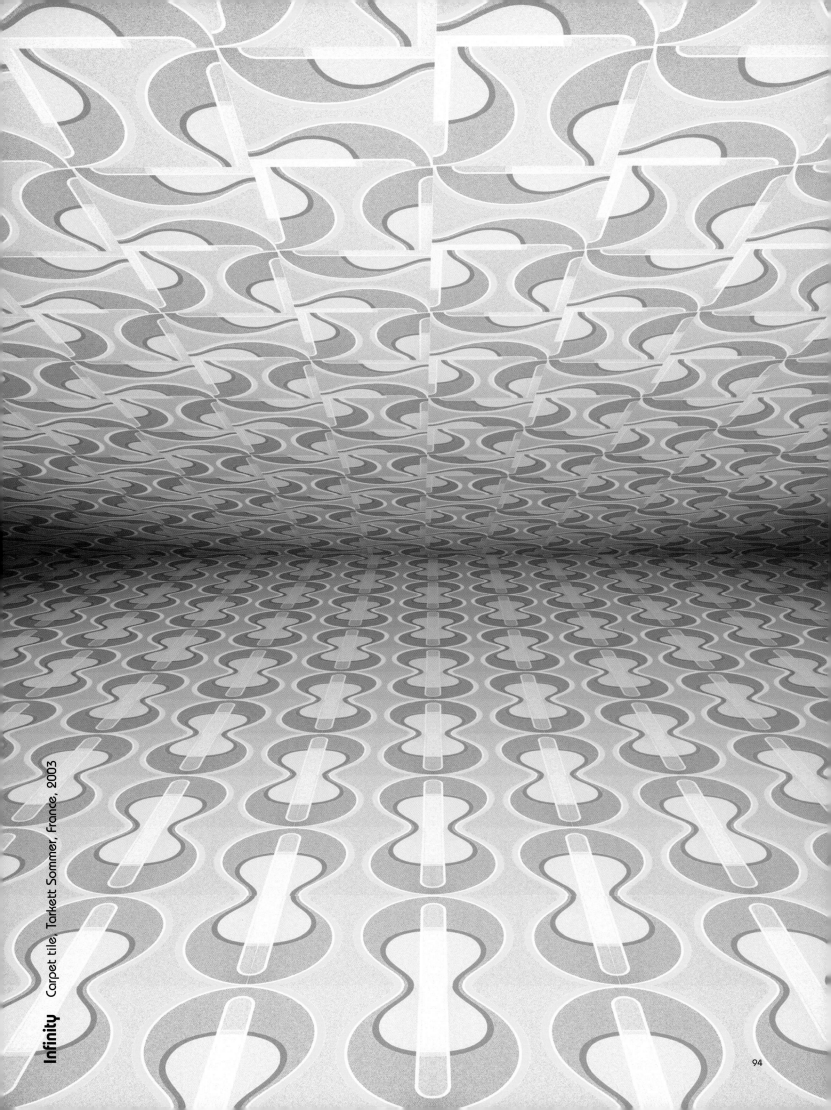

Infinity Carpet tile, Tarkett Sommer, France, 2003

MULTIPLICITY

The desire for a single object to do more—to provide multiple functions and to transform—is a natural impulse and an intriguing design objective. Since the ancient Egyptians and Romans, we have witnessed multiple functions in any given product, as well as module components or building blocks. Ultimately, more is more. A bed that becomes a divan that becomes a chaise lounge is like James Bond's Aston Martin transforming into a plane and a submarine. There are pragmatic reasons for multifunctionality, not least of which are small urban spaces, but the natural poetic articulations of surprise, of event, of the phenomenological change over time, is what people embrace. A typical argument against this change of function is the issue of compromising quality and performance. Is it better to have three objects that perform really well, or one that performs the three functions badly? Do we actually spend the time to change the object or does it always remain in one of its orders? Is it a question of merchandising seduction or image-retention? We have several orders of real change, or variation, in our built landscape: modularity, serialization, decoration, diversity, and individualism. The notion of reconfigurability and modularity all contribute to a behavioral vicissitude. One of the multi-functional icons of our last century is the wooden crate: a building block that started as storage for milk, became a vinyl record holder, then shelving, a bed support, and so on. Generations adapted the ubiquitous object to their personal use. The interpretation of the object is important here: a module allows for customization ad infinitum, and reconfigurability engages us both physically and metaphysically. There is an inherent beauty in objects that fit perfectly together: when they mate, join, hybrid, and marry— a unison that communicates organization, mathematical perfection, and logical order.

Karim Rashid

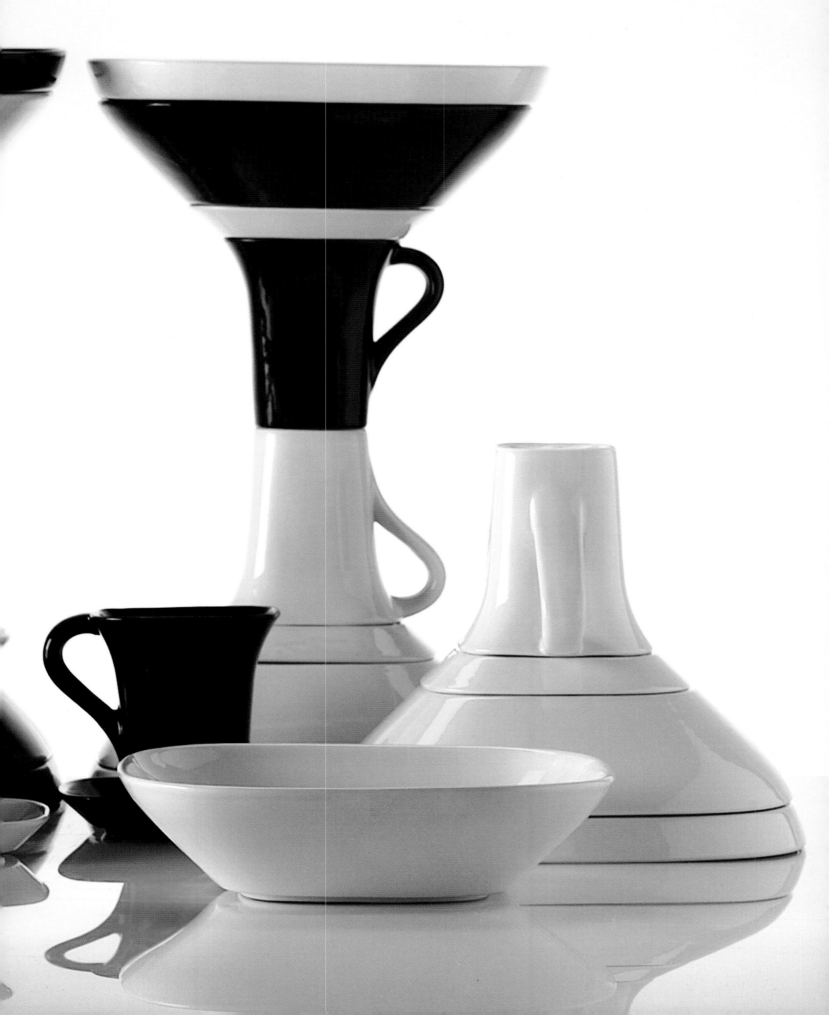

Ceramic Landscape Decorum, Italy, 2002

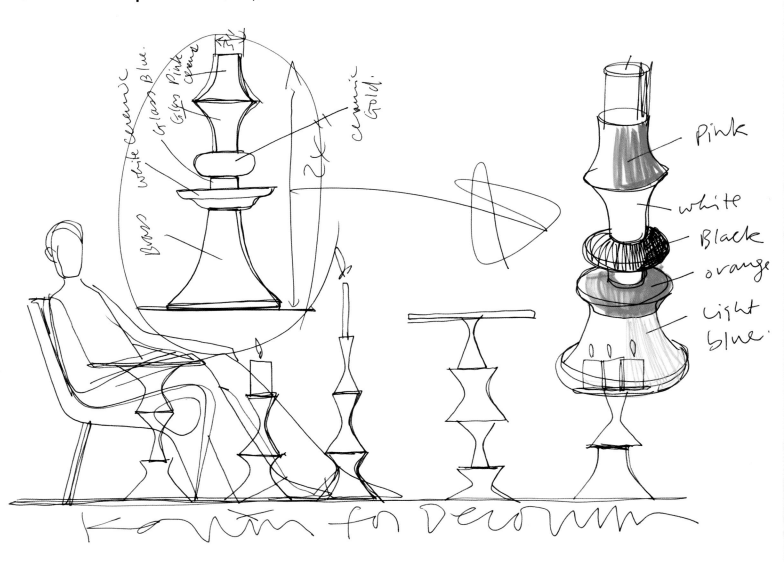

Bronze white ceramic
Gloss Blue.
Gloss Pink ceramic
ceramic Gold.

Pink
white
Black
orange
Light blue.

Karim for Decorum

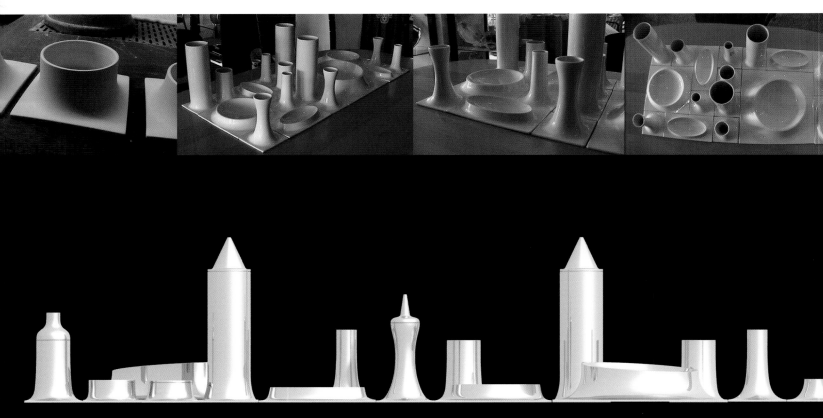

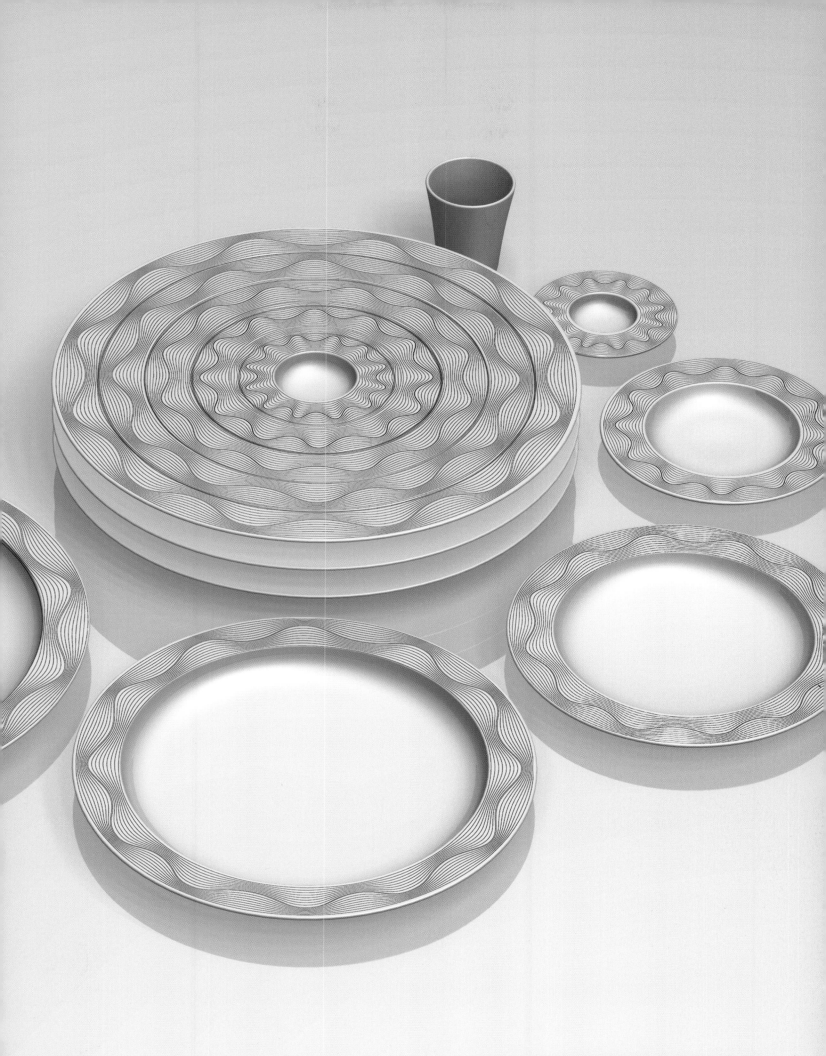

Dinnerware concept, Magppie, India, 2004

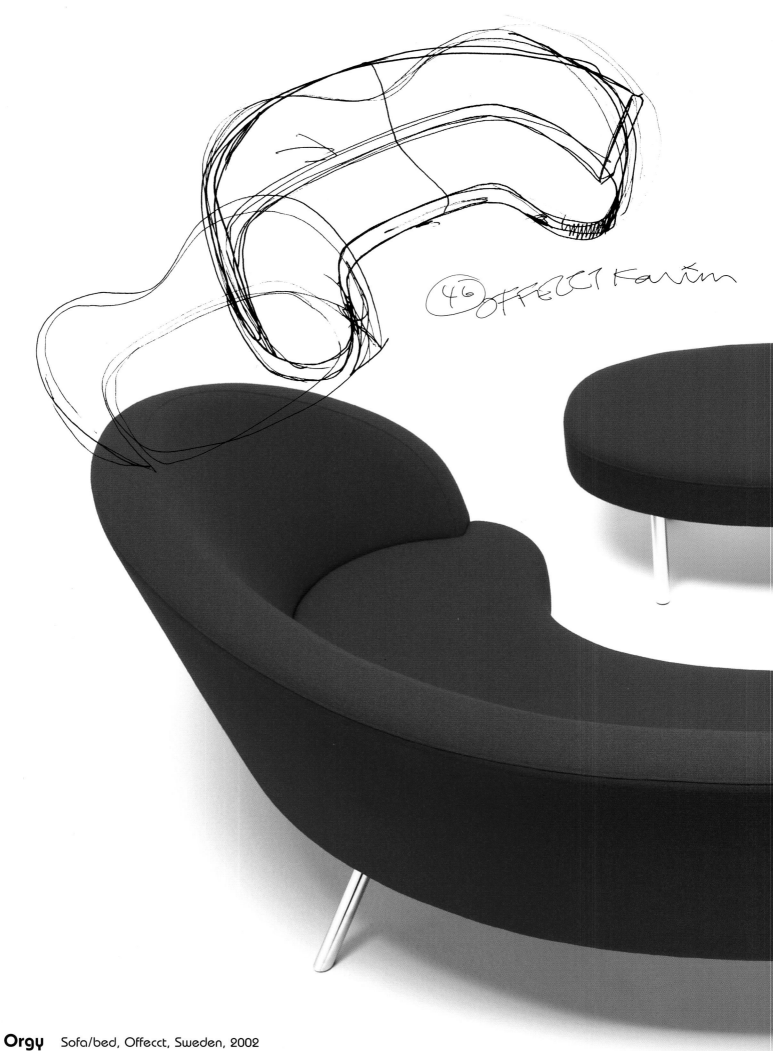

Orgy Sofa/bed, Offecct, Sweden, 2002

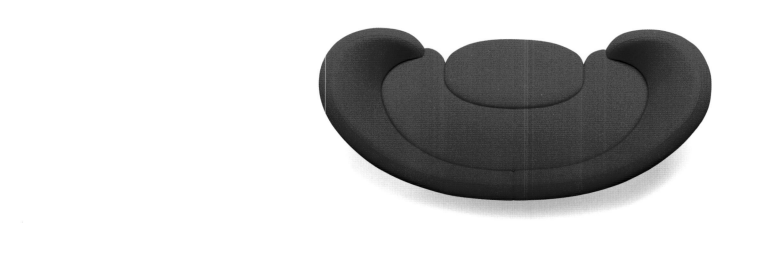

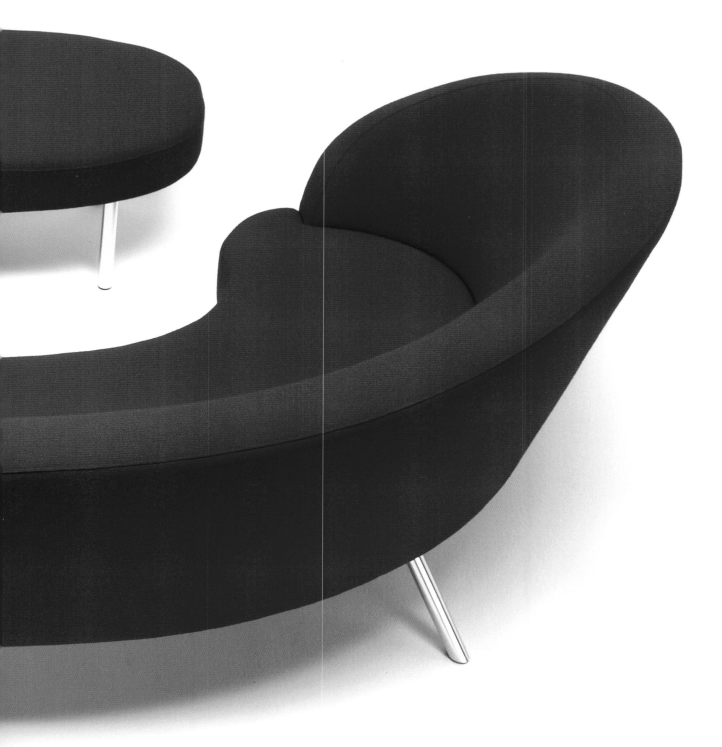

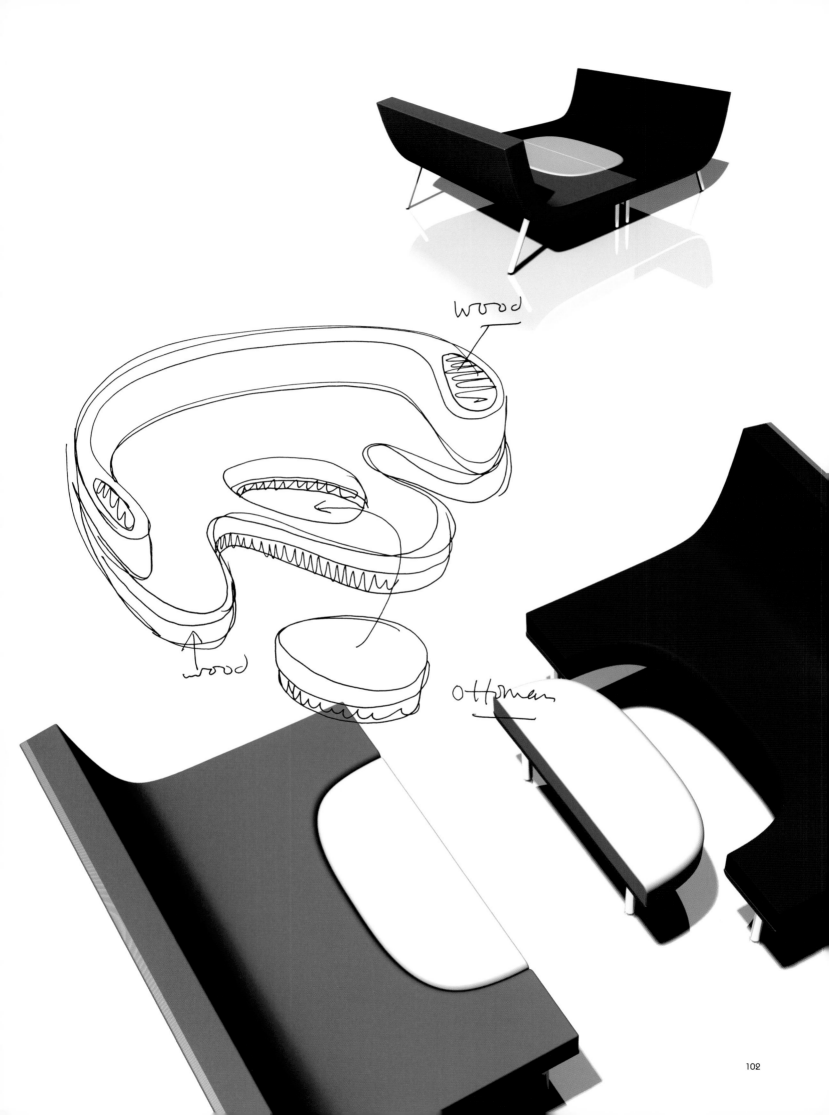

wood

wood

Ottoman

wood

Top View

coppertable

Ferrachi
Casa
SPAIN. June 2002

wood

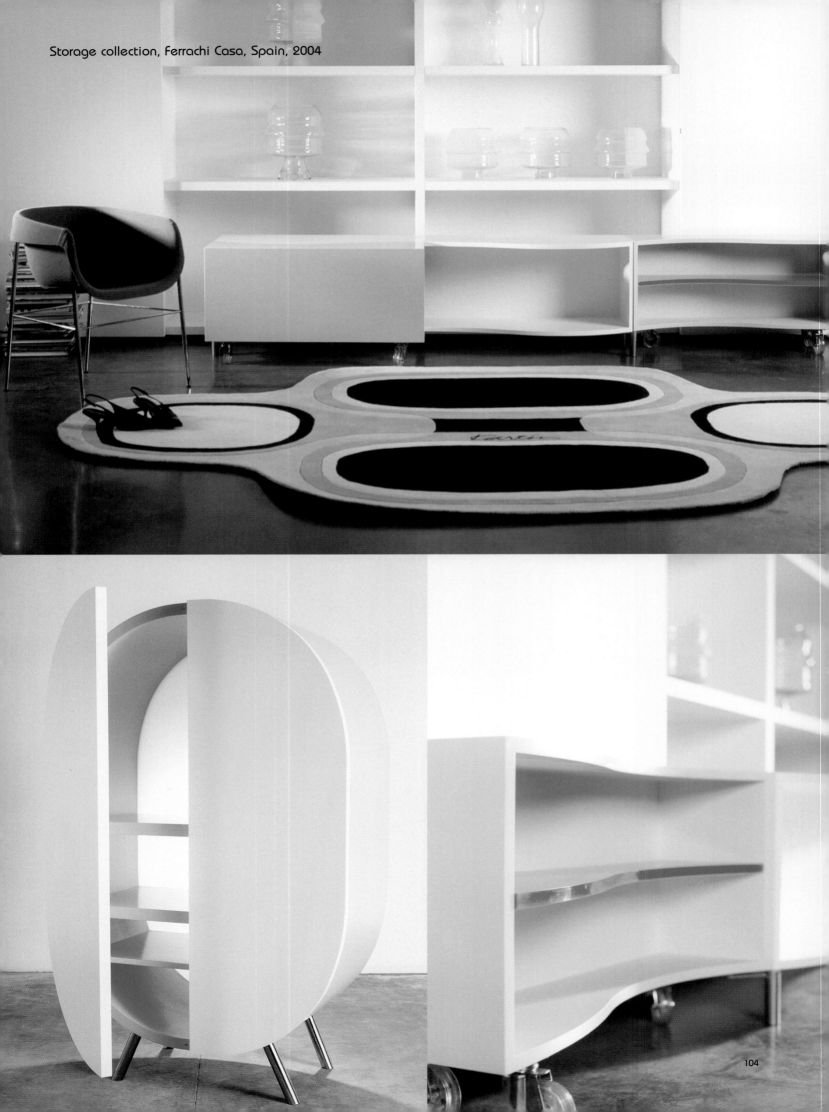

Storage collection, Ferrachi Casa, Spain, 2004

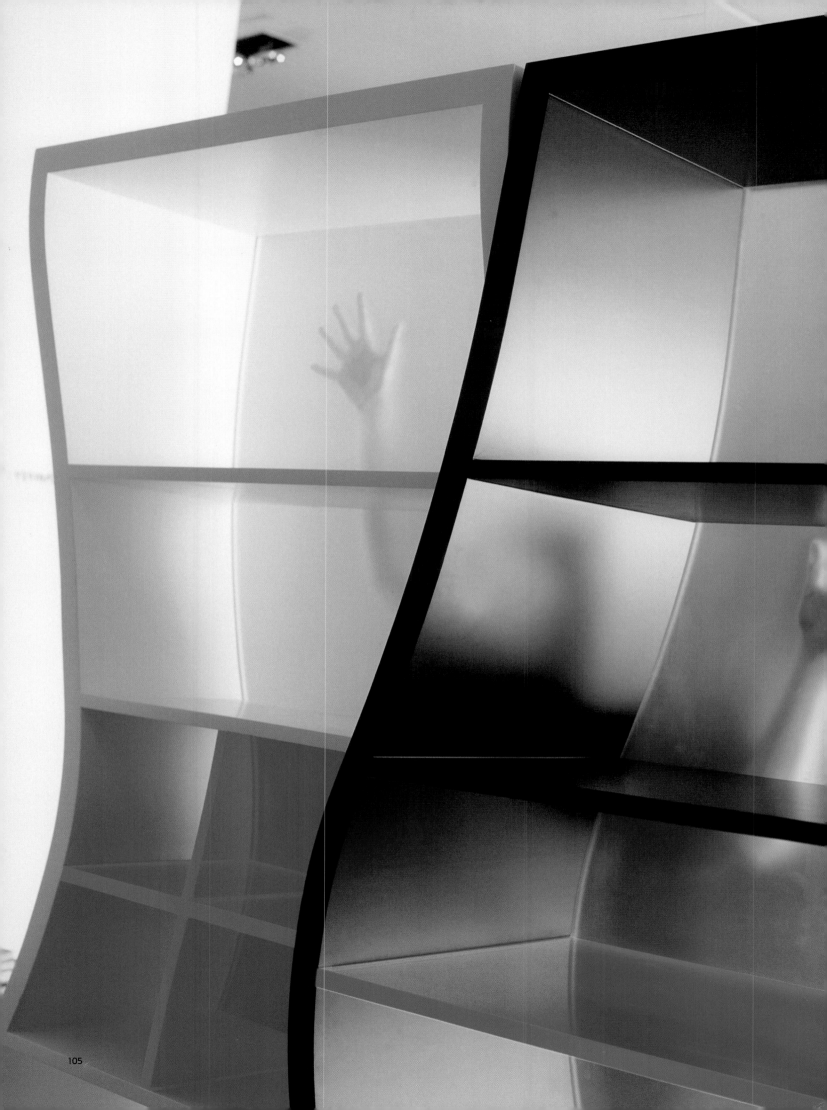

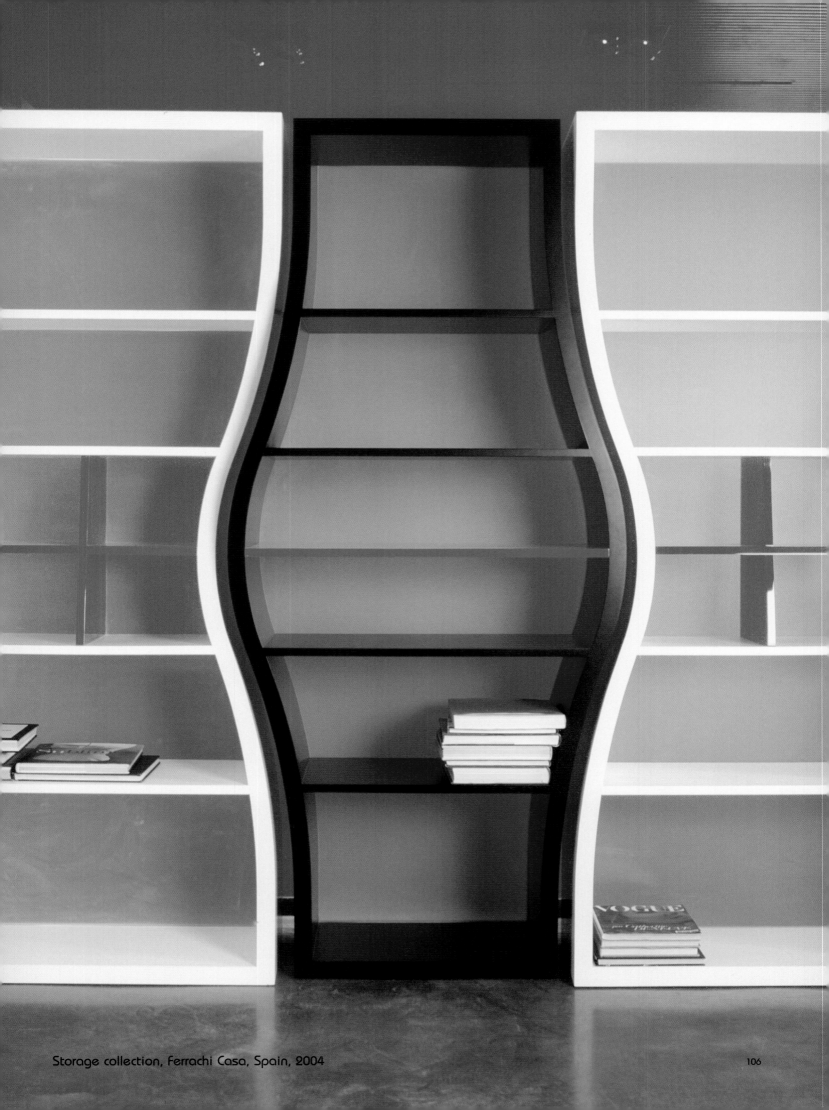

Storage collection, Ferrachi Casa, Spain, 2004

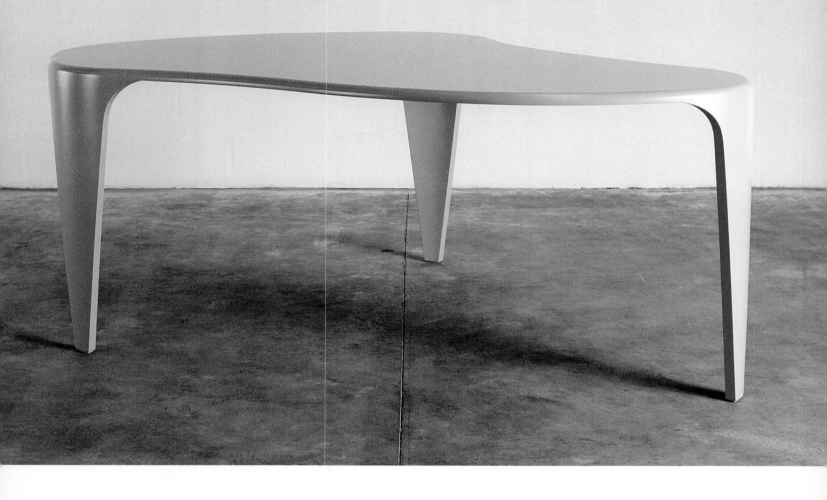

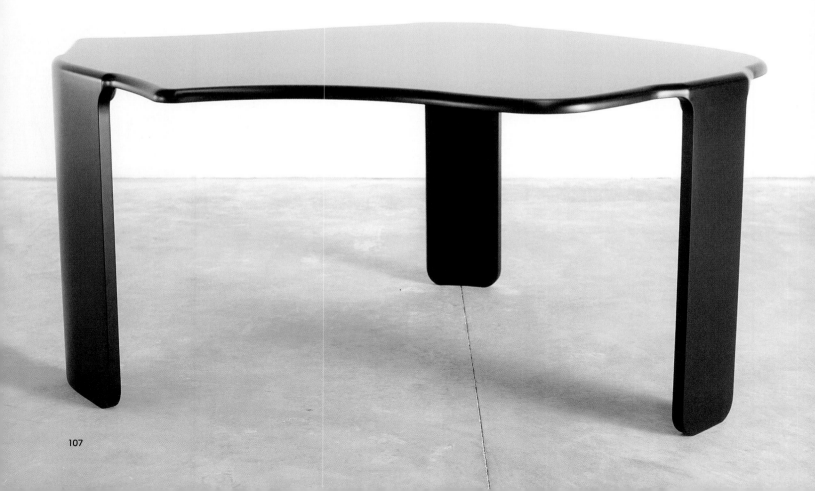

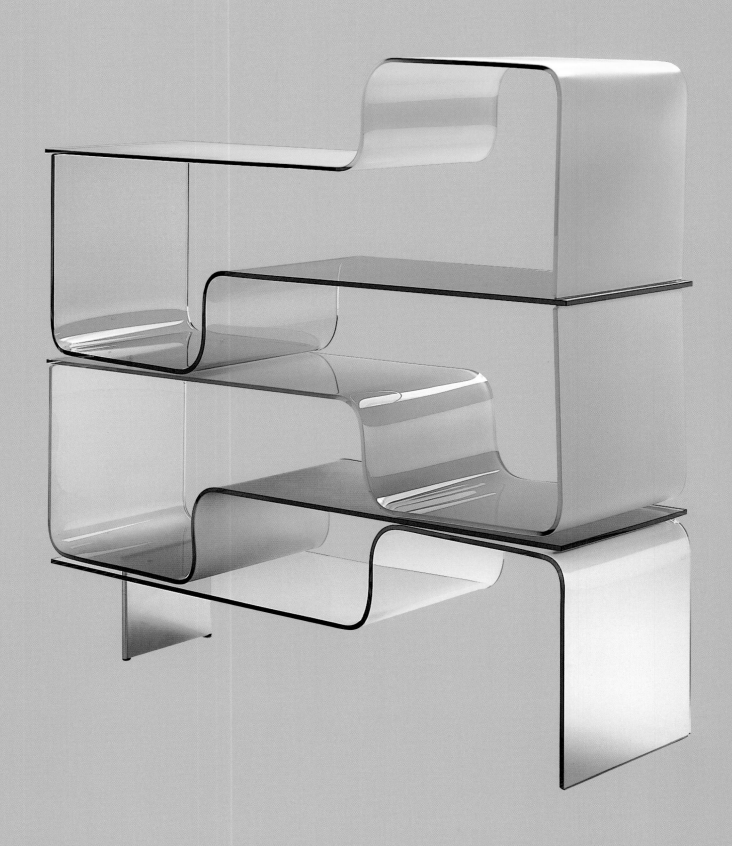

Kurl Zeritalia, Italy, 1998–2002

Glass units—reconfigurable into tables, shelves, and desks

108

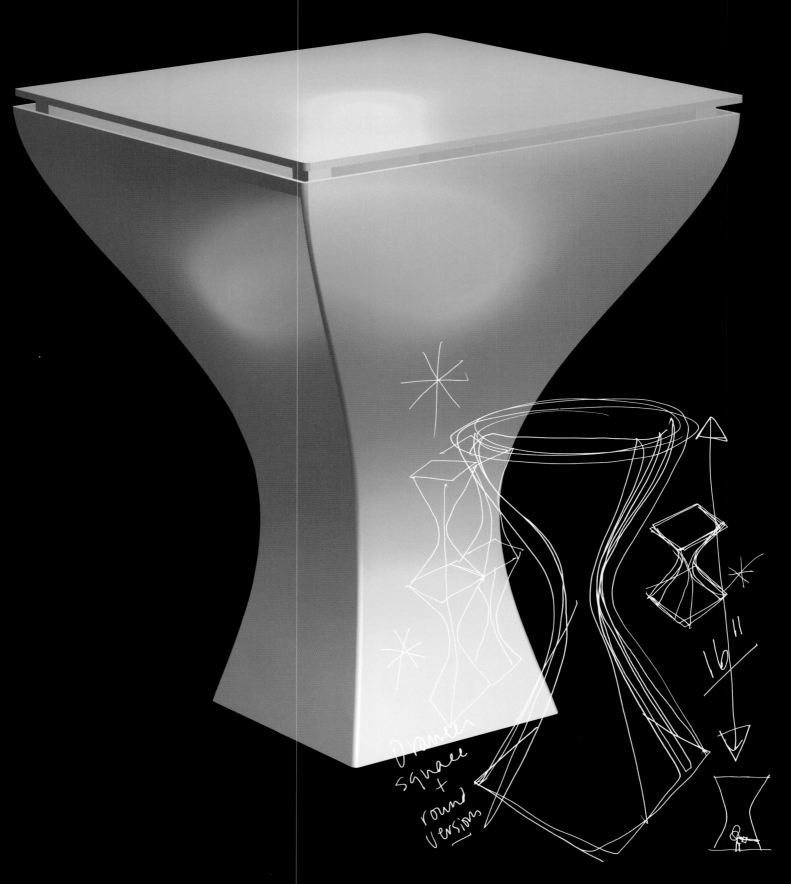

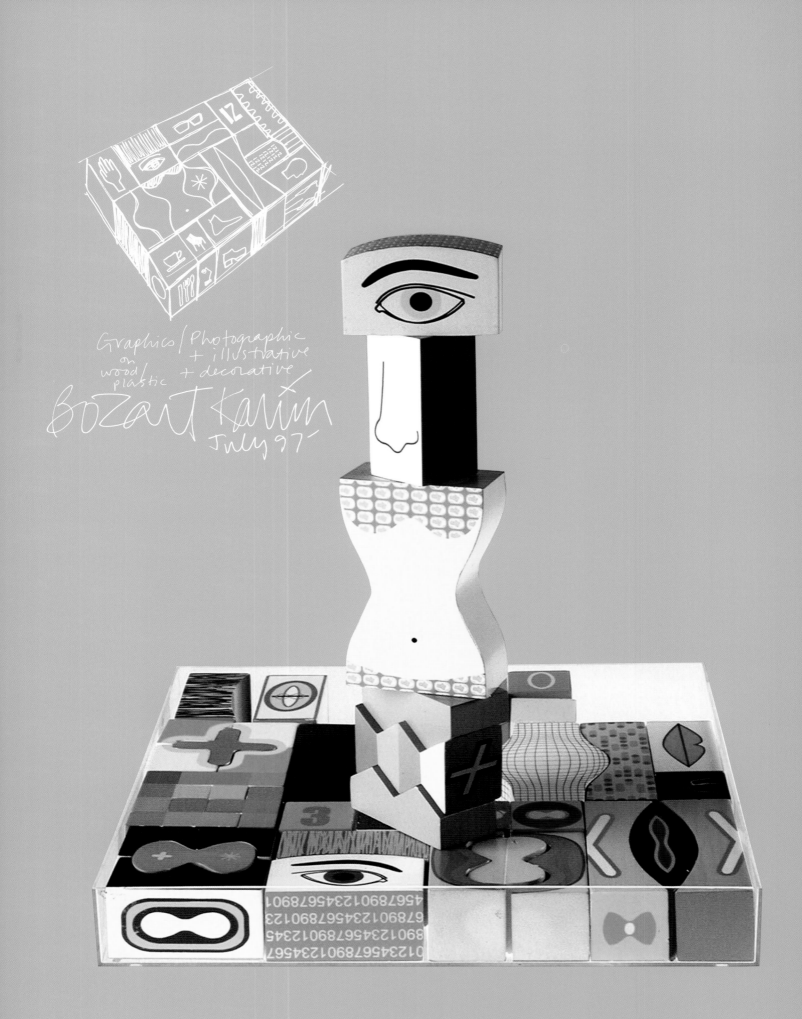

Graphics / Photographic
on + illustrative
wood / + decorative
plastic

Bozart Karim
July 97

Kosmos Blocks, Bozart, USA, 1997–2003

Backgammon Bozart, USA, 2002

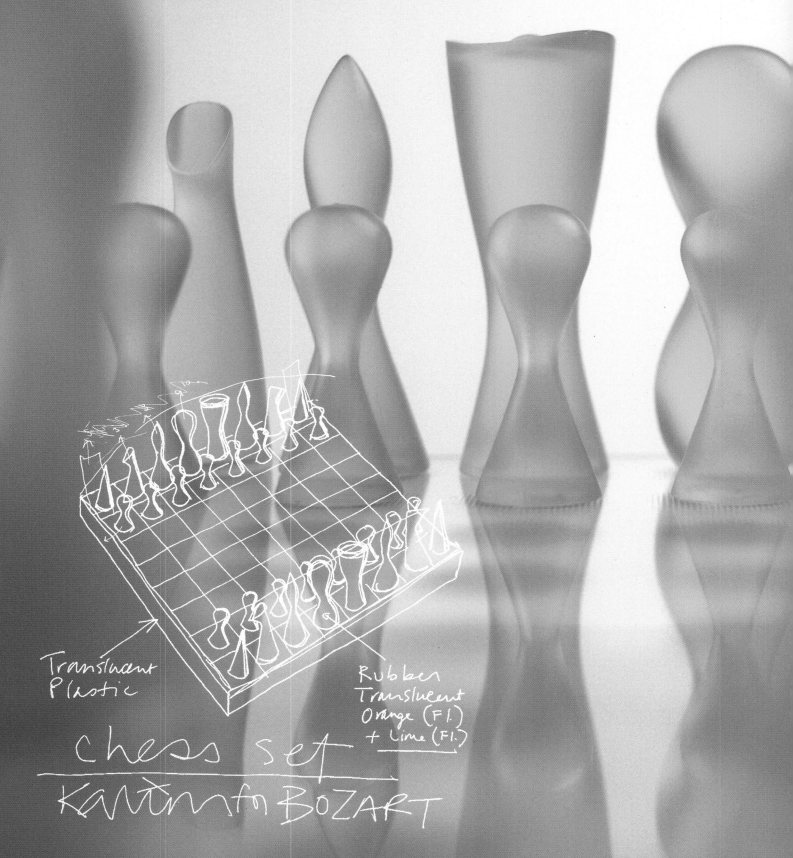

Translucent
Plastic

Rubber
Translucent
Orange (F1.)
+ Lime (F1.)

chess set

KARTM fu BOZART

Chess Bozart, USA, 2002

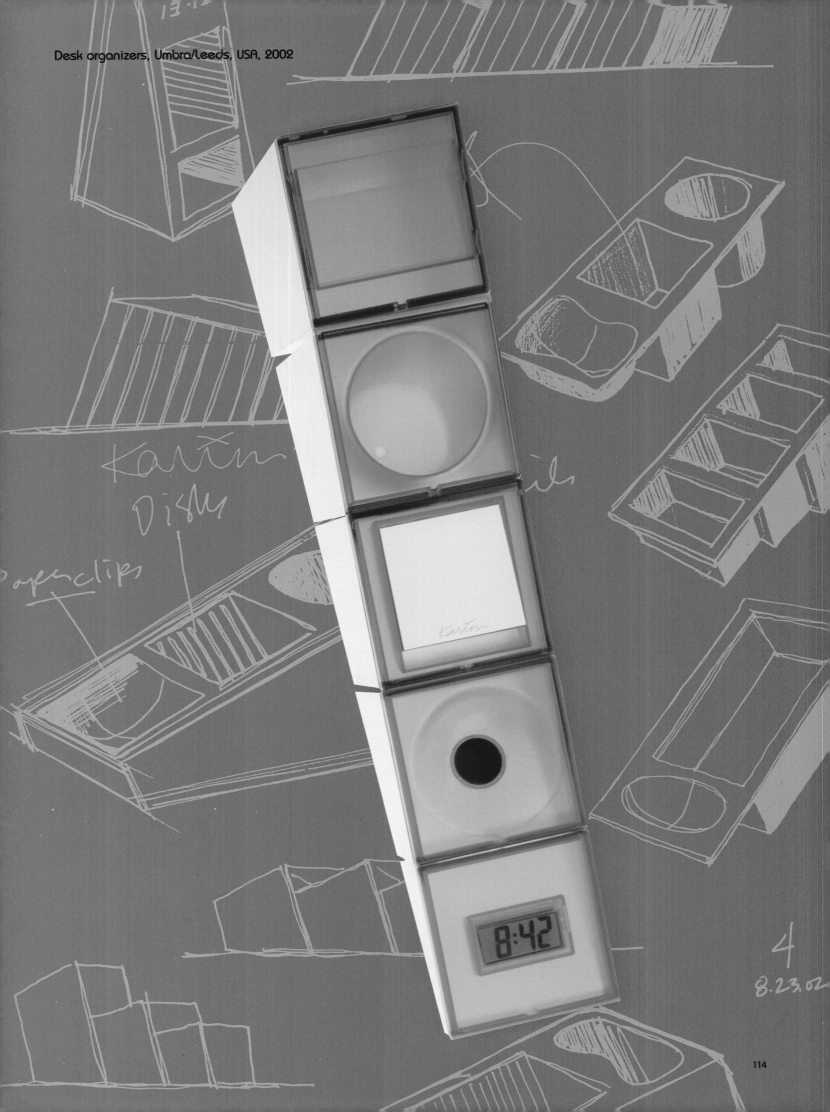

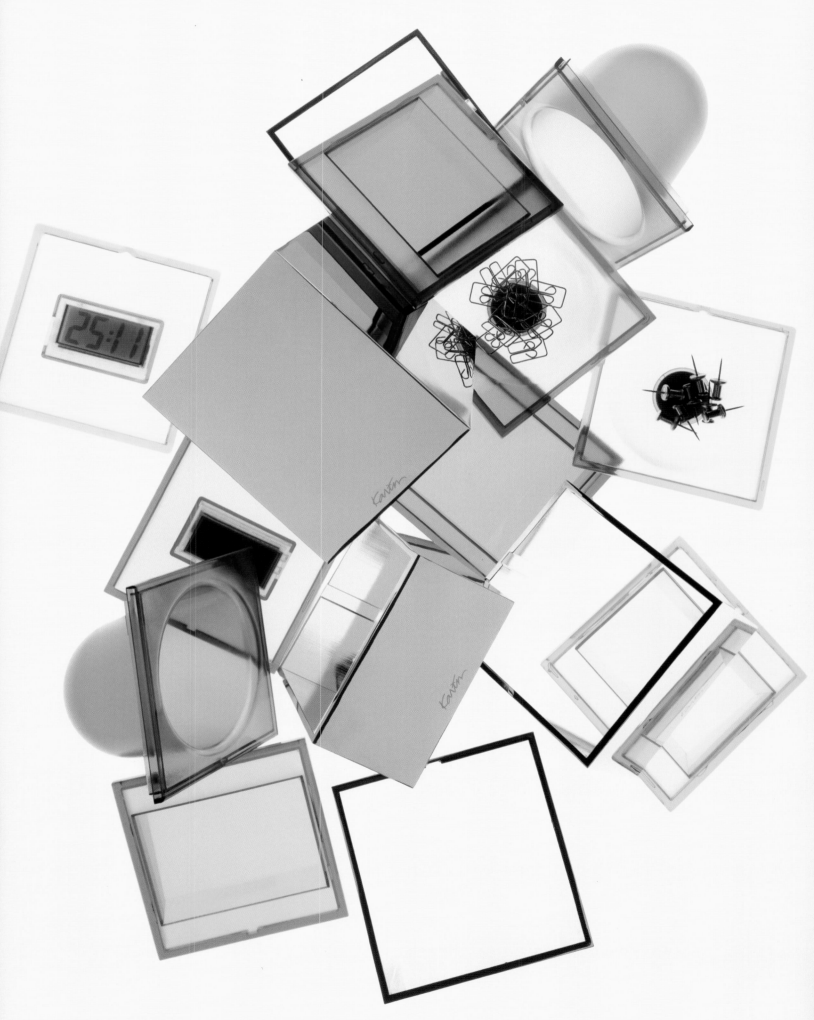

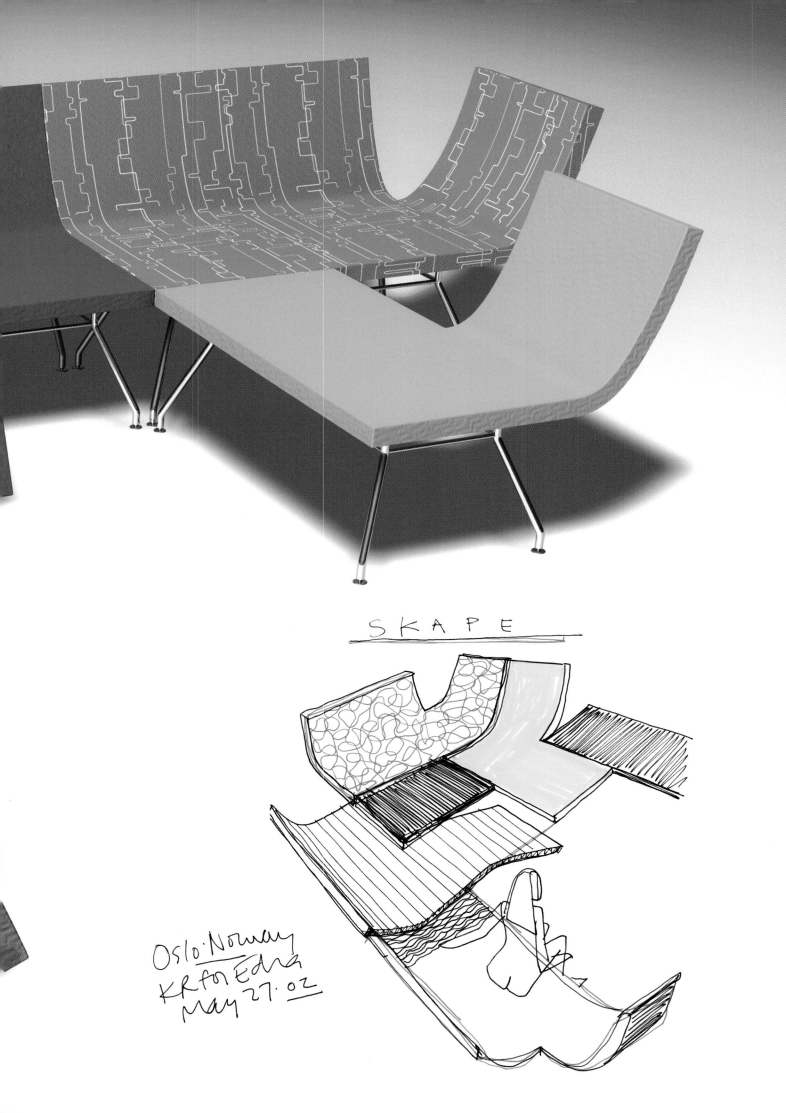

SKAPE

Oslo·Norway
KRATOEDRA
May 27·02

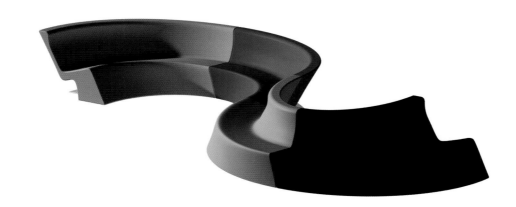

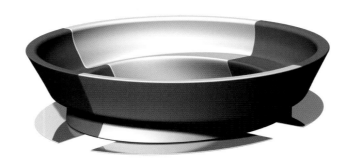

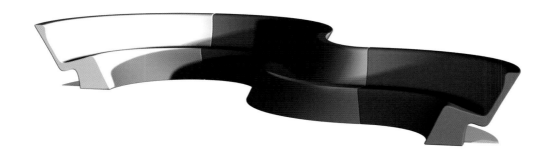

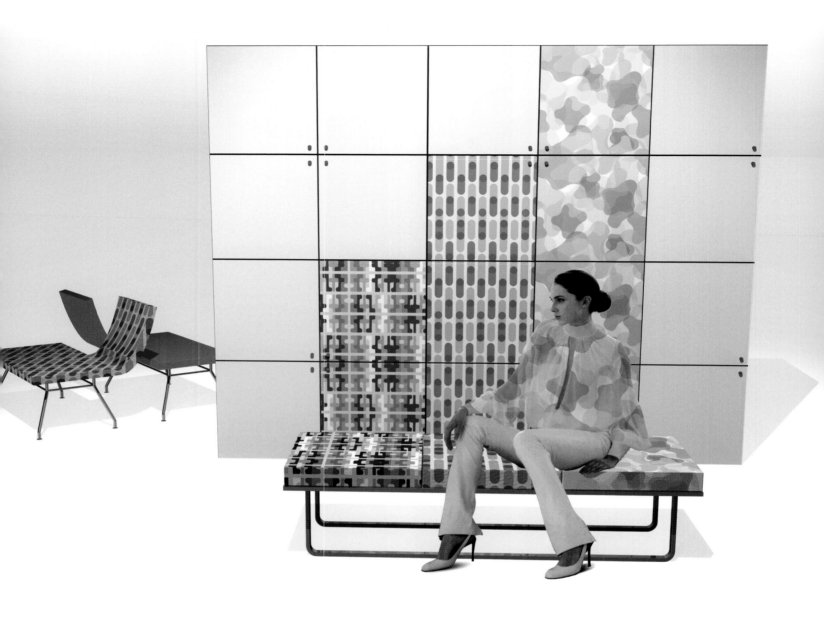

Paesaggi Decorative concepts, Edra, Italy, 2003

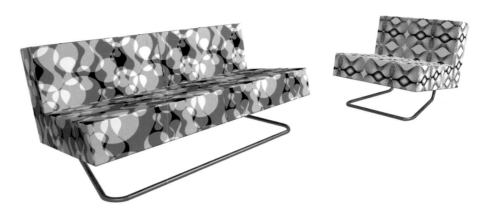

Plod Felicirossi, Italy, 2004
Collection based on a plastic interior module

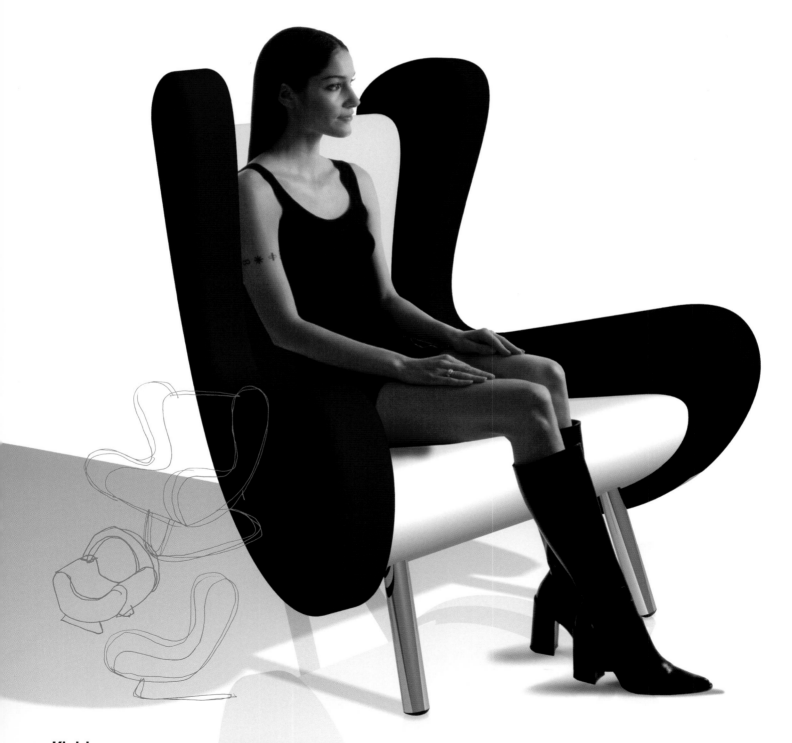

Klubby Clubchair concept, Natuzzi, Italy, 2004

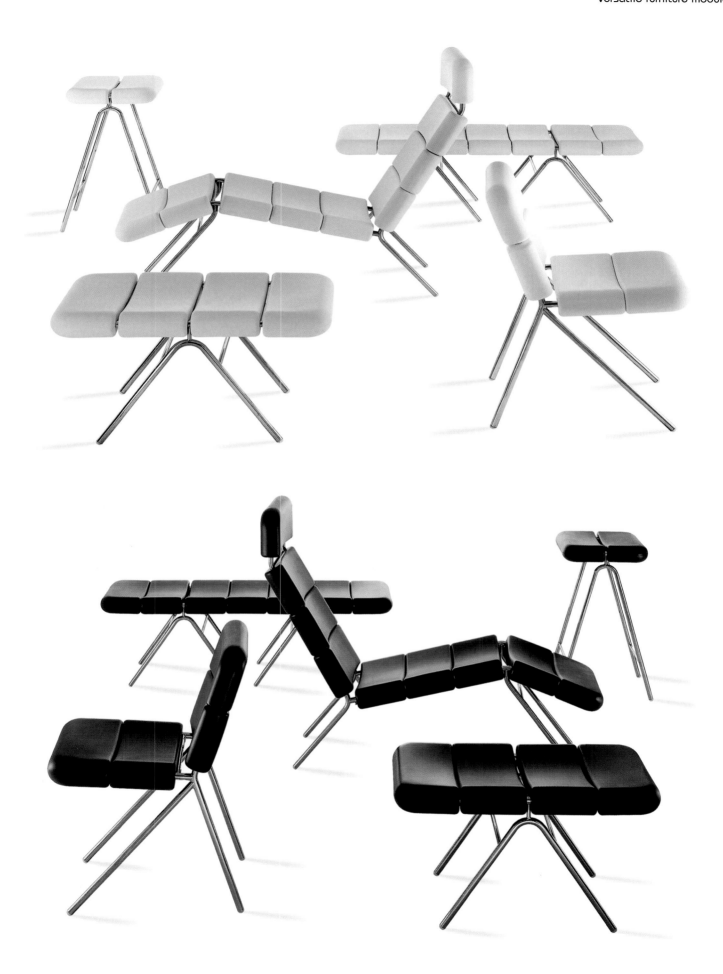

Terrashid Concept, Cassina, Italy, 2001–2005

12 reconfigurable furnishings. One space, infinite possibilities

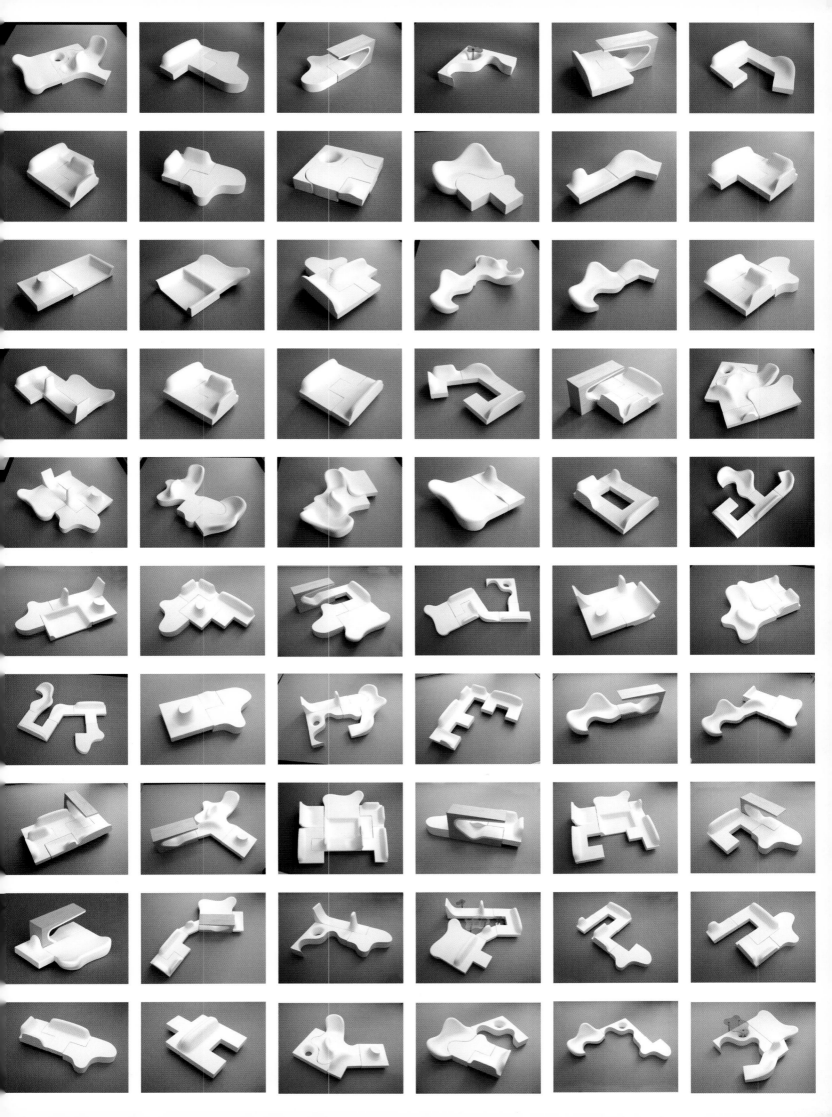

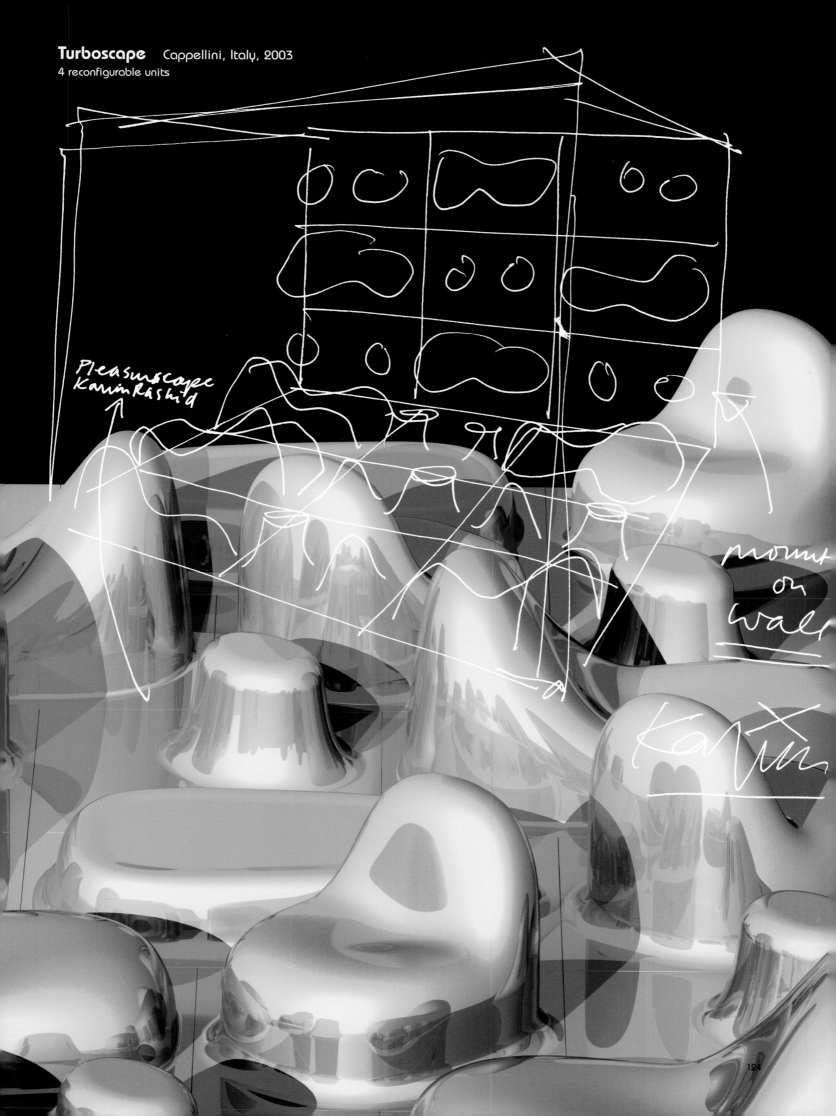

Turboscape Cappellini, Italy, 2003
4 reconfigurable units

Pleasurescape
Karim Rashid

mount
on
wall

Colorscape, Clearscape Cappellini, Italy, 2003
4 reconfigurable units

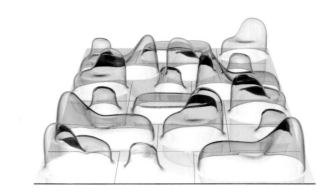

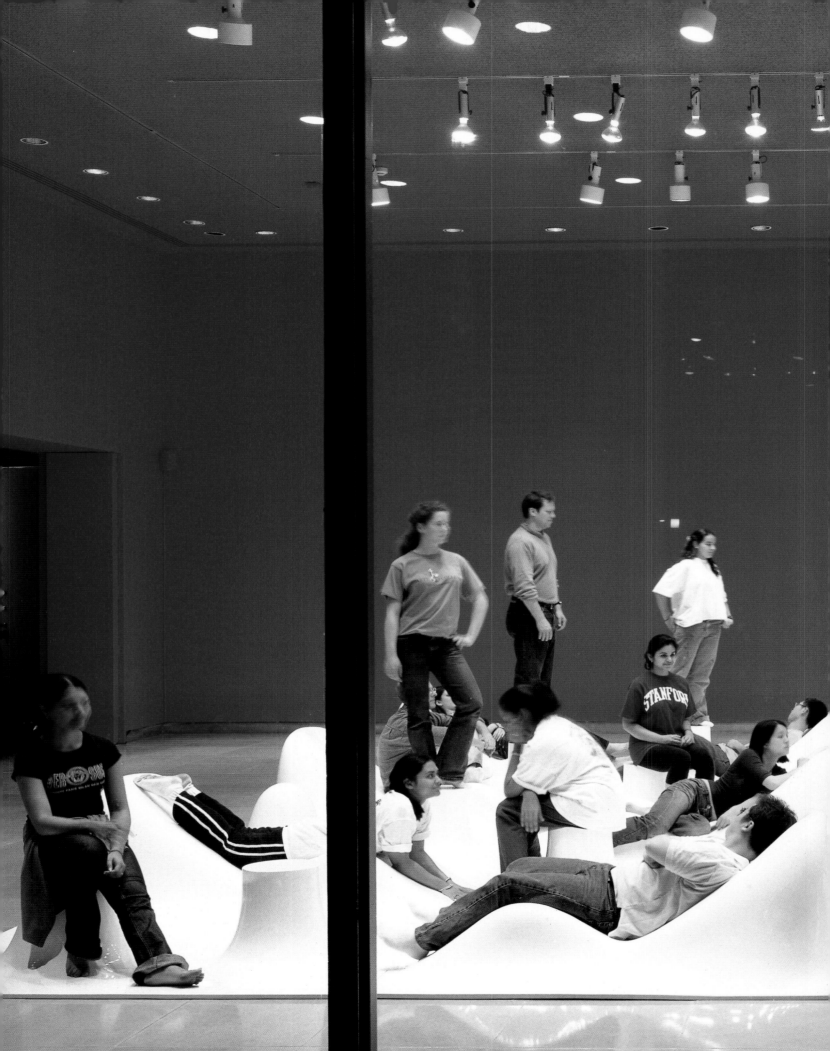

Pleasurescape Installation, Rice University Art Gallery, Houston, USA, 2001

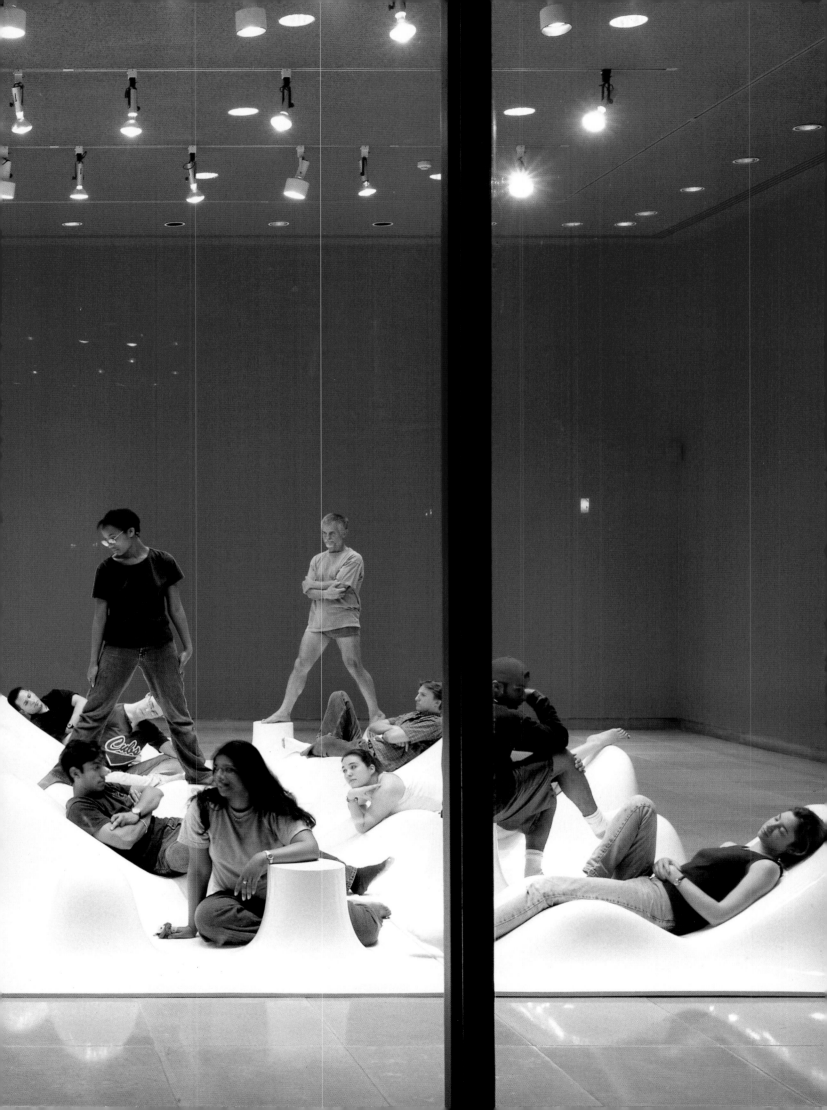

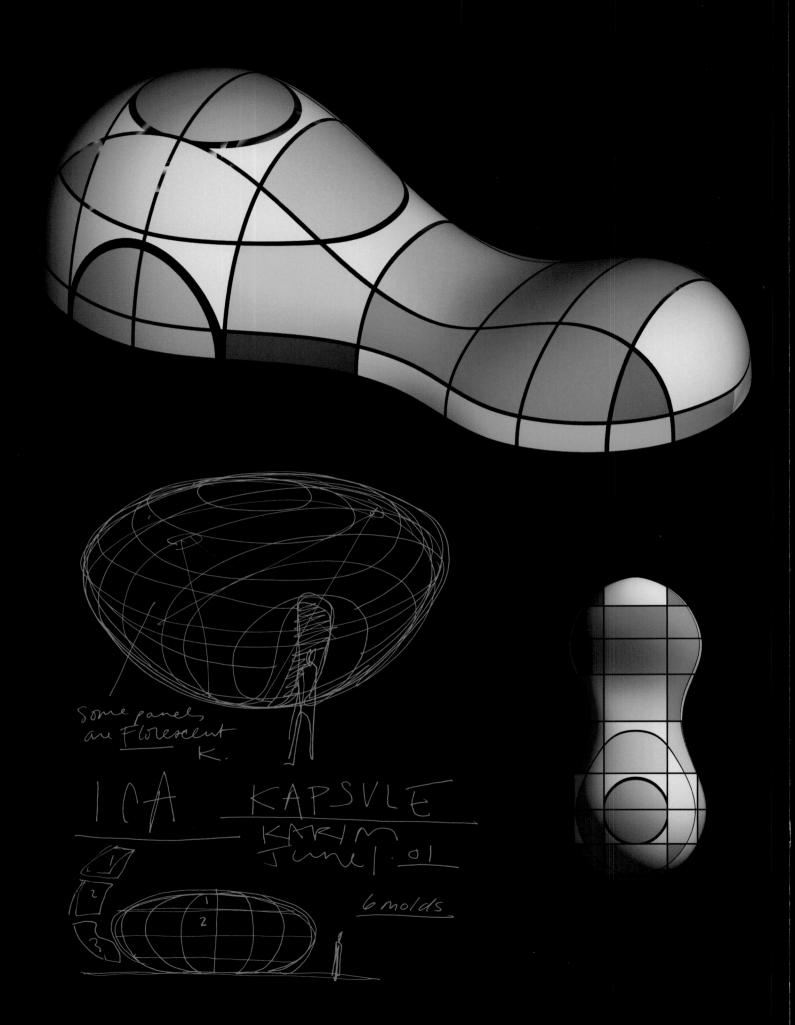

Some panels
are Florescent
K.

ICA KAPSVLE

KARIM
June 1. 01

6 molds

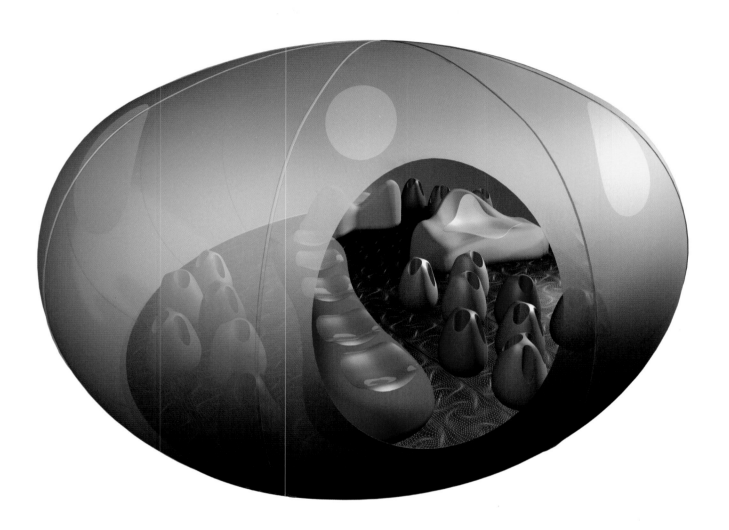

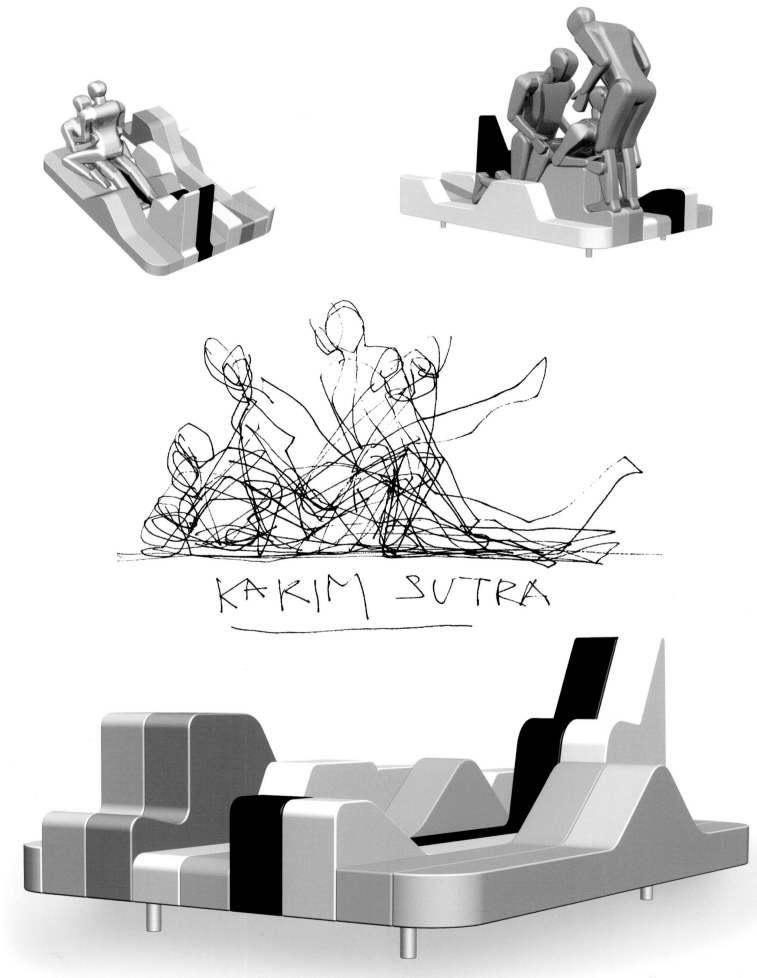

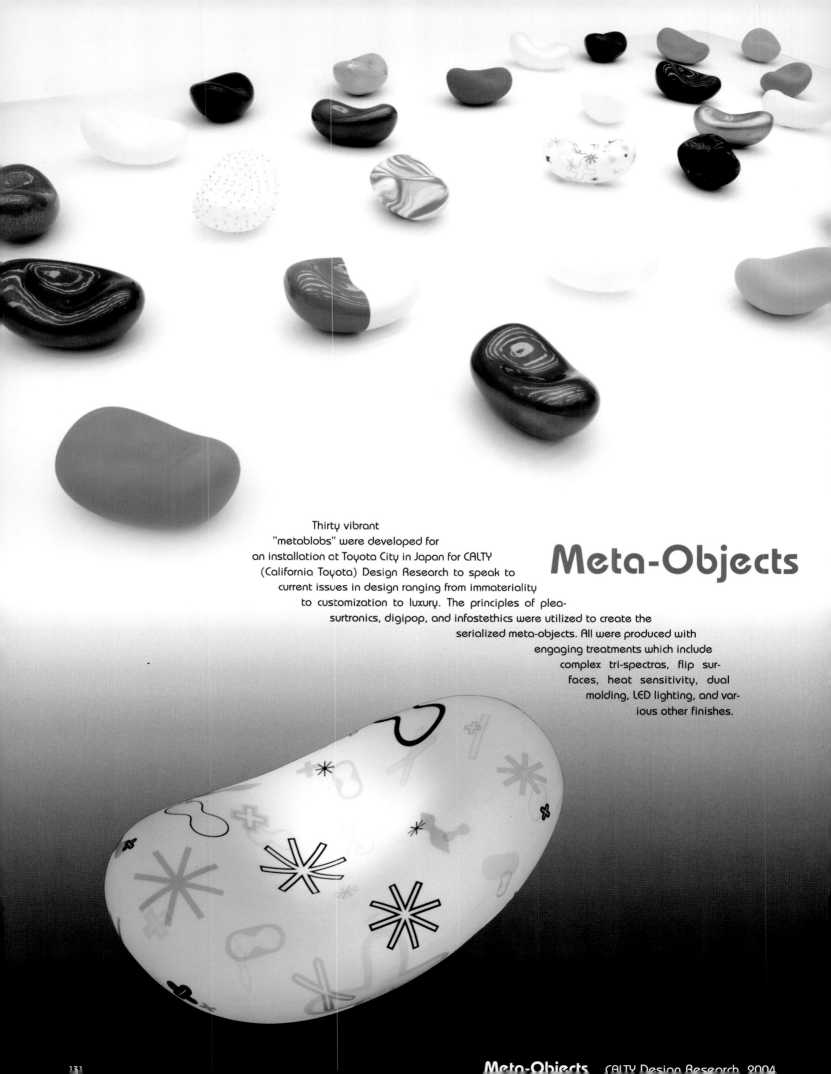

Thirty vibrant "metablobs" were developed for an installation at Toyota City in Japan for CALTY (California Toyota) Design Research to speak to current issues in design ranging from immateriality to customization to luxury. The principles of plea-surtronics, digipop, and infostethics were utilized to create the serialized meta-objects. All were produced with engaging treatments which include complex tri-spectras, flip sur-faces, heat sensitivity, dual molding, LED lighting, and var-ious other finishes.

Meta-Objects

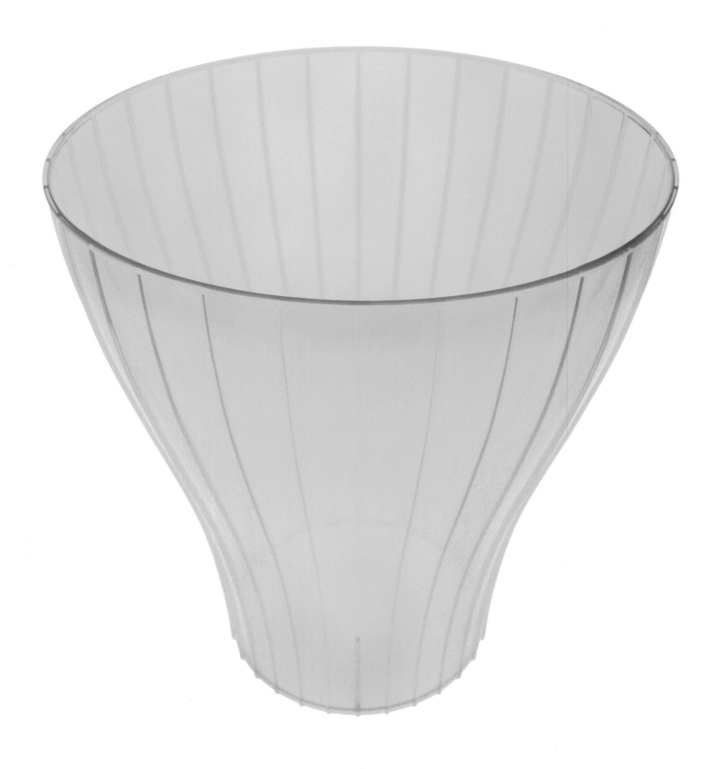

Afterglo Can Umbra, Canada, 2003

NO-STALGIA

We are all reading the same books, watch-
ing the same movies, looking at the same magazines,
listening to the same music, we're even drinking the same soda,
and, inevitably, our creative manifestations are beginning to converge.
The concept of simultaneous creative discovery is based on shared
information and, in turn, ideas becoming more similar. We are shaping similar
constructs—similar notions of physical space and time. At the same time, there is
no single dogma or school of thought, no formula, and no doctrine (unlike fifty
years ago). Modernism is dead. Modernity is an old concept, a way of creating a
scientific religion, Cartesian thinking, and rules. Rules are dead. Humans can
exist and domesticate the world with a new and freer spirit. The results are
in everything, everyone, every sensibility, every idea, simultaneously, in
real time, anywhere, and everywhere. The notion of "local" no longer
exists; it implies a myopic view of human behavior in a narrow
context. The world is shrinking and the only way to
perceive culture globally is to think freely, unob-
structed by political, social, historical, and
nepotistic issues. Local thinking is the
nemesis of free spirit and real creative
thought in our new globalization. We
live in a borderless world now, creative
disciplines are blurring, merging, hybrid-
izing. They are all under the umbrella of indus-
trial design, a profession based on both industry and
technology. Architecture is changing to become an industrial
product, as is fashion, where we are influenced by everything, all
information simultaneously, where things appear the same globally.
I love the autonomy of an eclectic landscape, where all human creative
thought and ideas are expressed regardless of their origin, culture, or history.
We live in a time when borders are breaking down, affording us real freedom of
expression. We are influenced by everything simultaneously. Things appear the
same globally but, at the same time, they are split into micro tribes, into thousands
of diverse sensibilities, tastes, views, beliefs, values, and feelings. I like this
contradiction (the global village versus an eclectic chaos). This is our new
contemporary aesthetic world, a plethora of expressions, signs, and logos. Art
and design have to be part of the collective global culture, not
removed, insular, elitist, or irrelevant. There is no good and bad
in design anymore. It's a Nietzschean idea beyond
good and evil. **Karim Rashid**

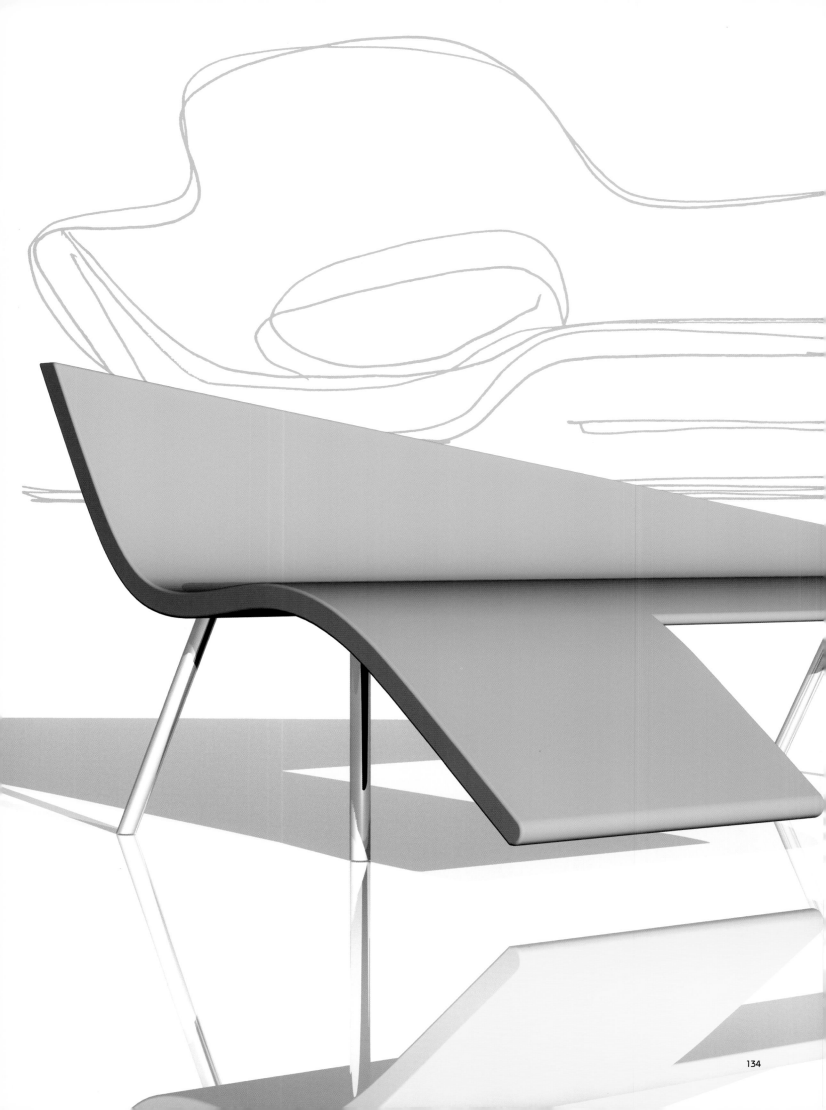

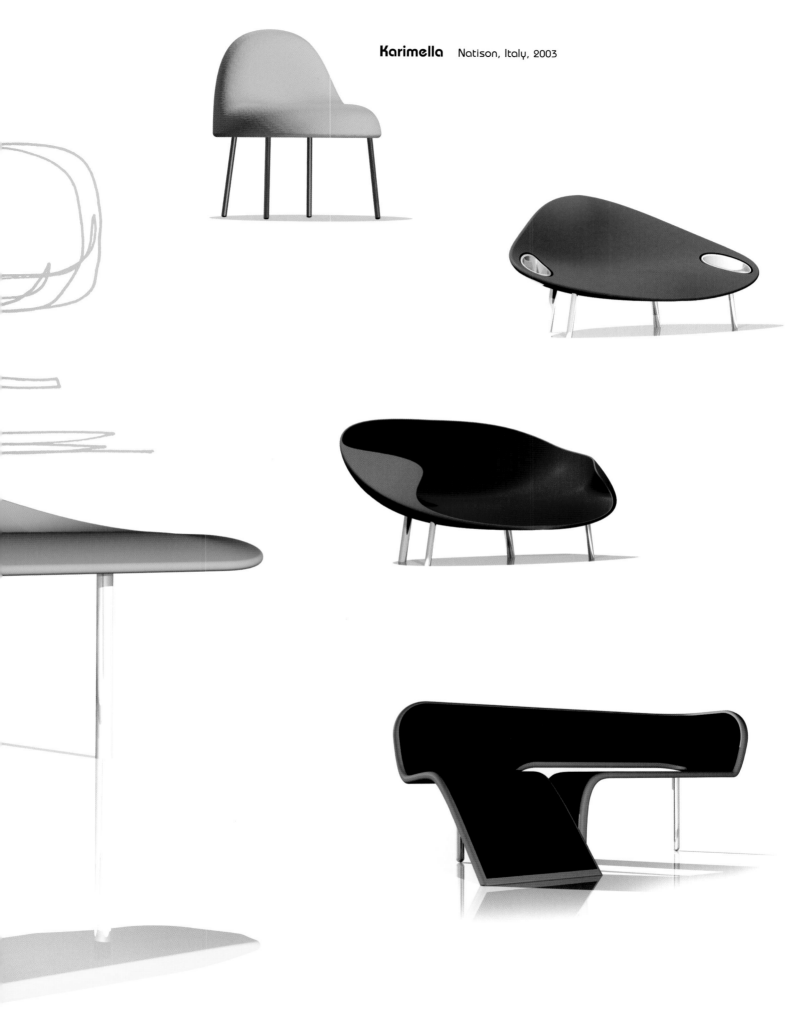

Karimella Natison, Italy, 2003

Seating concepts for Driade, Italy, 2003

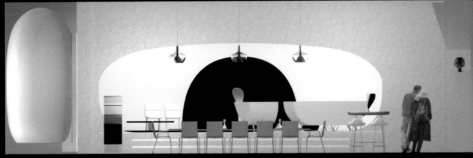

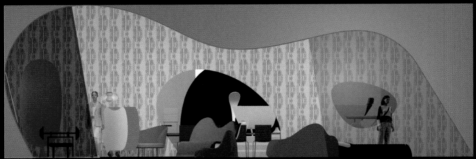

Mind Body S(e)oul House Seoul Design Living Fair,
LG Construction and Design House, Korea, 2004

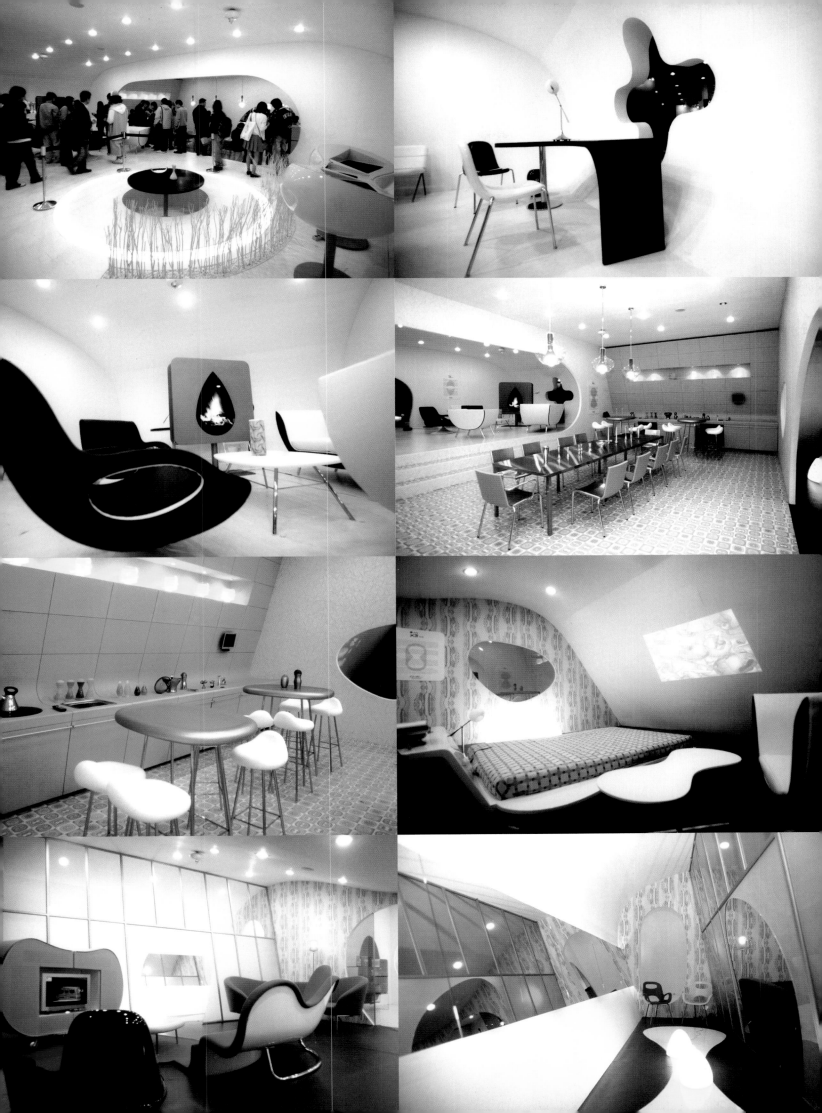

Purity Table Puredesign, Canada, 2000 **Ubiquity Carpet** Directional, USA 2000

Duo Vase Limited edition for Nambé's 50th Anniversary, USA, 2003

FUTURETRO

In this new century, we are
witnessing an exhaustive excavation
into the vaults of the past, even more so than
the postmodern 80s. It seems as if history is
unfolding at a hypertrophic rate, where we keep
searching into the past to unveil everything and
anything, good or bad. The difference in this revival
(as compared to neo-movements historically) is
new technology. Is it that the (market-empow-
ered) yuppies and boomers are trying to
revisit their past and are not willing to let
go? Is it a fear of mortality? Maybe we
collectively realize that the past
was more interesting than the
present so we are copying it
without compunction, be it
consciously or subconsciously.
We also pretend the past
did not exist. This is a phe-
nomenon of the "generation
of the now." But we can make
it better (the retrograde move-
ment of the 60s seems to be the
most inspiring because there was a
strong futurist optimism at the time, a belief
that we would reach another universe, live in a
seamless Technorganic world, and that there had
to be more to our existence than planet earth). If
you redo a 60s chair today, you can improve it
greatly with technology, production methods, and
materials—even improve its performance—but it is
easier to simulate the past than predict the
future. History is there to inspire and edu-
cate, not to be appropriated.

Karim Rashid

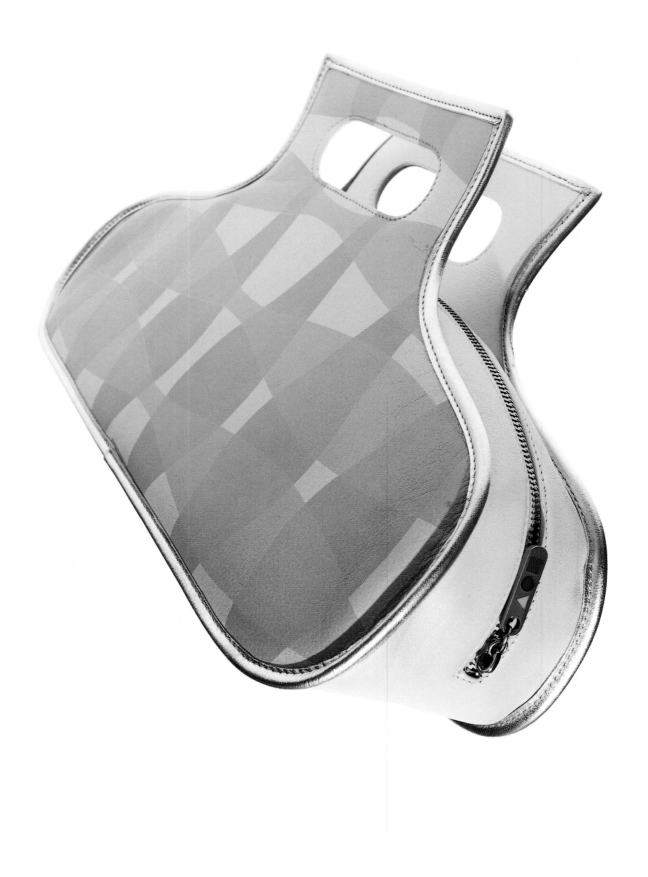

Megan Handbag ACME Studio, Maui, USA, 2004

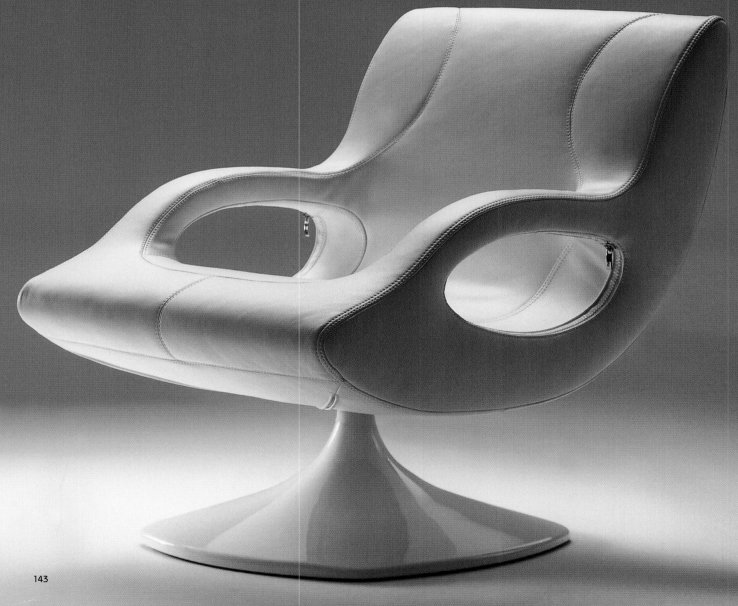

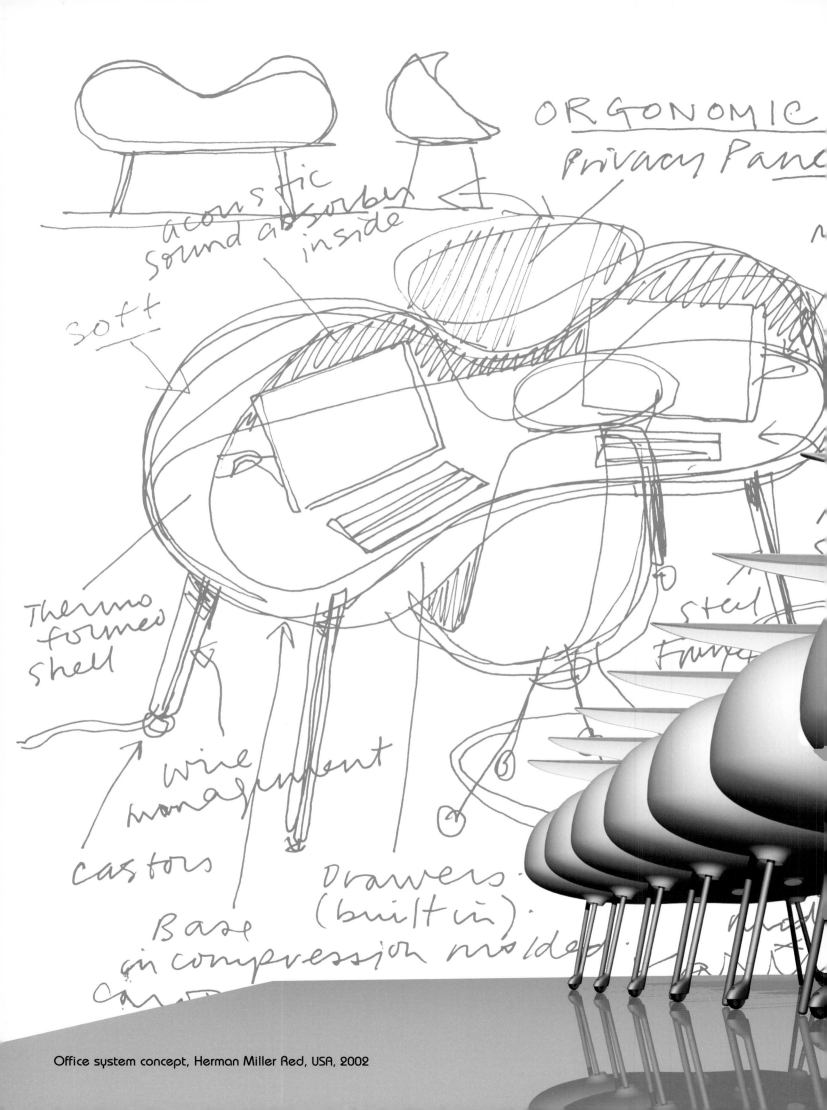

ORGONOMIC
Privacy Pane

acoustic
sound absorber
inside

soft

Thermo
formed
shell

wire
management

castors

Base
in compression molded.
Ca

Drawers
(built in).

steel
Frame

Office system concept, Herman Miller Red, USA, 2002

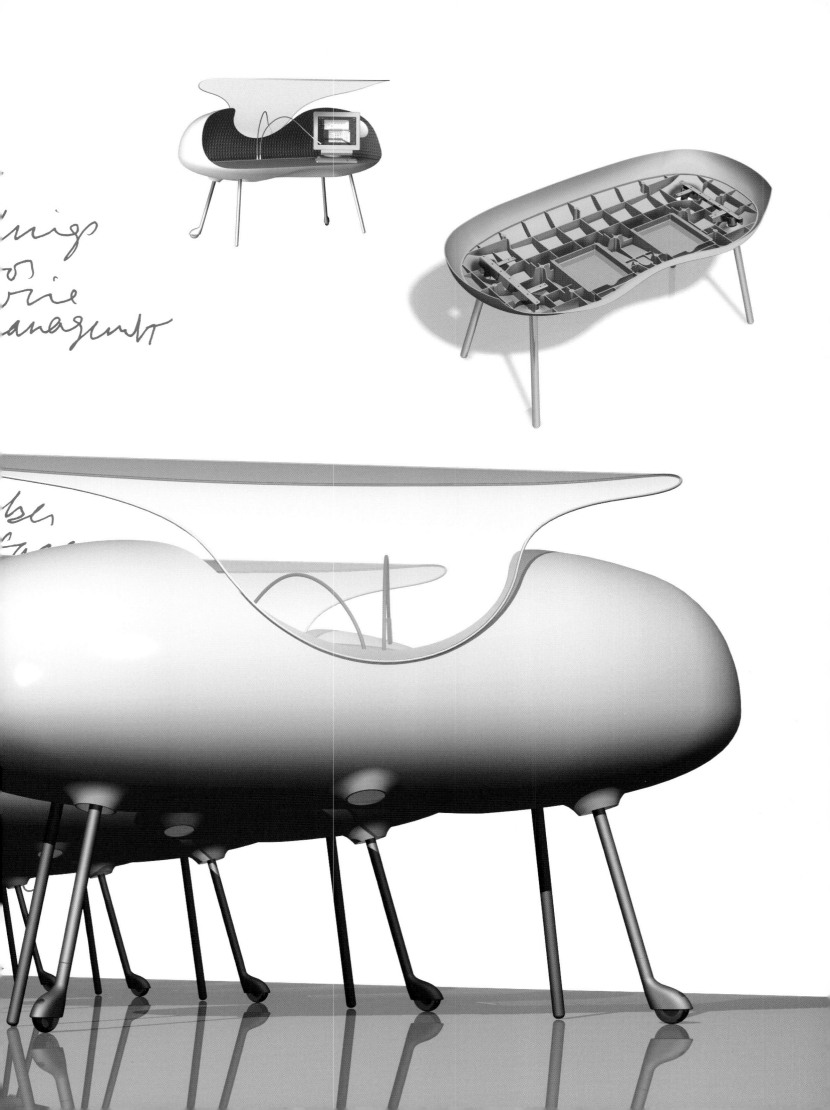

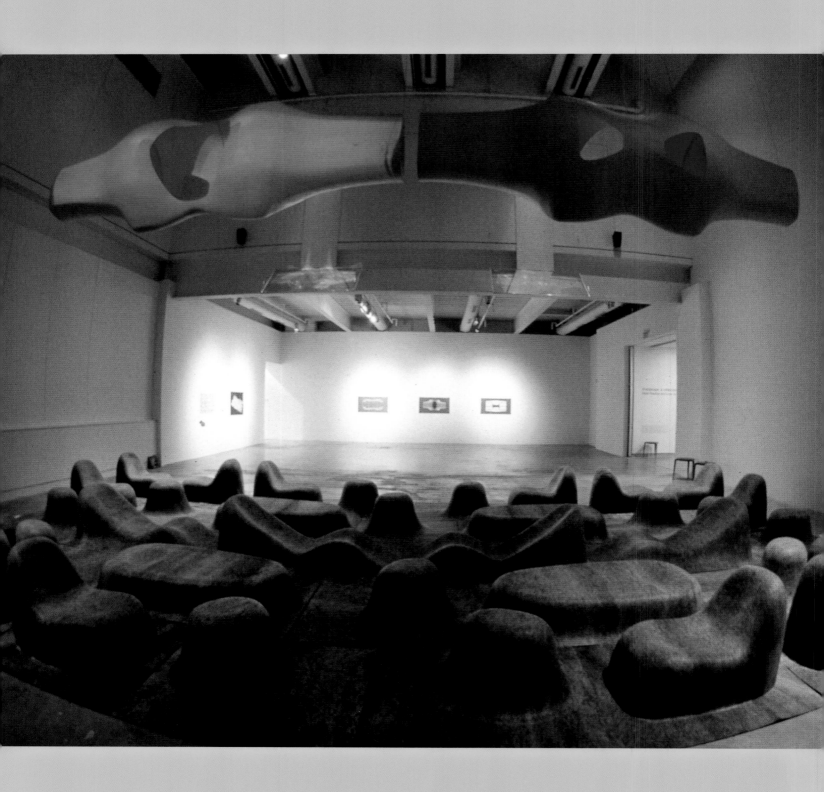

Stratascape Installation with Asymptote, ICA, Philadelphia, USA, 2002

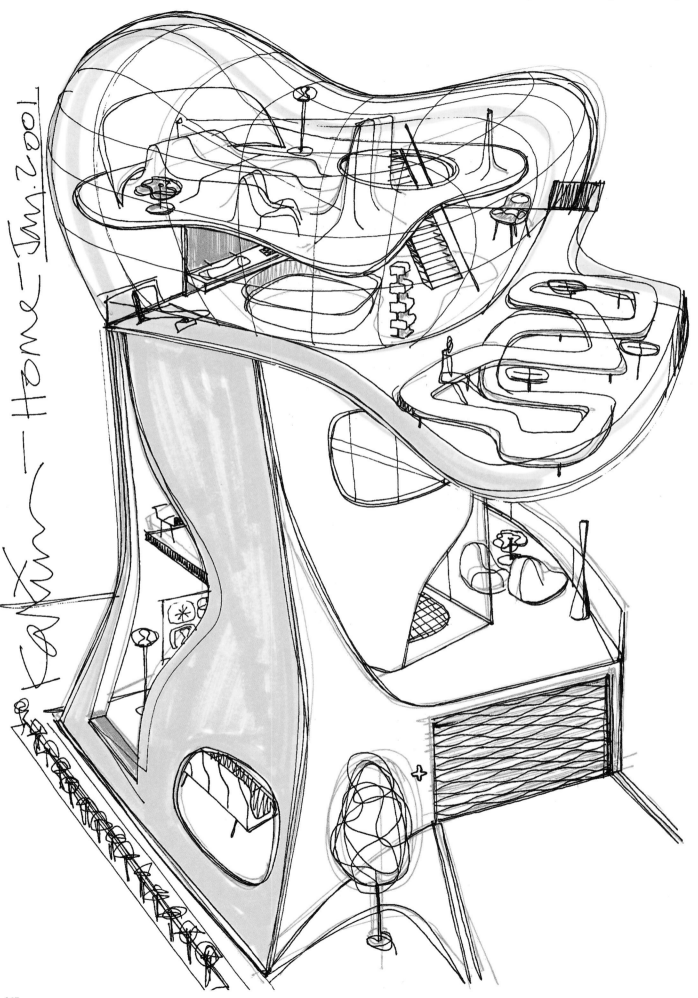

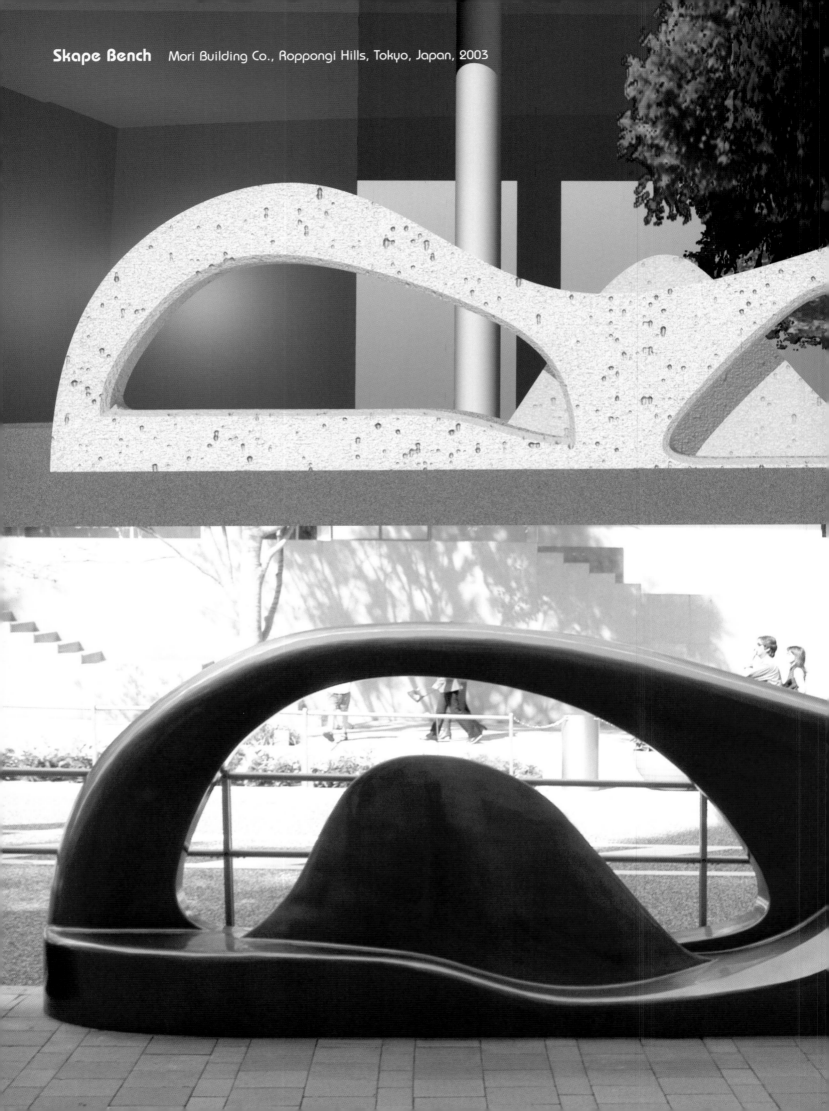

Skape Bench Mori Building Co., Roppongi Hills, Tokyo, Japan, 2003

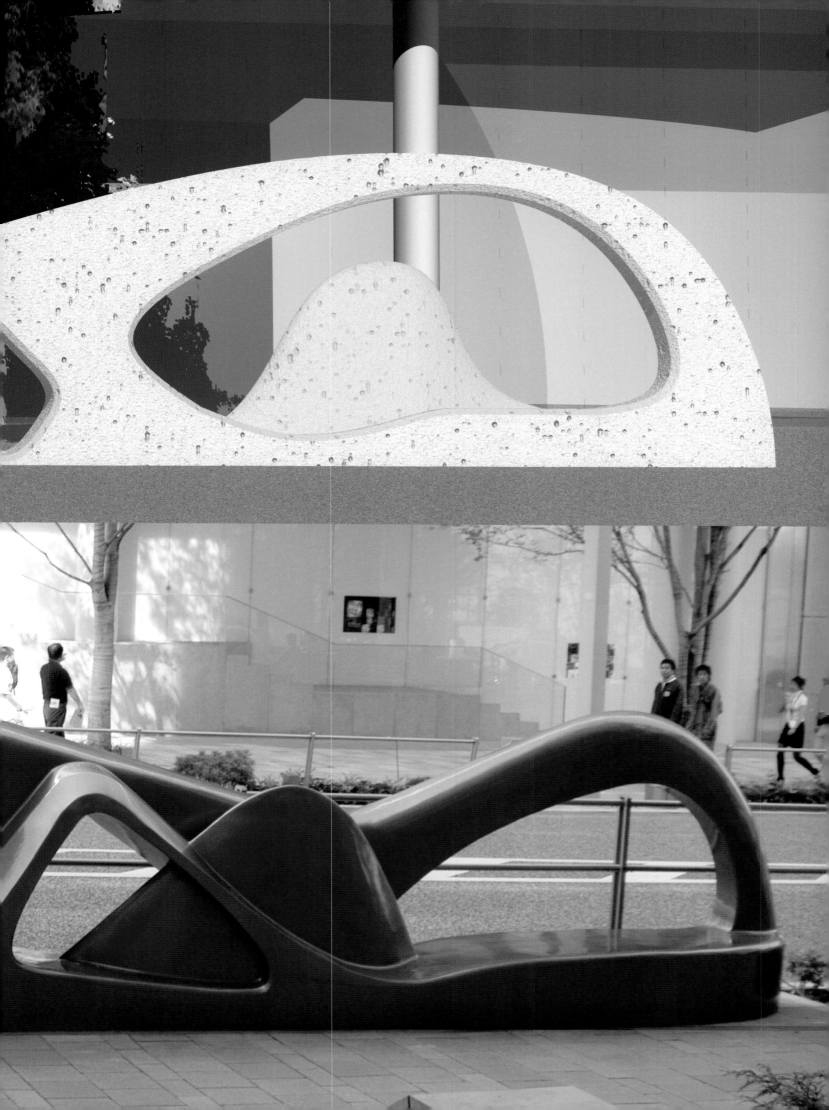

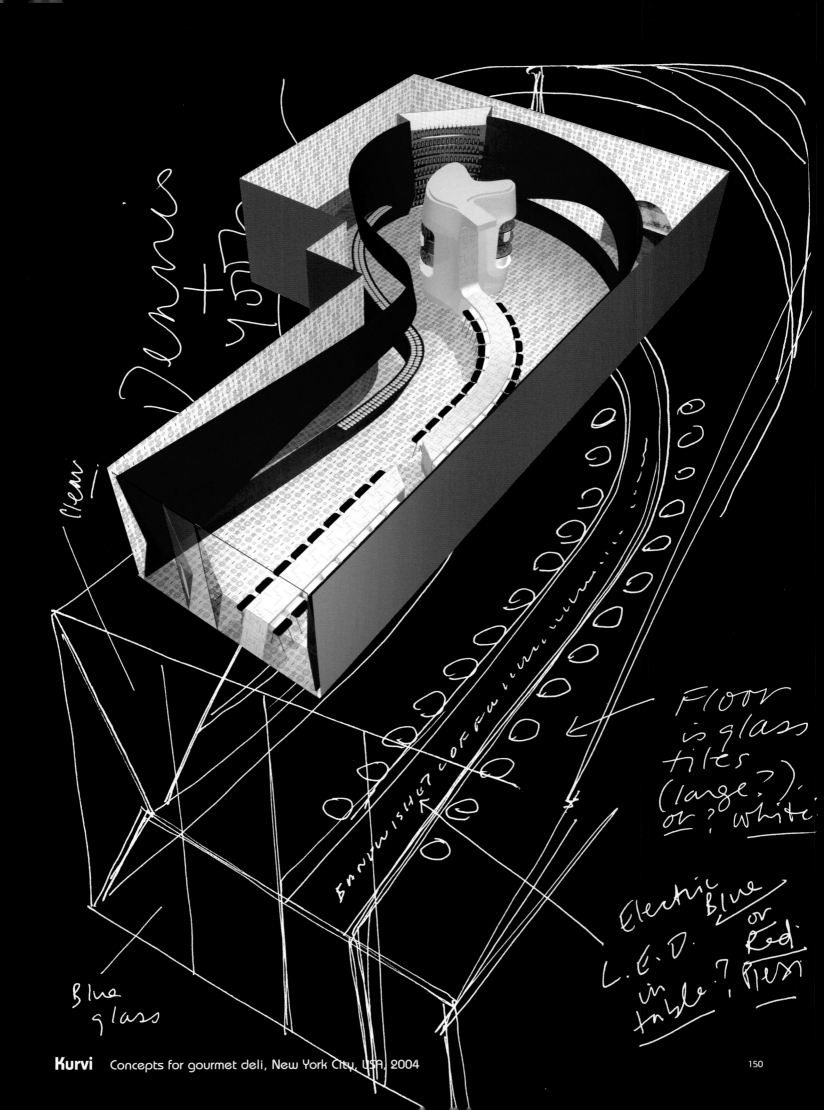

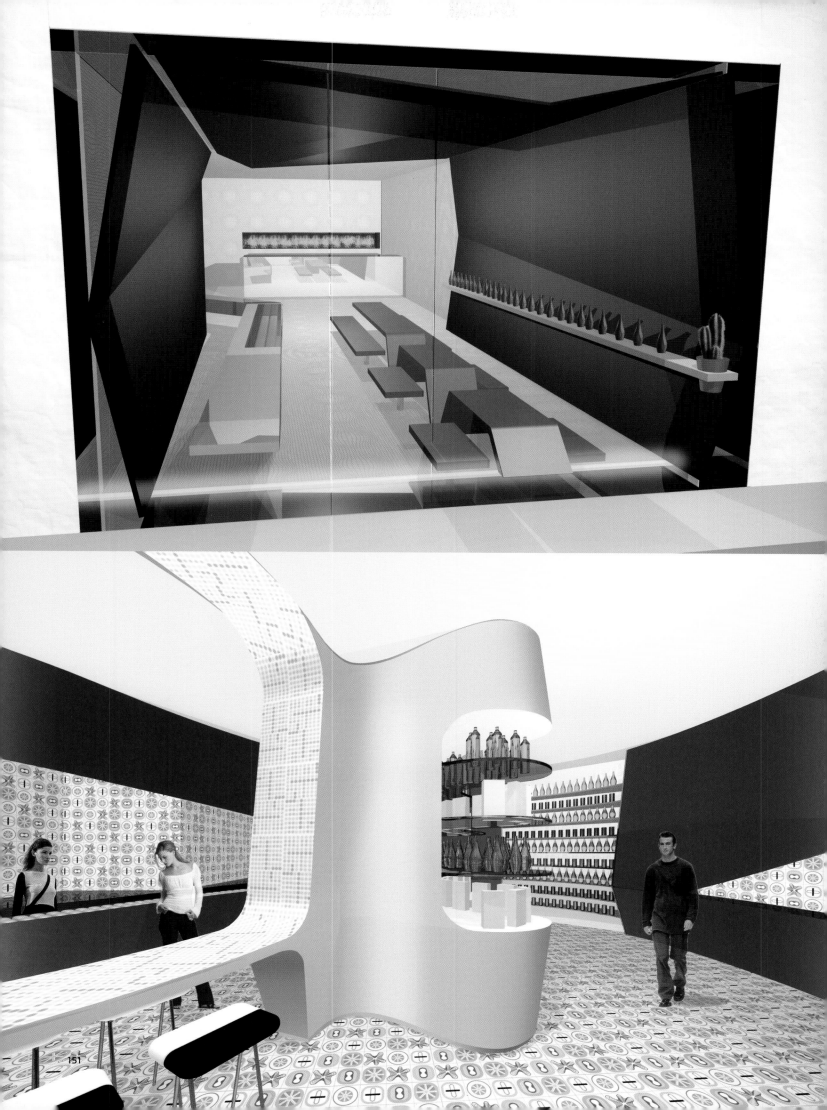

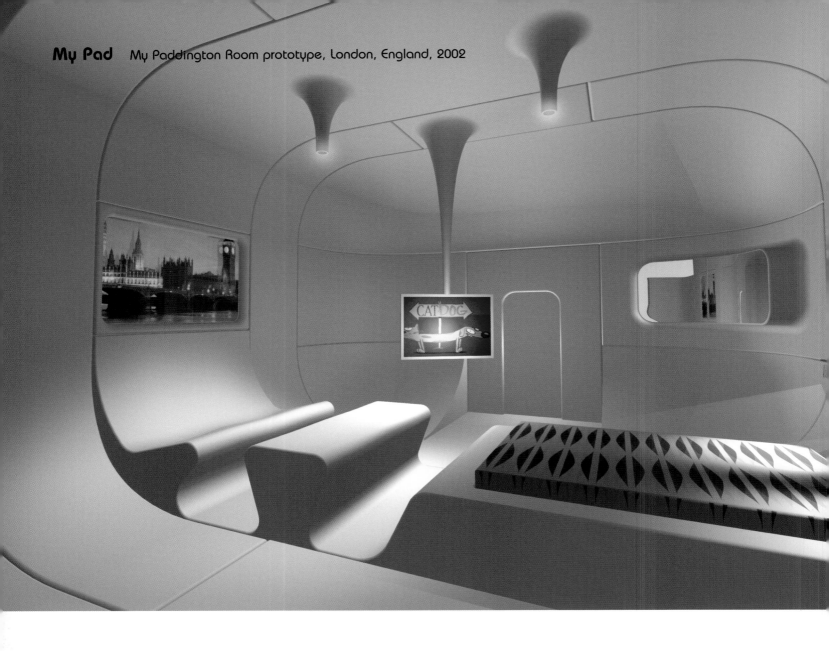

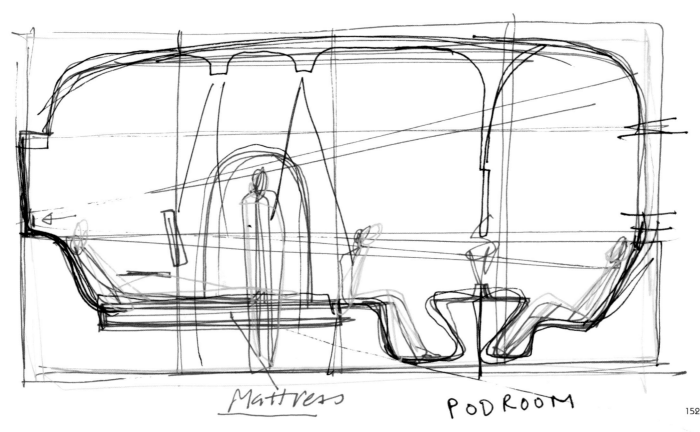

Mattress PODROOM

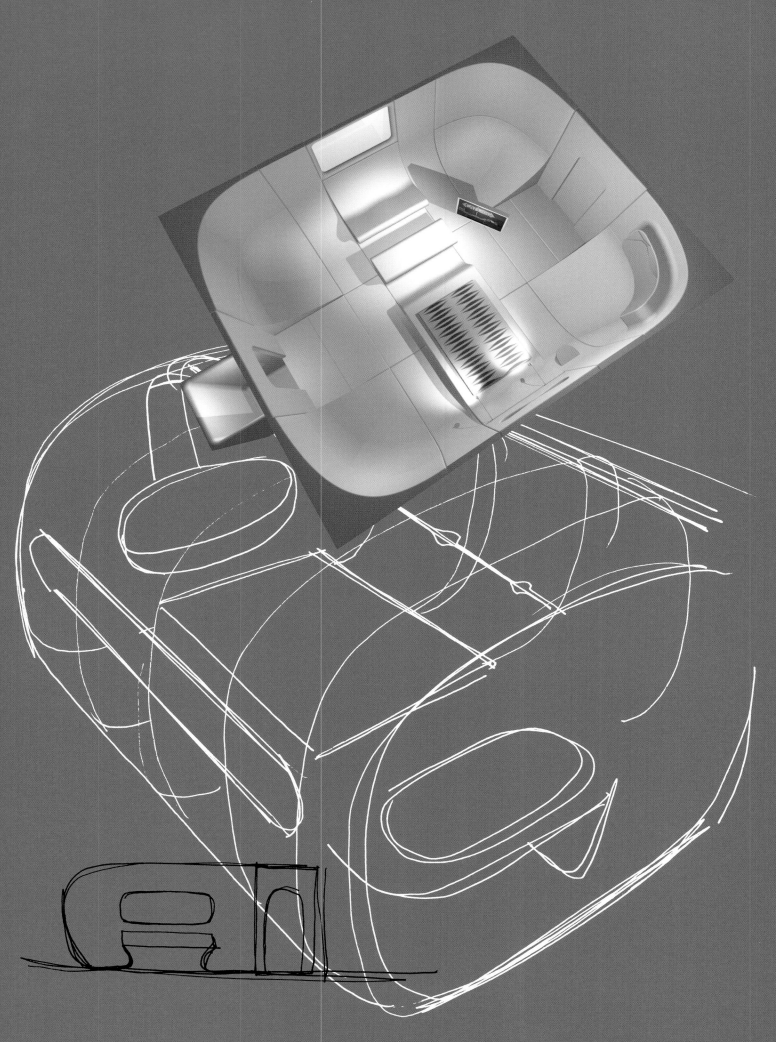

GOODESIGN In the controversial arguments of excess, sustainability, and market seduction, I believe that every new object should replace three. Better objects edit the marketplace. I have been successful with this philosophy several times. I have worked with companies to decrease their product lines, streamline production, increase efficiency, and elevate quality. I act as a design or cultural editor of our physical world. Ironically, the more that is produced the more design becomes necessary, as the saturation of objects needs to be balanced with higher quality and new ideas. I am interested in developing products that are accessible to everyone. I believe design is democratic; design for everyone. Good design, as far as I am concerned, is a combination of six elements: relevant intelligent ideas, functionality, expressiveness (semiotic relevance and aesthetic originality), appropriate use of technology and materials, impact on the environment (the product's full cycle), and quality (including maintenance and durability). Good design can also change human behavior and create new social conditions. Designers, purveyors of "good taste," spent a century trying to create a condition of clean, beautiful objects based on doctrines of proportions, scale, aesthetics, order, performance, and material. Trying to design within these acceptable signs of "taste" meant avoiding the figurative and the literal, not using or creating languages that were borrowed, cheap, low-brow, or poor replicas of the authentic. Kitsch is the result of a work of art that is transferred from its real meaning and used for a different purpose than originally intended.

The ennui of modernism's so-called "good taste," "timelessness," and "elite design" has fomented a revived underground movement that is surfacing to instill objects with other meaning, one-liners, humor, and intentional "bad taste." I believe that the digital age has created this new autonomy: "no class," "no-brow," and "no original," symbolic of the fact that kitsch can be redefined to coexist in our object culture. **Karim Rashid**

Double Shot Coffee Maker concept, Guzzini, Italy, 2004

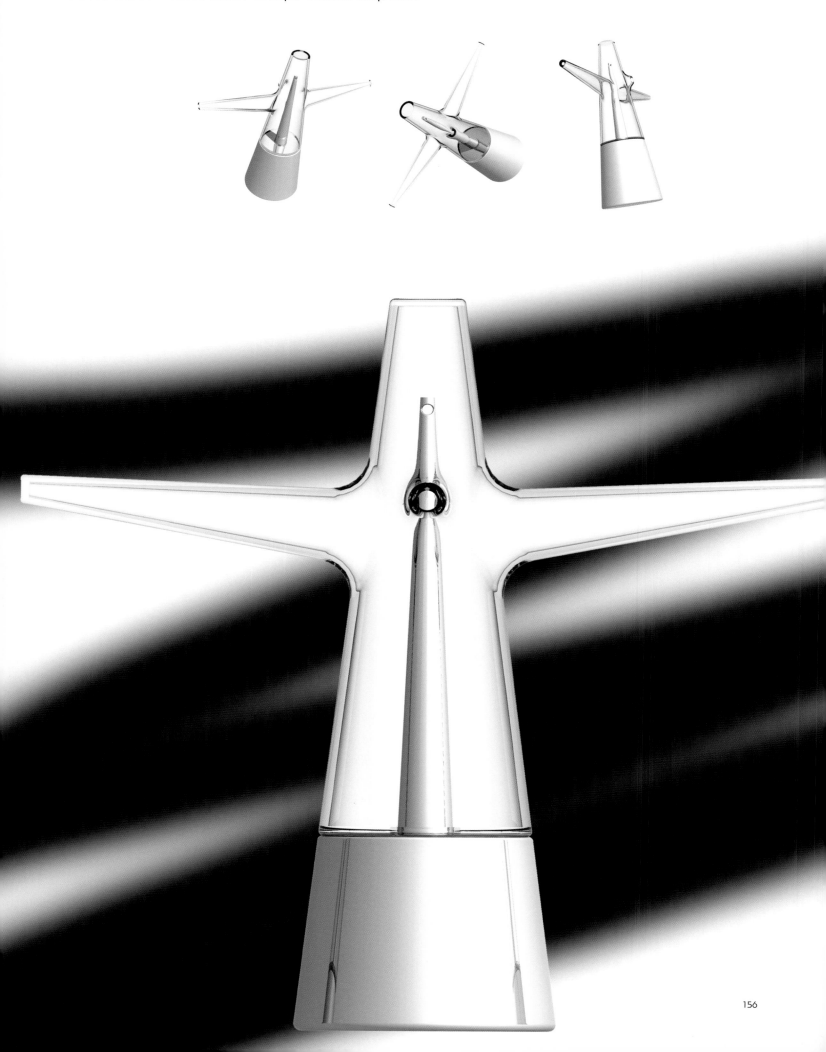

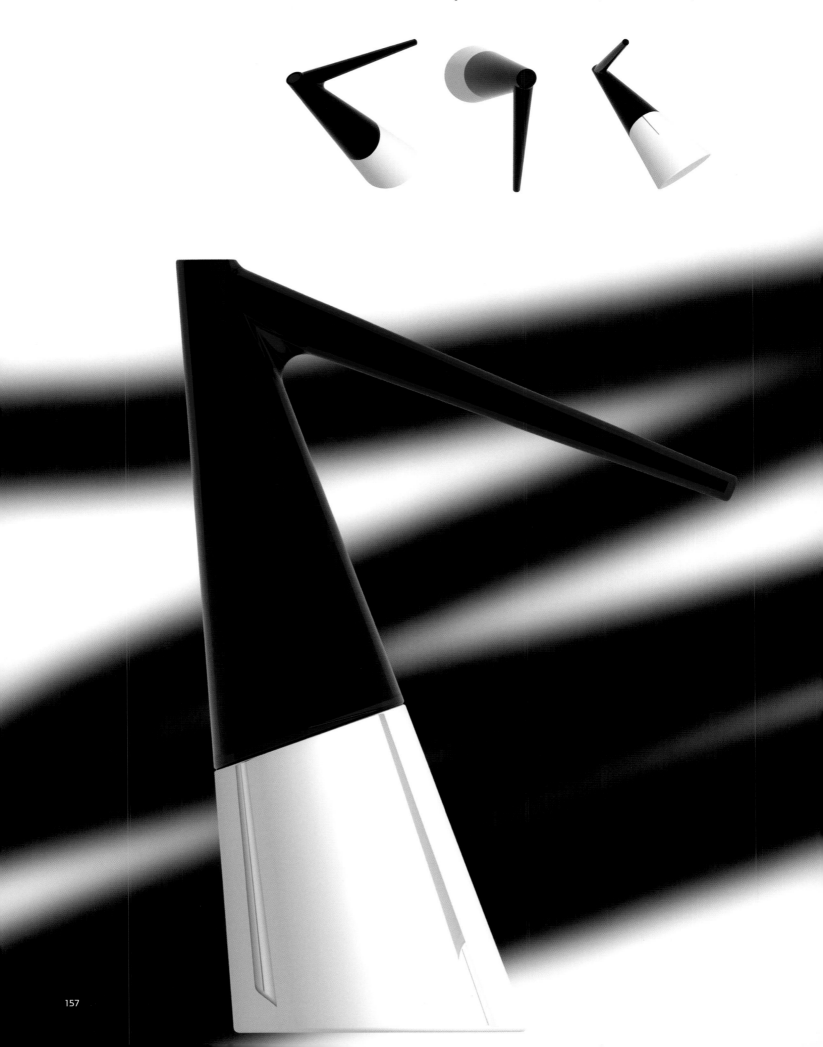

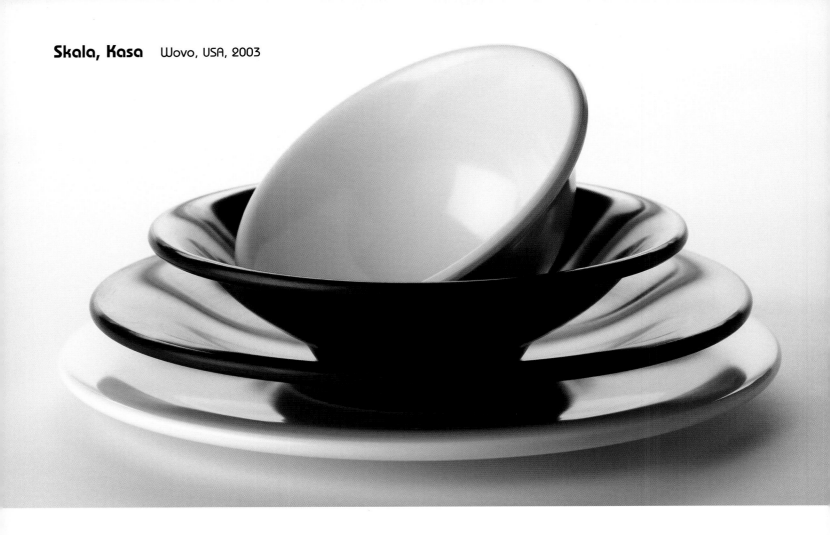

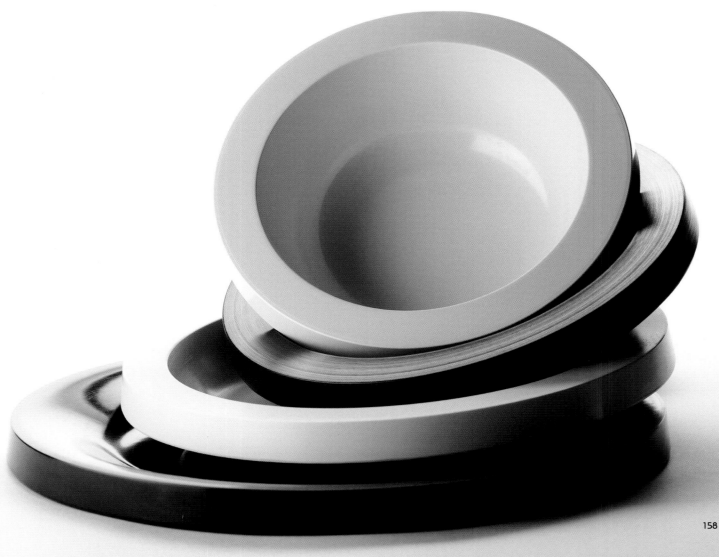

2003 GQ MAN OF THE YEAR:

Axis Mundo Award design, *GQ, USA*, 2003

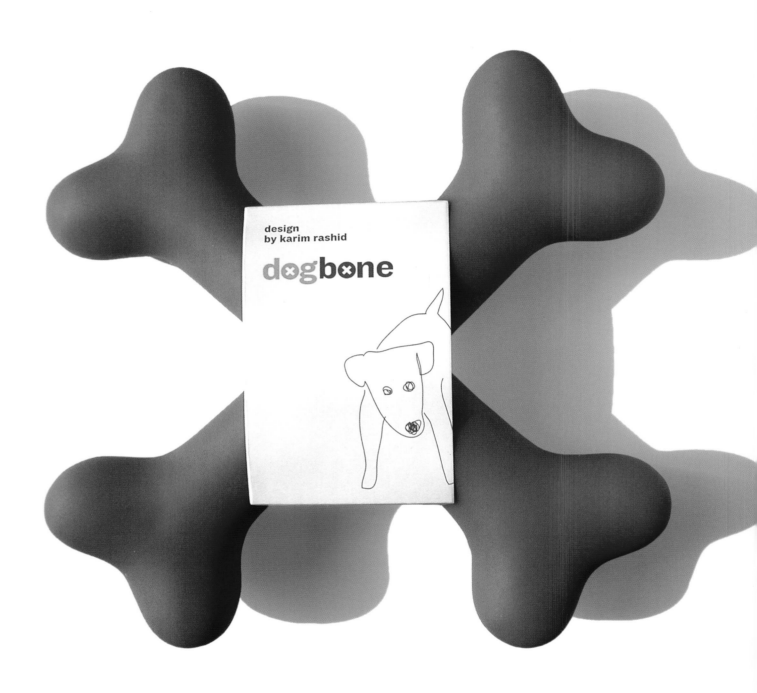

Dxg ßxne For The Dogs, Canada, 2003

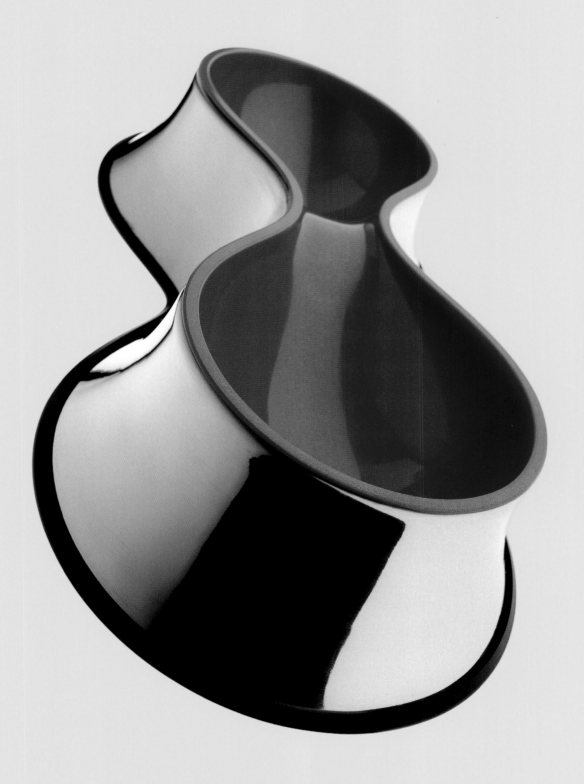

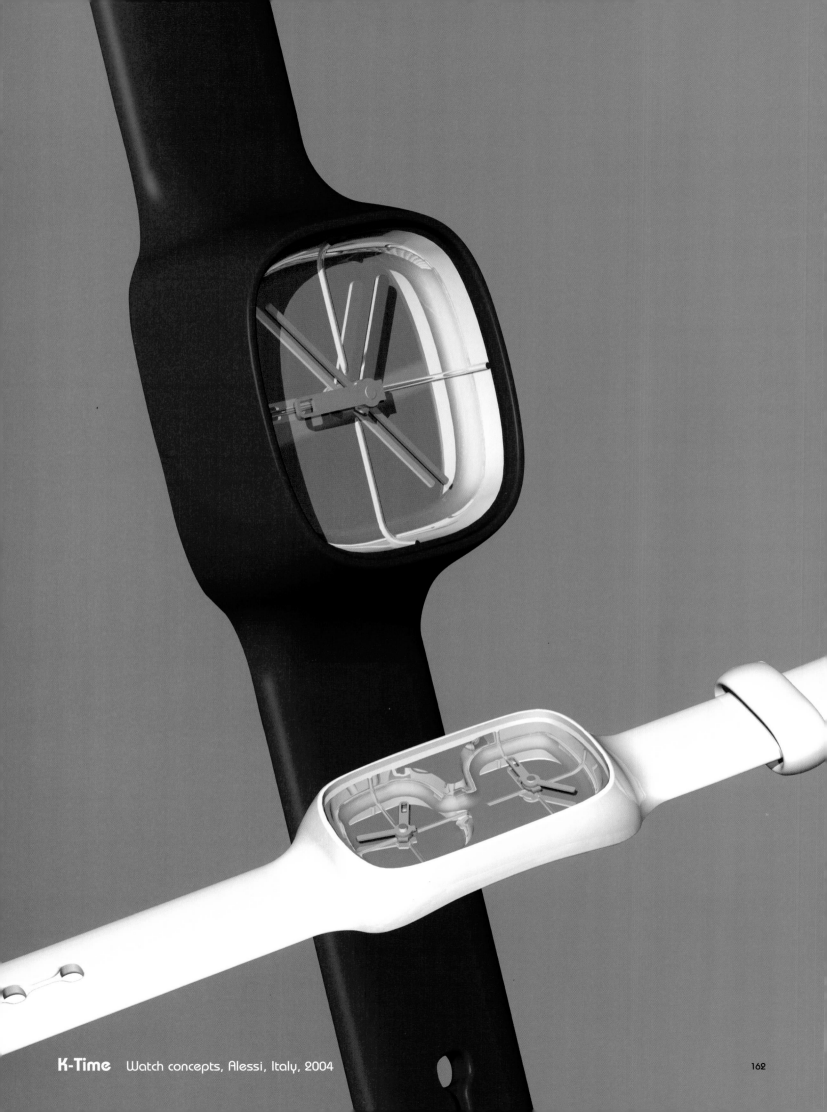

K-Time Watch concepts, Alessi, Italy, 2004

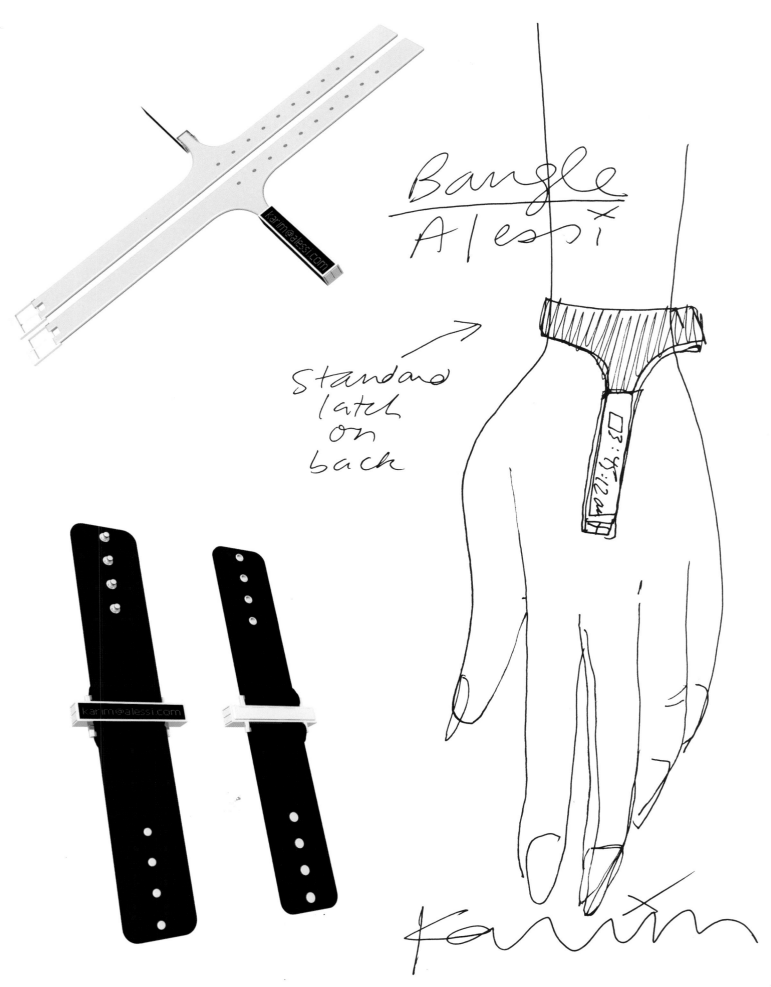

Bangle
x
Alessi

Standard
latch
on
back

Karim

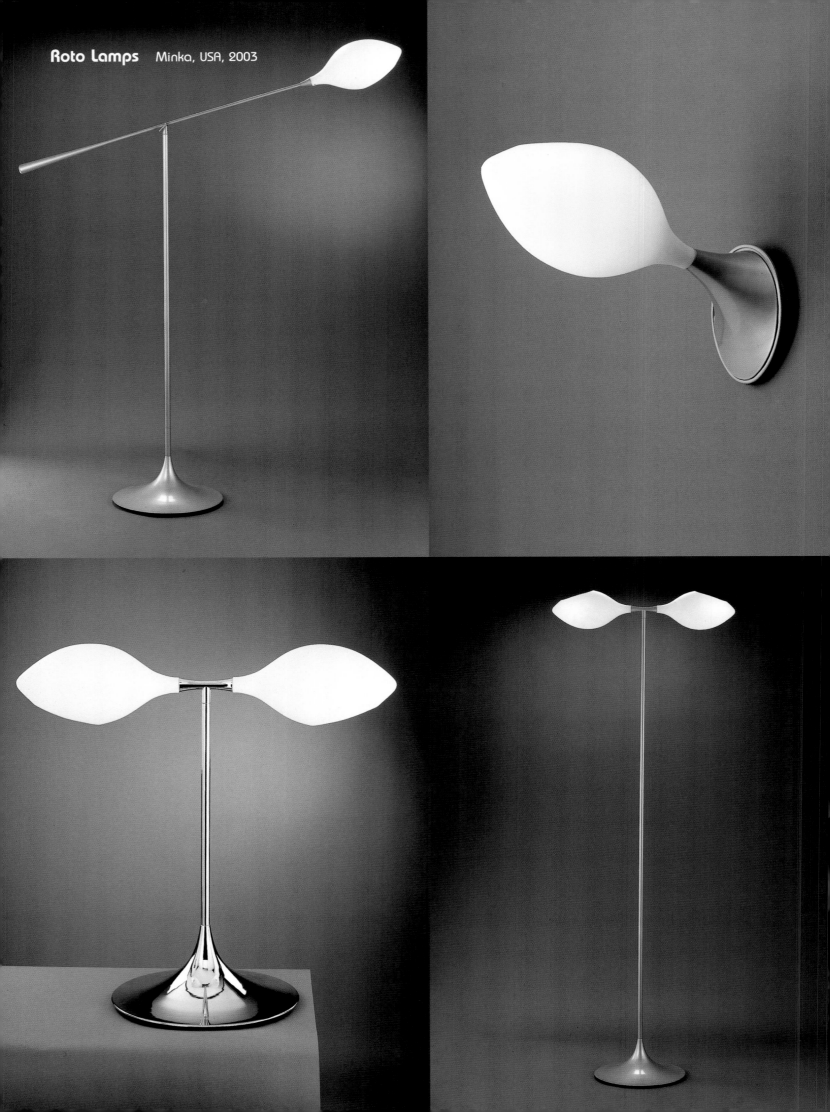

Roto Lamps Minka, USA, 2003

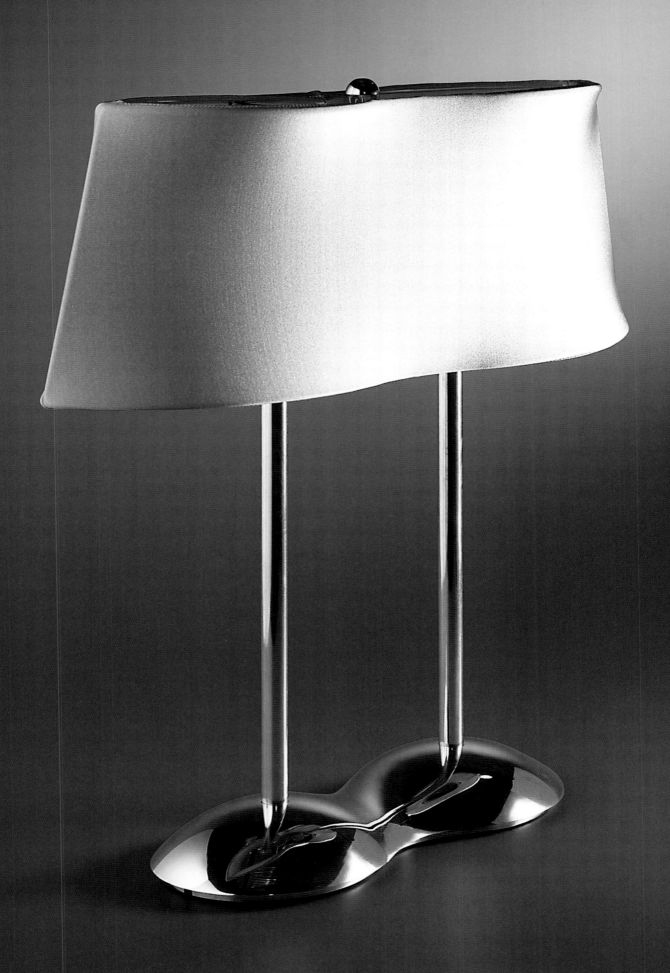

Para Lamp Nambé, USA, 2002

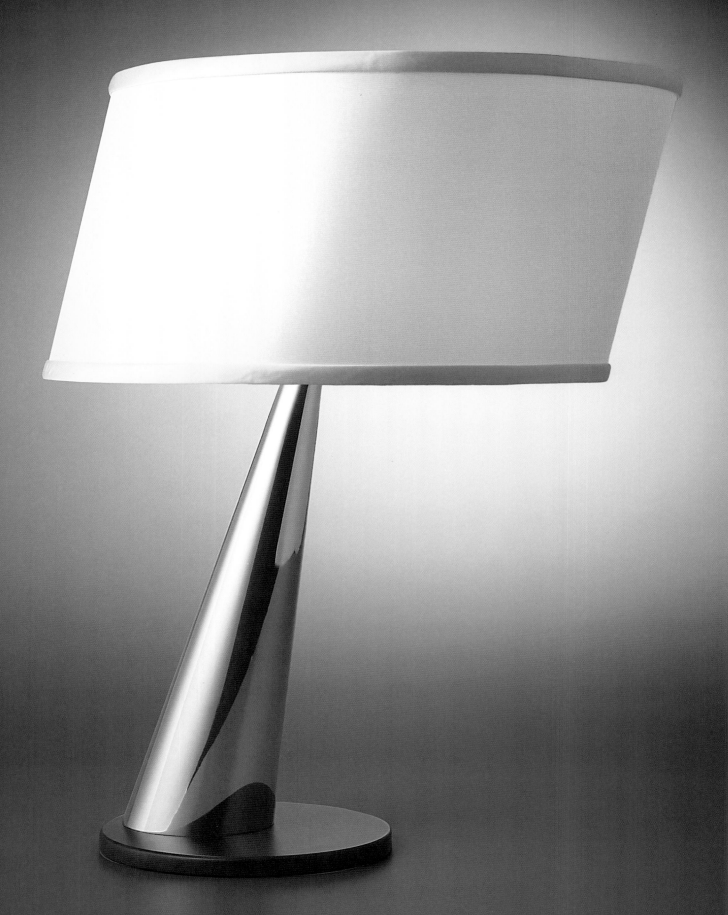

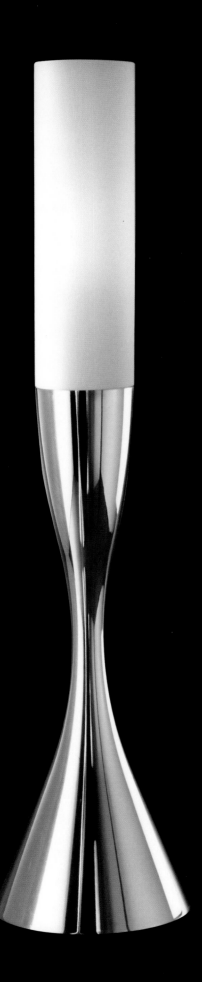

Concavia Lamp Nambé, USA, 2002

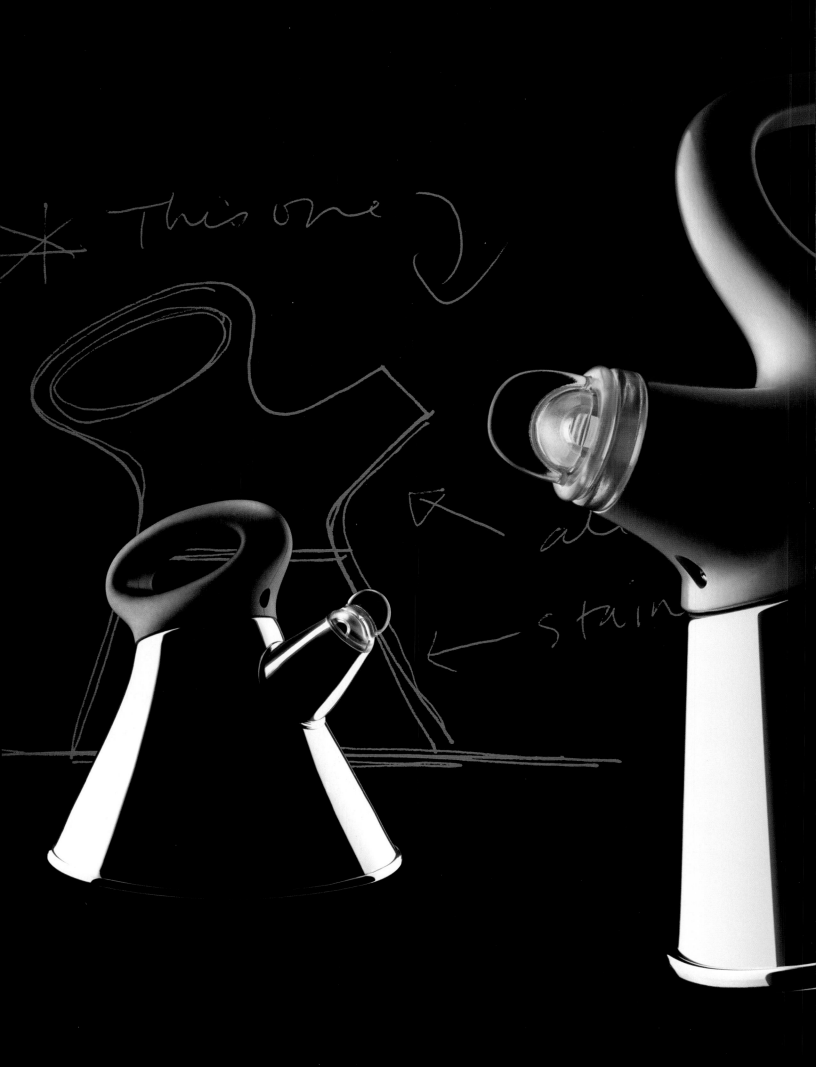

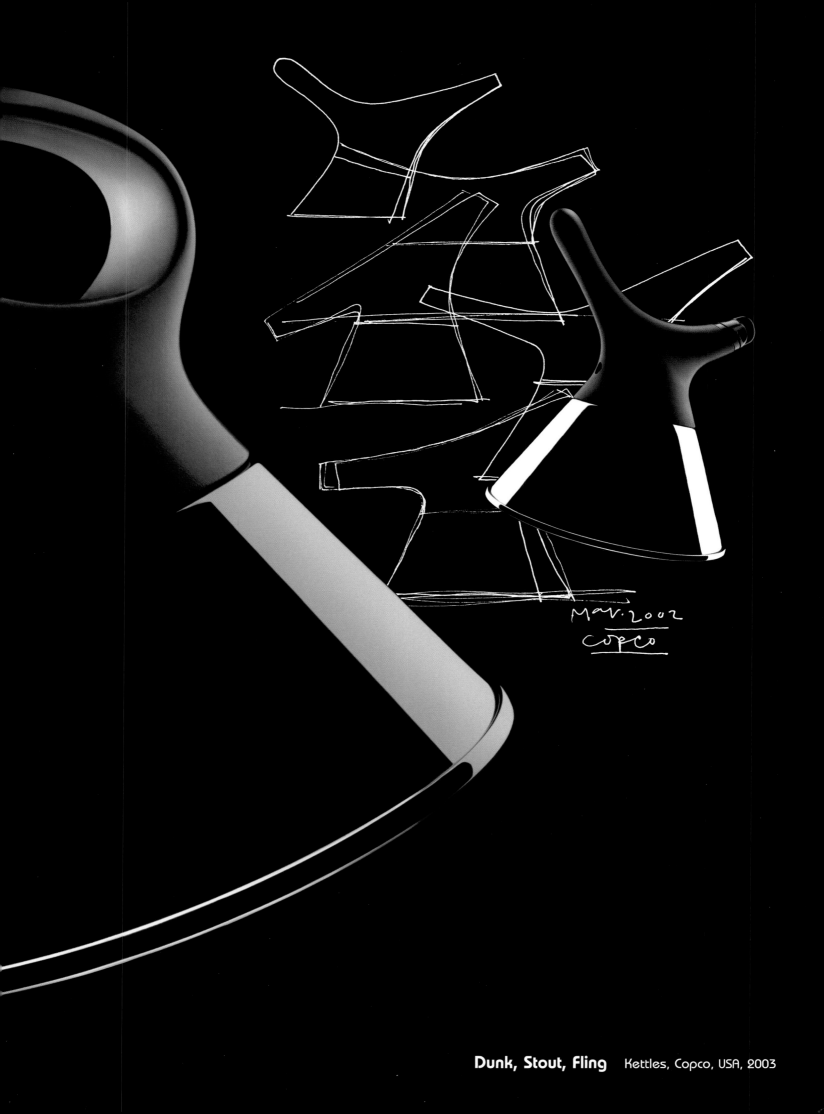

Dunk, Stout, Fling Kettles, Copco, USA, 2003

Wink Kettle, Copco, USA, 2002

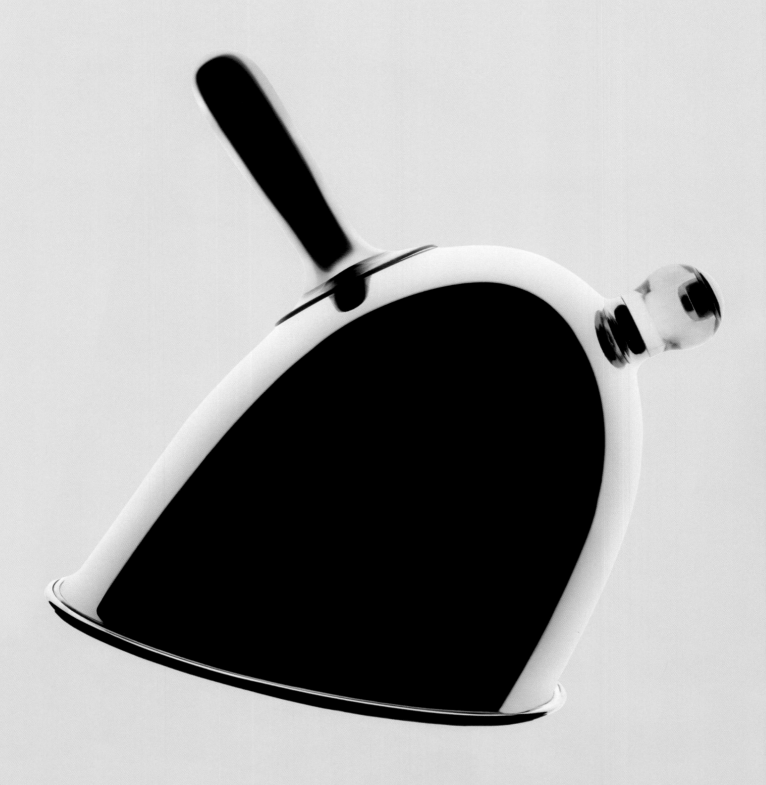

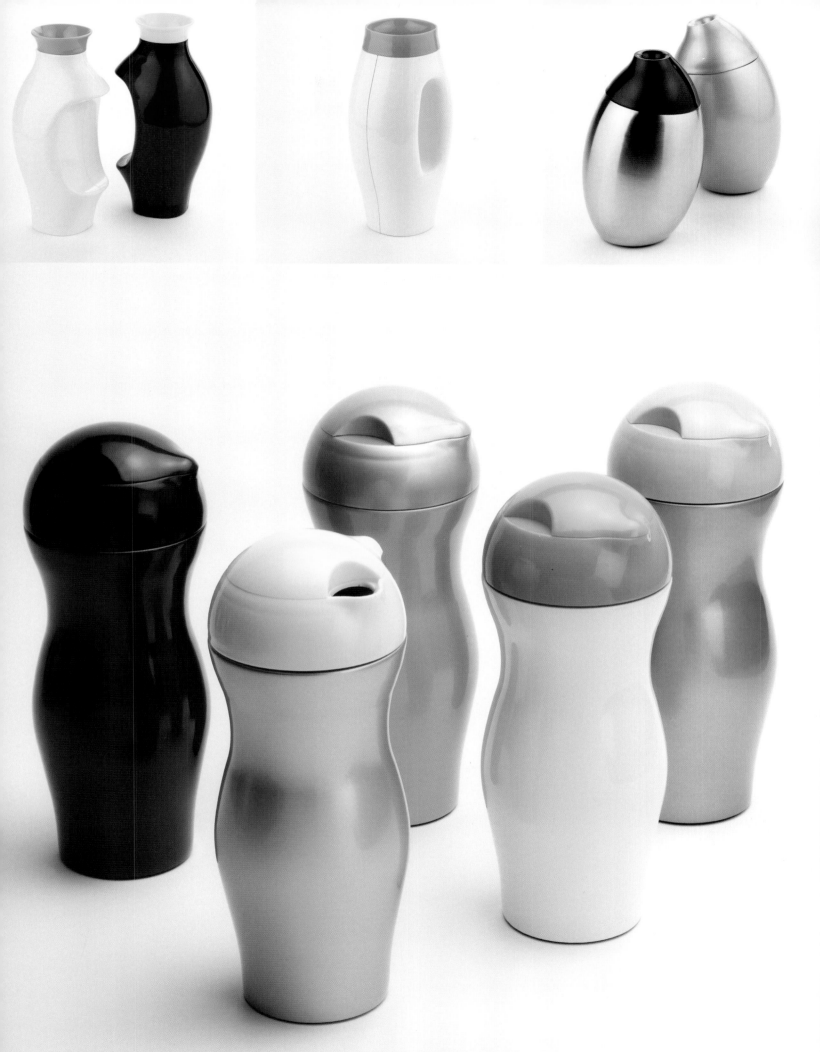

Buzz, Pudge, Soothe, Jive Thermos mugs, Copco, USA, 2002

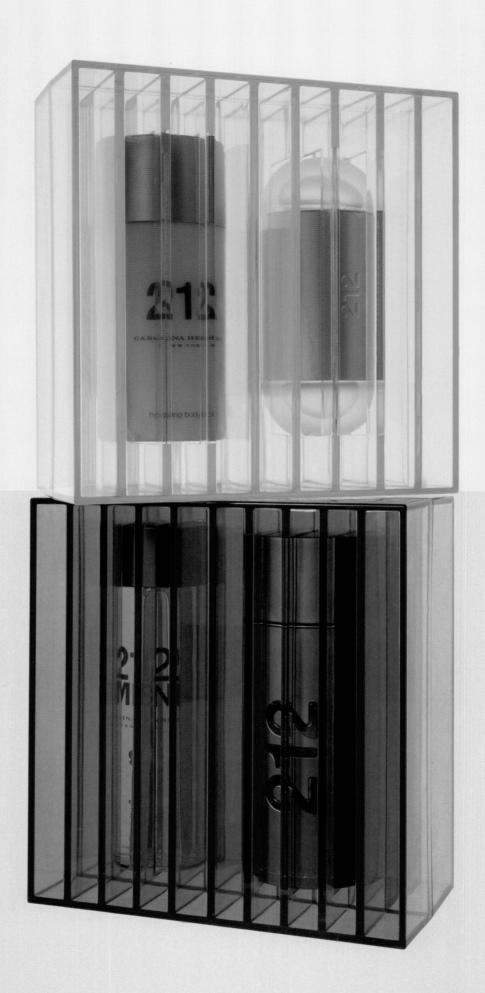

Secondary gift packaging, Carolina Herrera, Puig, Spain, 2002

KASUAL ENGINEERING The world is undergoing a "casualization" whereby we can drop the facades of dress codes, rituals, traditions, and formalities; where we can be who we are and express how we feel. Instead of some kind of dictatorial paradigm, an individual can judge and create for themselves how they speak, work, play, etc. Over the years, I have witnessed the world changing exponentially. Youth culture is informed and, in turn, interested in participating globally. Their cross-cultural positioning and views extend to an open-mindedness to change. The real goal is for everyone to be free and unbiased. Seminal to the fast-food industry, the paper cup (designed in the 1930s) shows how design changes our lives. In Japan, it was considered unorthodox to eat or drink on the street or in public but, over the last five years, I've observed a significant shift. Starbucks opened in Shibuya (the Times Square of Tokyo), and now young people take out coffees and drink on the street for the first time in Japanese history. The running shoe has changed the way people walk, and the men's-tie business has dropped forty percent in the last five years alone. The use of a single name like Madonna, Pink, or Jay-Z is another example of a new global casualness: the surname is no longer important. First class is disappearing in favor of business class; the most successful airlines in the U.S. (JetBlue and Southwest) have only one class. Jeans are part of the dress code in most offices; tattoos, piercings, and other personalized marks are now accepted by mass culture. The casualization that is spreading across the globe is a sign of open-mindedness and the expression of individualism. ¶ The new relaxed world and casual lifestyle do not refer to form and behavior alone but also to our new material landscape, where tactile surfaces give us comfortable and engaging physical experiences. New polymers, such as synthetic rubbers, santoprenes, evoprenes, polyolefins, silicones, and rubberized coatings, all contribute to the new softness of our products. Multiple materials on a single object made possible by new technologies such as dual-durometer molding and triple injection enrich the interface with our bodies. We have heightened our tactile experiences. Materials can now flex, change, morph, shift color, and heat due to the Smart material movement. From tooth-brushes to color-changing toys, these stimulating phenomena all play a role in our new, relaxed environments. The casualization of shape, form, material, and behavior are definitely a movement—one that is very much American. To use Victor Papanek's terms, America is "casually engineering" the rest of the world. It has created a kind of digital language, blobifying our world physically and immaterially. This is not the first time America has shaped the world. The blobject movement is here thanks to a handful of designers (myself included) who have taken a great interest in organic form and the technology that is allowing us to morph, undulate, twist, torque, and blend our concepts. New production processes and methods are contributing to this New World language. ¶ Nothing is permanent. Permanence as a doctrine is over. We live in a temporal, evanescent experience and our objects and spaces should reflect the moment in which we live—we should shape and change now and not worry about longevity, permanence, or the past. This new vast, ever-dynamic Casualism is our new contemporary condition. **Karim Rashid**

Limited edition print for *Contemporary Art Magazine*,
England, March Issue, 2004

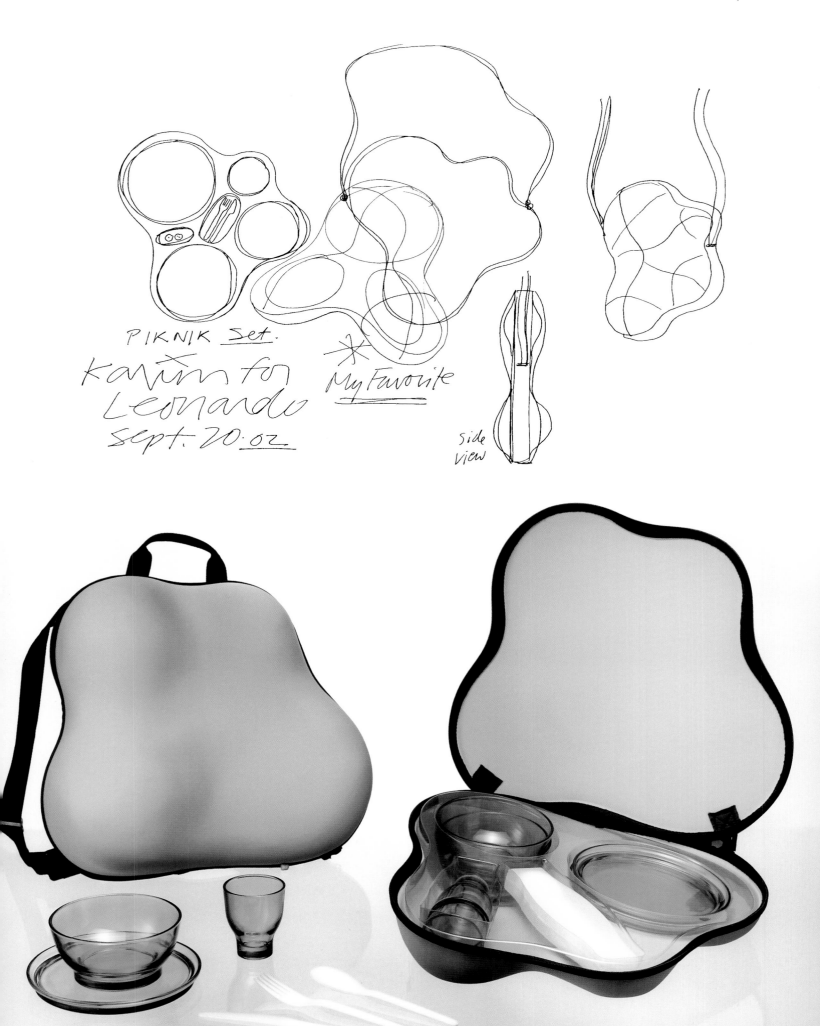

PIKNIK Set.
Karim for
Leonardo
Sept. 20·02

My Favorite

side
view

Rio, Bo, Tower, Flo Pens, Leeds, USA, 2002

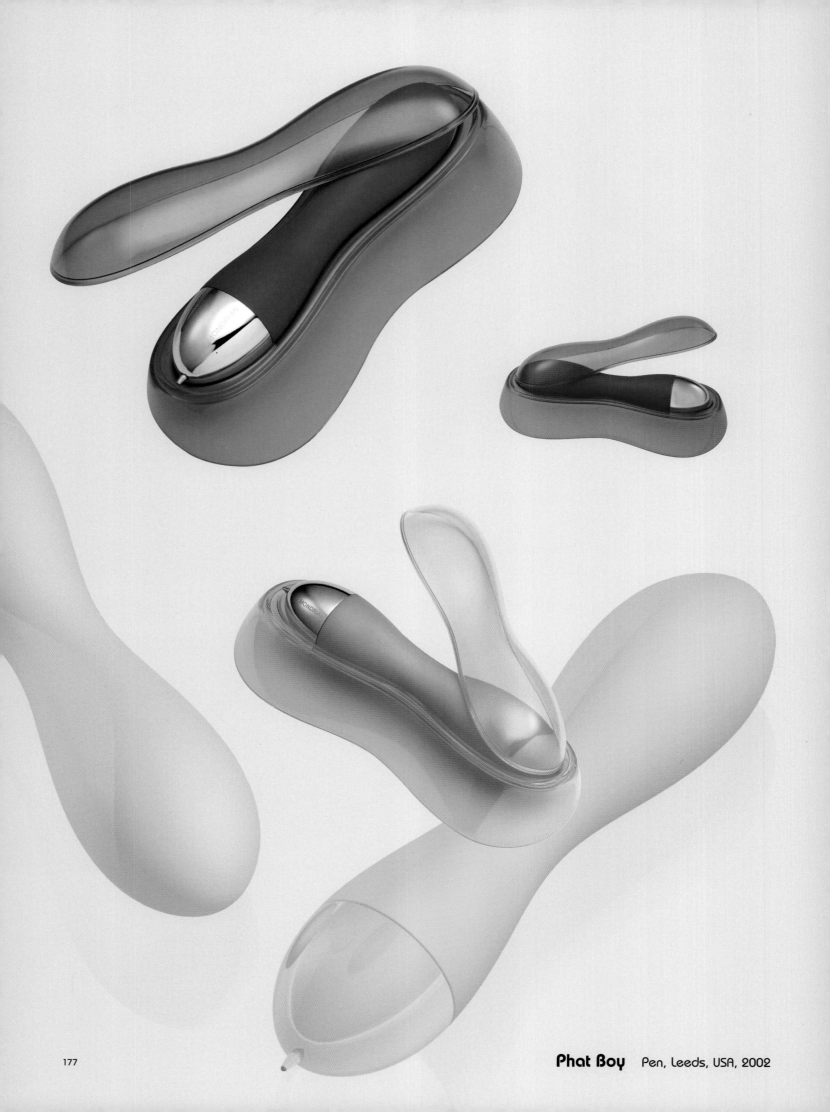

Phat Boy Pen, Leeds, USA, 2002

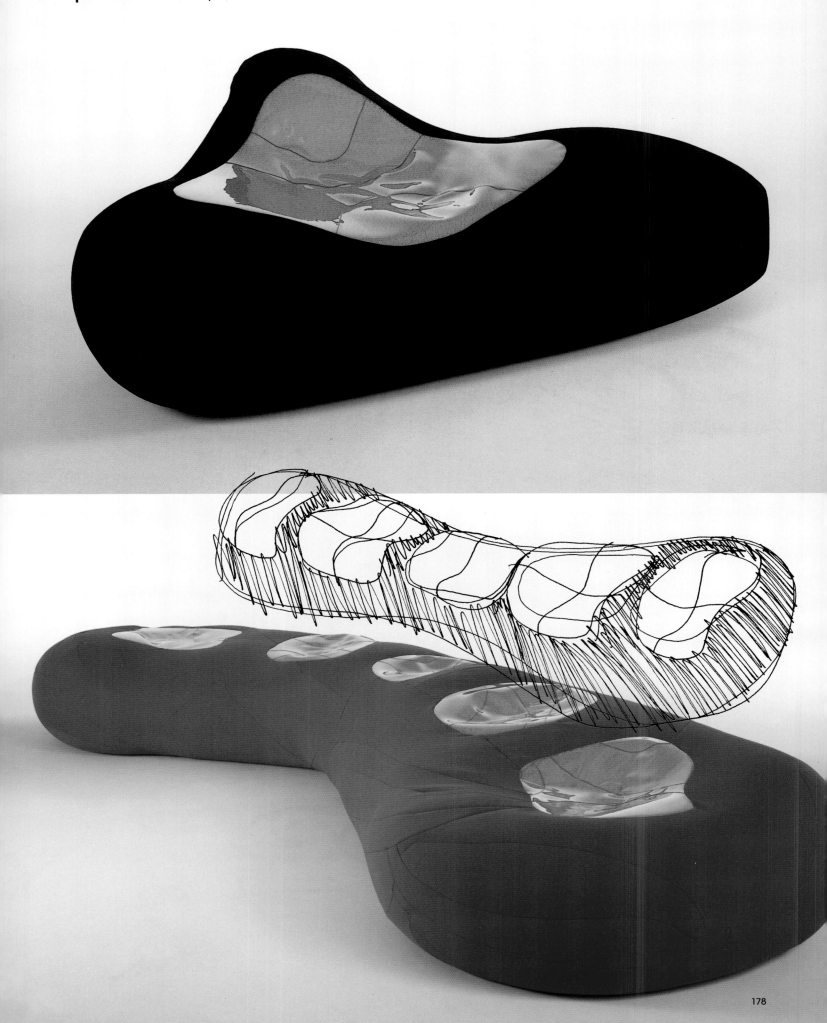

Plastic PVC 7
clear

Design Pattern
like Clothes

clear
Body Extension

like
sacco

Ath
neoprene
?

super blob

Nov. 2001 Kazim

179

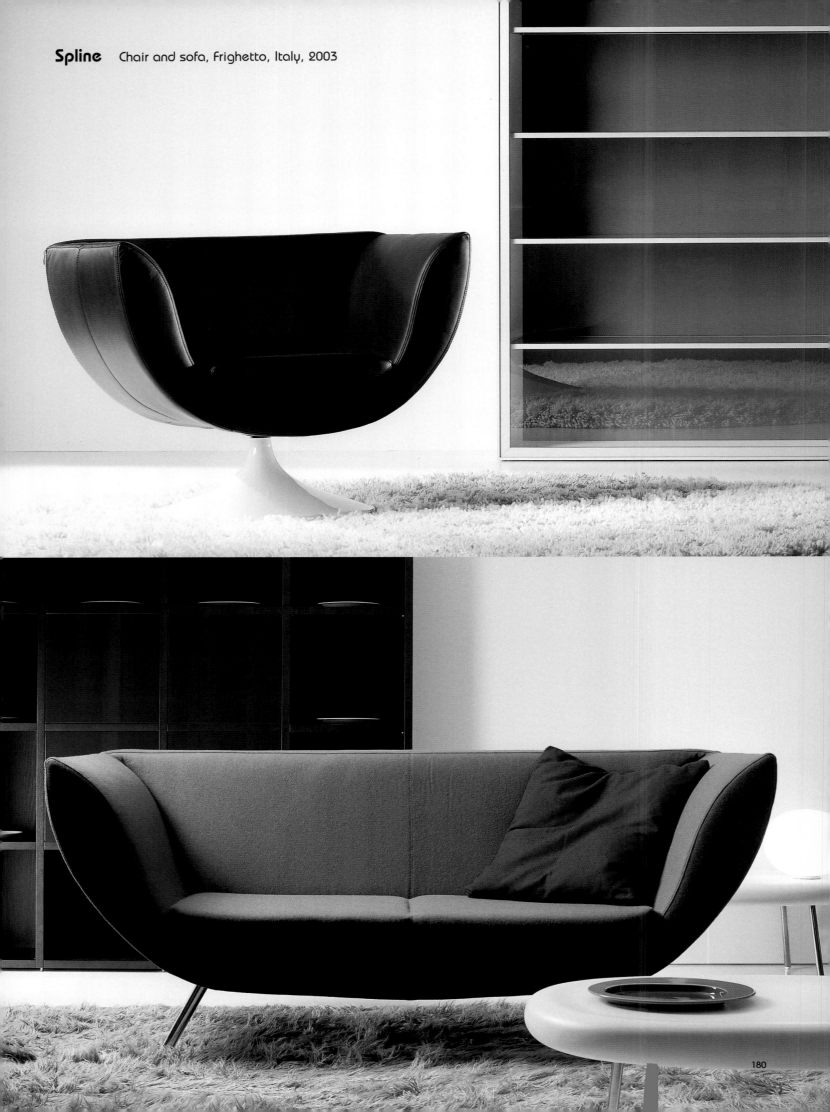

Spline Chair and sofa, Frighetto, Italy, 2003

180

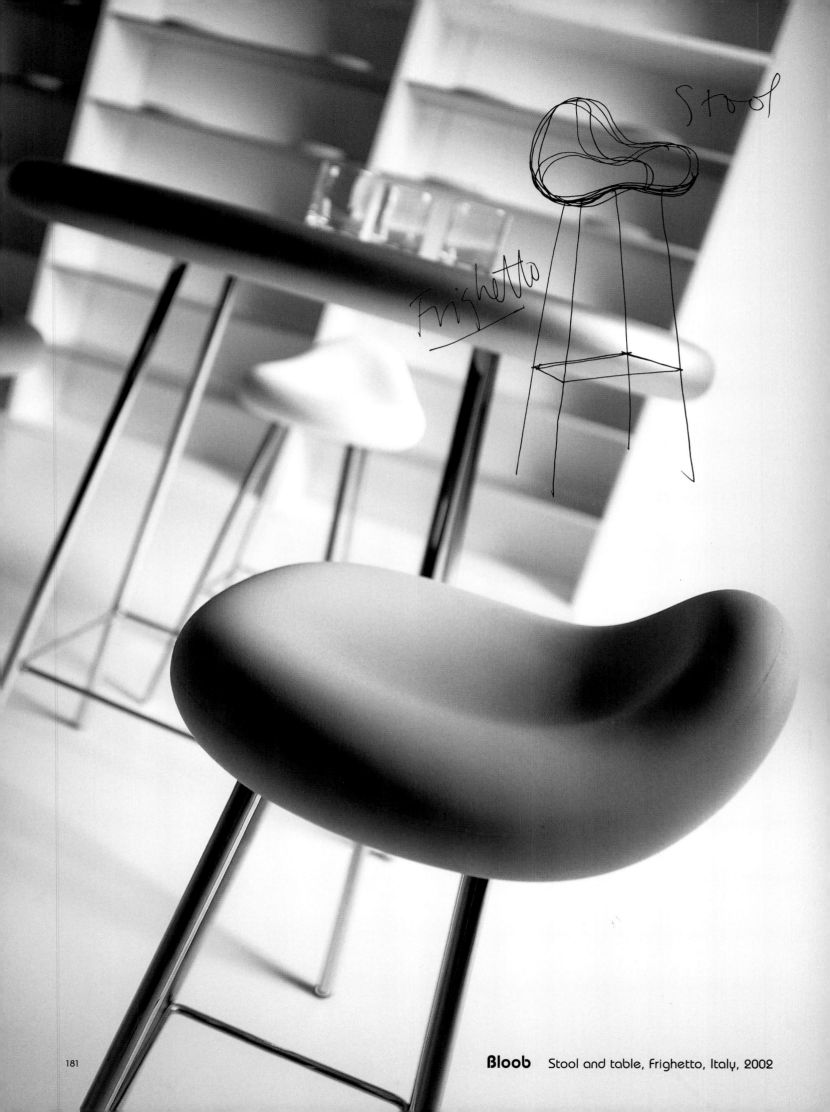

Stool

Frighetto

Bloob Stool and table, Frighetto, Italy, 2002

The Kurv chair and
Kurvman are designed as a
sensuous flexuous ribbon of formed
wood with an upholstered center.
The continuous band affords a soft
springing of the seat and back for
maximum comfort and a kinetic
bounce. The flowing form is design-
ed ergonomically to provide correct lounge seat-
ing for all contexts, from office to home, with an area below for magazines or
other storage. Taking the art of wood molding to another level, the chair is pro-
duced by curving a single ten-foot piece of laminated maple, made up of
twelve layers. This very complex laminat-
ing process uses five- and six-
part molds to simultaneously
bend the wood in differ-
ent radiuses.

Kurv

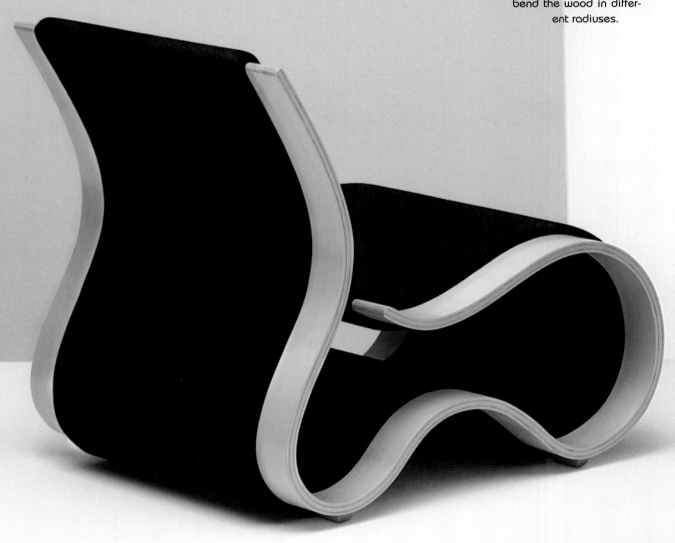

Kurv Nienkämper, Canada, 2002–2004

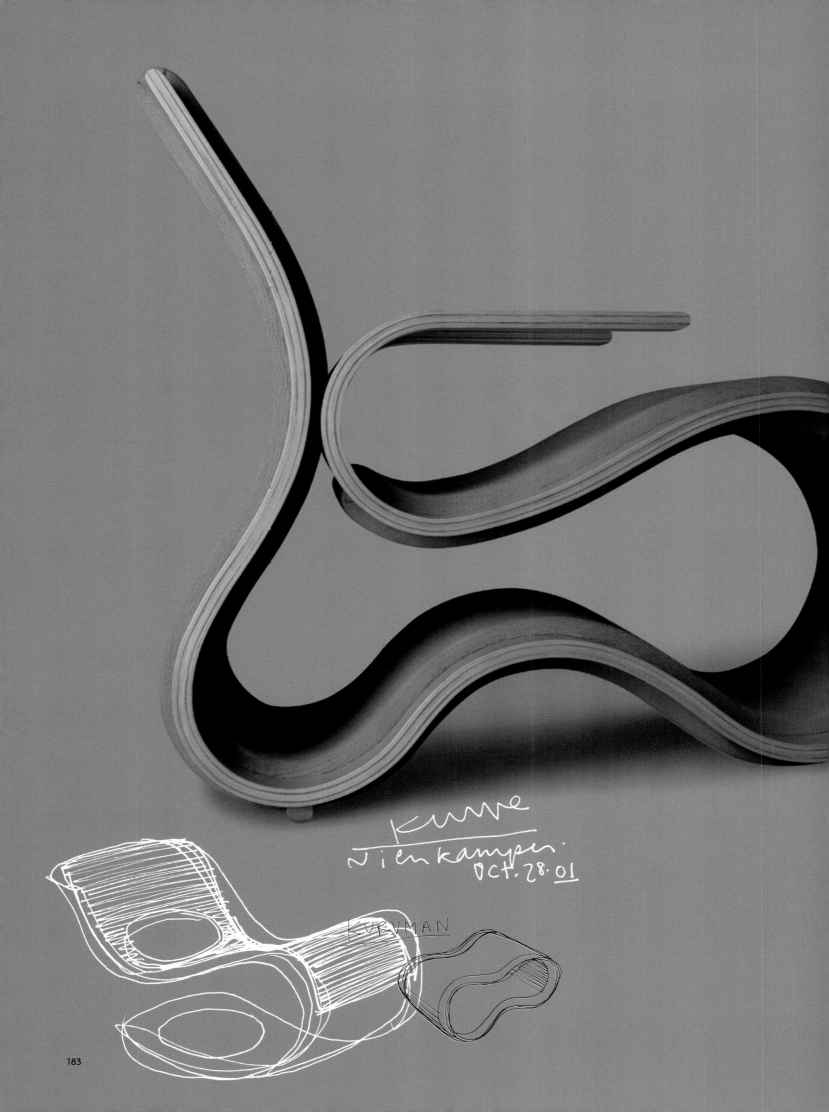

Kurve
Nienkamper
Oct. 28.01

KURVMAN

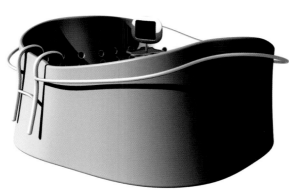

upper back jet
lower back jet

IV

concept 2

leg jets

Same as concept 1 expect undulating back (hight low)

Area for couples

HOT TUB

concept!

3m?

Ask him make size
or use their
existing sizes
as a guide

Must be

The building was a
parking garage on West
16th Street in Chelsea. The exist-
ing structure had a pitched ceiling
with several trusses so I softened and
carved the space by hiding them with
curved sheetrock and creating rounded compound ceilings and
walls. Once covered, the original trusses created three spaces that, although open
to one another, contain different colored light that result in the illusion of separate spaces.
We cut some free-hand organic-shaped holes through some of the walls between the exist-
ing structures allowing the spaces to connect through unusual, mysterious views and color
contrasts. The surrounding LED lighting is extremely flexible so that each space
can change tonality and contrast. For the interior,
concrete, chrome, colored glass, and
digital lighting are used in
broad strokes.

powder

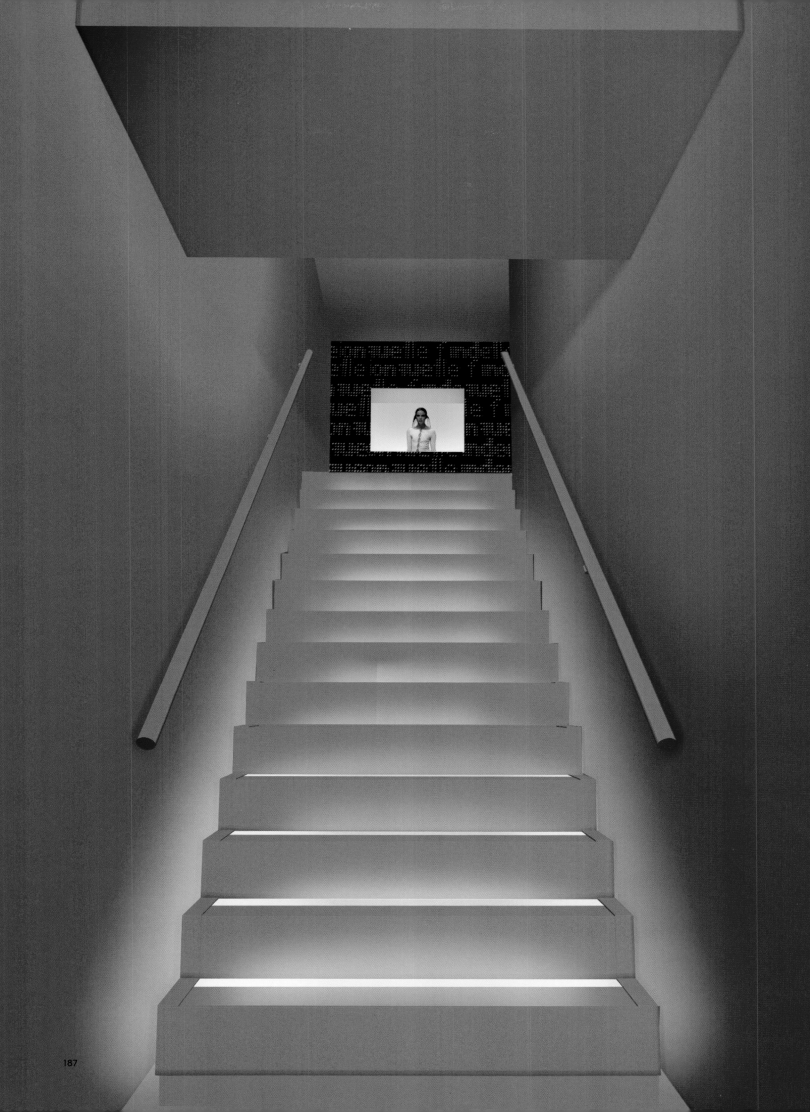

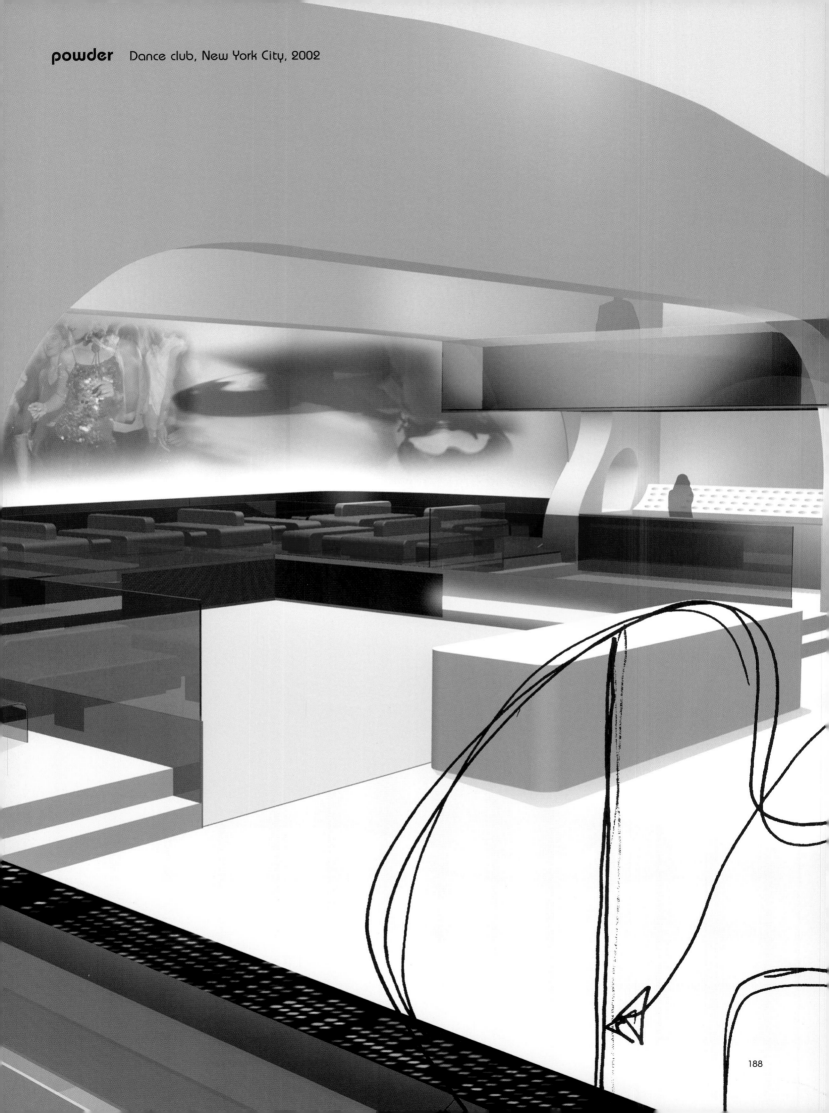

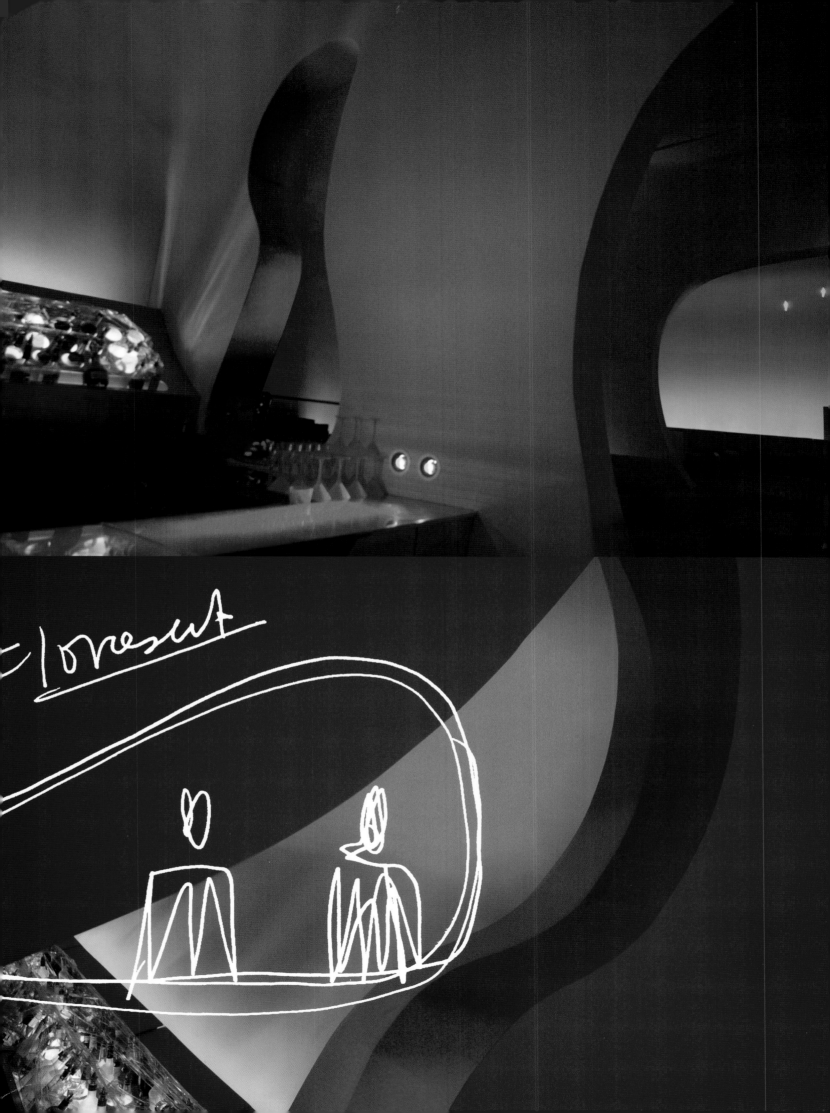

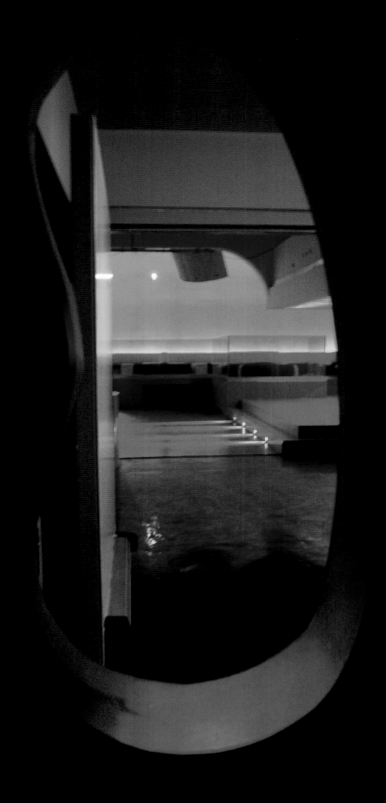

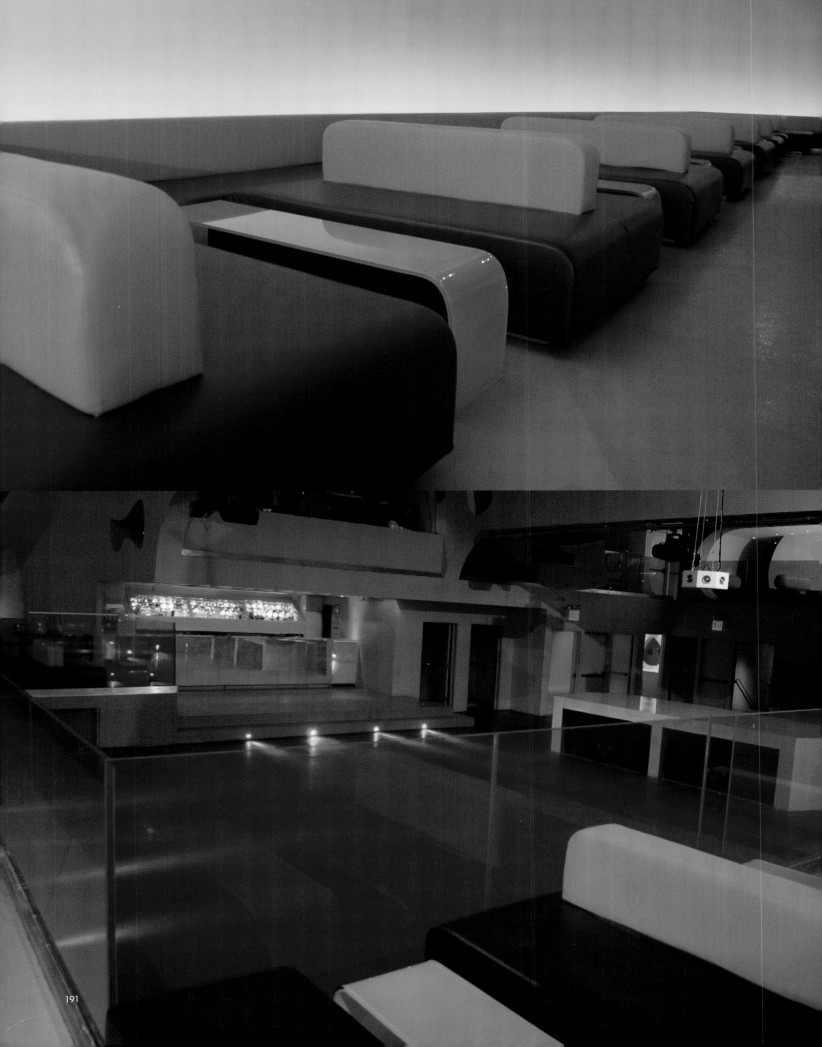

INFOSTHETICS

The use of forms, spaces, materials, colors, and textures that speak of our digital age is Infosthetic. It is the style of the 21st century. The world of information is full of signals, signs, forms, colors, and vernaculars that do not exist in our physical world. Inspired by virtual languages, we can create a physical landscape that is aesthetic and embodies all the clues, clarity, and energy necessary to infuse it into our daily lives and our everyday objects. Media philosophy has a direct correlation with the bombardment of imagery that is changing our visual landscape. As our spaces change, so do our objects. Our physical world is adopting a 4-dimensional language. Ideally, our living spaces should all be Infosthetic—combining new forms and technology. Our interiors could have liquid-crystal polymer wallpapers that communicate, the surfaces made of soft-touch polymers, such as synthetic rubbers, and translucent, transparent, and digitally changeable silicones. By touching the pellucid surfaces, images, text, and sound could be surfed, scanned, changed, and morphed. Windows should be made of polarized crystal so that they dim when the sun is too bright and vice-versa, while textiles should be made from aerospace synthetics that don't stain or fade. In effect, our spaces would acquire life, becoming the interface for direct or indirect relations with strangers, data, and imagery; crossing the bounds of history, fiction, reality, time, and space. Via new languages and materials, we can heighten our experiences. Our spaces can flex, change, morph, cool, heat, breathe, and shift color. Smart materials communicate and give us feedback; these stimulating phenomena play a role in our new, relaxed environments and represent our new aesthetic virtues. Spaces and objects need to be free of history and tradition—flexible, intelligent, beautiful, and highly experiential. Visually, they should speak to the information age.

Karim Rashid

Time and Space Artimede, Italy, 2003

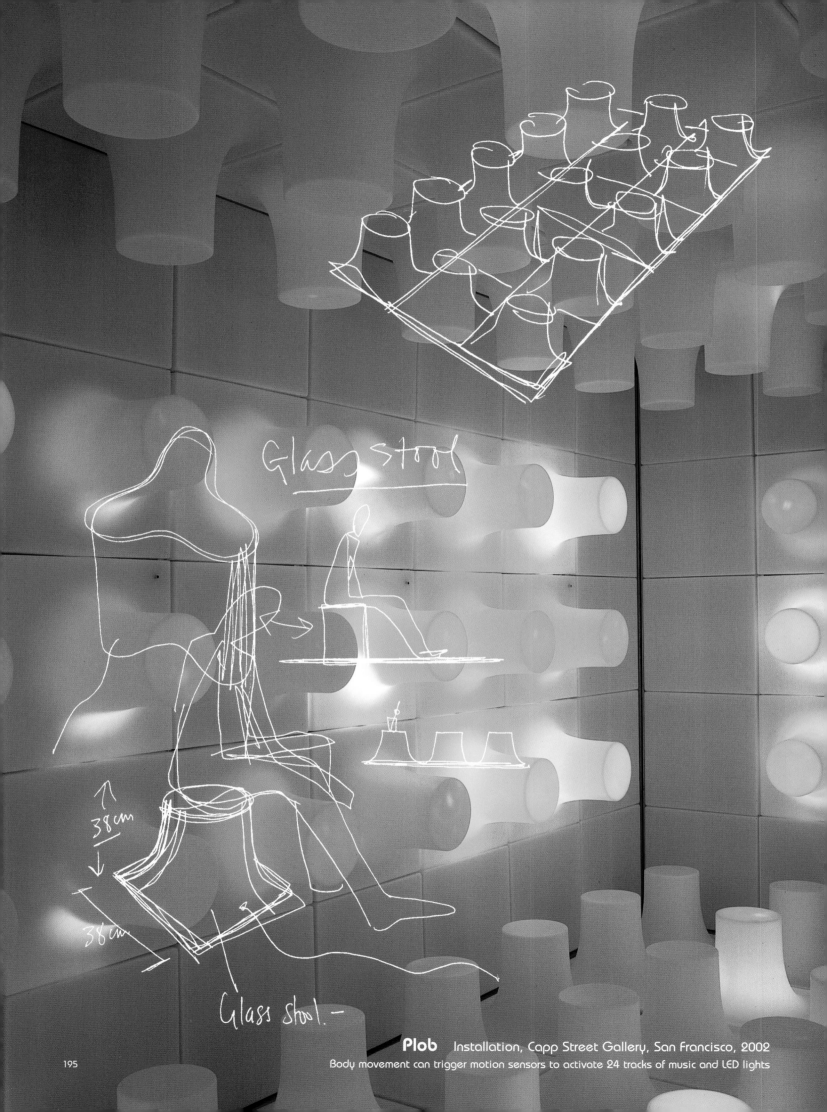

Glass stool

38cm

38cm

Glass stool.—

195

Plob Installation, Capp Street Gallery, San Francisco, 2002
Body movement can trigger motion sensors to activate 24 tracks of music and LED lights

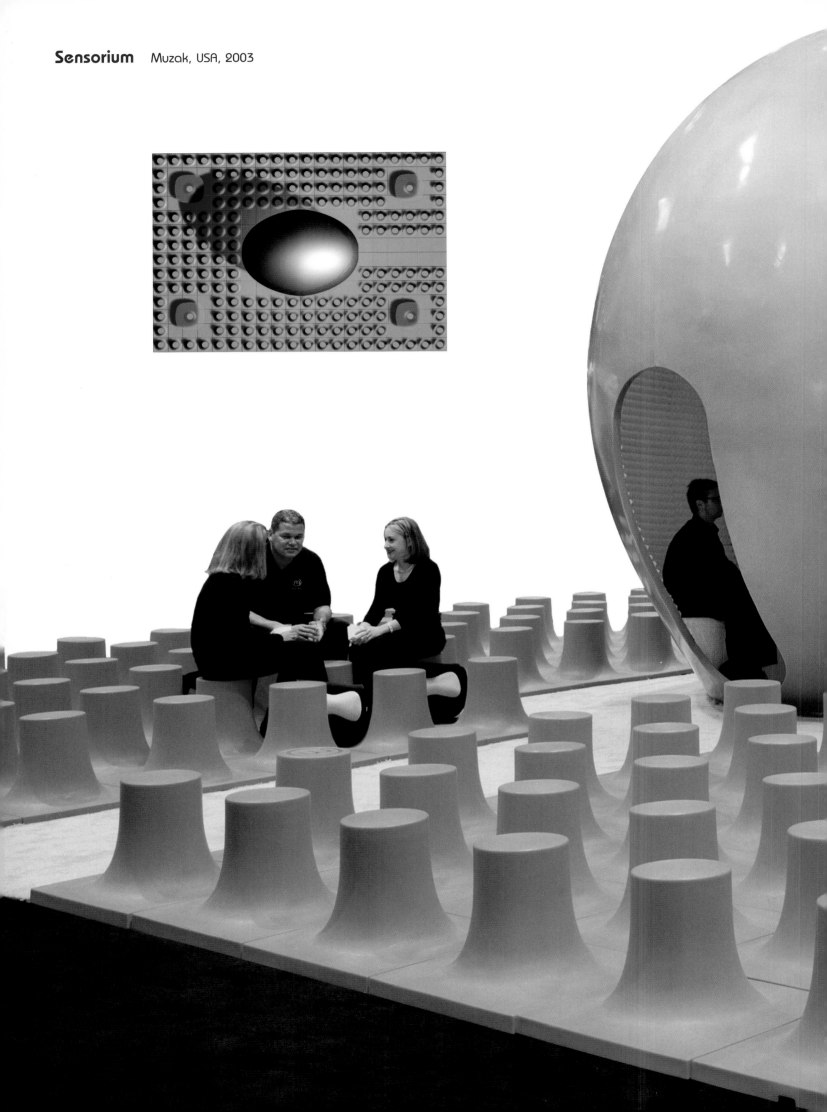

Music is fluid, music is movement,
music is sexy, fun, embracing, mnemonic, liberating,
emotive, experiential, memorable, and abstract. I designed a
field of "plobular" modules symbolic of our corybantic digital age—a
repeated element of binary notation surrounding an organic voluptuous con-
tainer of sound. I wanted to reconsider the trade show stand, not as a display but
as a micro-architecture symbolic of the new brand of Muzak, a sound architecture that
navigates seamlessly and pleasurably stimulates our senses and our ever-vast new experi-
ences. The Sensorium is a monumental grid of repeated elements that grows from the floor fram-
ing an elevated, spiritually loaded, bulbous, pseudo-amorphous form in a space that is organic and
omnidirectional like sound; one that resonates and emphasizes the volume of the irradiating beat.

Sensorium

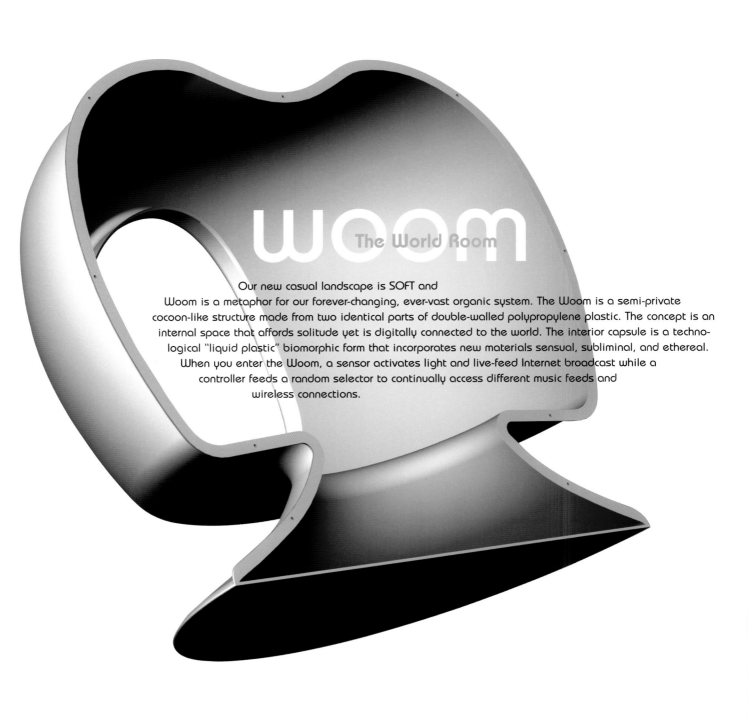

WOOM
The World Room

Our new casual landscape is SOFT and
Woom is a metaphor for our forever-changing, ever-vast organic system. The Woom is a semi-private cocoon-like structure made from two identical parts of double-walled polypropylene plastic. The concept is an internal space that affords solitude yet is digitally connected to the world. The interior capsule is a technological "liquid plastic" biomorphic form that incorporates new materials sensual, subliminal, and ethereal. When you enter the Woom, a sensor activates light and live-feed Internet broadcast while a controller feeds a random selector to continually access different music feeds and wireless connections.

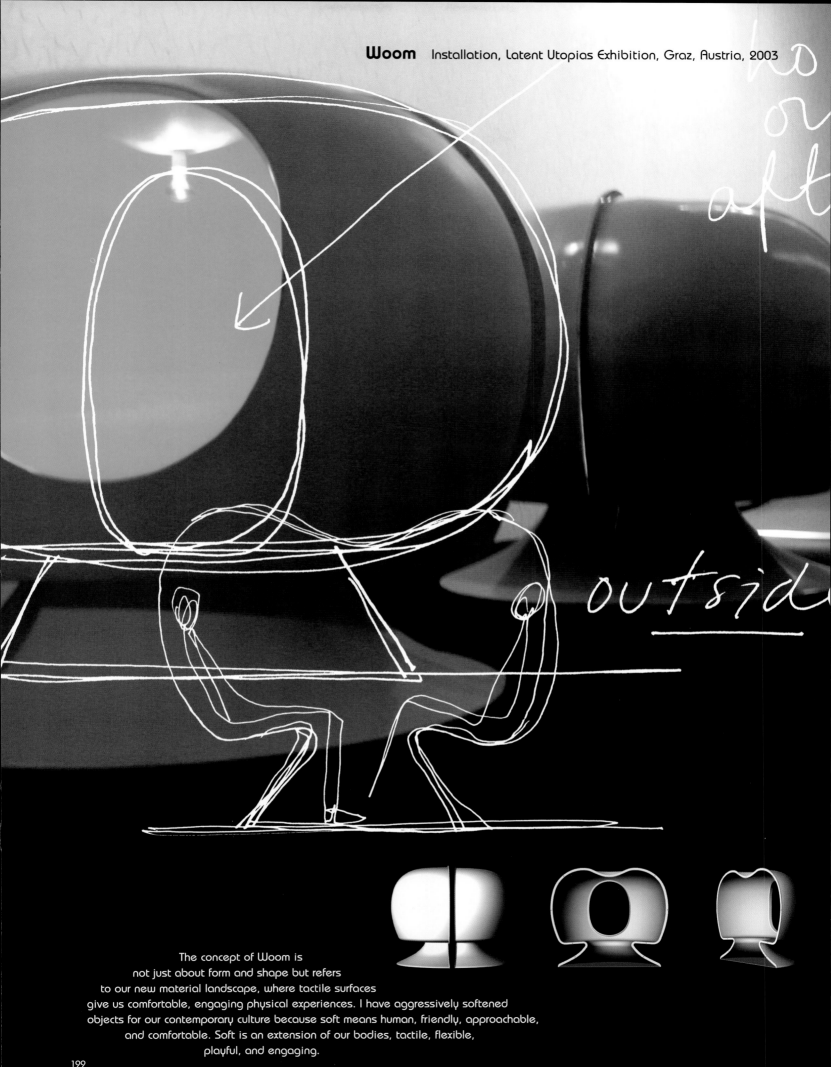

The concept of Woom is
not just about form and shape but refers
to our new material landscape, where tactile surfaces
give us comfortable, engaging physical experiences. I have aggressively softened
objects for our contemporary culture because soft means human, friendly, approachable,
and comfortable. Soft is an extension of our bodies, tactile, flexible,
playful, and engaging.

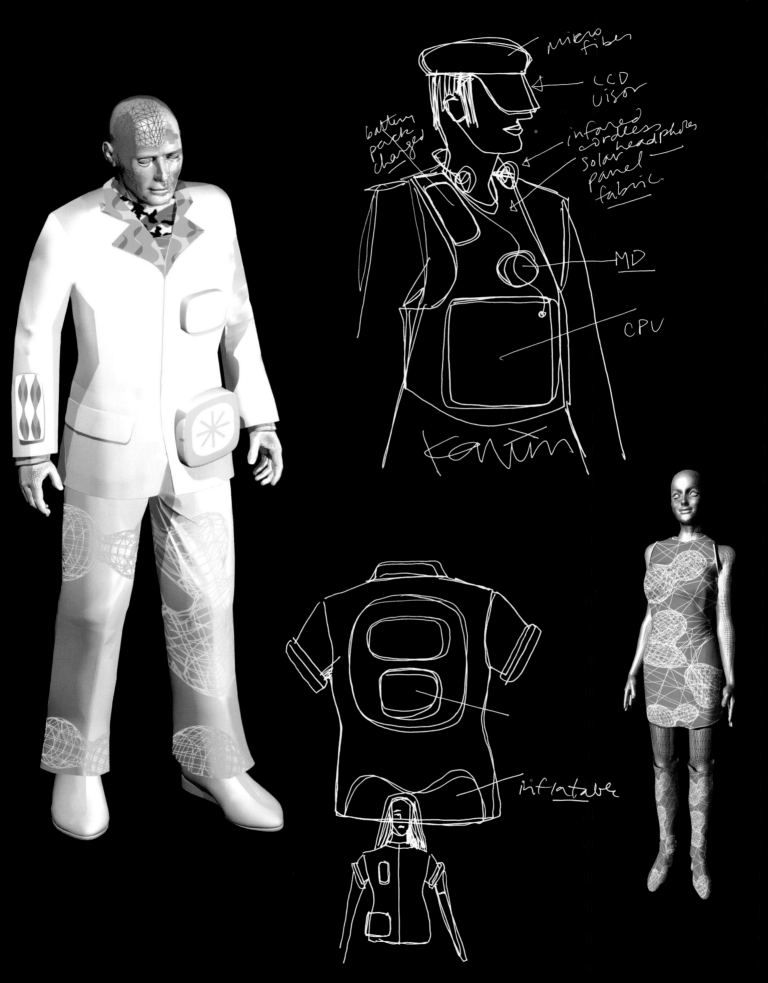

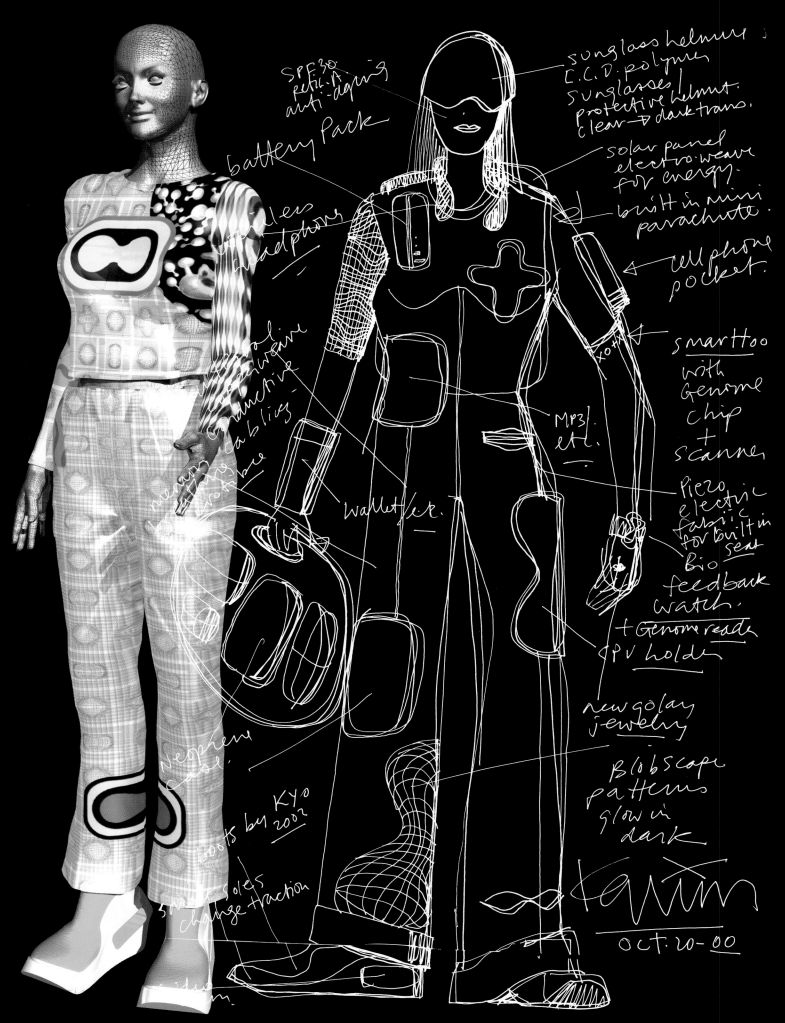

SPF 30
refill
anti-aging

battery pack

cordless
headphones

SPF 30
refill
anti-aging

memory chip
heating cables
electro-weave
parachute
neoprene
case.

wallet/etc.

boots by Kyo
2002

smart soles
change traction

sunglass helmet
L.C.D. polymer
sunglasses/
protective helmet.
clear → dark trans.

solar panel
electro-weave
for energy.
built in mini
parachute.

cell phone
pocket.

exotic

Mp3.
etc.

smart too
with
Genome
chip
+
scanner

Piezo
electric
fabric
for built in
Bio seat
feedback
watch.
+ Genome reader
CPU holder

new golay
jewelry

Blobscape
patterns
glow in
dark

Karim

OCT. 20 - 00

Hypermix Collection, customizable on Cybercouture website

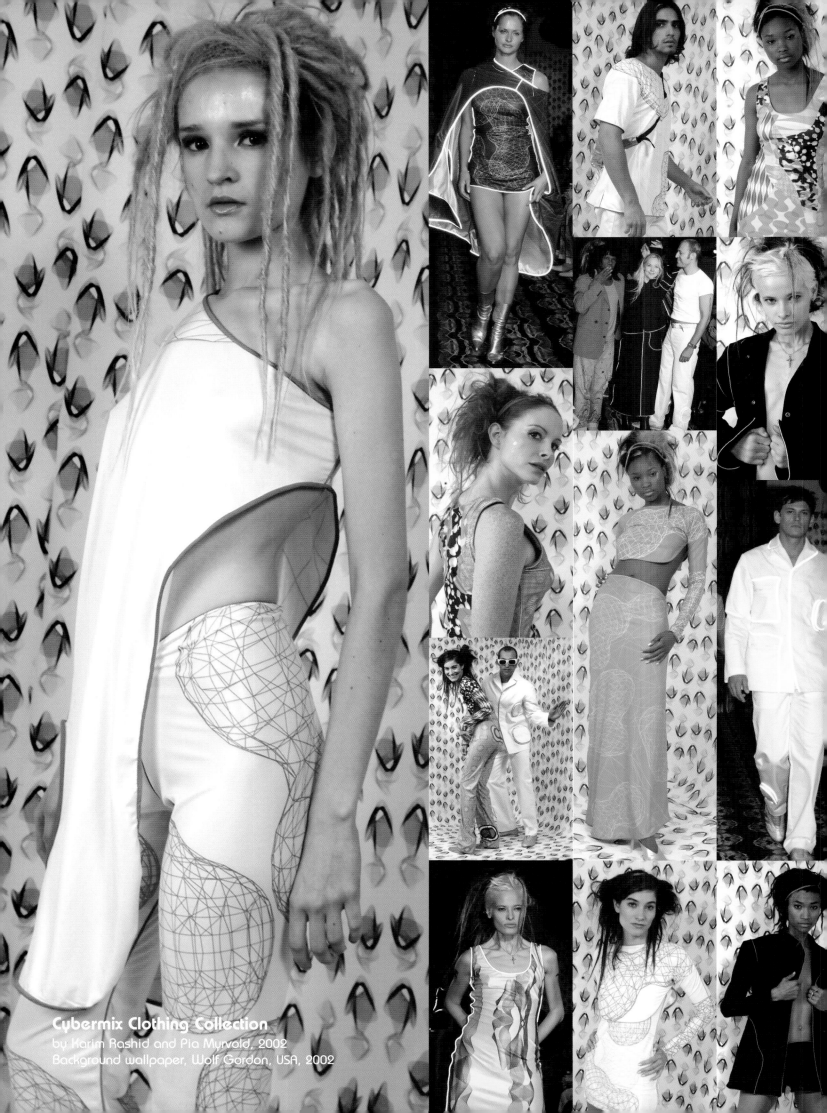

Cybermix Clothing Collection
by Karim Rashid and Pia Myrvold, 2002
Background wallpaper, Wolf Gordon, USA, 2002

HAIR!

Tattoo

3 Garnets
2 silver
1 Gold

Naked

cell phone

Karim for Knoll fashion show
7e-s-02

203

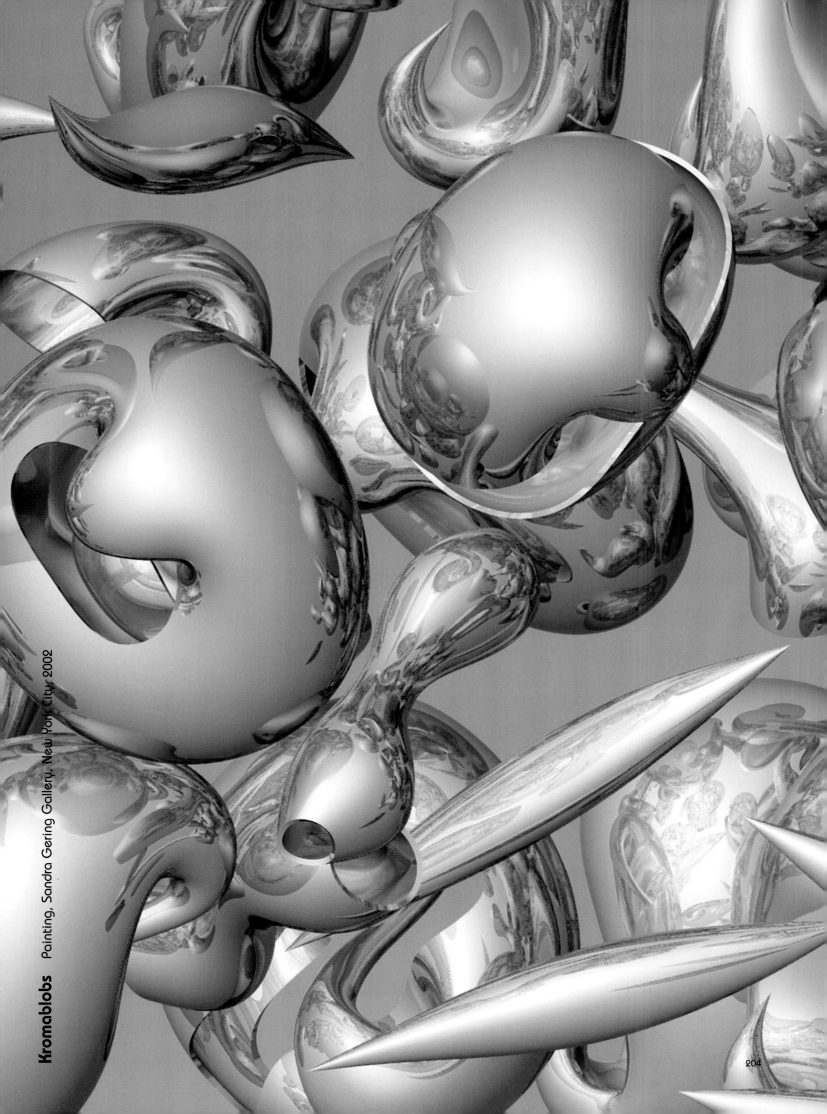

Kromablobs Painting, Sandra Gering Gallery, New York City, 2002

TECHNORGANICS

If freedom were a form it would be a never-ending, undulating, boundless, biomorphic shape in perpetual motion. Form follows Fluid. In our post-industrial age—the information age—conditions will be more relaxed, less rigid, soft not hard. Our experiences will be more hypertextual and less linear. It is not a coincidence that the driving force behind the changing and ever-shifting global lifestyle is becoming more casual, relaxed, softer—*blobular,* if you will. Blob Architecture will shape our environments, organic systems will change our paradigms, and Organomics (a term I coined for the study of ergonomics and organic form) will shape everyday objects. "Digital age," "information society," "global village," and "leisure culture" are all short-hand for a changing physical world where the soft, organic, and mutable defines our landscape. The design *rappinghood* is where a plethora of shapes, materials, mechanics, electronics, Digitalia, information, myths, markets, and tribes all form an ever-changing, dynamic, parabolic cosmos of our built environment that combines with the human body, softness, and tactility, to coalesce into new languages. All of these components inform form: our new formal landscape is SOFT. It is an axiom of our new physical reality, the desire to conquer all mathematical probabilities and create forms that previously could never be documented using any rational formulae. Are these new objects a result of advanced computer-aided tools of morphing? We are shaping a world inspired by highly complex dimensional tools: nurbs, splines, metaballs, and other bio-shaping commands are fostering a more relaxed organic condition— softer, globular, and blobular.

Karim Rashid

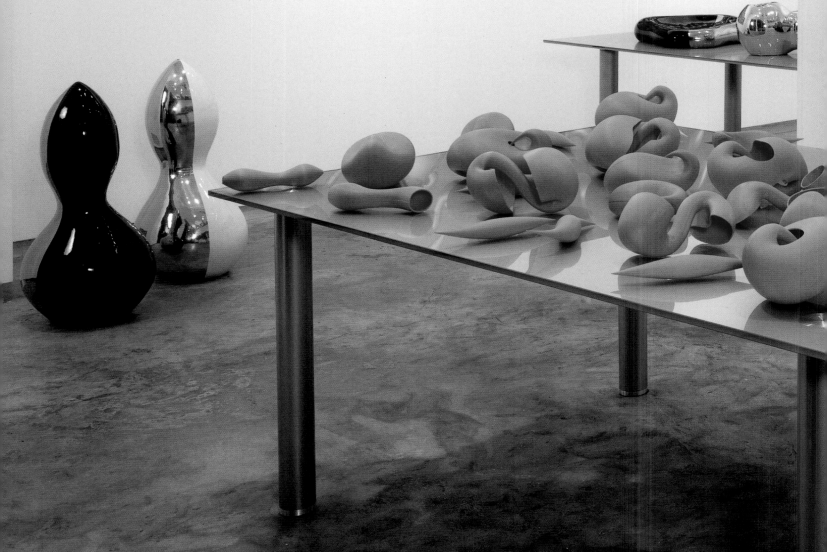

Organomica Sandra Gering Gallery, New York City, September 5 – October 5, 2002

Organomica

The Sandra Gering Gallery
presented an exhibition of my work that
included a series of Mutablob sculptures, related
digital paintings, and limited edition ceramics. The
sculptural objects in my Mutablob series embody sensual min-
imalism and a digital aesthetic I call "technorganic." Presented as a lin-
ear series, the Mutablobs recreate the evolution of a form from an embryonic
stage—a liquid plastic hermaphroditic evolution. The thirty sculptures are literally physical
manifestations of still frames of a computer-generated form that grows and morphs into itself—an evolving, mutat-
ing,"blobject" from a three-dimensional virtual world. At specific timed stages of the evolution of the form, the data is
sent to a rapid robotic prototyping machine and each piece of three-dimensional data is then built in plastic. What
looks like a viscous material grows, contorts, and finally wraps back around itself. The variety of forms created in
the Mutablob series also become compositional elements in four digital paintings. Each object is
one-of-a-kind: the data is destroyed so that the same object
can never be repeated. I coined the concept Digital
Craft in 1995, a way of using digital pro-
duction methods to create one-of-
a-kind objects.

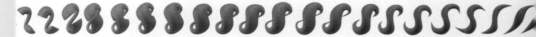

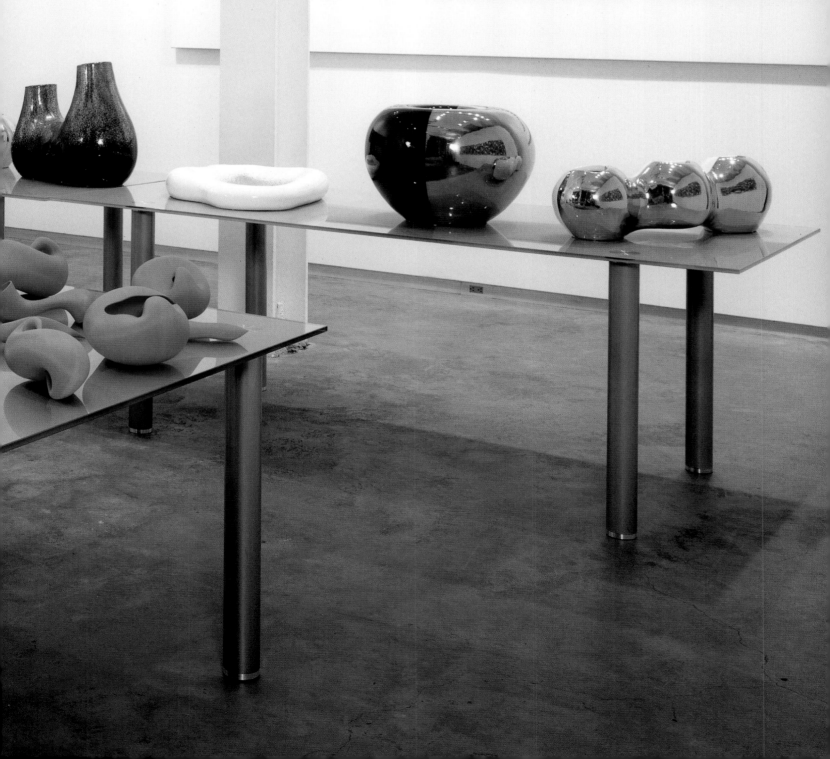

Blob 6 Chair Magis, Italy, 2002

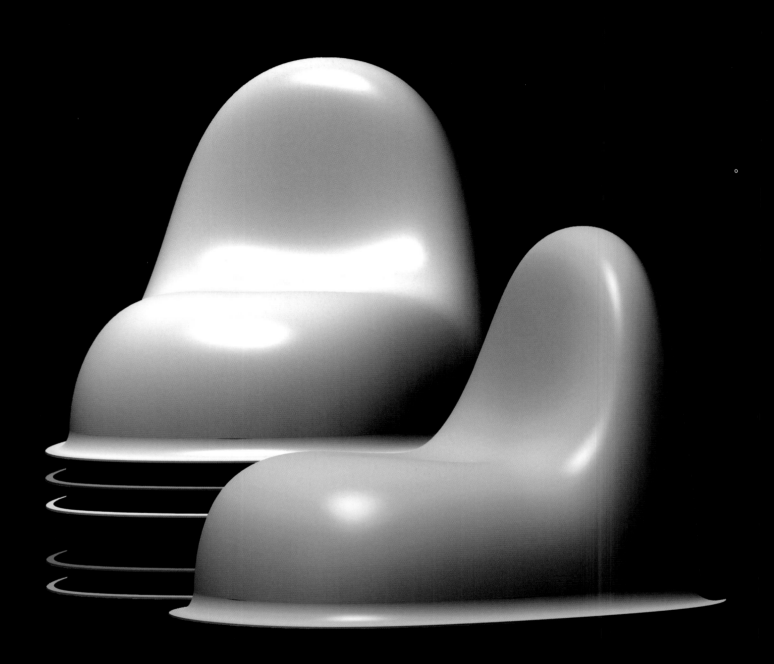

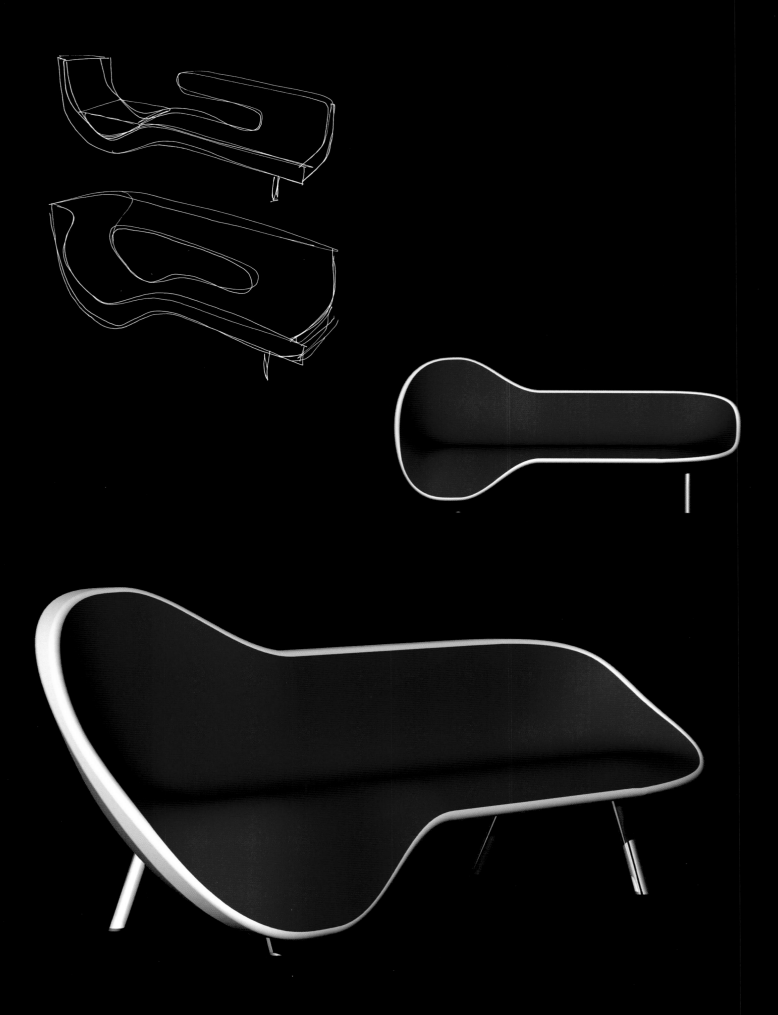

Orbit Concept, Cappellini, Italy, 2003

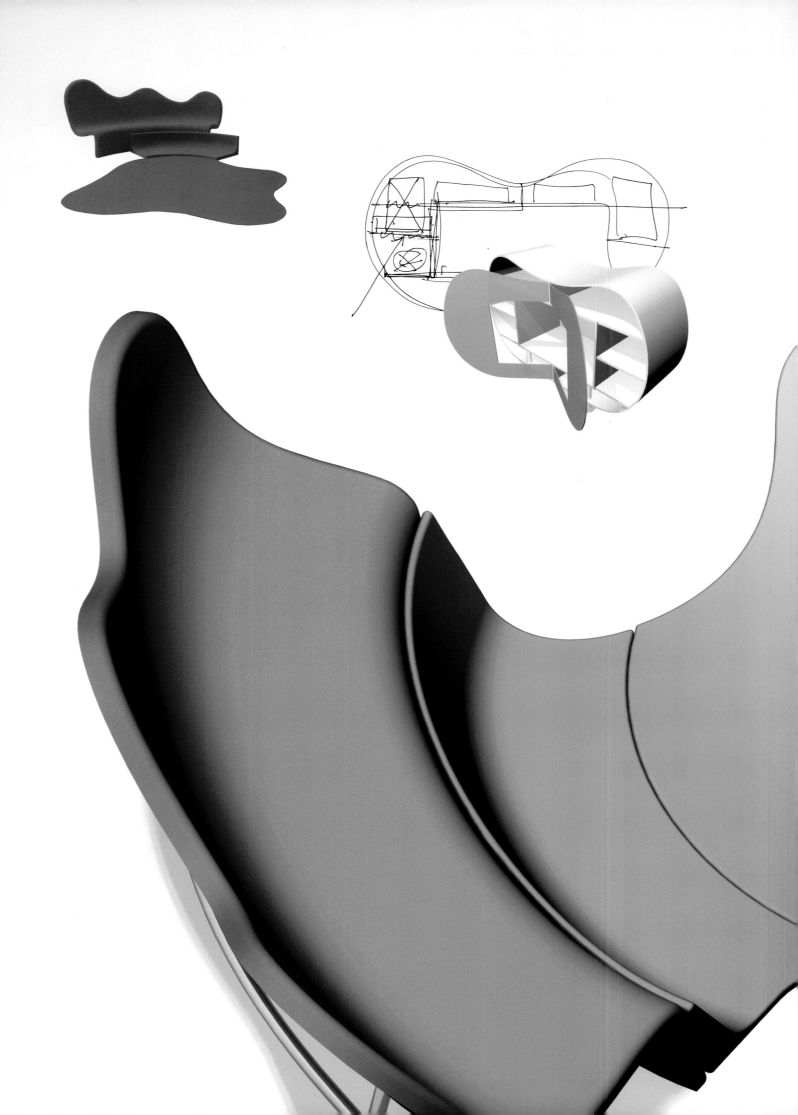

Gloss white fiberglass

Karim
FeliceRossi Dec. 13. 02

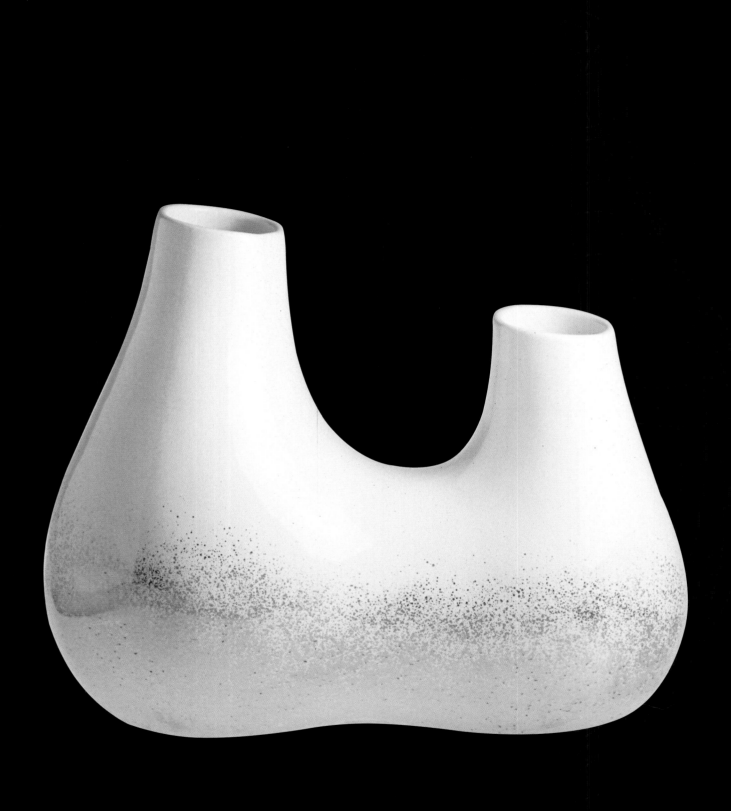

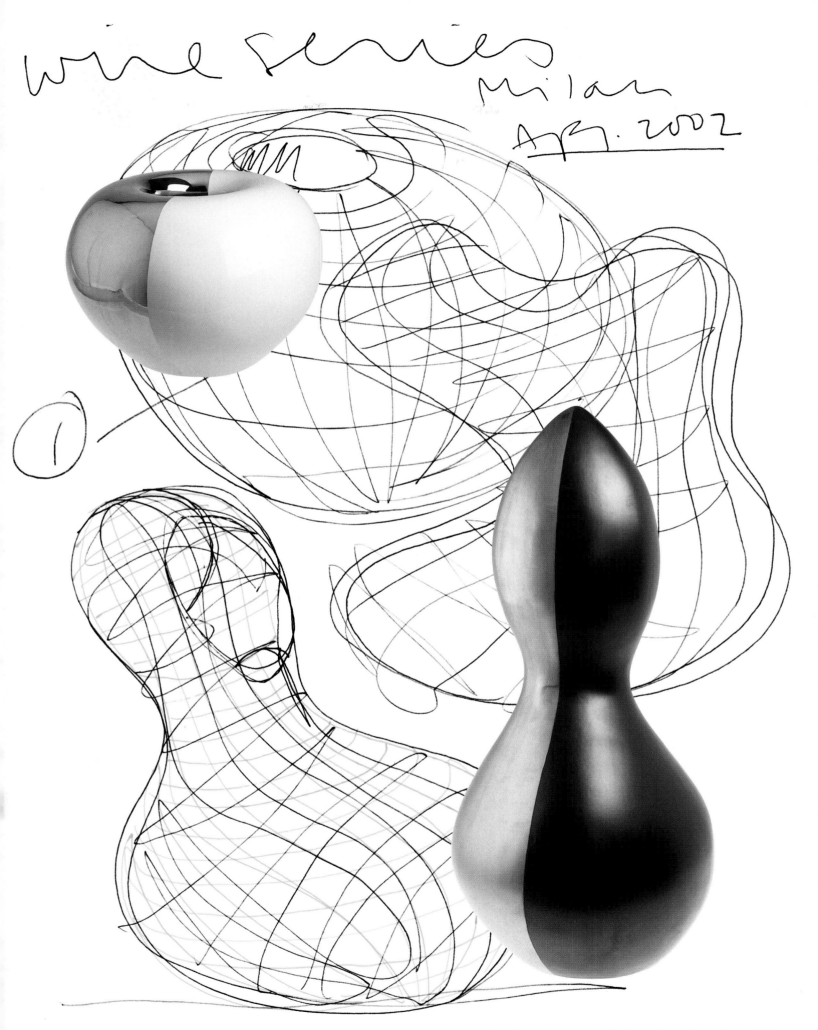

wine series
Milan
Apr. 2002

Ceramics, Sandra Gering Gallery, New York City, 2003

Mr. + Mrs.

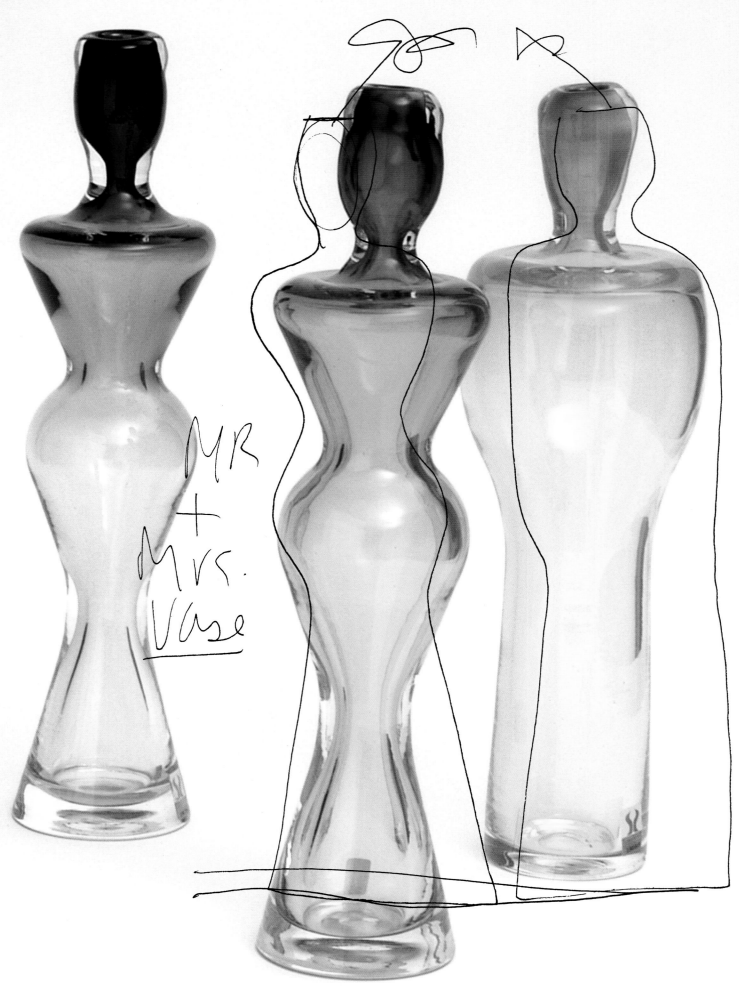

MR
+
Mrs.
Vase

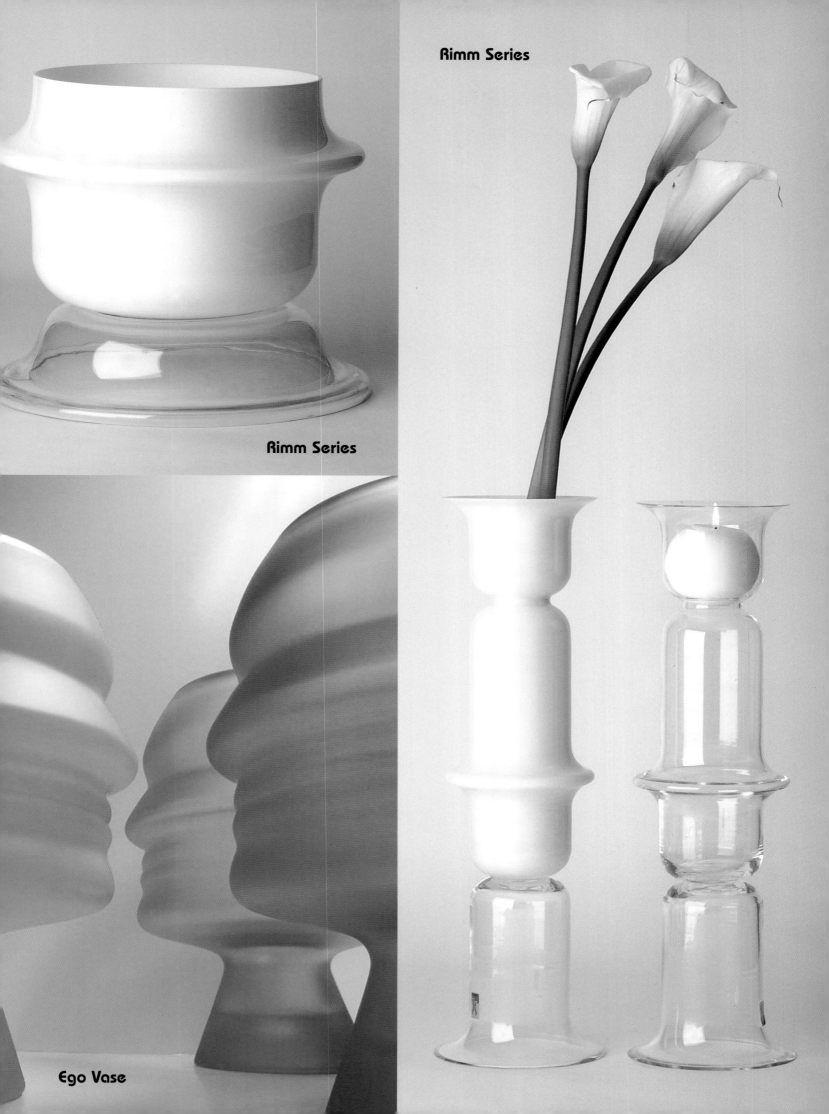

Rimm Series

Rimm Series

Ego Vase

Bloob

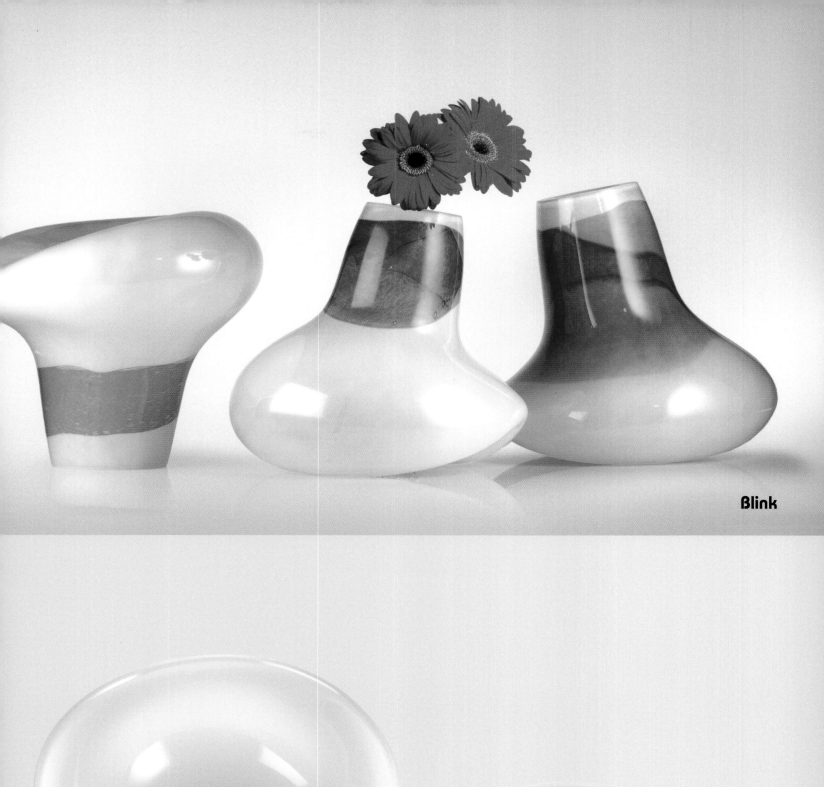

Blink

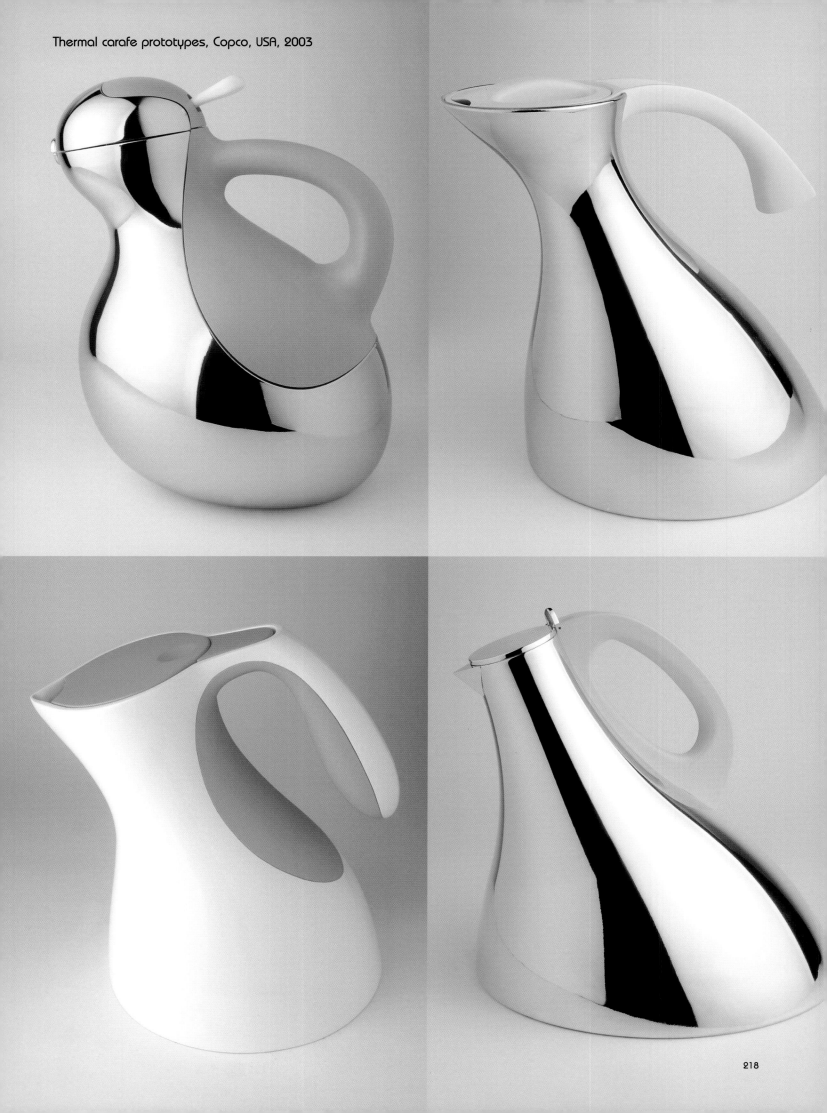

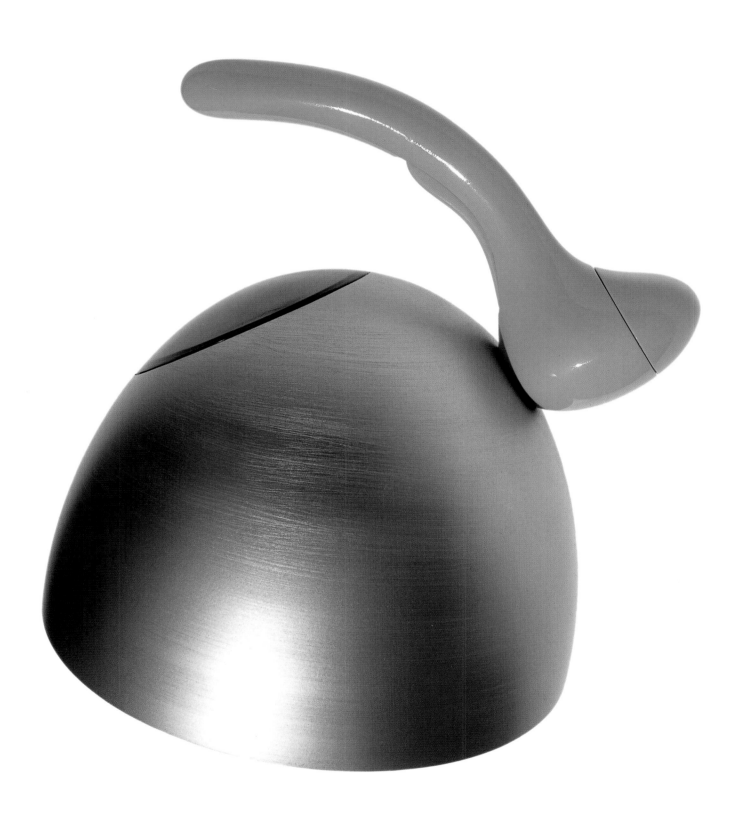

This Is Not A Pipe Kettle prototype, Copco, USA, 2004

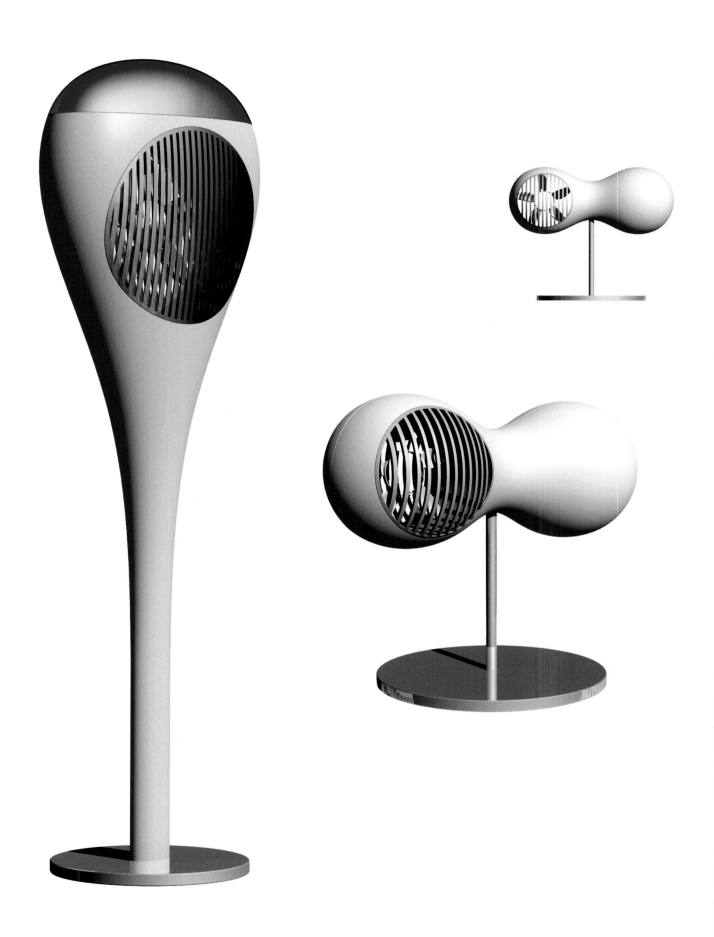

Fan and lighting concepts, Nemo, Italy, 2004

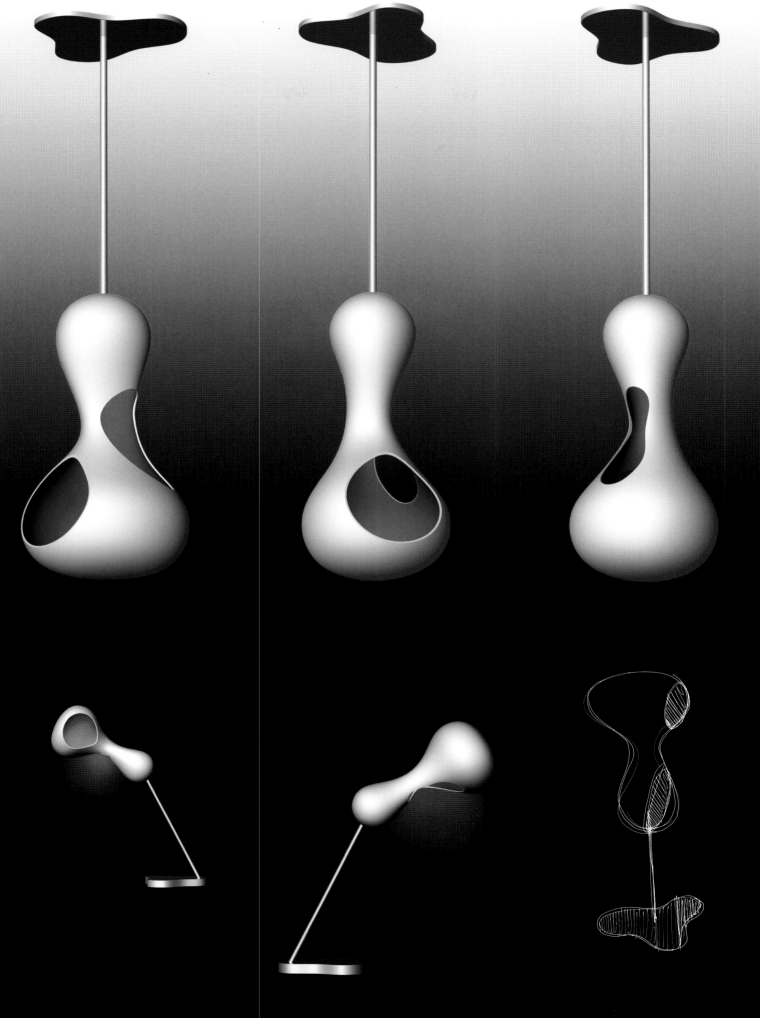

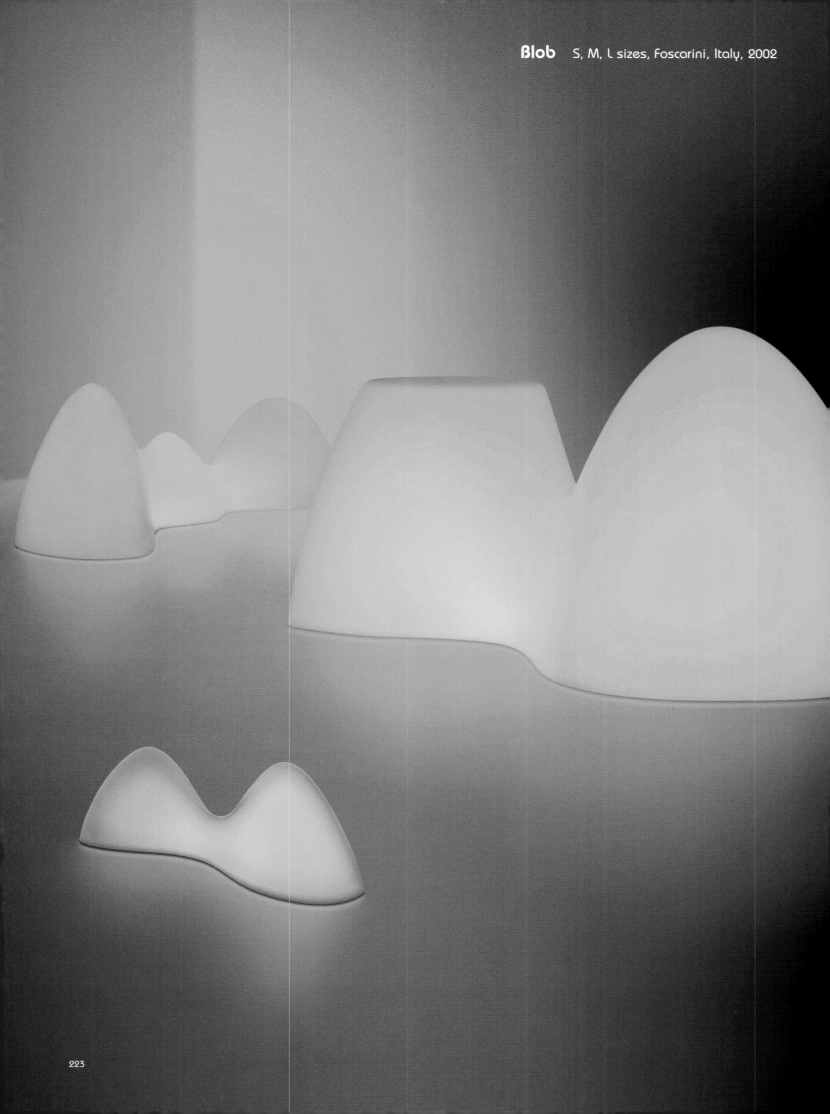

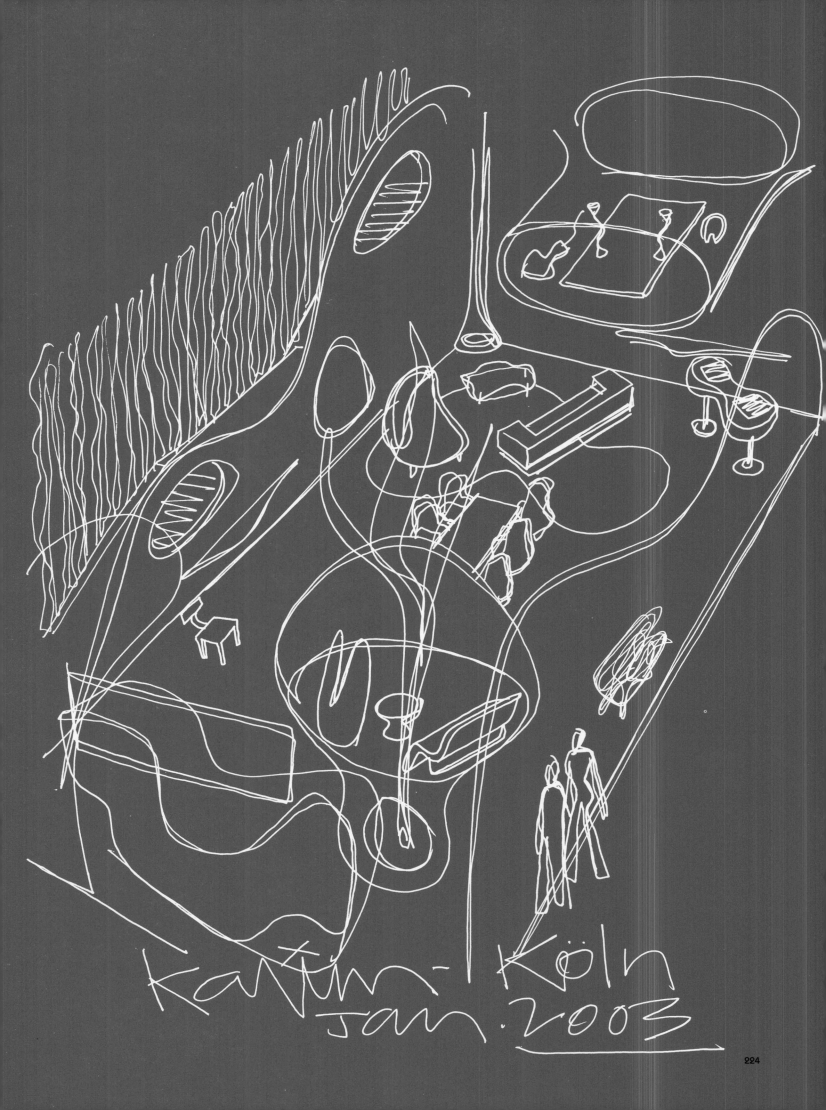

Karim–Köln
Jan. 2003

The world is becoming more aesthetically conscious and info-savvy. The energy and times are hypertrophic. Society is perpetually interested in being stimulated, in being excited about its physical environment. Is it the residue of the digital age? If the virtual world can be so flexible, so personalized, so complex, and so aesthetic, why can't the physical world? The Technorganic House is the Infotainment house (not Le Corbusier's house as a machine but the house as the personal information-entertainment refuge), a flexible, wired, connected, seamless interface house where design, interior, furniture, architecture, and technology merge. ¶ I was asked to create a house and select furniture from the Cologne fair as a curatorial project—a proposal for our domestic environment. Due to limitations of technology and budget, this house is only representative as a visual and ideological model of what I see as the future house. ¶ Ideally this house is "wired" through the floor with a grid of low-voltage current and data transfer capabilities, providing instantaneous tele-audio-sensorial communications. The furniture and walls are connected to the wiring, rendering them "live." The idea is that, through the manipulation of touch screen or voice command or even brainwave feedback, the occupant can change the environment instantaneously, altering qualities such as light, heat, smell, sound, and humidity. Light would follow you, radiated projected heat would follow you and keep you warm in a cool environment, music and sound would follow you and even automatically change based on your mood and behavior. There would not be any doorknobs and everything would be automated through your fingerprint. A smart bathroom would assess your health through analyzing your urine, giving digital feedback on your weight, vital signs, health, and appearance. The bathroom should have a rubber bath, watertight rubber floors, and lighting that can imitate daylight, moonlight, halogen, fluorescent, and disco at the flick of a switch. The sinks, toilet, lights, and everything should be automatic with no hand contact for perfect hygiene and, of course, a perpetuallly customizable scent.

the technorganic house

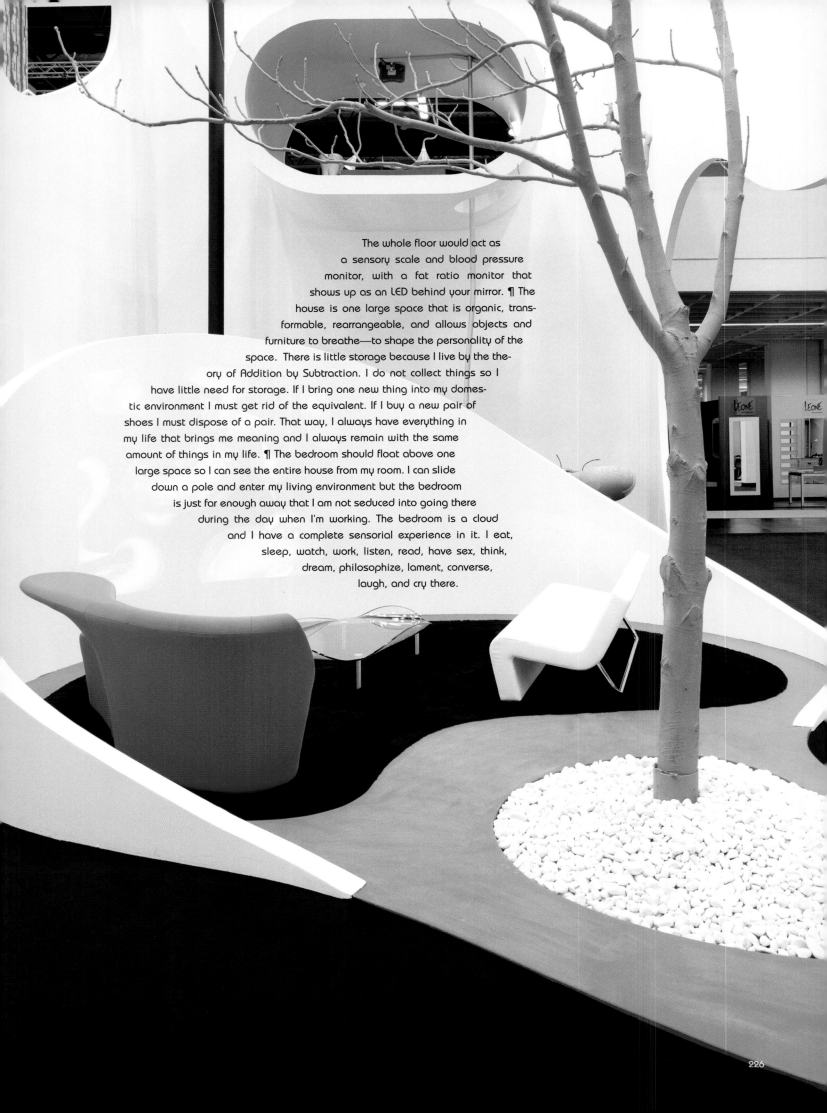

The whole floor would act as a sensory scale and blood pressure monitor, with a fat ratio monitor that shows up as an LED behind your mirror. ¶ The house is one large space that is organic, transformable, rearrangeable, and allows objects and furniture to breathe—to shape the personality of the space. There is little storage because I live by the theory of Addition by Subtraction. I do not collect things so I have little need for storage. If I bring one new thing into my domestic environment I must get rid of the equivalent. If I buy a new pair of shoes I must dispose of a pair. That way, I always have everything in my life that brings me meaning and I always remain with the same amount of things in my life. ¶ The bedroom should float above one large space so I can see the entire house from my room. I can slide down a pole and enter my living environment but the bedroom is just far enough away that I am not seduced into going there during the day when I'm working. The bedroom is a cloud and I have a complete sensorial experience in it. I eat, sleep, watch, work, listen, read, have sex, think, dream, philosophize, lament, converse, laugh, and cry there.

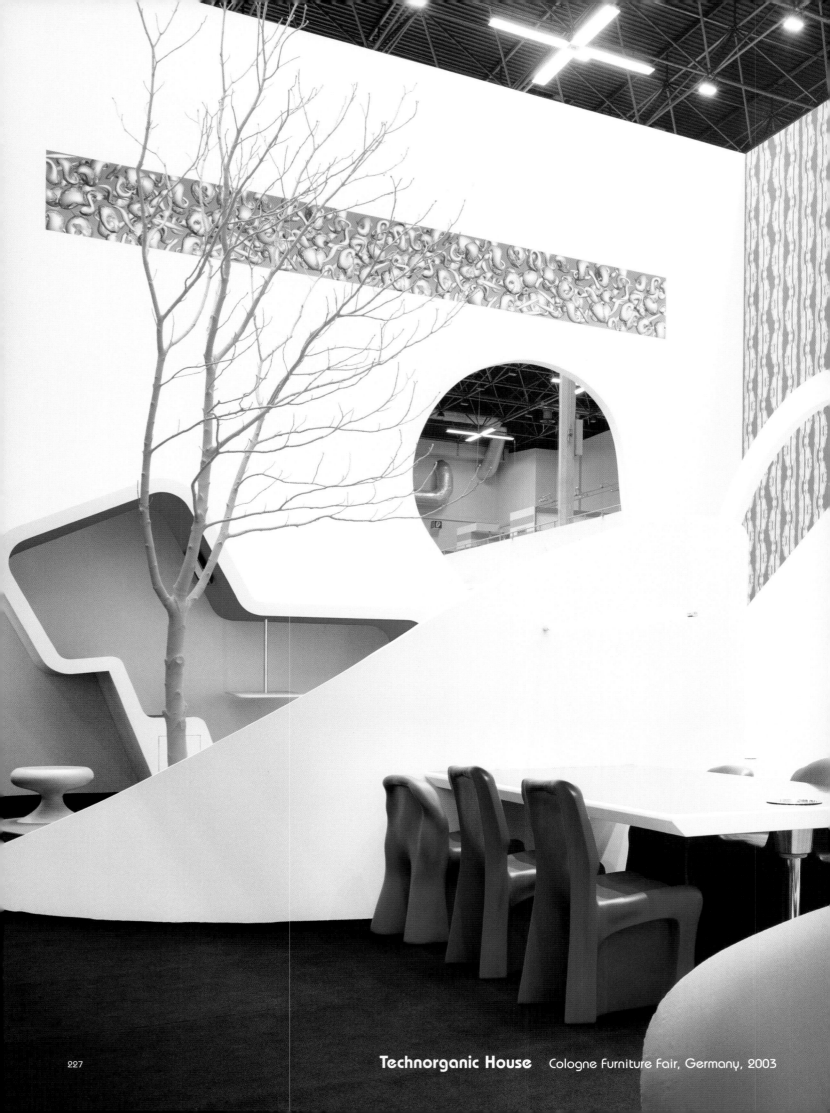

Technorganic House Cologne Furniture Fair, Germany, 2003

Technorganic House Colognese Furniture Fair, Germany, 2003

elevation

8m

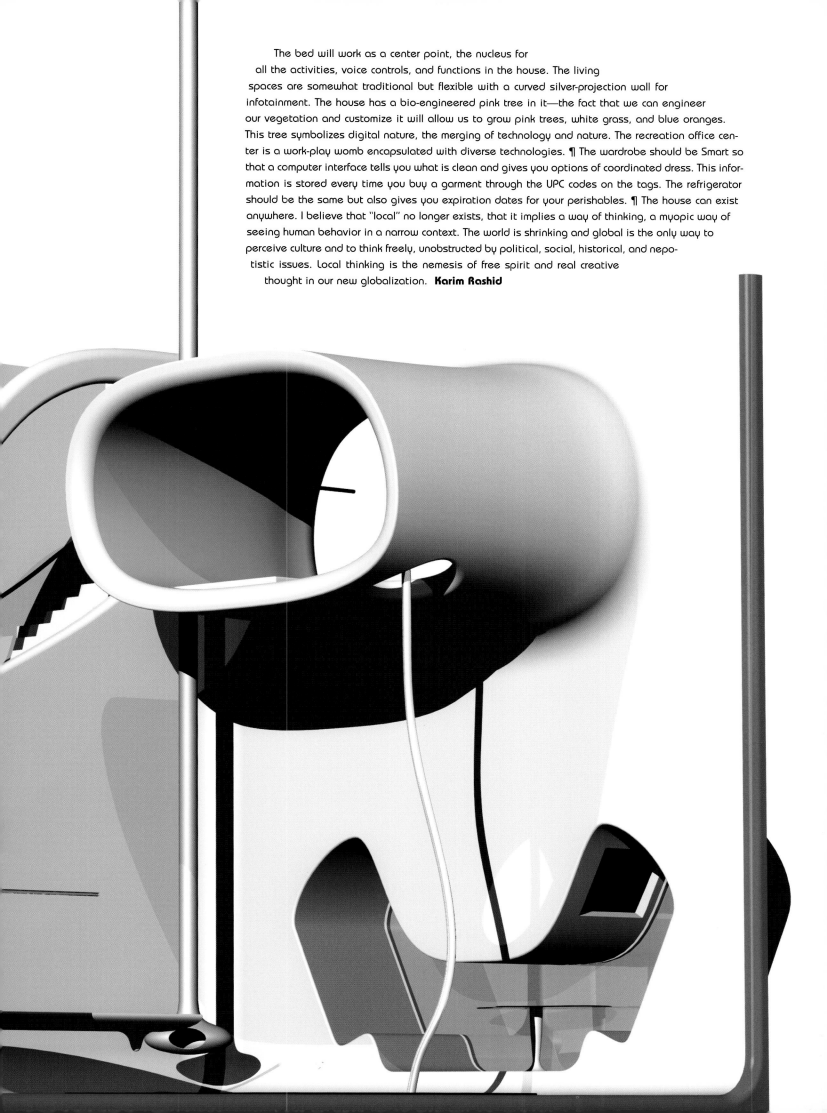

The bed will work as a center point, the nucleus for all the activities, voice controls, and functions in the house. The living spaces are somewhat traditional but flexible with a curved silver-projection wall for infotainment. The house has a bio-engineered pink tree in it—the fact that we can engineer our vegetation and customize it will allow us to grow pink trees, white grass, and blue oranges. This tree symbolizes digital nature, the merging of technology and nature. The recreation office center is a work-play womb encapsulated with diverse technologies. ¶ The wardrobe should be Smart so that a computer interface tells you what is clean and gives you options of coordinated dress. This information is stored every time you buy a garment through the UPC codes on the tags. The refrigerator should be the same but also gives you expiration dates for your perishables. ¶ The house can exist anywhere. I believe that "local" no longer exists, that it implies a way of thinking, a myopic way of seeing human behavior in a narrow context. The world is shrinking and global is the only way to perceive culture and to think freely, unobstructed by political, social, historical, and nepotistic issues. Local thinking is the nemesis of free spirit and real creative thought in our new globalization. **Karim Rashid**

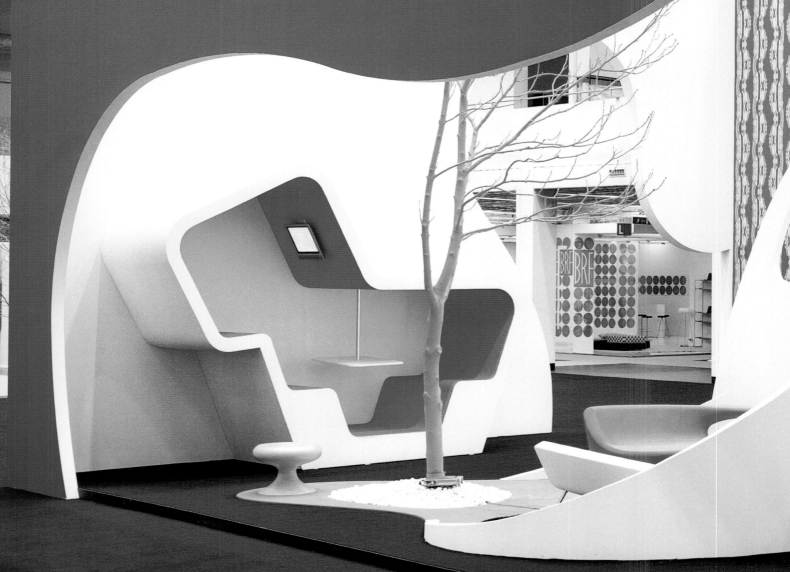

ideal house cologne

Technorganic House Cologne Furniture Fair, Germany, 2003

camouflage
wallpaper

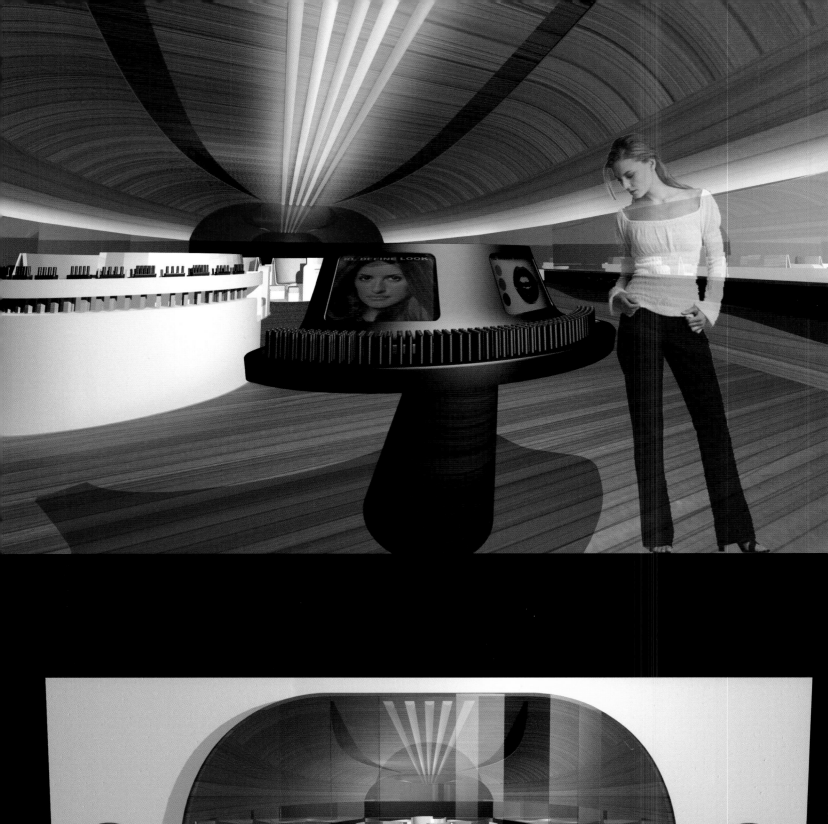

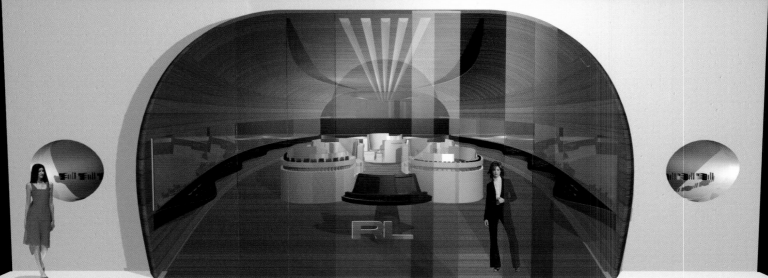

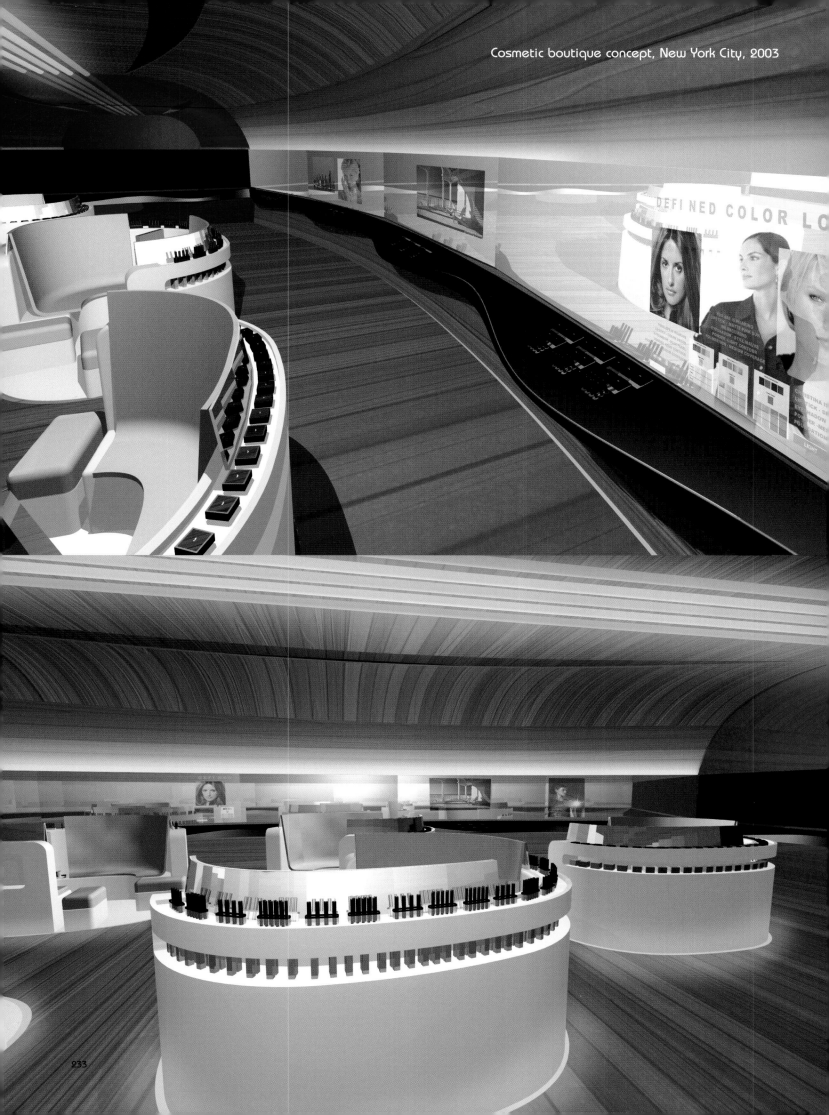

DEFINED COLOR LO

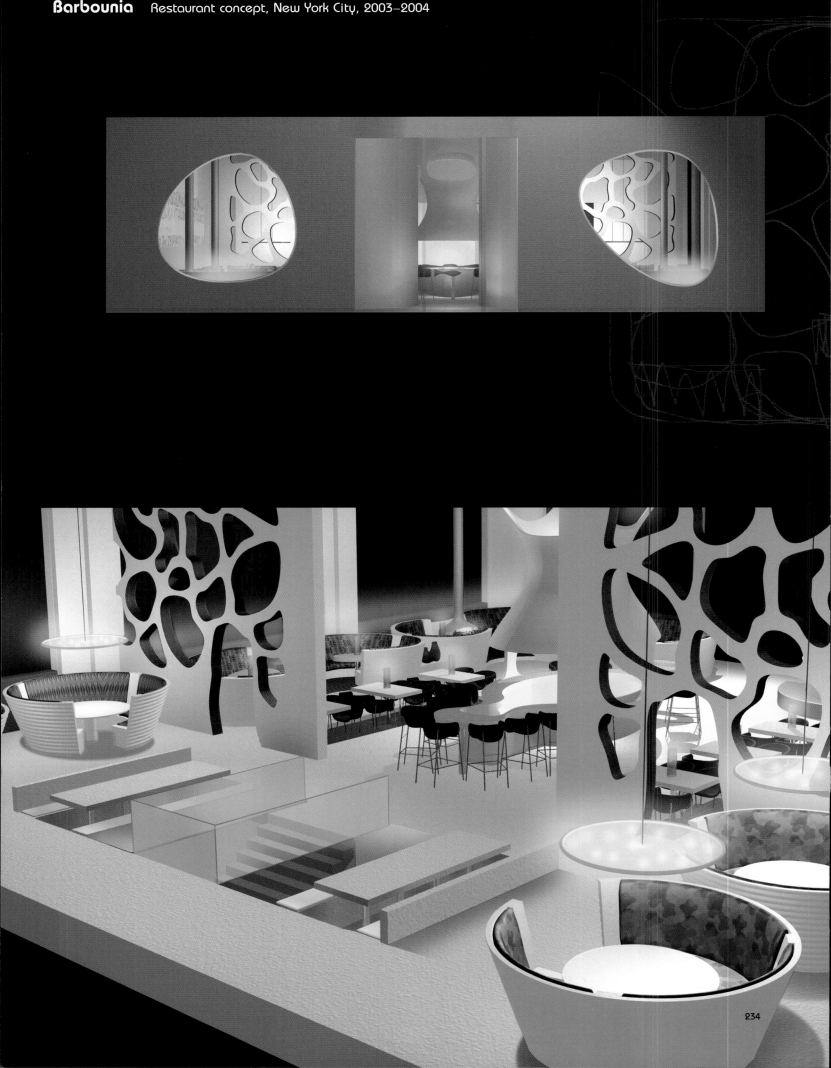

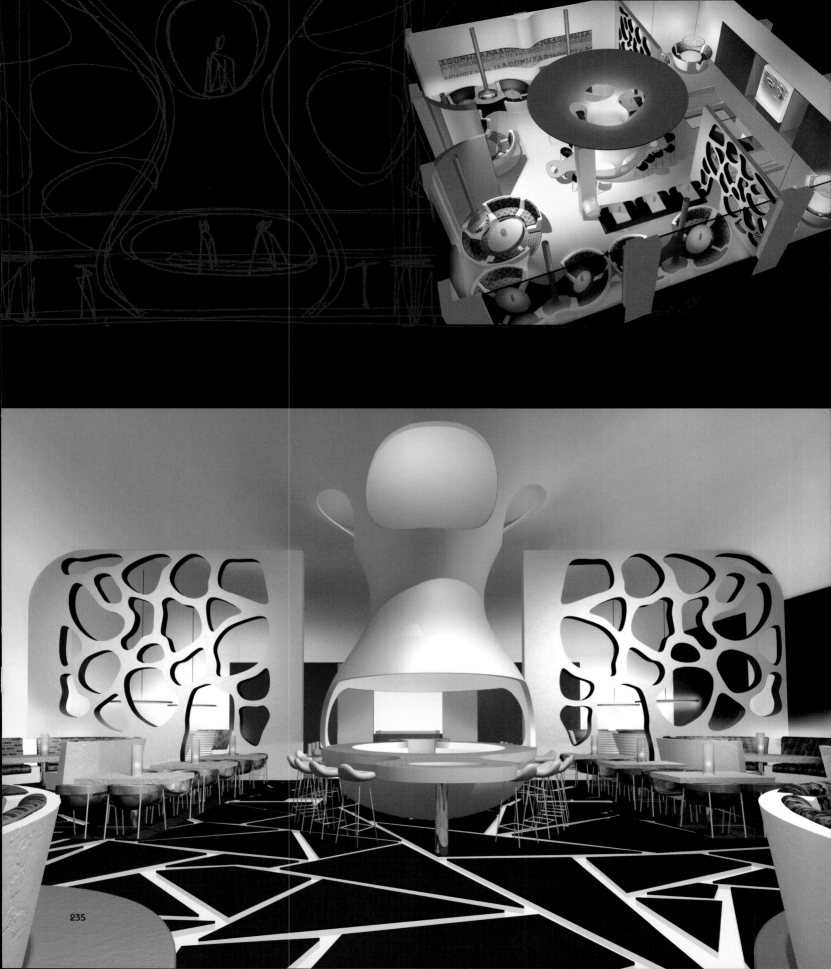

235

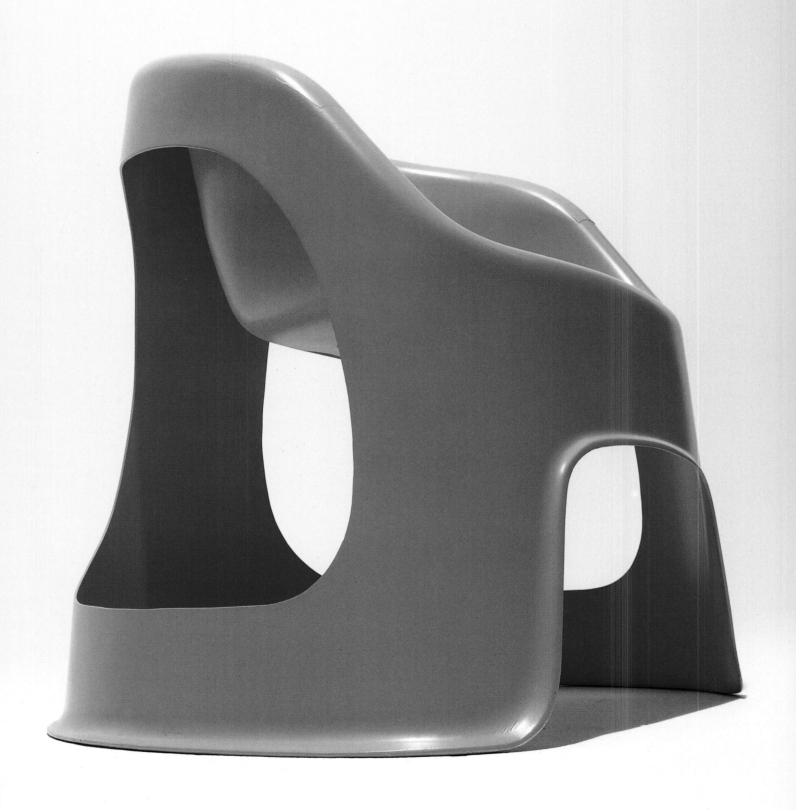

Koop Chair prototype, 2004

SYNTHETIC AND NATURAL AS ONE Freedom is not based
on religion, economies, and laws. It is based on one's own mind (freedom
is existentialism). Untouched by the influences of civilization and society, design can
respect, communicate, and work seamlessly with nature. The natural can be hybridized with our
synthetic physical landscape, and consumption can be made disposable yet perfect. I think that in the
future we will own nothing—this is the natural course of events—we lease cars and houses and soon we will
learn to lease everything, experience it for a short while, and move on to the next. We will create a hyper-
consumptive, forever dynamic, ever-vast, changing human condition, where everything will be cyclical, sustainable,
biodegradable, and seamless. This is Utopia, freedom, Nirvana. All the goods in the world will exist only if they give us
a new or necessary experience. We are nature so we cannot loose sense of it. Mortality is the biggest indicator and
monitor of nature. Death is nature. We are just shifting and changing, and that to be removed from certain historic
paradigms (we do not hunt, farm, etc.) is the natural order of progression. We are becoming hybrids of technology,
cybernauts. This too is nature: the inevitable course of our existence. At this moment in time we can replace the majority of
our body parts with plastic—that is incredible. It is our destiny. I believe that history is not something to perpetually
compare, or measure, the open mind is contemporary, the open mind really celebrates life. ¶ Smart materials respond to
environmental stimuli with changes in certain variables. In response to external conditions, Smart materials alter their
structure or composition, their properties (mechanical, electrical, apparent), or their functions. While we expect material to
change due to weathering and age—Smart materials anticipate variance—they can mutate into a desired state under
certain conditions, offering unprecedented precision and convenience. For example, thermoplastic mouthpieces for athletes
undergo molecular change when heated. It is anticipated that nanotechnology will have a momentous impact on variance.
By arranging a material molecule-by-molecule, atom-by-atom, the atom can become a modular building block. Developed
through micro-machines, using gears, levers, and switches of only two to eight atoms, such designs will be self-
contained, self-propelled, programmable, intelligent, and regenerative. Reassembling materials will be triggered by
certain amounts of electrical current, light, heat, and pressure. We may well find ourselves, one day, in a world
where objects morph in response to mere touch or an electrical charge. ¶ The 21st century is about new energy,
digital nature, a kaleidoscope of elevated experiences, and a democratic playing field—a Designocracy. A
world where everything should be accessible and without boundaries. The digital age represents a
place where real, unreal, virtual, metaphysical, and physical spaces are layered; one where
everyone can participate and everyone is equal. Objects smell, taste, breathe,
touch, and participate in all our experiences. **Karim Rashid**

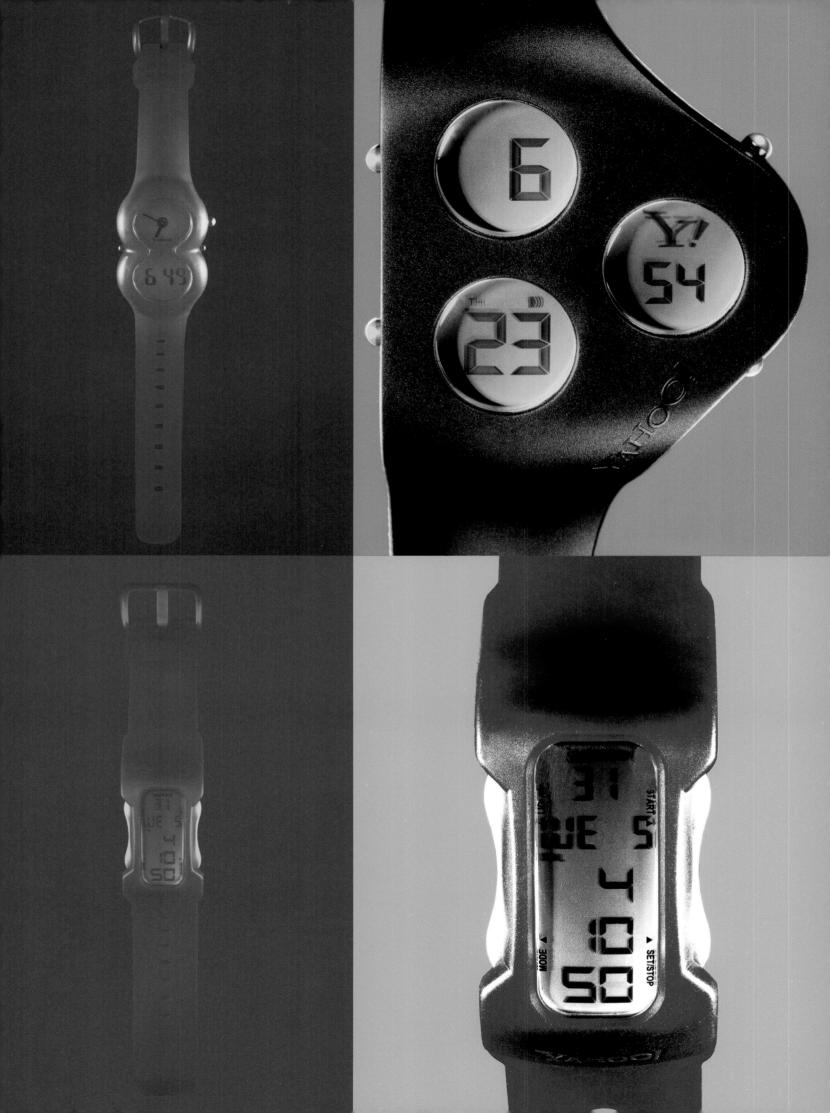

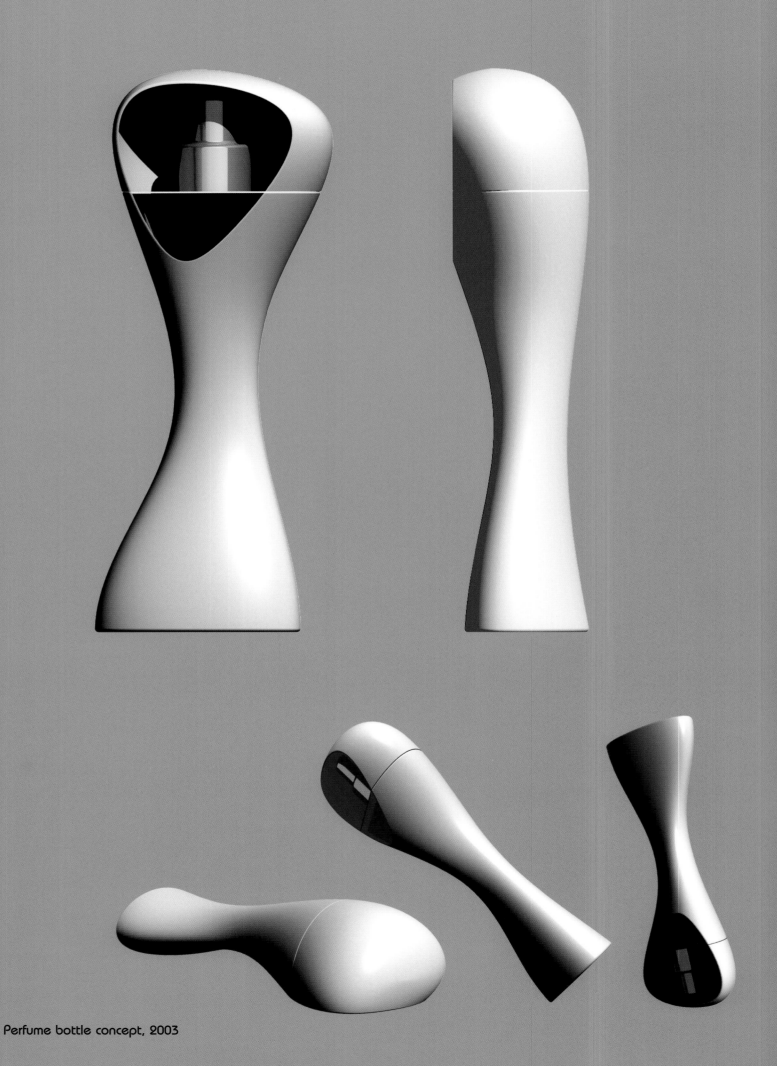

Perfume bottle concept, 2003

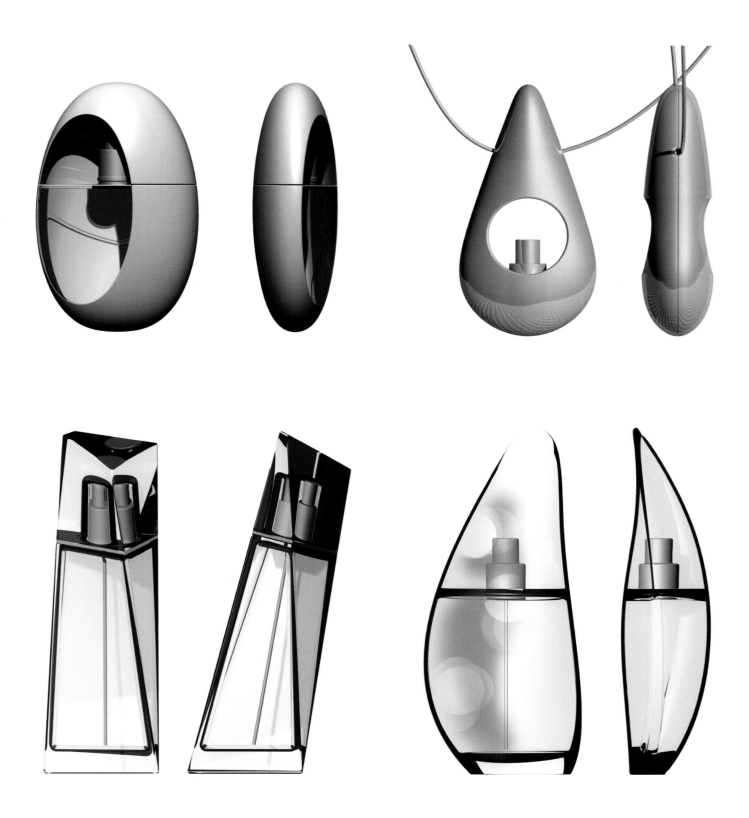

Perfume bottle concepts, 2003

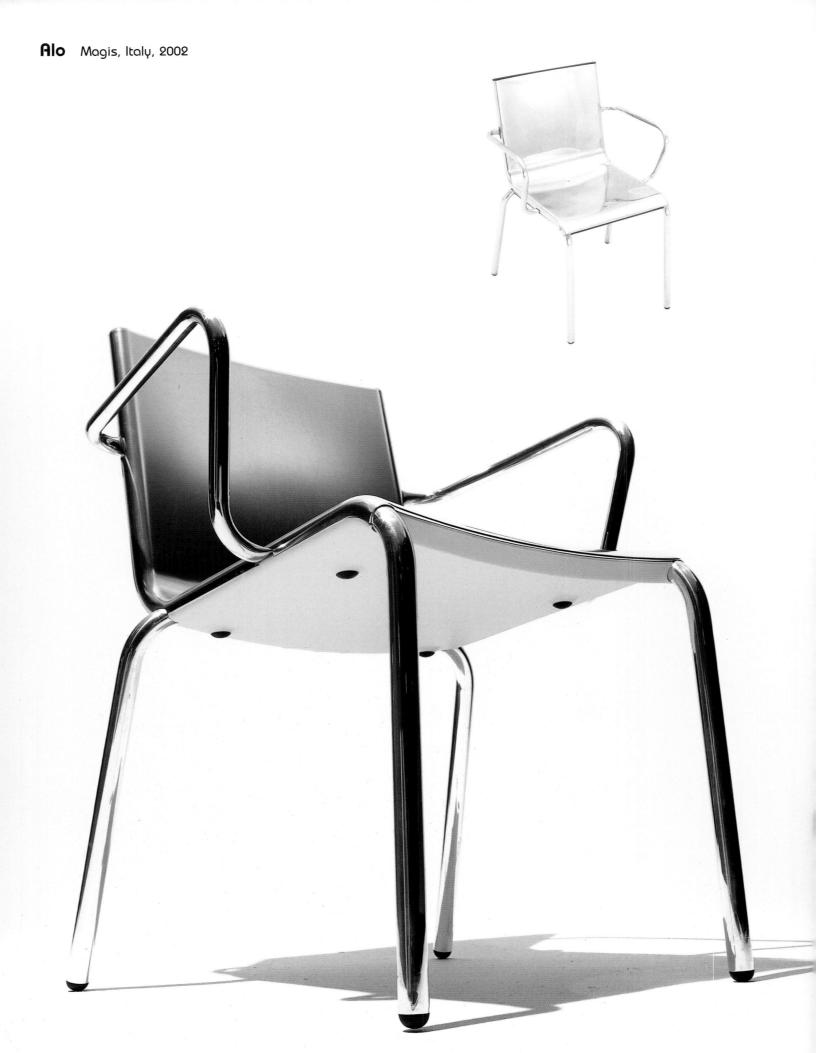

Möbilkom A1 Audio Forum Shop

The Image Sphere was conceived as a
series of spaces linked by an open circulation
core that connects all the floors moving cus-
tomers through the experience. There is a
formal and impressive entrance: automatic
yellow glass doors with an embedded
LED lighting display of the company logo.
The spaces that close earlier than the café
are easily separated by transparent parti-
tions that allow for a visual of the store while
providing security. The space is shaped with sensual curving walls that refer-
ence the never-ending reach of sound. It is divided by layers of form and trans-
parency and has few solid walls. The floors are connected through a series of
glass portholes. This is the heart of the project—connecting people through
communication and connecting space through light, trans-
parency, translucence, and openings.

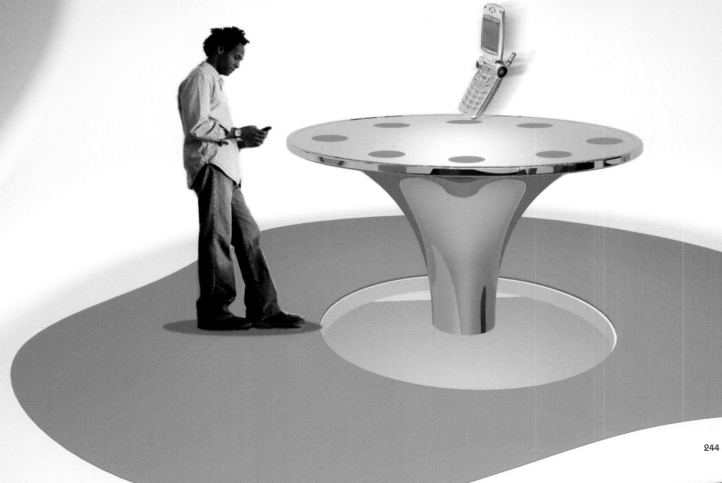

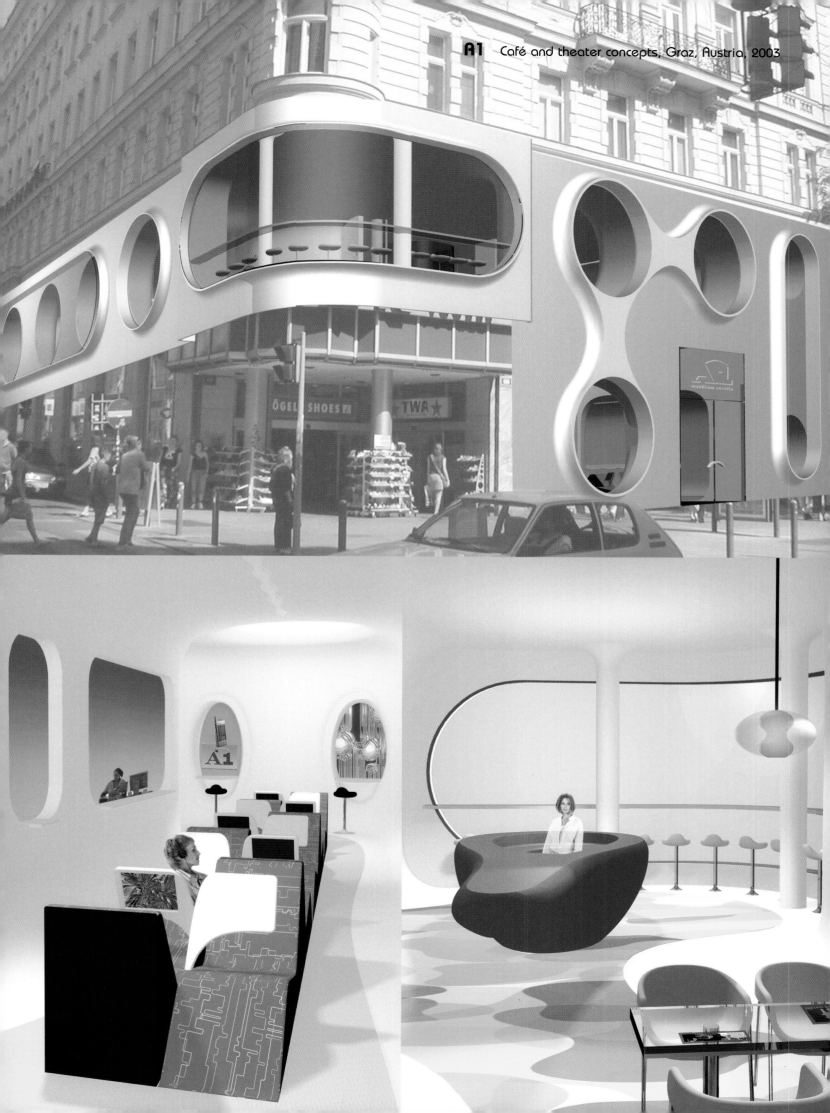

Kraze Wallpaper Marburger Tapetenfabrik, Germany, 2004

TECHNO

As we exist in a more and
more virtual world, our physical world is
developing a new importance. The furnishings
around us are becoming special considerations, more
beautiful, more diverse, and more personal. Our future fur-
nishings will be technological. Objects will become intelligent.
Although there are still not enough examples of the merging of tech-
nology, furniture, architecture, and objects, eventually we will have a
seamless marriage between these elements. High-tech and low-tech will
merge. We are creating a new post-industrial digital (Technosthetic) lan-
guage. I believe technology will combine seamlessly with humans and our
physical landscape. Designers are searching for new materials, Smart materials,
new production methods, and new ways of exploiting old and new machinery,
CAD/CAM software, to develop new, digitally poetic proposals for our material land-
scape. It seems that short-term production technology will change, design will become
less involved with the banalities of problem-solving and concentrate on more human,
emotional, and pleasurable experiences. We can have technology embedded into our
clothing, furniture, anywhere in order to meet more mobile transient conditions. Flexibility
is the key to a future where we can simultaneously be anywhere, work, communicate, and
play in an omnipresent real-time existence. Fashion will change. Conceptual clothing that is
reversible, flexible, and intelligent (possibly sprayed onto our bodies out of an aerosol can).
Fabrics will be thermo-conductive, mood-sensory, and incorporate digital interfaces so that we
can audio-video-telecommunicate anytime anywhere. New materials and textiles such as solar-
power weaves, flexible polymer LCD, and high performance engineering fabrics will be used. I
see technology eventually being embedded in our skins so that we become digital ourselves—
"Smart" human beings that can interface by touching skin (almost like having implanted key-
boards and chips) or by neural triggered synapses where our minds control the technology and
devices. Digital Desktop manufacturing and variable non-serialized design is the future of the
challenges of the 21st century. Desktop manufacturing will become omnipresent, allowing con-
sumers to build personalized 3-dimensional objects using devices such as 3-dimensional
printers. Products will meet individualized criteria and taste; as technology improves
objects, products, and space will all be highly customizable, highly personalized, and pos-
sibly designed by any individual. Everything will be unique. Customation is a combination
of "customization" and "automation" and describes the concept of mass-produced prod-
ucts customized and produced for a specific individual (anthropometric or ergonomic)
requirement. Examples are seats made exactly for your body shape, hand tools cus-
tomized to your dexterity, custom-tailored clothing produced digitally, or even sham-
poo for your particular hair. ¶ Companies will market individualization to address
smaller and smaller markets, tribes, cultures, and specific "specialized" groups,
just as the Internet is affording us today. Cars will be completely customized
down to the body-shape; fragrance will be totally individual, as will running
shoes, or even body parts. Manufacturers will utilize new 4-dimensional
computer-numeric machinery, tool-less production, and other sophisti-
cated methods for mass-production cycles of one-off individually
specified products. Today, this trend of variance is seen in
customized laser-cut Levi's jeans, bicycle manufacturing,
computer configurations, etc. Other forms of variance
are limited-edition, short-run production, chang-
ing decorative components, and designer
and consumer personalization.

Karim Rashid

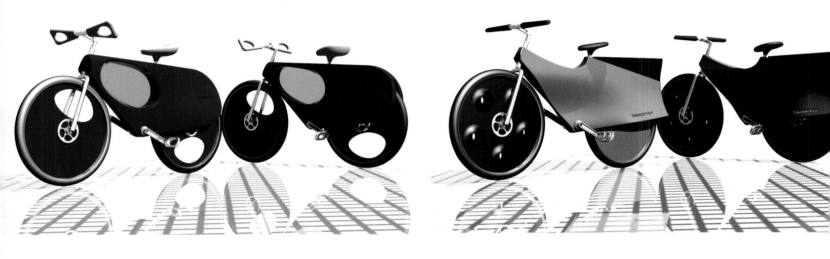

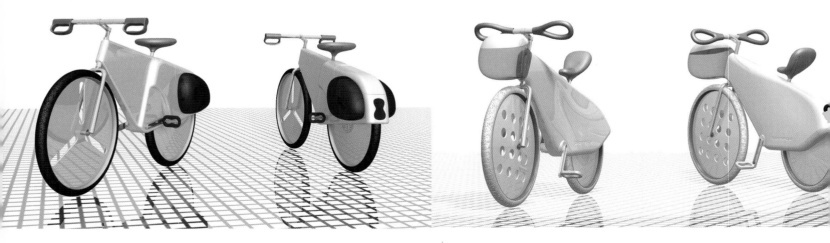

Bikarim Bicycle concepts, Biomega, Sweden, 2003

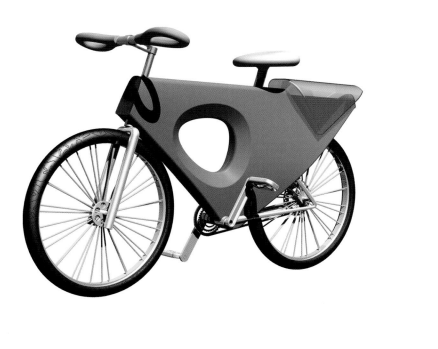

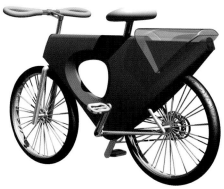

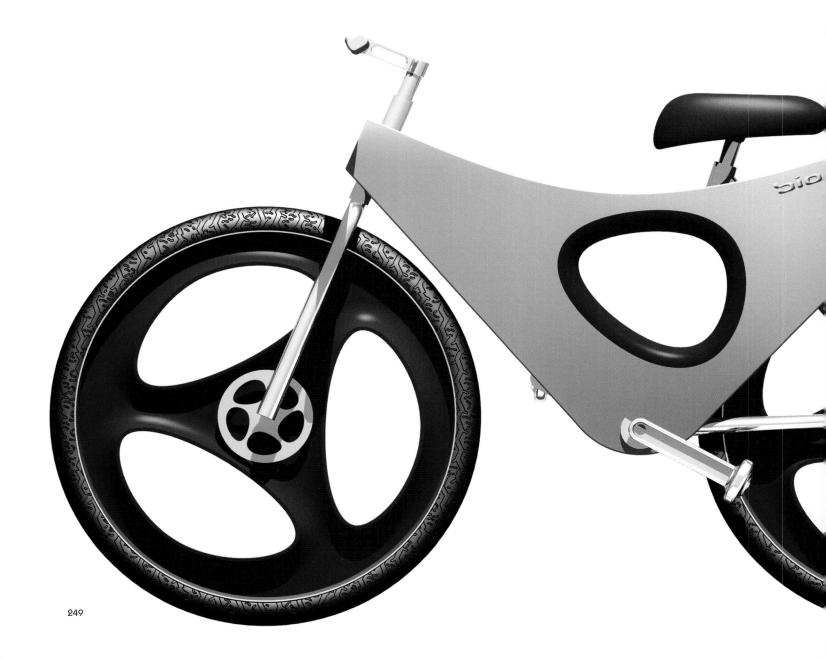

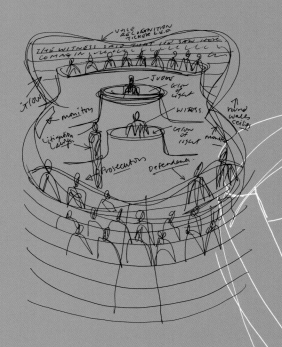

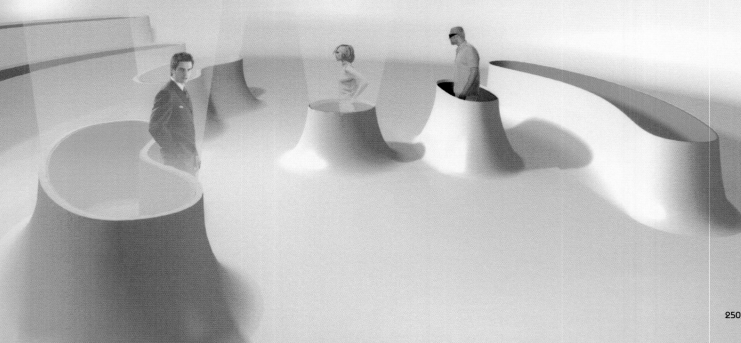

Kourtroom

Inspired by the idea that most courtrooms have not changed for centuries, *JD Jungle* magazine asked me to envision the courtroom of the future. My response was to design a "non-space"—a void you enter to focus on matters of great import. ¶ The room is made of reinforced ovoid glass-polyester that makes for outstanding acoustics and thereby intensifies the experience of the proceedings. The walls are screens where a transcript of the trial and all the evidence is projected and rotated around the room in real time for all to see. Each party has an individual podium. These womb-like spaces, equipped with swinging doors that disappear when closed, reflect competing interests more effectively than traditional, exposed wood tables. Multicolored lights emerge from the floors, reinforcing the attorneys' opposition with contrasting colors. When the verdict is announced, the jury box also lights up: red for guilty, green for innocent.

KNIFE." THE PROSECUTOR ASKED THE WITNESS: "DID YOU SEE THE
H THIS KNIFE?" PROSECUTOR HOLDS A KNIFE (EVIDENCE NO.
THE WITNESS SAID, "YES. THAT'S THE KNIFE." PROSECUTOR: " NO
UESTIONS." JUDGE: MISTER DEFENDANT. ANY QUESTIONS TO THE

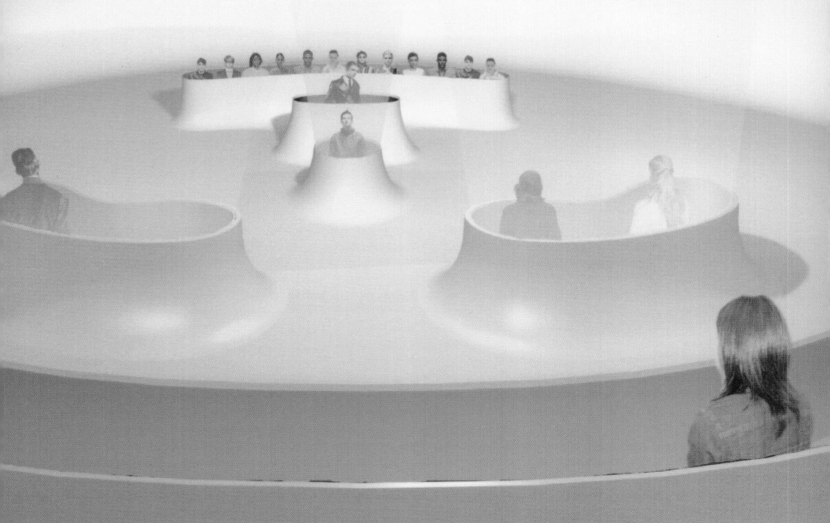

Kourtroom *Concept, JD Jungle* magazine, September–October, 2002

DEMATERIAL

I would like to stop talking
about design. I don't really think
about objects anymore; for me, they are
similar to an automatic secretion, something
almost shameful, like sweat or earwax. I design
all the time. I could say that I design out of
laziness. Today, I'm mostly interested by the
lines of objects; lines that are very personal,
almost fantastic. These lines don't try to be true,
but for me, they are in a way, since they are
tools. Piece by piece, a somewhat coherent tool
appears that allows me to pursue an adventure: the exploration of our wonderful animal species.
My role as a great maker of things allows me to understand their dreadful side: it generates in me a strong desire to go
somewhere else. Being in contact with the material world creates a longing for the immaterial. It's from this place that I speak. I am
aware that my situation might seem paradoxical. But I believe that it's the thief who most desires honesty, the opulent who longs for
simplicity, and the poor who dreams about wealth. ¶ History is full of these perverted men in search of their ideals. Instead of denying
these apparent contradictions, it is necessary to use them to go somewhere else. ¶ I am fully aware that it is my familial heritage and the
fortunes of my professional life that have made me who I am today. My desire to surpass myself has pushed me to create, my religious
education has given me a sense of abstraction, and unpredictable circumstances have brought me to design in order to fill a void. These
three parameters have created a personality that might seem paradoxical, but that is, I believe, very coherent. ¶ If the sole act of
designing satisfied me, I would feel ashamed. When I'm designing a toothbrush, if I only thought about designing, I would be either
an idiot or a mercenary. I try to be neither: this is the necessary approach. I must think of the mouth that's going to use this
toothbrush, and I must know the owner of this mouth. I have to ask myself questions about this person. I have to
know about the society that has given birth to
this life. I have to know about the animal species
that have created this civilization. ¶ At the
species level, some major lines, locks, walls, and
challenges arise. I don't have the power to
overthrow them but, when I see them, I try to
make sense of them. I then go the other way
and walk down the stairs feeling better since,
at this point, I know why this is the right
design. I try to use this process of
thinking in all my creations.

Philippe Starck

Zip Fessura, Italy, 2003
Removable upper allows changing.

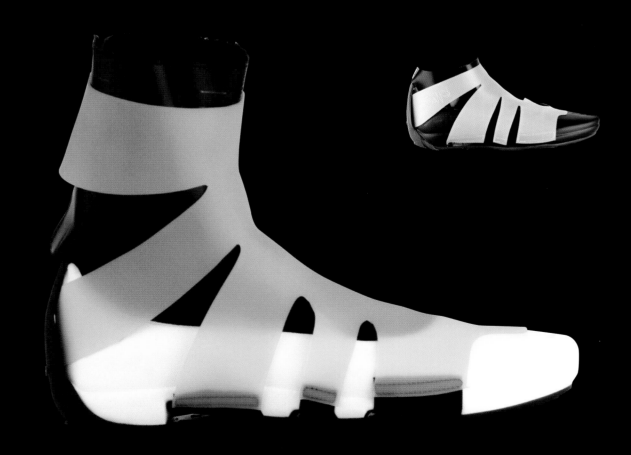

Sway Wastecan, Umbra, Canada, 2003

PHENOMENA

We do not need many things. In fact, all
that is necessary are simple objects that have meanings
and memories that are sacred to our lives. They are few and
personal. As we shift into the post-industrial age, products, signs, and
languages are becoming similar. Traveling throughout the world, I cannot help but
see cultures becoming similar, languages converging, and universality becoming a present
phenomenon. Why do I shop when I travel? To search for rarefied, exclusive, local goods not
available elsewhere. It is the physical experience—the relations, the contact, the event, the touch,
the smell, the taste, and the spirit—that continues to bring us together with diversity. The objects act
as catalysts. Convenience and reliance on what already exists is numbing; blind repetition creates
dullness; routine foments ennui. How can anyone be bored today? Routine means not experiencing time.
We like routine because it is easy, comfortable, and accommodating. It takes great effort to break from it
and have new experiences. Generally, one experiences change as the awareness of time, the unveiling of
an actuality. This phenomenological moment of surprise in the event elevates our sense of living, of life, of
being. Objects found outside of the expected, the phenomenological world, elevate our lives. When we
experience beauty, comfort, luxury, performance, utility, sensorial motivations, we are more aware of
life. Despite the explosion of options that functionality has created, ours is an age of technological
hypertrophy that threatens individuality. In this breach of numbing neutralization, designers
can compose the idiomatic and variable, create things that change over time, reveal new
phenomena, and increase our awareness of the experience—making our physical
world not only more potent and humane, but more transcendent as well.
Playing on the diversity and richness of "change over time"
honors the senses, the individual, and the soul.
Karim Rashid

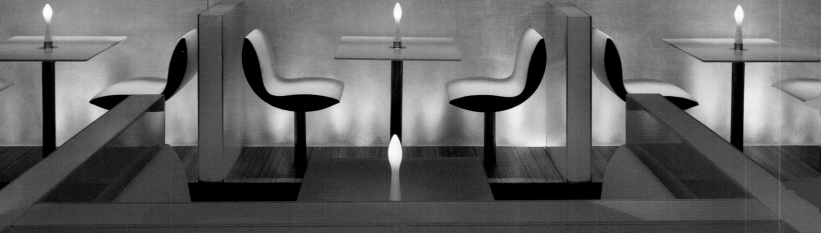

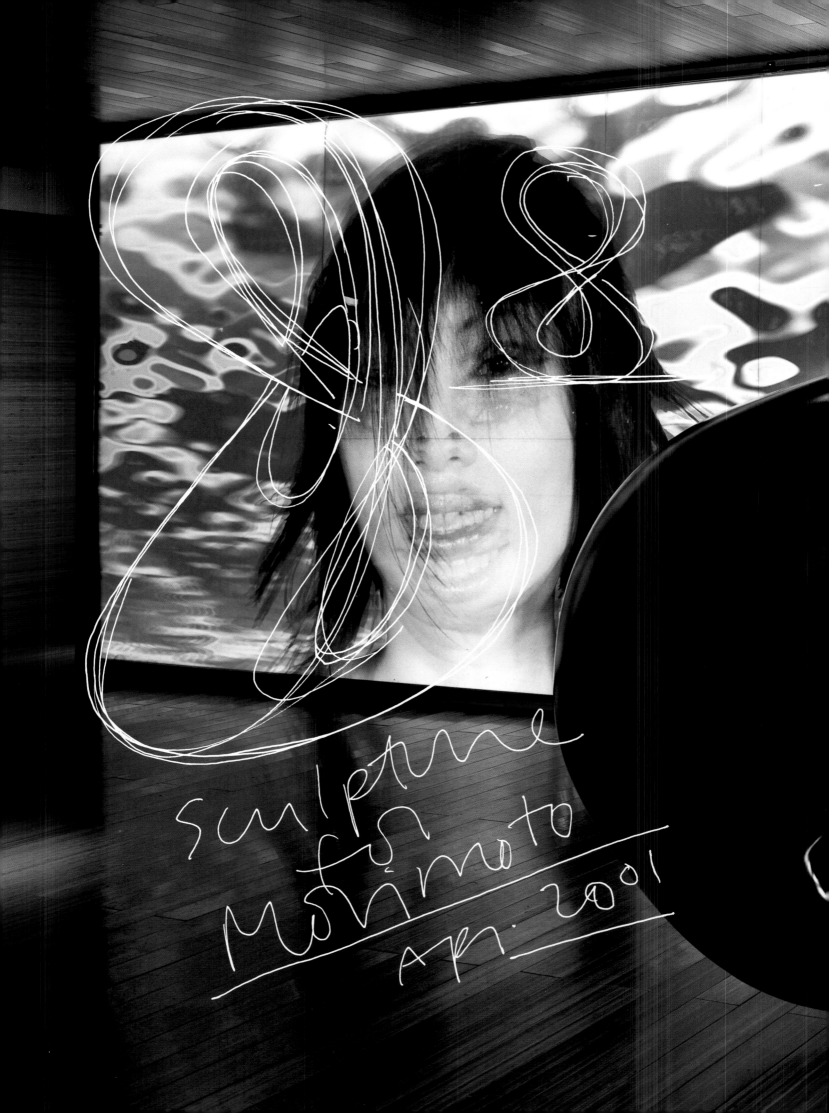

sculpture
for
Morimoto
Apr. 2001

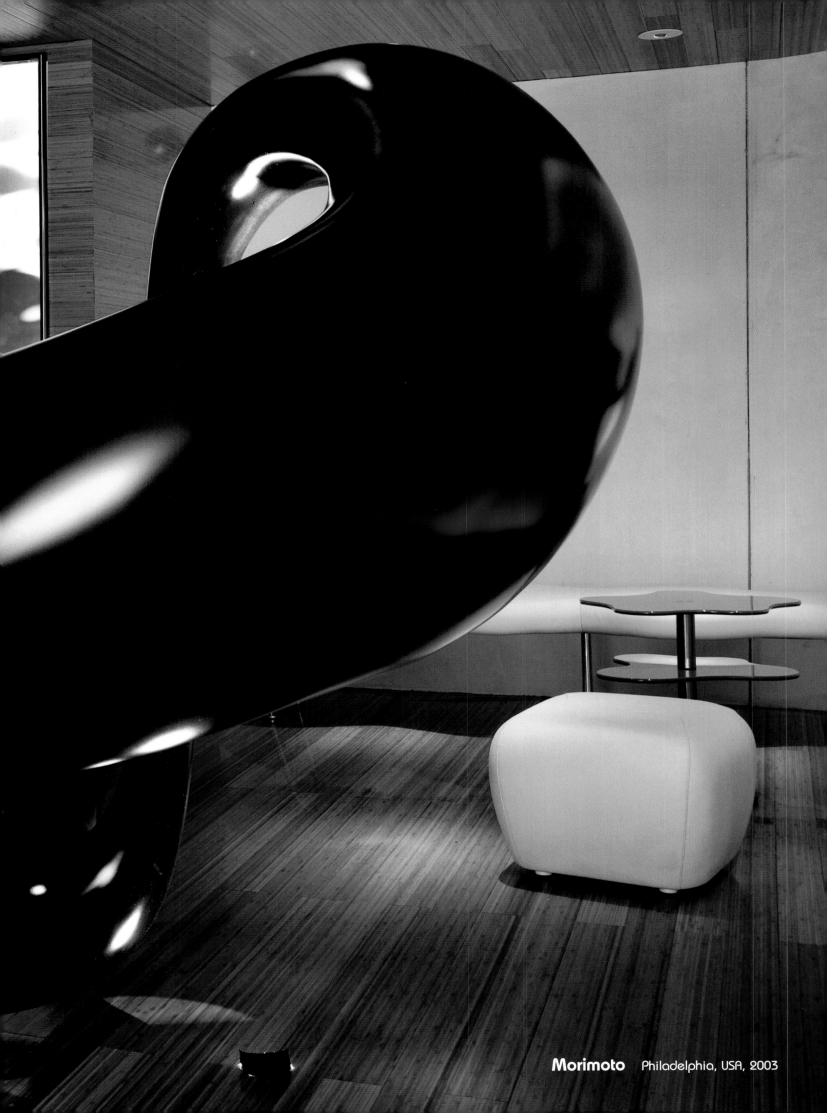

Morimoto *Philadelphia, USA, 2003*

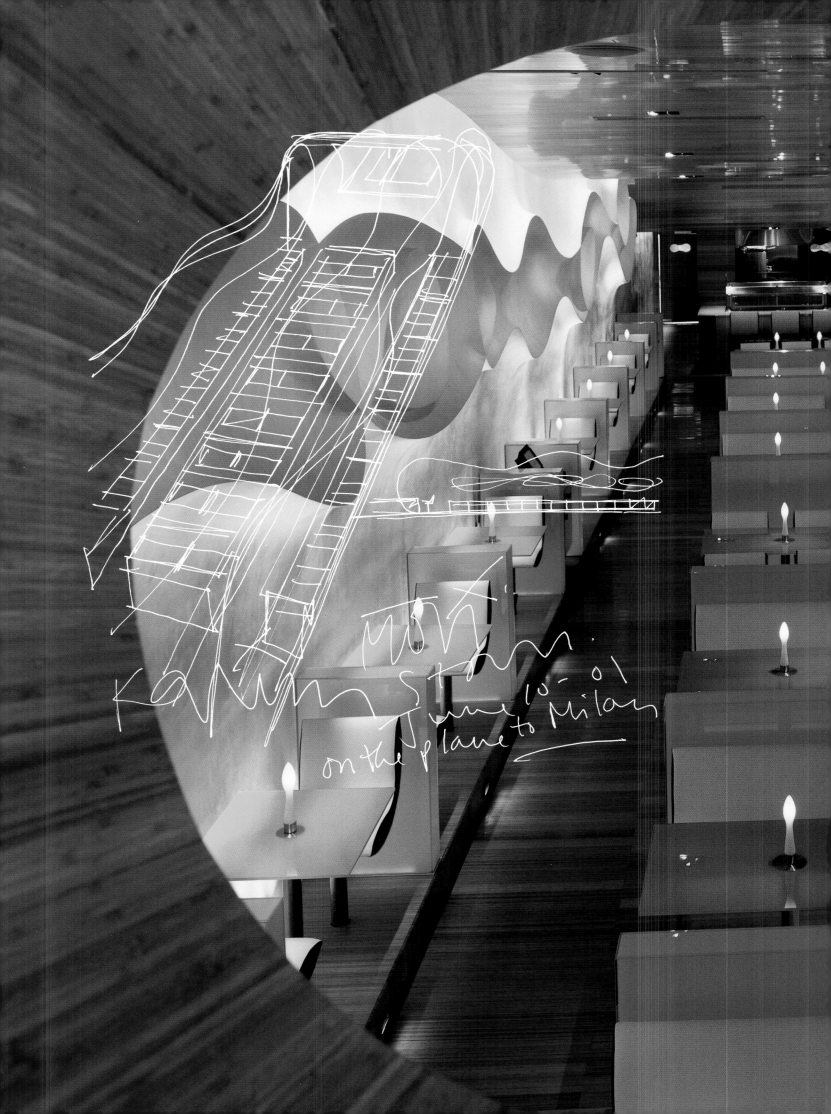

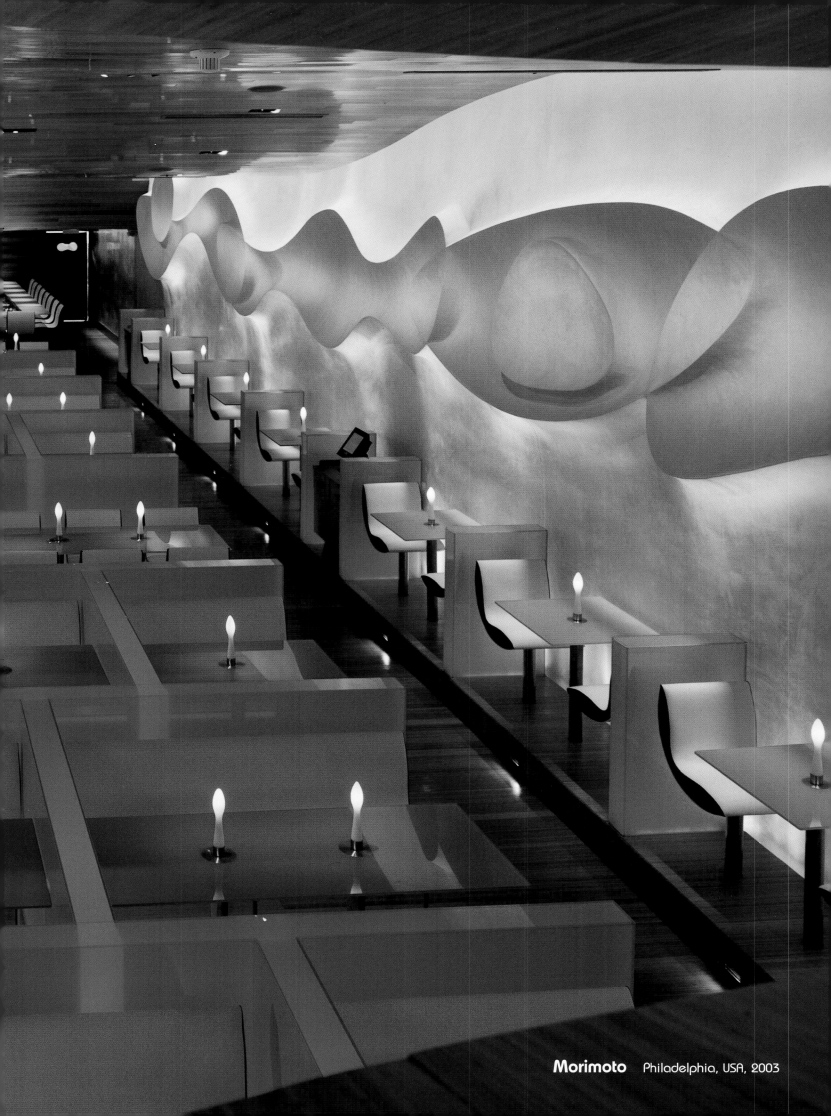

Morimoto *Philadelphia, USA, 2003*

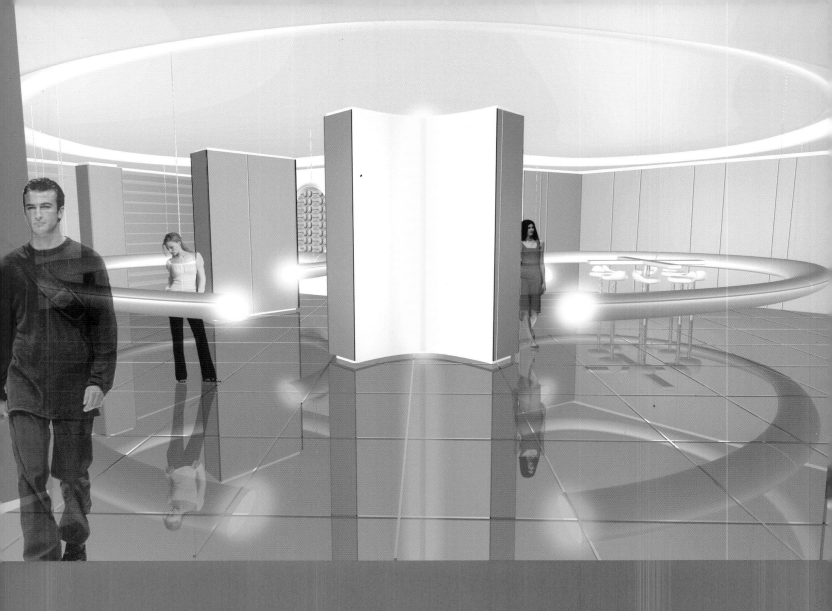

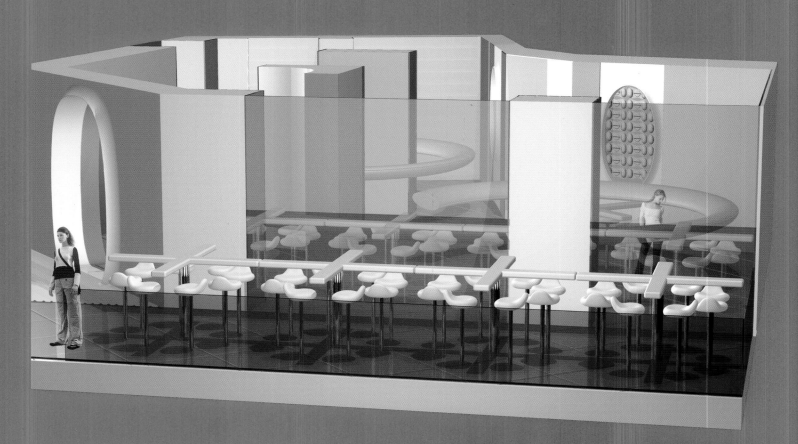

Concept for gourmet café, Fauchon, Paris, France, 2003

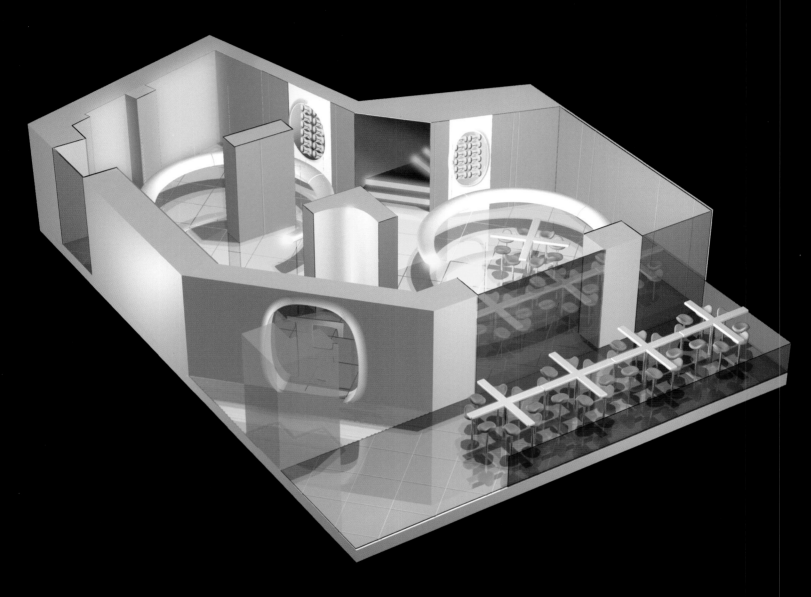

digital spiritual rebirth

i travel everyday
whether i leave or not,
i touch and talk to the world
a virtual astronaut

i talk in my language
a visual rappinghood,
a very secretive argot
i try to make understood

to bring meaning to everyone,
to design democratic,
words create objects
objects speak words not fanatic

i see a non-stop amorphous plastiscape
that denotes a world with no boundary,
fluid and transforming, evolving, morphing, + an alchemic foundry

the freedom of material
the metals of fission
transformable,
a digital vision

space extends itself
via organic modules of repetition,
a continuum of surface
based on an voxel composition

reconfigurable and sizable ad infinitum
lightweight rearrangeable abstractions,
grows from the floor, walls, and ceiling
artistic factions

all the notions of objects as singular dispelled
replaced by an environment, rising out of the ground,
tomorrow's world is gelled

the continuous white field
surrounded by an aura of fluorescence,
to allude to the world of technology from a digital excrescence,
new vistas form our daily convalescence

blob is a metaphor
for continuous space,
a neutral landscape,
a global place

if freedom were a form
it would be perpetually in motion,
an undulating never-ending blob,
fluid extrasensory potion

the state between liquid plastic and solid material object
a state of endlessness,
a physical bliss
continual ephemeral experience

inevitably our entire landscape will merge and connect
body and space fuse,
object and environment,
no obstacles, just a collective muse

city and town,
water and ground,
highway to highway, being to being.
world worth seeing

i communicate with the ether
i talk with all my mates,
i shape the scape, the pleasurescape
and connect the virtual gates

from a natural landscape to the artificial one,
when the doors open to this world
organic possibilities, human shaping,
touching everything and everyone

all the cities are one in my eyes,
london, tokyo, milan, new york
people, places, nature, things
single cultural paradise

when i hear words that keep us believing
that the world is changing
that it changes as we speak,
the future is not bleak

we will have an impact on the future
the rebirth of time and space
we are not aesthetically bankrupt,
there is a single human race

beauty in the cities,
flexible inside,
soft and colorful,
a place to hide

i want to love all the time,
love everyone in our biosphere
keep the thought powerful
without shedding a tear

sensual romantic world,
a physical and digital rebirth,
elevating our collective pleasure
one church, one mirth

a casual world we will be,
an atlantis in the sky and the sea,
one global paradise we will see

karim rashid

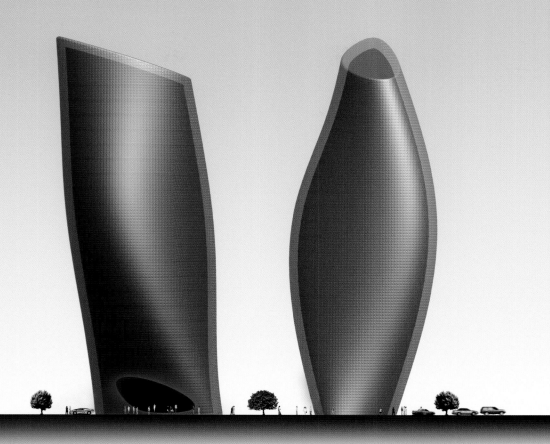

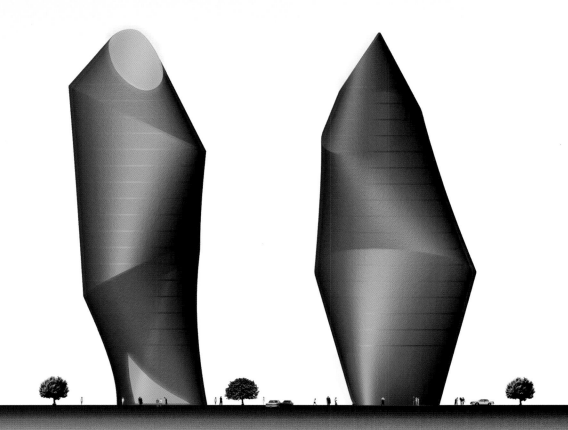

I have
found inspiration in
virtually every corner of the
earth, mostly from the unfamil-
iar—the lost locales of industrial
parks, alleyways in big cities, airport
hotels in small cities, shanty towns in South
Africa, a mall in Florida, a gym in Hong Kong,
a bathroom in Paris, a casbah in Morocco,
mopeds in Athens, the cuisine in Qatar, coffee in
Istanbul, everything that is new to my senses.
Smells, tastes, and sounds all inspire me. Beauty
can be found in everything and everyone. Creating
something from nothing is our purpose on earth. I
create, therefore I am. + I want to thank everyone
who worked so diligently on this book, including
Michael Regan, Stephen Case, Stephen Schmidt,
Ilan Rubin, and all my staff. I must thank
Megan, my mother, my family, and all my
great supportive friends, clients, and
everyone who supports the work I
manifest in the world. THANK YOU
ALL and thanks to the human
spirit! Create don't
destroy.

Karim

Sunshine 2003

First Published in the United States of America
in 2004 by UNIVERSE PUBLISHING
A Division of Rizzoli International Publications, Inc.
300 Park Avenue South
New York, NY 10010

2005 2006 2007 2008 / 10 9 8 7 6 5 4 3 2

Library of Congress control number: 2004105000

ISBN: 0-7893-1197-6

Editor: Stephen Case
Designer: Stephen Schmidt / Duuplex
Copy Editor: Ilaria Fusina
Project Manager: Michael Regan / Karim Rashid, Inc.

Printed in China

PHOTOGRAPHERS

Principal Photography

Ilan Rubin: cover (front and back)
pgs. 7, 8, 11, 29, 49, 57, 77, 78, 114, 115,
132, 142, 161, 168, 169, 170, 171, 172, 219,
236, 238, 239, 242, 252

Additional Photography

Courtesy ACME Studios: pg. 58, back cover
A.K.A. Advanced Kit Art S.r.l (press office): pgs. 254, 255
Courtesy Arnolfo di Cambio: pgs. 18, 19
Courtesy Artemide: pg. 194, back cover
Courtesy Bluefish studio: pg. 30, back cover
Antoine Bootz: pgs. 110, 111, 112, 113, back cover
Courtesy BPI: pgs. 14, 15, 50
Courtesy Capp St. Gallery: pg. 195
Courtesy Copco: pg. 218
Courtesy Cybercouture: pg. 202
Courtesy Davidoff: pg. 17
Thomas DuBrock: pgs. 126, 127
Courtesy Edra: pgs. 92, 93, 178
Courtesy Egizia: pgs. 86, 87
Courtesy Ferrachi Casa: pgs. 104, 105, 106, 107
Thomas Francisco: pgs. 22, 23, 25, 26, 27, back cover
Courtesy Frighetto: pgs. 82, 143, 180, 181, 222, back cover
Lynton Gardiner: pg. 164
Massimo Gardone: pg. 223
Courtesy Sandra Gering Gallery: pgs. 206, 207
Walter Gumiero: pg. 46, back cover
Neil Hill: pg. 182
Jean-Francois Jaussaud: pg. 138
Lisa Javornick/Javo Studios: pgs. 56, 176, 177
David Joseph: pgs. 258, 259, 260, 261, 262, 263, back cover
Joáo Kendal: pgs. 214, 215, 216, 217
Ingmar Kurth/Constantin Meyer: pgs. 226, 227, 230, 231
Courtesy Leonardo Glaskoch: pg. 175, back cover
Young Lim for gd International: pg. 137
David Marlow: pgs. 40, 41, back cover
Peter Mauss/Esto: pgs. 196, 197
Jean Baptiste Mondino: pg. 48, back cover
Steve Moretti: pg. 183, back cover
Yujin Morisawa: pgs. 148, 149
Cristina Morozzi: pg. 129
Stan Musilek: pg. 28
Courtesy Occhiomagico-Milan: pg. 70, back cover
Dick Patrick: pgs. 20, 21, 139, 165, 166, 167, back cover
Gio Pino: pgs. 96, 97
Nicolas Prahin for Golay: pgs. 12, 20, 35, back cover
John Pylypczak: pg. 160
Peter Räberg: pgs. 100, 101
Peter Ross: pg. 64
Courtesy Swarovski: pg. 192
Ramin Talaie: pgs. 189, 190, 191
Courtesy Toyota Motor Corporation: pg. 131
Courtesy Umbra: pgs. 16, 55, 67, 256, back cover
Adam Wallcavage: pg. 146
George Whiteside: pgs. 4, 5
Courtesy Wovo: pg. 158
Courtesy Zeritalia: pg. 108
Courtesy Zerodisegno: pg. 121

KARIM RASHID KREW

Dennis Askins
Valeria Bianco
Robert Blue
Yoon Sun Chung
Steve Cozzolino
Brian Cutter
Gabriele Haag
Joshua Handy
Jeanne Hardy
Lynnel Herrera
Elysha Huntington
Chia-Ying Lee
Arthur Leung
Rui Morisawa
Michael Regan
Tobias Reischle
Jalan Sahba
Camila Tariki

Book endpapers are Replicant wall covering,
designed by Karim Rashid for Wolf Gordon, USA, 2002

karim rashid evolution